Toward
a National
Taste

Toward a National Taste

America's Quest for Aesthetic Independence

J. Meredith Neil

The University Press of Hawaii · Honolulu

Library of Congress Cataloging in Publication Data

Neil, J Meredith, 1937–
 Toward a national taste.

 Bibliography: p.
 Includes index.
 1. Arts—United States—History. I. Title
NX503.N44 700'.973 75–6873
ISBN 0-8248-0340-X

for *Ginni*

·✠ Contents ✠·

Preface ... ix

1 Democratic Definitions 1

2 The Arts and Civilization 23

3 The Artist as Patriotic Leader 51

4 Sculpture and the Tyranny of the Greeks 96

5 Painting and Engraving: Moralistic Neoclassicism Embattled 106

6 Architecture and Interior Decorating:

 "Elegance and Convenience" 140

7 Music and Dancing: The Rise of Genteel Romanticism 171

8 American Town and Country: Regularity,

 Rural Felicity, and "a Degree of Wildness" 202

9 From the Grand Tourist to the Romantic Traveler 236

10 Conclusion 267

 Notes ... 283

 Bibliography 359

 Index ... 391

ᴇᖚ Preface

*T*he scholarly treatment of nationalism has a reasonably
long and rich history, and recently some sophisticated
comparative studies have responded to the obvious need of de-
veloping relevant guidelines for newly independent nations.[1]
But so far, the books and articles of this type have largely
ignored the aesthetic dimension of cultural change and mat-
uration. Consequently we can only make poorly informed
guesses about the importance and the role of aesthetic opinion
in the achievement of full national independence. Is it generally
true that less numerous and more remote peoples "have more
difficulty in coming to feel at home in a new land," for ex-
ample; or can we only say that "the growth of an identifiable
and characteristic culture in a new land is unpredictable; it fol-
lows no particular and established sequence or timetable and is
governed by no known, immutable laws"?[2] Perhaps by limiting
our scope, we can be more affirmative: "The genesis of a local
literature in the Commonwealth countries has almost always
been contemporaneous with the development of a truly national
sentiment."[3] Certainly, there is no "established sequence." One
may readily discover that aesthetic opinion played a crucial
formative role in German and Australian nationalism, while
modern tastes probably resulted from, rather than caused, politi-
cal and social change in Meiji Japan and Risorgimento Italy,
and it remains unclear what position aesthetics held in the
nationalism of New Zealand, India, or the Congo. Not only are
the necessary comparative studies lacking, but few individual
countries have been considered in the light of aesthetic nation-
alism.[4] Consequently, this book hopes to provide a case study by

carefully examining the first efforts to formulate and achieve an American national taste.

Early American taste has been doubly ignored by historians. Looking for native thinkers comparable in stature and coherence to a Winckelmann or Lessing in Germany, a Burke or a Kames in Great Britain, a Diderot or a Voltaire in France, Americanists pass quickly by the first half-century of our national existence to study Emerson, Thoreau, and other giants of the "American renaissance." Part of the reason for this cavalier treatment is that the American early national period coincided chronologically with a major shift in thinking throughout Western civilization, from the Enlightenment of the 1700s to Romanticism in the nineteenth century. While some scholars have grappled with the process of the shift,[5] more commonly the habit has been to devote major attention to each Zeitgeist in its mature form.[6] In American cultural development, this has meant the proliferation of works on the colonial period and for the years after 1820, with the intervening time given only slight attention. This has been reinforced by an apparent lack of first-rate artists between John Singleton Copley and Thomas Cole, or between Benjamin Franklin and Washington Irving.

A far more important reason for the neglect of American aesthetic opinion prior to the mid-nineteenth century is the generally prevailing assumption that "the American environment was not particularly conducive to art, even at the close of the eighteenth century, and not many Americans expressed great interest in it. . . . No American aesthetic theory emerged in their time."[7] To dispatch the latter part of this dictum first, suffice it to say that it rests upon the erroneous assumption that American aesthetic theory might vary from European ones in content but not in form. As should be perfectly clear by the end of this book, many Americans indeed expressed interest in the arts before 1815, though not in the form of systematic treatises. The American declaration of cultural independence involved

as drastic changes in the media of aesthetic expression as in its content. Instead of formal, book-length theories for the learned few, American tastes were formulated and expressed primarily in periodicals for the literate many.

The allegation that America prior to 1800 "was not particularly conducive to art"—what I wish to call "the pioneer fiction"—is so widely accepted as to be a truism. The noted cultural historian Louis Wright has stated the pioneer fiction succinctly:

> The evolution of thirteen separate and distinct English colonies into a nation with a republican government was a slow and arduous process that consumed the energies of its people and left little time for the development of a taste for the fine arts and all that an interest in the arts implies.[8]

And yet it has no firmer factual basis than the notion that Americans evinced little interest in aesthetic concerns. "No other country," one critic recently concluded in exasperation, "seems to have had such talent for disposing, again and again, of its past."[9]

This ritualistic denial of our past can best be understood as one aspect of Americans' insistence that they had a fundamental obligation to bring forth the New Adam. Our "City upon a Hill" would be free of the class barriers, political inequality, and moral corruption that the immigrants fled in coming to the New World. Americans, therefore, persisted in believing, regardless of facts, that everyone had an equal opportunity to gain fame and fortune. Since art patronage in Europe seemed to be dominated by the aristocracy and the Catholic Church, it was literally unthinkable that a republican and Protestant American would have anything to do with such dangerous, if not downright vicious, matters.[10]

This reaction can be clearly seen in John Adams' notes, taken while touring English country seats with Thomas Jefferson in

the spring of 1786. Adams conceded that "Architecture, Painting, Statuary, Poetry are all employed in the Embellishment of these Residences of Greatness and Luxury." But he immediately pointed to "a national Debt of 274 millions sterling accumulated by Jobs, Contracts, Salaries and Pensions in the Course of a Century [which] might easily produce all this magnificence." Artistic achievement seemed inseparable from corruption. Far better, Adams concluded, to take pleasure in the natural beauties of our own land:

> It will be long, I hope before Ridings, Parks, Pleasure Grounds, Gardens and ornamental Farms grow so much in fashion in America. But Nature has done greater things and furnished nobler Materials there. The Oceans, Islands, Rivers, Mountains, Valleys are all laid out upon a larger scale.

Even here, of course, Adams left the aesthetics of landscape unquestioned.[11]

In order to pursue the research for this book, a basic decision had to be made as to the best sources. A thorough examination of contemporary newspapers would have been desirable but was impracticable because of the great mass of material that would have to be covered. Periodicals were a much more manageable source, although those published up to 1815 fill all or part of nearly two hundred reels of the microfilmed American Periodical Series. Magazines had the merit of being relatively broad in their appeal while containing many extensive articles extremely rare in newspapers before the era of the feature story. All nonfictional material conveying aesthetic opinions to be found in American periodicals published in the United States up to December 1815 were analyzed for my doctoral dissertation at Washington State University (1966). The method used for my dissertation may be summarized as a sensitive content analysis that did not use statistical techniques.

After completing the dissertation I felt that its findings

needed supplementing and cross-checking for validity. For this purpose I studied the papers of a few national leaders, ranging from artists (Charles Willson Peale and Benjamin Latrobe) to connoisseur (Robert Livingston) to political leaders with well-known aesthetic interests (Thomas Jefferson and John Quincy Adams) and without (John Adams). I consulted all books containing personal papers of all these men. In addition, I worked carefully through the unpublished Peale and Latrobe papers and scanned the unpublished papers of Livingston and Jefferson for selected topics.

Toward a National Taste integrates the findings from the two phases of my research. From its first stages in 1964 until its completion in 1970 I have incurred a variety of scholarly debts. Professor Ray Muse, who directed my dissertation, deserves a round of applause for his perceptive ability to be helpful without needlessly complicating the task of finishing one's doctoral work. Archival research during the summer of 1968 was made possible by a stipend from the National Endowment for the Humanities. I owe thanks to Sam Houston State College's work-study program for providing a typist during the 1966/1967 academic year, and to the University Research Council of the University of Hawaii for the same service during the 1967/1968 and 1968/1969 academic years. Two men have been particularly important to me: William R. Taylor, who in 1962 and 1963 at the University of Wisconsin initially stimulated my interest in the history of American taste, and Alan Gowans for his scholarly example and his friendship. Finally, I have dedicated this book to my wife, Ginni, as a token of my appreciation for her patience and understanding.

Boise, Idaho
March 1973

1. Democratic Definitions

The first task for Americans in search of a national taste arose from the need for a domesticated terminology to deal with aesthetic issues. In Great Britain and on the continent of Europe numerous thinkers had occupied themselves during the eighteenth century with systematic discussions of aesthetic principles. Only a faint glimmer of that extensive theorizing appeared in post-Revolutionary American correspondence and diaries. As young men of the 1750s and 1760s, John Adams, Thomas Jefferson, and undoubtedly many of their peers indulged, for example, in abstruse analyses of the nature of genius. Very few counterparts of these essays can be found in the writings after the 1770s of either these men or their sons and daughters. Instead, they contented themselves with short, generally simplistic dicta when called upon to voice their aesthetic theories. Indeed, neither Jefferson nor the vast majority of other leaders of the new republic had a philosophy of art in the sense of a clearly constructed, formal system. Much the same can be said for the relevant articles in contemporary magazines.[1]

The postwar American aesthetic terminology cannot be explained as the result of ignorance or colonialism. Literate Americans cited Voltaire, Burke, and other European aestheticians frequently enough to prove that they were known in the United States. Rather, Ameri-

cans were struggling to free themselves from a foreign aesthetic vocabulary with its obnoxious political and social implications. In England the small and elitist governing class, an oligarchy of wealth and power, kept tight control over the standards of good taste. French discussions of taste were dominated by an intellectual aristocracy, with results almost as antidemocratic as in England. Americans, on the other hand, wished to carry the democratic aims of the Revolution into all realms of their life, including aesthetics. By the early nineteenth century a strong critical consensus demanded that American art illustrate the democratic values of optimism, health, cheerfulness, and morality. How firmly entrenched the values soon became may be seen clearly in the schoolbooks of the time. And in order for this to happen, an initial definitional consensus had to be attained.[2]

Americans defining beauty to suit nationalistic ends concentrated upon a few elements. Probably the most repeated motto, "All Things Beautiful in Their Time," suggested the increasing, sentimental emphasis on the passions evident in late eighteenth-century European neoclassicism, though this subjective relativism took on a more cautiously conservative and genteel appearance in America than in Europe. A young lady giving a talk to her academy classmates typically argued that the perfect balance between variation and uniformity that produced beauty could be found in the changes of the seasons and the unifying power of God evident throughout nature. The image of the seasons and of God's controlling law nicely characterized the contemporary American need to balance change with overall regularity and order. A self-styled "Hermit," writing for the *Port Folio*, equated regularity with simplicity and change with re-

finement, concluding, "The perfection of taste will be found in that middle point between extreme simplicity and extreme refinement."[3]

This relativism did not go to the logical extreme of denying any independent existence of beauty. Its American proponents snugly settled themselves in a rather genteel and distinctly simplistic subjectivism, blending Scottish commonsense philosophy with the seventeenth-century "school of taste" known by the phrase, *"je ne sais quoi."* The defense varied in detail. Some argued that "the eye is the inlet of all that is beautiful in nature," asserting that "my perceptions are those of innocent pleasure," yet tacitly suggesting that the structure of the human eye imposed a basic uniformity. Other authors preferred to emphasize that beauty represented "a mean of all the forms which come under our inspection." The blend of acknowledged variation and assumed larger uniformity may be seen in Jefferson's explanation of his description of the Potomac Passage in his *Notes on Virginia*: "It is true that the same scene may excite very different sensations in different spectators, according to their different sensibilities. The sensations of some may be much stronger than those of others." Instinctively, Jefferson limited the qualitative variability of the first sentence to one of mere quantity in the second.[4]

The idea that variety often revealed certain flaws found ready acceptance; indeed, some magazine writers claimed that there could be no sensation of beauty without such flaws. As one put it, just as there could be no sense of pleasure without the existence of pain, "without *deformity* we should entertain no peculiar ideas of beauty," and without these sensations existence would be *"lifeless indolence* without real *enjoyment."*[5]

Grace often received attention as a third important component of beauty. According to the *Boston Magazine*, grace was "the last finishing and noblest part of Beauty," combining flowing movement with the complete avoidance of impropriety. As can be seen here, discussions of gracefulness tended to hark back to and reinforce the idea of a necessary balance between uniformity and diversity. "Ever changing under the eye of inspection," according to one allegorical personification, "her variety, rather than her figure, is pleasing," and beauty resulted from one's appreciation of all her various forms.[6]

The favorite criterion for distinguishing beauty before 1815 was utility, the democratic implications of which John Kouwenhoven has fully explored. The typically "anti-aesthetic streak" of English preference for "a technique rather than a style," as Nikolaus Pevsner put it, received firmer emphasis in America, married to a middle-class, democratic ethic uncomplicated by the intricacies of the English class structure. Numerous expressions of this utilitarian view of beauty appeared in American writing. As early as 1756 Poor Richard preached that "*Simplicity, Innocence, Industry, Temperance*, are Arts that lead to Tranquility," defining simplicity as "pure and upright Nature, free from Artifice, Craft or deceitful Ornament." After the War of Independence, magazine readers frequently were assured that "after all, elegance is but of secondary consideration; usefulness is of the first." However, the best statement of this view, anticipating Horatio Greenough by a generation, appeared in an 1808 series published by the *Lady's Weekly Miscellany*. Succinctly, the anonymous author stated the doctrine of "Form Follows Function":

The ancients had the most enlarged and elevated notions of beauty; they did not look upon it as a mechanical assemblage of purely material perfections. They remarked, that all the objects of nature have a form peculiar to themselves. . . . Hence, they could not but conclude, that, as the nature of each object was different, their beauty must likewise be different. . . .

Since beauty varies according to the different nature of objects, beauty, therefore, is nothing but the expression of the perfections of the object. We may consequently assert, that an object is beautiful when it possesses the perfection of its nature.

Beauty, therefore consists not in any particular form, but in the relation of those forms to the functions for which they are intended.

We can see here, at least in embryo, several of the most important strategies by which aesthetic nationalists fought their way free of European control. Frequently, the power of prevailing European aesthetic doctrine was refuted by reference to the examples and ideas developed in ancient times. Thus, the presumed need for collections of art, obviously a barrier to rapid aesthetic development in an America without such collections, was cast aside by citing the ancient doctrine of functionalism. To distinguish this variety of functionalism, which emphasizes use, from that focusing on symbolism, let us call it instrumental functionalism. Though seldom stated so clearly, this doctrine governed the thought of many Americans when they made aesthetic judgments, long before Greenough "pioneered" an American critical theory. On occasion, instrumental functionalism could throw into doubt the validity or meaningfulness of all systematic theories. Magazine editors enjoyed quoting Voltaire: "Ask a toad what is beautiful, what is

perfect beauty, he will answer you, it is his female."[7]

Seldom were European thinkers so approvingly cited. At a time when British and Scottish critics vigorously debated the proper distinctions among beauty, sublimity, and the picturesque, Americans remained largely uninterested in anything beyond very basic definitions. John Adams voiced a common opinion when he wrote Jefferson that metaphysicians, within which category he lumped aestheticians, could only "pretend to fathom deeper than the human line extends." Though Jefferson, in his reply, defined such thinkers as "investigators of the thinking faculty of man," on other occasions he would also use the word *metaphysical* in a pejorative sense. The great aesthetic debates of Europe received very short shrift by American writers. Generally, beauty was held to evoke a "calmer emotion than sublimity, . . . more gentle and soothing, [that] does not elevate the mind so much but produces an agreeable serenity." Sublimity, by contrast, produced "that sort of delightful horror, which is the most genuine effect, and truest test of the sublime," usually from sheer vastness. As for the picturesque, "roughness, . . . sudden variation, and a certain degree of irregularity, are ingredients in the picturesque, as smoothness, gradual variation, and a certain degree of uniformity are in the beautiful." Such definitions certainly placed few educational or perceptual barriers between discussions of taste and most Americans; this, apparently, was the intended result.[8]

American distrust of, or indifference toward, serious philosophical discussion of aesthetic theories clearly revealed itself in their treatment of European books on the subject. We can imagine the situation in many private libraries when we hear that the painter John Trumbull shipped home in 1803 his library of 725 volumes, only

one of which was an art book, and that one a travel guide
to Italian art collections. Charles Willson Peale long
treasured his copy of Matthew Pilkington's *Gentleman's
and Connoisseur's Dictionary of Painters* (London,
1770), but more, perhaps, because it served as his fam-
ily's place to register births and deaths than for any in-
fluence it had on his taste. If American artists showed
little interest in theoretical treatises it should come as no
surprise to find their countrymen at least equally un-
responsive.[9]

Book reviews in American magazines may be taken
as a fair measure here. The steadily increasing volume
of reviews after 1800 mainly considered belles lettres
and travel accounts, paying very little attention to philo-
sophical works. Editors sometimes took snippets from
Burke's writings on the sublime, but only two reviews
of his works appeared up to 1815. The first, in 1795,
dealt only with Burke as an oratorical and prose stylist.
The *Port Folio* of 1813 included a long review of Vol-
ume 9 of Burke's collected writings, largely a series of
quotations pertaining to the American and French Revo-
lutions. In neither case did the reviewer even mention
Burke's aesthetic theories.[10]

The first American review of Hugh Blair's *Lectures
on Rhetoric and Belles Lettres*, an important statement
of the Scottish critical school, came as an extract from the
English *Annual Register of 1783*. It damned the work
with faint praise: "Just such a work was wanted for the
instruction of young gentlemen." More typical of
American reviewers was the complaint that the *Lectures*
evidenced "very little else than a dull compilation of all
the commonplace criticism, which before his time, had
been scattered up and down in various volumes, ancient
and modern." *Salmagundi's* William Wizard quickly

dispatched Blair: "His *Lectures* have not thrown a whit more light on the subject." Americans might accept Blair as a useful textbook or reject him for being dull; neither response involved any serious appraisal of its philosophical merits.[11]

The one systematic work to receive widespread attention was the second edition of Archibald Alison's *Essays on the Nature and Principles of Taste* (1811). The first edition, published in 1790, obtained no significant consideration either in Great Britain or the United States. By 1811 English and American readers were ready to consider the revolution in aesthetic speculation entailed in Alison's theory of associationism. Rejecting the existence of intrinsic beauty, Alison's *Essays* voiced a thorough subjectivism based on the belief that human aesthetic responses came from a pleasurable series of memories and fancies. Americans tended grudgingly to grant Alison "considerable praise" for ingenuity, "great accuracy of observation," and "a manner singularly engaging." Yet they were not persuaded to accept his conclusions that went beyond the important place of the mind vis-à-vis beauty. A major fault of Alison, according to American reviewers, was his concentration on psychological analysis, "so repugnant to the common sense of mankind and to almost all the disquisitions on beauty." Furthermore, Alison's systematic approach, like that of all philosophers, suffered from the fact that "the habit of mental speculation blunts the natural feelings of every sort." Careful aesthetic analysis, in short, violated common sense and seriously weakened one's sensibilities. Even more than the Scottish propounders of the philosophy of common sense, Americans were loath to tolerate any thought not readily perceivable by the ordinary adult.[12]

The moralistic implications of Alison's associationism could not fail to interest Americans of the early nineteenth century. Perhaps a few would agree with Jefferson's belief that taste "is not even a branch of morality" and that "we have an innate sense of what we call beautiful." For most Americans, however, Alison had the virtue of emphasizing the dependence of human beauty on the moral sense rather than on any combination of forms and colors. On the other hand, the argument that good taste tended to form good morals "completely inverted the right order of things." The *Christian Observer* probably expressed a widely held American preference for "a far less dubious, and therefore, more important doctrine, which is, the *necessity of religion to the highest enjoyments of taste.*"[13]

The moralistic bias in American discussions of beauty is nowhere more evident than in the hundreds of articles appearing in American magazines describing and prescribing human—that is, feminine—beauty. They constantly reiterated the same themes, showing a very strong consensus that is only re-emphasized in the writings of Jefferson, Adams, and other contemporaries. By their numbers and tone one gathers that these discussions arose from a compulsion, based on both religious and political fears, to defend the consensus against common indifference. The usual short article entitled "On Beauty" began by distinguishing two kinds of personal beauty: one of the mind, consisting of virtue and wisdom; the other of the body, based upon "just proportion of the parts," "disposition of the features," complexion, and "shape and mien." Corporeal beauty, a great gift of nature, often led to a "vicious taste" prizing only external beauty. Indeed, "properly considered," physical beauty deserved "no real estimation," since people soon

forgot the looks of those they knew. Physical attractiveness proved to be nothing more than "a varnish, which dame Nature uses to gloss over her works." Partaking of a rhetoric long since domesticated by *Poor Richard* and similar works, these articles revealed in their moralistic emphasis the devaluation of external beauty to a dangerous "varnish," and in the strongly didactic tone, a fear that people could and would forget their scruples by taking pleasure in the "vicious taste."[14]

The religious objection to an interest in physical beauty started with the reminder that only God was truly lovely. Therefore, it followed that "a lovely soul [reflecting God] is the essence of beauty." At best, external beauty reflected the internal harmony "like an instrument turned in concord," and only "when all the faculties of the soul harmoniously conspire in their several operations in due proportion to their nature" would the external reflection be truly pleasing. Right-thinking people, consequently, recognized that the real criteria for physical beauty were such moral attributes as animation, wit, and virtue, without which the finest features, symmetry, and complexion would fail to impress. Allegorically, Venus always appeared to her greatest advantage when accompanied by Wit. The pervasiveness of this viewpoint may be seen in a comment of Benjamin Latrobe, scarcely a strict Christian, when he saw the "beautiful faces and forms" of the ladies at a ball in New Orleans. Remembering the sights of aristocratic belles harshly chastising their slaves, "I fancied that I saw a cowskin in every pretty hand gracefully waved in the dance; and admired the comparative awkwardness of look and motion of my countrywomen, whose arms had never been rendered pliant by the exercise of the whip

upon the bound and screaming slave." Physical beauty marred by even the memory of vicious temperament held no attractions—at least none to be admitted—for Latrobe or most Americans of his time.[15]

But why did these discussions almost always imply the feminine gender? Were there no handsome men in America threatened by the "vicious taste" of over-emphasizing their physical attractiveness? Of course. But they had the vote and other legal rights, which the equalitarian rhetoric of the Revolution suggested to some women that they should share. The moralistic didacticism of definitions for human beauty helped to fend off the first stirrings of feminism in America. Many of the Founding Fathers had wives and women friends who repeatedly reminded them, as Abigail Adams wrote to her husband, of the "trifling, narrow, contracted education of the females of my own country." The men had no trouble seeing that equality in education might all too soon lead to pressures for equality in the political and social spheres. The tactic they chose to put down this incipient rebellion may be seen in John Adams' reply to his wife: "Your sentiments of the importance of education in women are exactly agreeable to my own. Yet the *femmes savantes* are contemptible characters." In other words, agree to more education but be sure that it is kept safely domestic and genteel in nature. Jefferson was no more responsive to the women's desires than was Adams, writing from Paris that "our good ladies, I trust, have been too wise to wrinkle their foreheads with politics. . . . They have the good sense to value domestic happiness above all other, and the art to cultivate it beyond all others." Accordingly, he carefully arranged his daughter's curriculum to include music, drawing,

dancing, French and English literature, but without any of the history, law, or other subjects needed for entry into public life.[16]

In view of the potential danger of feminism, the upbringing of young ladies required careful consideration, and numerous magazine writers, virtually all of them men, pondered the matter. They tended to agree that it required a careful blending of the dictates of nature with some civilizing cultivation. "Beauty, like Truth, never is so glorious as when it goes the plainest." Yet native beauty left unrefined was like a precious stone left unpolished. "Spirit of '76" declared American women to be far more beautiful than Europeans. "The Italian *Brunette*, or the French *rogue*," he proclaimed with a flourish, "can never excell the ruddy hint of health, unmixed with artificial color, which decks the blooming complexions of the fair daughters of Columbia." Still, the dangers of vanity required "ornamenting their minds" if they were to avoid becoming "a burthen to society." The requisites for an attractive woman, then, included not only virtue, modesty, and good nature, but also good sense and "good breeding."[17]

Just as surely as in the discussions of beauty in general, the essayists on human beauty took a functionalist position. The purpose of feminine attractiveness was not to enable a woman to get a good job or be elected to office; all thoughts should be directed toward the encouragement of good marriages, and such frivolous considerations as figure and complexion had to be put in their very subordinate place. Some writers, fearing a shapely girl's vulnerability to flattery that would cause her "to come to grief," found relief in the fact that most women were not externally beautiful. This "wise and benevolent dispensation of Providence" encouraged compensatory

efforts at self-improvement in amiability and virtue. One enthusiast even penned "An Eulogy on Ugliness," noted the frequency in history of evil beauties like Cleopatra and Helen of Troy, and concluded: "Come, then, grim-visaged maulkin, Ugliness, come with thy goggle eyes, and snaggy teeth, thou antidote against inordinate desires."[18]

Most beautiful wives might avoid moral depravity, but too often they tended to be shallow and boring, in marked contrast to the radiance of the charming woman of plain looks. This explained the great need for "improving the mind" of the attractive young lady. Critics urged her to realize that "a little taste for the fine arts . . . will be of singular use." Prior to marriage, these accomplishments would enable her "to become entertaining to all." After she had found the right young man and married him, "it is impossible a woman can too much study the *taste* of her husband; and she must likewise endeavour to excel in those amusements which he most approves." The implication that a proper young woman and wife should be a docile and virtuous adornment to her husband frequently received explicit statement. Ideally, a man would be noted for his intellectual and physical strength; women "can only expect to please the senses." Her only active role of leadership permitted in this scheme of things came from using her charms to "promote good breeding, learning, and taste in the world" by making her home the fountainhead of culture.[19]

Americans of the early Republic clearly agreed that the development of good taste was of crucial national importance. When Jefferson professed himself "an enthusiast on the subject of the arts" he voiced, as we shall see, a belief widely held among his fellow Americans:

"Its object is to improve the taste of my countrymen, to increase their reputation, to reconcile to them the respect of the world and procure them its praise." The question remained as to the proper basis of a refined taste. Magazine writers in the first generation of national existence devoted considerable effort to come up with an answer that fit the needs of an American, democratic aesthetic.[20]

Some answered that sensibility, "when it proceeds from right principles of taste, and is happily tempered by reason," yields a correct, refined taste. Though the emphasis upon sentiment tended to increase throughout the period to 1815, the modifying allusions to reason persisted. Authors often contented themselves with reiterating that " a *good Taste* seems to be little else than *right Reason,* which we otherwise express by the Word *Judgment.*"[21]

This tautological approach went nowhere unless one presumed some external authority to define the central terms. The matter gained little clarity when certain catchwords were thrown out as tests of "right Reason"— regularity, proportion, uniformity, noble simplicity. Clearly, Americans here merely repeated the clichés of neoclassical doctrine without any real effort either to understand them or to make them nationalistically relevant, showing this approach to be nothing more than the fag end of provincialism.

If traditional aesthetic doctrine smacked of ill-digested European thought, Americans could scarcely avoid recognizing, as they had begun to do a half-century before, that nature in the New World could be claimed in something other than purely European images. Sidestepping the dead end of "right Reason," one could argue that taste could be satisfactorily found by reliance upon principles "drawn from nature." While neoclas-

sicists enjoyed reasoning from nature, they commonly referred to a synthetic, idealized "general nature." Americans preferred to phrase their discussions in a way suggestive of the later Transcendentalists:

> A quick apprehension of these beauties and deformities [of natural scenes], and a lively sensibility to the pleasures and pains proceeding from them, we call *taste*. Taste, therefore, signifies *feeling* corrected, and at the same time heightened by that portion of philosophy which embraces the laws of criticism.

Reminiscent of neoclassicism in its emphasis on laws, this stance nevertheless acquired a readiness to worry less about theoretical correctness in favor of a fresh openness both to beauties and deformities as they were seen. At this point the use of nature as a basis for taste sometimes received an overlay of panting romanticism, marking a transitional stage somewhere between Sir Joshua Reynolds and Ralph Waldo Emerson.[22]

Natural rules for taste provided means for a wide public to approach works of art with some confidence that it had critical tools fitting the predominant functionalist predilections of the period. The "fine oeconomy of nature" whose "beauty is but another name for her regularity" yielded the primary critical rule that tasteful works of art revealed "the preservation of that consistency and uniformity in the moral, which is observed in the natural world." Relying upon the reader's familiarity with the definitions of beauty as a balance of uniformity and variety, and the insistence upon moralistic criteria, this self-styled "Gentleman at Large" inserted a commonsense idea of nature as the underlying sanction for those definitions and criteria. Nature's economy, the argument continued, demonstrated an unswerving adap-

tation of form to function, of means to ends. In the same way, all human art "should be calculated to promote its proper end. . . . any palpable deviation from these purposes, even though attended with pleasure to the imagination, is offensive to taste itself." Fanciful adornments violated functionalist doctrine since "its own proper end" excluded the play of the imagination for its own sake. We can see here how Americans could maintain a check on fanciful excesses, using an austere instrumental functionalism to obviate the need for a foreign, elitist "right Reason."[23]

The weight of tradition and moralistic fears, however, proved too great for Americans to escape easily the compulsion to consult long-respected examples of great art as a basis for good taste. As one reviewer of Alison's *Essays* noted, "The natural feelings of many are corrupted and destroyed by moral depravity and debasement." Since the prevailing interpretation of functionalism depended on a person's acceptance of the normative example of the divinely arranged "fine oeconomy of nature," it followed that moral corruption could rob a man of the essential source of that functionalism. Therefore, some argued, great care had to be taken to nurture instinctive sensibilities, with numerous examples of great art as a safeguard. This, in turn, could easily slide into a prissy avoidance of the unseemly in deciding what constituted great art:

> It is the business of Art to imitate Nature, but not with a servile pencil; and to chuse those attitudes and dispositions only, which are beautiful and engaging. With this view we must avoid all disagreeable prospects of nature, which excite the ideas of abhorrence and disgust.

A painter accepting such a viewpoint would never show a vermin-ridden, half-eaten carcass, though there are,

admittedly, "many scenes of horror, which please in the representation, from a certain interesting greatness" connected with the sublime. Thus, Latrobe reacted in horror at the sight of a clinically realistic crucifix: "The artist had represented the subject so naturally that nothing but habit could reconcile the eye to such an exhibition."[24]

By such a roundabout way the allegedly extraneous and morally suspect pleasure cast out by functionalism crept back into the fold as "suitability." Just as a taste for food was finest when it preferred the salutary, according to a contributor to the *Literary Magazine*, and rejected the noxious, so, in the fine arts, taste would savor the "beautiful, useful, or grand." One pundit summed up the simplistic, relativistic, and class-conscious implications of suitability by defining taste as that which "every body of taste does in polite life."[25]

The dangers of complete relativism in defining taste appeared, indeed, to be as grave as it had been in defining beauty. Customs obviously varied drastically in time and space. The resulting diversity, which had "long staggered the most learned," made any standard of taste seem "so aerial and volatile in its nature that it can scarcely be grasped by the metaphysician." On the other hand, to deny any ultimate standard would not only deny the fundamental similarities among human beings' thoughts and emotions—a belief so basic to Christian and to neoclassical dogma as to make its denial unthinkable—but it would also raise the specter of a most ungenteel populism almost equally unthinkable to the "better sort" in early America. How did one affirm some standard of taste without becoming a metaphysician or a spokesman for "the great unwashed"?[26]

Periodical writers happened upon two acceptable criteria of good taste, both with strong democratic impli-

cations that still preserved an important role for what some have called "the rich, the wellborn, and the able." The first argued that while there "remains a prodigious difference" among men with regard to aesthetic issues, this remained true "only where the public voice has not had time to declare itself." Eventually, perhaps within a generation, the public voice clearly selected the masterly models, such as Homer in literature and Handel in music. Obviously, the educated social leaders would have great influence in shaping and voicing this decision.[27]

The second criterion operated much more immediately, denying the significance of apparent variations among people in their aesthetic judgments. Sir Joshua Reynolds' *Discourses* provided an impressive authority both for rejecting metaphysical jargon incomprehensible to most people and for the idea that "the natural appetite of taste of the human mind, is for the truth." This meant that "what exists in the nature of things is the standard of our judgment; what each man feels within himself is the standard of sentiment." The key term here is "natural appetite." It might well be that fashion, "the offspring of caprice" and "perfectly arbitrary," all too frequently vanquished taste, but that did not disprove the existence of a "natural appetite" common to all men. The power of fashion only illustrated the corruptibility of one's natural taste; his hankering after ephemeral fashions showed the need for education to protect natural taste from becoming depraved.[28]

Both criteria—the test of time and the notion of natural taste—conveniently avoided the dilemma of affirming the existence of intuitive taste while asserting that it remained crude and fluctuating in the thoughts and manners of all but the discriminating few. Accordingly, human genius was held always to develop slowly,

and "the greatest men have but gradually acquired a just taste and chaste simple conceptions of beauty." In contrast to the more egalitarian ideas, which freely termed all sorts of competent craftsmen "extraordinary Geniuses" and claimed that the powers of genius came as gratuitous gifts from Heaven, the aesthetic aristocrats claimed that no untrained person had the good taste to prefer a violoncello to a flute, the coloring of Titian to that of obscure Dutch painters. For such correct preferences, one required "artificial taste"—that is, training and experience—as well as natural sensibilities. Still, the "seeds of taste" were "sown in the breast of the peasant as well as the prince." Everyone, the elitist patronizingly concluded, could concern himself with "neatness of apparel. This principle is equally distributed, and equally within the reach of all."[29]

The popular pressures in America for a democratic aesthetic, to be seen in these reluctant equivocations of the elitists, were strikingly evident in the widespread antipathy for aesthetic expertise. The "discriminating few" found themselves in a position analogous to that of the Federalists in politics, and the art critic had as uncomfortable a public role as the disinterested public servant envisaged by John Adams. The critic had the patriotic duty of aiding the formation of good taste in the new nation, but anything smacking of esoteric terminology was immediately discountenanced. Charles Willson Peale expressed in his autobiography the common suspicion of men who "lard their discourse with lattin terms" and pretentiously "gets by heart the technical terms in Painting." The bias against theoretical precision sometimes reached absurd proportions, and the vocabulary of criticism suffered repeated distortions. The indispensable and varied uses of the word "style" inflated it be-

yond recognition to include the way one knocked on doors or coughed. "Art" became a term to describe any work of great ingenuity, including a lock weighing only one and one-half grains, a "hog-voice organ" for a French king, or a Scottish revenge statue that killed the unwary with poison darts.[30]

The critic incurring American displeasure was indicted for being a connoisseur. Apparently aware of the fashionable and aristocratic origins of the term in eighteenth-century England without recognizing the related effort to educate a wider public, American aesthetic nationalists and democrats took a connoisseur to be one of those importers of criticism engaged in spiteful condemnations of American productions and in manipulating terms like "the miserable juggler." John Quincy Adams, stung into a rage by unfriendly reviews of his published lectures on rhetoric, castigated the *Port Folio* and "all the other federal common sewers of literature and politics" for mimicking a style made fashionable by the *Edinburgh Review*. "They give the title of a book, and then publish a dissertation of their own upon the subject . . . ," he lamented, "tinctured with strong prejudices, mingled up with a curious compound of scholastic dogmatism and fine gentlemantility." A handy definition for children to recognize the villainous connoisseur was offered by one magazine writer:

> Though born in America, he has travelled long enough to fall in love with everything foreign, and despise everything belonging to his own country, excepting himself. He pretends to be a great judge of painting, but only admires those done a great way off and a great while ago.

This unpatriotic pedant sinned especially in encouraging too much concern for technical skill. Every art, of course,

had certain arbitrary rules, as well as being based on nature, and the man of taste had to learn these. But the connoisseur took such pleasure in demonstrations of technique that he encouraged such unpopular excesses as bravura in music and gymnastic feats in dancing. Grace, beauty, and natural simplicity, many felt, failed to receive their proper emphasis.[31]

The proper rules of criticism tended to parallel those distinguishing true beauty and taste. Most importantly, the critic should rely upon "the most plain and simple truths" and "avoid subtle and far-fetched refinement." Preciosity made an able Sophist or a connoisseur, perhaps, but never produced a useful critic. He should take care to focus on the praiseworthy elements of his subject rather than its faults, following the example of the ancients by forsaking the desire "to dispute and cavil by the way, instead of giving ourselves fully to the admiration and pursuit of beautiful truth." This reaction against the examples of the connoisseurs led, on occasion, to a complete disregard for execution. In viewing an historical picture, the spectator should try to forget that it was a picture. Were the actions interesting, the faces expressive? Were you told something remarkable? If one could answer affirmatively, then it was a fine picture. Thus, the doctrine of form following function received such zealous application that form was ignored. The critic should strip away the "merely accidental" embellishments of the artist. If the "spirit, the soul of a performance" seemed trivial, the work might "be compared to a palace of ice, raised in the most regular form of an habitable structure, but . . . totally useless." Therefore, one should judge a piece of art by the thought expressed through it, whether it be in music, painting, or architecture.[32]

The ultimate test for critics, as for taste, had to be

pleasure, again modified by a strong need for suitability. All that was "*low, indecent,* or *disagreeable*" ought to be condemned by the watchful critic. Whether expressed by a critic concerned for the delicate sensibilities of the ladies, or by a tired merchant looking for "relaxation from thought and care," passive acceptance of pleasure bounded by propriety remained the goal for the fine arts. In the increasingly frequent discussions of the character of genius, this meant that the artist did not differ from his audience in the possession of taste, but that, in addition, he had the active, creative touch. Taste and criticism only arranged and digested; "Genius is creative." These attitudes gained force from the concomitant European transition from neoclassicism to romanticism. As Sue Greene has pointed out, that transition, in the New World, also became a transition from British critical authoritarianism to American originality. The romantic emphasis on originality and inspired genius, as we shall see, helped free Americans from British or classic models and doctrines.[33]

The American search for aesthetic definitions, concentrating on beauty, taste, and criticism revealed, we may conclude, a real consistency by 1815, though vigorous debates would continue long thereafter. Fending off or deemphasizing systematic philosophizing, aristocratic predilections, and mindless trailing after Europe, American writers repeatedly emphasized their preference for instrumental functionalism, morality, equalitarianism, and nationalism in aesthetic judgments. No American had yet pulled all of these elements into a single doctrine, but a consensus awaited such an undertaking.

2. The Arts and Civilization

*A*mericans had a very specific motive for endeavoring to formulate distinctively American aesthetic concepts and terms. They were necessary, it was commonly believed, if an American taste were to be fostered, which, in turn, had to appear if full national independence were to be achieved. The aesthetic nationalism so evident in American thought and actions at least up to 1860 has recently received some attention from historians. Both Neil Harris and Lillian Miller have produced very useful studies, although neither book examined sufficiently closely the first generation of national independence to explain adequately American attitudes toward the arts prior to 1815. Thus Miller claimed that "Americans who reached their maturity between 1790 and 1830 still clung to British neoclassicism as an aesthetic ideal," while Harris concluded that "the complex structure of neoclassical aesthetics was received by Americans in a passive manner. . . . Conventions about the nature of art entered national thought but without any vigorous counterthrusting or measuring." As we have already seen in Chapter 1, such an interpretation simply misses the very real criticism of European aesthetic vocabularies going on in America soon after 1783. In this chapter we will consider the next step in the American search for a national taste—the creation of a rationale for aesthetic progress by selec-

tive adaptation of European ideas to American needs.[1]

The dominant wave of neoclassicism in late eighteenth-century European writers on taste did, inevitably, have its impact on American opinions. Only beginning to work for real cultural independence, thinkers and writers in the United States tended to mirror contemporary European ideas, though with decreasing precision after the 1780s. The heavy archaeological orientation of neoclassical works on the arts resulted, for example, in the frequent citation in American magazines of the German art historian J.J. Winckelmann as a final authority. Seemingly self-evident propositions supported asides like "As to painters, the ancients have never yet been exceeded by the moderns" or "The excellence of the Greek statues is unrivalled." Yet Americans could find little comfort in some of the implications to be drawn from such doctrine. If all the arts reached perfection in classical Greece, then art history portrayed only a long, dreary, unsuccessful holding action. Most Americans preferred a far different historical interpretation. To quote Abigail Adams, "As our Country becomes more populous, we shall be daily making new discoveries and vie in some future day, with the most celebrated European Nation; for as yet; we may say, with the Queen of Sheby, the one half has not been told." Just as in all other aspects of life, so in taste America ought to embody the hope of the future, not the bitter end of decline without even ancient ruins for consolation. The neoclassical correlation between the state of the arts and the general level of civilization strongly implied that the United States represented an advanced stage of decadence before it had had a chance to get fairly started. These ideas could only be intolerable to a people in the first flush of nationalistic pride and stimulated them to

throw off the bonds of neoclassicism in favor of faith in a reasonably steady progress in the arts and in civilization throughout human history.[2]

If the infant American arts were to have any chance to grow to maturity, patronage must be made possible by casting aside the tyranny of the ancients. This need to refute the pessimistic implications of neoclassicism explains an otherwise pointless profusion of magazine articles showing the superiority of modern artists over the ancient ones. Apparently, few could follow Jefferson in his ready acceptance of ancient models for continued emulation while rejecting the "Gothic" idea of "bigots" that "we are to look backwards instead of forwards for the improvement of the human mind." Partisans of modern artistic achievement commonly shook the faith in neoclassical reverence for the classical world in a more roundabout way. They backed their opponents into a trap by using another tenet of neoclassicism: "Refinement of manners and taste ever goes hand in hand with a cultivation of the arts and sciences." It might seem churlish to deny the ancients their laurels in having perfected all of the fine arts, but certainly ancient laws and customs kept women in repressive obscurity; and that proved terribly damaging to the reputation of the ancients in the eyes of the many Americans who believed that "friendly intercourse with the fair sex is absolutely necessary to soften and polish the manners of the people."[3]

A few writers persisted in the claim that ancient superiority in some of the fine arts remained unchallengeable, but the apparent barbarity of ancient civilization greatly reduced their persuasiveness. The ancient poverty of colors in painting (generally asserted by authorities in the eighteenth century) made up only one proof that

"their imaginations were not wrought up to the delicacy of conception and effect which has been attained since." The ancients might be left with the claim of having impressively portrayed "the animal beauties and emotions of mankind," but their artists never enjoyed the benefit of "the improving era of christianity" when "the divinely affected soul of genius transferring its raptures to the canvas . . . is at once beheld!" So thoroughly had the critique of ancient superiority done its work that by 1804 even the conservative *Port Folio* admitted utter defeat: "I know of no. more consolatory reflection, or to the eye of philanthropy, a more exhiliarating prospect, than the striking and universal preeminence of the modern over the ancient world, even when in the zenith of its reputation, and in the most celebrated eras of its renown."[4]

Actually, the result never could have been in doubt. Americans had advanced, in their perception of their surroundings, far beyond colonial incomprehension or provincial timidity. The American scene was vivid proof that human progress could occur, and, if so, then why presume any artificial ceiling set by the attainments of people who had lived in past millennia? Jefferson fully enunciated the vision that Frederick Jackson Turner would eventually make famous. Travelling from the Rocky Mountains eastward, a "philosophic observer" would see all the stages of human history, "from the infancy of creation to the present day." As Americans occupied the West, according to John Quincy Adams, "their moral and political character far from degenerating improves by emigration." Few could have doubted that taste would follow the pattern of demographic, political, and economic development so evident in the United States. Therefore, the causes of artistic and cultural progress were far more interesting than continued

assertions that that progress could be historically defended.[5]

Religion played a primary role. "In every age and country," the *Massachusetts Magazine* acknowledged, religion "has been a presiding cause over rude essays and finished inventions in all the departments of taste." Primitive and pre-Christian as Greek polytheism had been, it had caused the artists, "continually panting after the loveliness of the celestials," to produce their greatest works. By the same token, the crudity of Persian art could be attributed to "the nature of their mythology." The higher moral caliber of Americans augured well.[6]

A variety of other causes of artistic progress received serious attention. Munificent patronage turned out to be essential whether one looked at Periclean Athens, Augustan Rome, Medicean Italy, or France of Louis XIV. A good market and appropriate supporting institutions seemed to be as vital for the fine arts as for commerce. That the history of patronage, like the history of religion, might better be construed as a series of cycles or waves than as linear progress was a consideration of little interest to American aesthetic nationalists. The important question concerned America's chances for greatness in art and taste. They conceived the central issue to be upward progress in America, rather than throughout human history. The probable difficulties of generating sufficient patronage and institutional support in the new nation somewhat counterbalanced the hope gained from the role of religion.[7]

The connection between political liberty and artistic greatness naturally attracted Americans since they felt it to be axiomatic that their country provided more freedom for its citizens than did any other contemporary government. The history of the rise and fall of artistic

achievement in Greece and Rome seemed to depend on the rise and fall of liberty. Americans took this to mean that opulence, thought to be a major cause of the decline in liberty, was very dangerous. Governmental despotism and massive private fortunes alike nurtured toadies and court favorites, not great artists or men of fine taste. Art flourished, however, where governments cherished the liberties of the people. American political and social freedom and the absence of any American Medicis, in short, might well be more important as liberating conditions than the resulting scarcity of patronage.[8]

Frequently, eighteenth-century European theorists had stressed the importance of climate in accounting for the artistic achievements of Greece and Rome. American optimists attempted to adopt the interpretation to favor their hopes by asserting that temperate climate made up "the first and most essential condition" of mankind's physical and moral development. The "delicate flower" of beauty, after all, could not withstand any but the most favorable weather. Partisans of American aesthetic development hastened to deny the significance of the Mediterranean climate for Roman art, pointing out that it had depended on the stimulus of the Greeks. In addition, the Americans noted that northern Europe, with no more attractive climate than America's, had produced great artists. The net result was the neutralization of the importance of climate in producing artistic greatness.[9]

Aesthetic nationalists had less success in responding to the related notion of natural models. Classicists would cite Winckelmann on the importance of the ancient practice of dancing in the nude, enabling the artist to "familiarize himself with all the beauties of nature." In addi-

tion, ancient youths were taught to be graceful in sitting, standing, walking, and running. Aware of the impossibility of following these leads in early republican America, the nationalists, nevertheless, could muster only the weakest of responses. They conceded that such models helped produce great artists, but they tried to weaken the concession by claiming that the artists' students were cowed into blind imitation, thereby stultifying imagination and hastening artistic decline.[10]

The hardiest foes of American artistic development were the widespread, indigenous fears of its political and moral consequences rather than theories about climate or any of the other neoclassical, European ideas. To this domestic opposition the proponents of an American taste devoted their greatest attention. According to the notion of "natural progress," crudity evolved by way of convenience and elegance to nicety, and "the passage is very short from elegance to luxury." The danger of America slipping into tasteless luxury after briefly touching elegance continually worried Americans. Ruth Elson has summarized her analysis of nineteenth-century textbooks: "Art and the decadence of the individual and society are regarded as natural companions in many of these books. . . . the Europe that produced great art is also the Europe of rigid class distinctions, vice, and degeneracy." Also, England provided an object lesson of the hazards of commercialism. As the Reverend John Bennett complained, Englishmen "are too much engaged with trade and politics, to cultivate, in any extraordinary degree, the finer emotions." The sun of the Augustan age had already set, once again showing the dangers of wealth to the artistic and moral integrity of a nation.[11]

An important defense against the corrupting influence of luxury and commercialism could be the influence of

the ladies. When in love, men fell under "petticoat gov-
ernment," and the women might use their power to
refine their menfolk's manners and taste. Apparently,
many Americans acted on this belief. By 1800 painting
and drawing held an important place in every female
seminary; thirty-four teachers, schools, and academies
of drawing and painting were being advertised in Ameri-
can towns and cities; and a large variety of art instruction
books were widely available. Aesthetic nationalists, how-
ever, could hardly take much heart from all this activity.
All too often, the teachers were recent emigrés overly
proud of their training "in the present London style."
Alexander Robertson's drawing school in New York, for
example, proudly advertised its "very extensive collec-
tion of Patterns" from "the chief countries of Europe."
The nationalists would have agreed with John Adams'
exclamation: "My dear countrymen! how shall I per-
suade you to avoid the plague of Europe!"[12]

Proponents of art in America often preferred to urge
the interconnections between art and good taste. Great
art, according to some magazine writers, provided the
opportunity to develop a polished taste, which in turn
elevated manners and morals. At the very least, the
fine arts constituted "a *necessary* ingredient of human
happiness, and our *only* reliefs under the pressure of"
sickness and frustration. More importantly, "to human-
ize and soften the ferocious passions of man . . . the culti-
vation of the fine arts had a very happy tendency to
produce these salutary effects." They socialized man,
rendering him susceptible of the tender emotions of
sympathy and compassion. Thus, taking a leaf from the
book of Alison, American friends of the fine arts hoped
to end objections by establishing a close connection
among great art, good taste, and refined society. Given

that linkage, opposition to the fine arts amounted to a defense of barbarism.[13]

This logical trap could be avoided by minimizing the importance of art in producing a high culture. Evidently the fine arts addressed themselves to the passions and did gain the attention of barbarians. "They have only an indirect tendency, therefore, to render mankind rational" by taming the passions. One might admit that the fine arts turned interest away from "war, gaming, gluttony, and idleness, which are the vices of all savages." But once a modicum of civilization had been gained, the fine arts "have done their duty," and "are of little real value." After all, one writer concluded, Scotland had largely ignored the arts for over two hundred years and yet remained "one of the most fertile measures of intelligent and accomplished men." Presumably, this would justify America's indifference toward the fine arts and, following Scotland's example, suggest concentration on philosophy, medicine, and the useful arts.[14]

A taste for the fine arts, in the opinion of Christian moralists, involved real threats to morality rather than enhancing it. In the first place, artists were thought to be "men of low taste in other respects . . . and profligate in their morals." If one struggled to be a good artist, he might very well endanger his soul by consorting with such people. Certainly, he would damage his social status—"The character of a fiddler certainly suggests no ideas of dignity and honor"—and the moralists found loss of gentility almost as ominous as ethical unsteadiness.[15]

Grave Christian objections could be raised against even a cautious, amateur interest in the arts. Obviously the doctrine of stewardship could not tolerate spending

immense sums for a ballroom gown to be worn only once. That would represent the "most frivolous, transient, selfish" waste of money. Could any expenditures to gratify one's taste be justified in Christian terms? Fortunately for the nationalists, the answer remained in doubt and they never had to cope with an unambiguous Christian indictment. A long, inconclusive dialogue published in the *Evangelical Intelligencer* typified the issues and positions. Hermas and his wife lived in a mansion "not indeed magnificent, but strongly marked with taste" in a setting possessing "an air of elegant simplicity, indicative of nice and unconquerable attachments to nature." This rather stereotyped young romantic, "touched with melancholy," received a visit from his friend, Apelles, an aged, godly minister. Unimpressed by Hermas' claims that he gave generously to charities, Apelles argued that the cost of a tasteful home and grounds showed too little regard for Christian duties. "An attachment to [these ornaments] proves the heart to be in a measure evil, and has a tendency to make it worse." When one's heart stayed closely directed to God, Apelles continued, such frivolous toys were avoided; they only wasted time and thought. The beauties of nature ought to be sufficient relaxation, and "these *refinements upon nature* become necessary more by *habit* than *original* taste." Hermas defended his style of life: "Mere plainness, it seems, has no tendency to meliorate the heart." The Bible taught that a moderate use of the pleasures of this world had divine sanction. Apelles agreed, but with the reservation that the claims of charity had to be met first. An impasse had been reached. "You bear my heart away by your heavenly zeal," Hermas admitted, "but you do not yet convince my reason." The author dodged any resolution by having the two men called to breakfast. Many writers

supported Hermas. "Pilgrim" noted that God "has implanted the love of beauty, grandeur, and novelty, in the soul," and these required timely culture. Consequently, it was blasphemous to condemn the search for good taste. Religious writers sometimes reiterated the aesthetic nationalist view that, in an enlightened age, "you will scarcely believe to what a degree good morals depend on good taste, and good taste on morals."[16]

Though aesthetic nationalists eventually found some allies among Christian moralists, their support raised another issue. What was the true hierarchy among the arts? Clearly, they did not all affect people in precisely similar ways, and therefore some art forms must have more salutary effects on morals than others. A due concern for the welfare of society necessitated emphasizing the more desirable arts. The search for criteria to establish the hierarchy, an endeavor laughably quixotic in mid-twentieth-century eyes, was vigorously pursued throughout most of the 1800s. No consensus emerged, before 1815 or after, but the variety of opinions advanced had all seen print by 1815.

One popular idea emphasized magnitude of impression. Poetry and music, some believed, ought to be most encouraged, for they "have certainly the most powerful influence on the human passions." Unfortunately, this criterion tended to push all of the arts out of the limelight. Sublimity in natural scenes, it was said, brought greater emotional intensity than any painting or music, and yet "the majesty of nature sinks to nothing in comparison with the exercise of heroism and virtue."[17]

The preëminence of the fine arts, especially painting, returned if "fancy" and naturalness were the tests. The *Port Folio* reprinted a lecture by Martin Shee, British academic painter and poet, which sang praises to the

painter. He "pours forth his ideas in the glowing language of nature . . . and approaches nearest to the powers of the Creator in the noblest imitation of his works." Shee was confident that painting remained "the most arduous enterprise of taste . . . the most extraordinary operation of human genius," for it combined powerful impression with immediacy and purity.[18]

Another alternative would be permanence, either throughout human history or of the impression made by an art work upon an individual. The oldest art form in human history seemed to be music, and some took this as prima facie evidence of music's superiority over the other arts. Partisans of poetry's primacy pointed out that music's impact upon listeners, though powerful, rapidly subsided, whereas the younger art of poetry had the most permanent effect of all the arts. Dancing, on the other hand, frequently went to the bottom of the hierarchy for its "merely fugitive amusements."[19]

Some moralists regarded all of the arts as hopelessly ephemeral; after a brief span of attention devoted to any masterpieces, they "must inevitably lose their powers of attraction." In view of man's duty to God to husband time, the fine arts could be defended only on the basis of their tendency "to be solidly edifying" rather than as mere entertainment. But, like the dialogue between Hermas and Apelles, and like so many moralistic caveats, this suggested no clear guidelines for the place of the arts in civilization. The aesthetic nationalists and religious critics were no doubt gratified to turn their attention to the commonly acknowledged enemy of all right-thinking men—the capricious tyranny of fashion.[20]

The threat of fashion diverting aesthetic progress was even more serious than that posed by moralists, since it manifested an unthinking giddiness apparently unre-

sponsive to reasoned argument. As "Clio" wrote in the
New York Commercial Advertiser, "Certainly our in-
dependence ought to extend to dress, as well as other
local habits. We are now grown so rich, are situated so
far off [from Europe], and plainess so much inculcated,
that it is passing strange Americans have not yet accom-
plished this important national desideratum." Unlike
many nationalists, however, Clio concluded that the
fashions then prevalent "are much to my taste." Equat-
ing fashion and taste would probably detour aesthetic
growth into an unmeaning variation of styles and render
the whole struggle for a national taste terribly vulner-
able to religious condemnation. Consequently, Jefferson
and many other cultural leaders of the new nation called
the rule of fashion "a great evil," not merely "passing
strange." Furthermore, they feared that the evil could
not be expunged. "It is the particular domain," Jefferson
wrote in 1815, "in which the fools have usurped domin-
ion over the wise and as they are in a majority they hold
to the fundamental law of the majority." Certainly the
yearly stream of speeches, sermons, and magazine arti-
cles condemning the rule of fashion had achieved no
identifiable change since the 1780s. In the process, none-
theless, the enemies of fashion expressed prevailing ideas
and beliefs that would have a central place in aesthetic
nationalists' prescriptions for a distinctively American
taste.[21]

The variations in fashionable clothes, decorations, and
conduct provoked criticism on a number of counts. In the
first place, the boundless, unnatural fancifulness of
fashions are counter to the need for balancing variety
with order by using nature as a normative guide. Regard-
less of how "preposterous and absurd" fashions might
be, "The Drone" lamented, "custom . . . soon makes

them common." The invidious dichotomy between natural simplicity and reasonableness, on the one side, and customary, artificial absurdity on the other could also be seen in the objection that fashion was essentially "a varnish, much used for the purpose of creating a false gloss. It is like most other varnishes, of a poisonous nature." The ideological as well as physical nature of the poison could be seen in the frequent attribution of a fashionable excess to some foreign, effete aristocrat attempting to hide a physical deformity. Thus the dichotomy of nature and social convention gained strength by the inclusion of democracy, nativism, and moralism on the side of nature.[22]

Fashion threatened any progress toward good taste, tending rather to vulgarity and frivolity instead of elegance. The "Purveyor of Fashions," according to his opponents, generally copied ancient modes ever more tastelessly. The worst fault of this crude stylistic reiteration was its pollution of the well of refined taste: "We naturally look to the female sex as the guardians of purity . . ." since "the female mind is particularly formed to enjoy work that is distinguished for its taste, beauty, and elegance." By distracting the mothers of taste and refinement into an endless, capricious effort to outdo one another, fashion imperiled the whole drive toward an aesthetically superior society. An occasional defender of fashion would argue that its real purpose was the improvement of "the modes of amusement . . . still nearer to that perfection in which they must subsist in the highest states of refinement and civility." The great majority of American aesthetic nationalists immediately shouted down all such heresies.[23]

Aesthetic indictments of fashion invariably drifted into social criticism. As in the effort to formulate an Ameri-

can terminology, the educational and social élite strug-
gled to use the popular appeal of democracy in building
a rationale for progress in the arts without actually
yielding their power to the "mobocracy." At most, the
élite accepted a variety of cultural democracy tightly
leashed by a deferential social system. Consequently,
aristocrats worried over any and all tendencies to blur
proper distinctions, and fashions of dress seemed to do
this in a number of ways. The "meretricious ornaments
of ART," that is cosmetics, like the emphasis on girth
in dresses so prominent in the 1790s, "hides the distinc-
tion that ought to subsist between married women and
virgins." An elderly woman ought to wear clothes "cor-
rectly sober, and suited to her age and station"; in
general, "women should never aberrate from their
proper sphere." American social leaders, it can be seen,
feared fashion as much for its threats to status symbols
as for its deleterious aesthetic impact, though the two
fears reinforced one another.[24]

Properly used, clothing should have served to denote
social rank. When the servant aped or even rivaled her
mistress, both following the same imported fashions, "all
sorts of people are consequently confounded or melted
down into one glaring mass of absurdity or superfluity."
Proponents of such notions indiscriminately mixed aes-
thetic, social, and moral biases. The defense of class
distinctions tied to a genteel hierarchy of mores revealed
once again a prevailing commitment to an instrumental
functionalism supported by what the eighteenth century
called natural philosophy. For example, "The Visitant"
drew from the literary rule that style ought to fit the
subject the conclusion that ornament ought to be used
with great restraint and in accordance with one's means
to be truly elegant. Reflecting an upper-class pastoral

sentimentalism, other authors chimed in to praise the beauties of the innocent and simply decorated country maid as the best contrast to fashionable nonsense and excess.[25]

More commonly, and appropriately for early national America, a middle-class orientation appeared in the diatribes against fashion. The ideal in dress should be an elegant simplicity, which "can scarce be carried too far, provided it be not so singular as to excite a degree of ridicule. . . . though splendor be not necessary, you must remove all appearance of poverty." The middle-class values implicit here were perfectly justifiable, for "the middle ranks of mankind are the most virtuous, the best accomplished, and the most capable of enjoying the pleasures and advantages which fall to the lot of human nature." Not having the time for fashion-minded foolishness, the bourgeoisie proved by example that "there is certainly a standard of rectitude in manners, decorum, and taste," though the upper classes persisted in flitting after new modes and the lower ranks cravenly followed along.[26]

Upper- and middle-class partisans might sometimes quarrel among themselves, but they never doubted that fashion threatened to violate the natural distinctions between men and women. Reflecting the antifeminist bias already seen in the definitions of beauty and taste, they proclaimed that the proper rule, "Appear in your true colors," dictated "beauty, delicacy, softness, refinement" as the criteria for women. Men's clothes "obviously, have a greater proportion of simplicity." Fops and "macaronis" blurred the proper order by competing with women in ornamenting their dress. Fashionable education, on the other hand, might educate women beyond their proper sphere, robbing them of their social

value. "Mary Muslin" complained that her excellent
schooling produced a lamentable result: "I have only
unlearned the language and lost the manners of that
society in which I am to live." That she entitled her
plaint "The Mischiefs of Fashion" pointedly indicated
that Americans before 1815 construed the word fashion
in no narrow sense. Excesses in education as much as in
clothing showed the ubiquitous influence of fashionable
caprice.[27]

The moral dangers of fashion received nearly as unan-
imous a repudiation. Worldliness necessarily aroused
religious suspicions. Since, throughout the world, "*Evil
is a more practiced quality than any other*," "A.M."
reasoned, "we must therefore conclude that the *Fashion
is Evil*." Daringly revealing dresses provoked lustful
thoughts, so fashionable life "must be in some measure
a life of dissipation." To avoid seduction a girl should
strive for modest dignity. Good Christians clearly had an
obligation to avoid luxury and ostentation; "to be easy
and clean" and very sparing in the use of jewelry ought
to be their aim. Quite simply stated, "generally—a
fashionable dress is of all others the most contrary to
Revelation, and the light of nature." The holy orna-
ments of chastity, meekness, piety, and good works made
gaudy decorations utterly needless. The religious jour-
nals fulminated against the giddy "votaries of fashion"
who committed "virtual fornication," thereby polluting
the house of God. The "refined debauchers" of fashion-
able clothing intentionally provoked lustful thoughts,
thereby violating Jesus' warning against lust in the
heart.[28]

The provocation of all this wrath came from the in-
creasing popularity in America of the Empire style from
France. "Modestus" summed up the ensuing change:

> [Before the French Revolution] women had been the slaves
> of silly customs and of ridiculous and *Gothic* fashions; they
> suddenly burst asunder all the fetters which bad taste had
> imposed upon them, and taking as models the *Grecian* wom-
> en, so celebrated for their beauty, they exhibited, together
> with the perfection of taste, a complete neglect of decency.

She concluded by summing up the basic problem: "A
dress too prudish conceals beauty; a costume too free
prostitutes it." She offered as her solution an emphasis
on the Greek feeling for the golden mean—not the
scantiness of attire presumably typical in ancient times—
in following the Greek mode. A few stoics tried to take
comfort in the belief that, though they were confronted
with "a lamentable scene of degeneracy and profligate-
ness," the censors of every age had voiced the same ob-
jections. More commonly, contemporary French fash-
ions were seen as uniquely lascivious, warranting the
sardonic description of a fashionable lady, "Oh! she is a
nude of the *finest transparency*."[29]

Fortunately for Americans scandalized by the Empire
styles, they could base their objections on the emerging
functionalist and moralistic thrusts of American aesthetic
opinion. The distressing frequency of death by consump-
tion among American women seemed to prove the dan-
gerous inadequacy of fashionable clothes. The prevalence
of cotton instead of more substantial materials and the
lack of bulk favored in the Empire style must have been,
critics reasoned, a major cause of feminine illness. One
author no doubt outraged the women with his sugges-
tion that the need for warm clothes required flannel un-
derwear. They may have given a sigh of relief when
other writers urged them to put aside whalebone stays
on the grounds that "everything that confines and lays
nature under a restraint, is an instance of bad taste. . . ."

Invoking nature as a normative guide, the *Literary Magazine* jeered at fashion for bringing forth "a heterogeneous combination of incoherent forms, which nature could never have united in one animal, nor art blended in one composition." Middle-class attitudes coincided nicely with moral objections. The bourgeois interest in efficiency could be easily recast into religious phraseology: "We are forcibly warped from the bias of nature . . . [and] are totally changed into creatures of art and affectation." Evidence could be gathered not only from women's costume, but also in fashionable music and popular perfumes like musk, "the unwholesome juice of dung." Fashion set examples "agreeable to the depraved heart," perverting God's purpose of emulation as the means of socializing the child into a moral life.[30]

The emphasis on the dictates of nature could, conceivably, be turned against the opponents of fashion. "Moranda," a fashionable young girl, strenuously protested the implication that a gay girl should be sequestered in the country to enjoy "the poetical charms of turbid ponds, bellowing cattle, ragged negros." After all, the flowers and trees never showed "that dull simplicity which you recommend to us. . . . Nature made us to be various, changeable, inconstant, many coloured, whimsical, fickle, fond of show if you please." Most of the critics did not please, and quietly ignored Moranda and her ilk as beneath their magisterial notice.[31]

Instead, they tended to agree with Ralph Izard that "a few wholesome sumptuary laws" were needed. Jedidiah Morse and David Daggett, candidates for Master's degrees at Yale in 1786, debated the issue. Their arguments, as we might expect, relied heavily on class-conscious and moralistic ideas. Taking the affirmative,

Morse argued that virtue was essential to the preservation of the nation, and, quoting Montesquieu, "Luxury has a direct tendency to enervate and destroy virtue." Continuing this statement of what Edmund Morgan has called the Puritan Ethic, Morse noted with dismay that luxuries were rapidly progressing in the United States, the housemaid now outdressing her mistress. Furthermore, with the importation of foreign luxuries came related vices; restrictions curtailing the former would end the threat of the latter. Daggett contested the legality and effectiveness of sumptuary laws, insisting, in addition, that luxury had the economic merit of speeding up the circulation of money. With America's vast wealth in natural resources, the economic threats of foreign trade could be eliminated by strengthening the powers of Congress to encourage domestic economic growth. The debate illustrated how eighteenth-century Americans were not anti-aesthetic, as the pioneer fiction has argued, but that they saw aesthetic issues inextricably interrelated with questions of public policy.[32]

Discussions of sumptuary legislation mirrored many Americans' patriotic concern about the foreign source of fashions. "Titus Blunt" expressed a widely held opinion when, condemning fashionably shaped but uncomfortable shoes, he wrote that the "best proportioned shoe" actually fit best, and *"true taste* never deviates from these [functionally determined] proportions." Aesthetic nationalists felt that, left to themselves, Americans would have followed such self-evidently sensible rules without a quibble. "It is the authority of foreign manners," Titus Blunt grieved, "which keeps us in subjection, and gives a kind of sanction to follies which are pardonable in Europe, but inexcusable in America." The moral fiber of the new nation, as well as its taste and

comfort, was imperiled by "this servile imitation of Parisian actresses." Realists recognized that Daggett was right. Banning of obnoxious imports would be intolerable to freedom-loving Americans. The only acceptable alternative would be to urge greater discrimination upon their countrymen. Instead of false diamonds and "French paste," imports ought voluntarily to be limited to "all that is durably useful, and gloriously resplendent"— Parisian sculpture, Italian paintings, Scottish literature, and English justice, valor, and generosity. By eclectically exploiting Europe's treasures, cultural independence could replace continued bondage.[33]

The introduction of greater discrimination would, in itself, evidence a dramatic rechanneling of fashion. Just as a person's dress served as no inconsiderable symbol of his personality, many aesthetic nationalists asserted, so a nation's character could be judged by the prevailing costume. Therefore, Americans should develop a "decorous and comely apparel, in which convenience and elegance might be blended" to show strangers "the political and moral sentiments of our country." Just as surely as every independent country had political sovereignty within its boundaries, so too should it have distinctive customs and manners. Without the latter, a nation's true independence fell into doubt. "It is time for us to lay aside the leading strings to which we have been so long accustomed," and show American taste in clothing.[34]

By 1815 American aesthetic nationalists had firmly put aside the pessimistic implications of neoclassicism in favor of a faith in the evolution of the arts from barbarity to refinement. They believed that the development of American art and taste would recapitulate that in older cultures and not merely mimic foreign styles and attitudes. But this flowering of aesthetic refinement was by

no means inevitable. It was, in fact, imperiled by distractions threatening national refinement, independence, and morality if appropriate actions were not taken. For artistic greatness to appear, a refined national taste had to be secured, which in turn depended on a high level of morality. Fashion constantly tended toward capricious frivolity and vice. Good taste, virtue, patriotism, great art, the subjugation of fashionable variation—all of these were reciprocally interdependent. No better example of how a patriot might try to respond to this challenge can be found than Peale's Museum, one of the most ambitious projects to be undertaken in the first generation of American independence.

Charles Willson Peale (1741–1827) might be rather unkindly characterized as the "illustrator and showman" of the Jeffersonian circle institutionalized as the American Philosophical Society. Actually, he epitomized American attitudes and feelings in the first years of national independence. An itinerant painter who had taken an active part in the War of Independence, his patriotic and aesthetic enthusiasms could be seen in the verve with which he responded to a commission by Congress, in May 1782, to make a public display of transparencies in Philadelphia's State House Yard to honor the birth of the Dauphin of France. Though he would lament, from time to time, that "the state of the arts in America is not very favorable at present," he dauntlessly continued to paint the portraits of Revolutionary heroes for his burgeoning picture gallery. Yet Peale never maintained a wholehearted commitment to his art, for "to acquire knowledge of Natural History is more congenial to my feelings than is the pursuit of works of art which heretofore have engrossed too much of my time."[35]

Even in its origin, Peale's Museum characterized American development. Its ad hoc and pragmatic beginnings paralleled the fragmentary and almost chaotic form of early national aesthetic doctrine. The curious and immensely optimistic effort to weld science, art, and patriotism in a fashionable gathering place emerged only gradually. The museum began simply as a picture gallery, attached to Peale's home in Philadelphia, where he displayed his growing collection of portraits of national heroes. In the summer of 1784 a seemingly unrelated opportunity led to the amalgamation of scientific exhibits with the portrait collection. Peale had been asked to make drawings of a mammoth's bones, and, when he had completed that task, he placed the bones on exhibition in his gallery. The public response, along with suggestions from friends, inspired Peale to organize a real museum. With the inclusion of moving pictures (panoramas on rollers) to enliven the scenes of nature, and the housing of the museum in Philosophical Hall during the next few years, it took its mature shape. Later additions, broadening an already eclectic variety united only by Peale's wide-ranging interests and hopes, followed a similar pattern of accretion. Following the example of the Paris Museum, established in 1794 as a national depository for exhibits of inventions, Peale eventually had a Model Room which included useful inventions—a clothes washer, a threshing machine, and the like—and a variety of exotic curiosa such as casts of fourteen hundred antique gems and the salt cellar of Oliver Cromwell. When a South Carolinian returned to America with a collection of casts of classical sculpture, Peale happily added his Antique Room.

By 1800, Peale had rationalized such a diverse compendium of artifacts to his own satisfaction:

Can the imagination conceive anything more interesting than such a museum?—Or can there be a more agreeable spectacle to an admirer of the divine wisdom! Where, within a magnificent pile, every art and every science should be taught, by plans, models, pictures, real subjects and lectures. To this central magazine of knowledge, all the learned and ingenious would flock, as well to gain, as to communicate, information.

A spectacle it certainly was! With the aid of the map and description of the layout given by Sellers, we may grasp Peale's almost utopian scheme. From the moment a visitor entered the Long Room under the organ loft, and faced a display of hundreds of stuffed birds in simulated natural habitat, overarched by portraits of American worthies, the experience of the museum was one of continuing wonder at the diversity and number of specimens. Unlike some modern art galleries, the intended mood was one of comfortable, dignified relaxation. Among its other functions, the Long Room became "a promenade to show off gay bonnets and cashmere shawls," where one might have a pleasant chat with friends while partaking of the more serious pleasures offered by the museum collections. The visitor could have his silhouette taken by James Peale, enjoy the sensation recorded by Manasseh Cutler—"I fancied myself introduced to all the General Officers that had been in the field during the war"—or admire Peale's "natural curiosities" which "were arranged in a most romantic and amusing manner." In order that the museum's variety be properly impressed on the spectator, the organ played to emphasize the unity and harmony of nature as well as to enhance the richness and dignity of the scene.[36]

Peale's Museum embodied far more ambitious aims than its minor American counterparts. It aimed far higher than, for example, Waldron's Museum in New York, which promised, "Those who have no leisure to read, may, at a trifling expence, furnish themselves with a considerable portion of knowledge." Waldron's advertisement moved closer to the spirit of Peale's Museum when it advertised, "Even a slendor knowledge of nature removes a certain littleness of mind, protects us from compositions which affected greatness too often attempts on ignorance and credulity, and calls forth emotions of gratitude to the great Parent of All." Peale did wish to aid in refining American taste, avoiding all improprieties: "Nothing must have a place in this museum which can call up a blush." In addition, he welcomed the chance to overcome the antiartistic implications of his belief that "the pleasure arrising from the contemplation of the beauties of nature are pure," while with "works of Art, we may admire them for a time, and the relish passes away." By uniting the purity of nature with the "relish" of art in a museum focusing on American examples, Peale could hope to bring together into one impressive whole most of the divergent tendencies pulling at himself and his countrymen. As summed up by Sellers, "Here he would propound the Philosophy of Reason by bringing all nature into one comprehensive view— unite Art and Science, and with them paint [an American] 'world in miniature' ". It would be, in short, "a new kind of painting." In the process, he would generate patronage for American artists— painters, sculptors, and musicians—and "diffuse a beneficial taste and knowledge" throughout the land.[37]

The genteel, patriotic combination of salon, circus,

and school struggled along from crisis to crisis, and only
its author's self-sacrifice and endurance kept it from
lapsing into its constituent elements, which it did soon
after Charles Willson Peale's retirement. A brief ex-
amination of the museum's difficulties and handicaps will
point up the obstacles facing other aesthetic nationalists
in their efforts to inculcate an American taste. Perhaps
most fundamental, the ambitious nationalists suffered
from the serious weaknesses that were the obverse of
their strengths. Spreading their interests as wide as they
did, to encompass a multitude of ideas, institutions and
art forms, they could scarcely avoid a dangerous dis-
persal of energies. Peale confessed in a letter to a patron,
"I know the interest you took for my welfare and success
as an artist—and the same perseverance I have pos-
sessed, might have been directed to better effect, but like
a child of Nature unrestrained, I have strayed a thousand
ways, as the impulse lead I drove on with little regard
to the result." His "straying" brought his museum into
being, but it also gravely endangered its longevity. And
since it was essential to his conception of the museum
that "I can only make the foundation and Posterity must
finish it," it faced almost certain failure.[38]

Peale's public was not essentially different. It, too,
had many claims on its attention and appeals for sup-
port. That being the case, continuous dedicated ingenuity
had to be exerted to obtain and hold public interest.
Peale tried to gain official recognition and financial back-
ing from local, state, and national governments with
only indifferent success. But without widespread public
attendance, even generous governmental aid would not
have prevented the failure of Peale's hopes. Conse-
quently, he repeatedly worked for new ways "of pleas-

ing the public and thereby obtaining funds to enlarge and extend the usefulness of my Museum." It needed money if it were to continue, but its utility to the public would be measured mainly by the volume of attendance and proportionally large receipts from admission fees. Only in Philadelphia, according to Jefferson, had an American museum "succeeded to a good degree." That it took "a measure of zeal and perseverance in an individual rarely equalled" and "a population, crowded, wealthy, and more than usually addicted to the pursuit of knowledge" suggested trouble for less ambitious or less fortunate proponents of an American taste.[39]

Finally, Peale in developing his museum, and other aesthetic nationalists in propounding their ideas confronted a vicious circle. They strove to create an American taste to patronize American artists, but the artists who would benefit from this interest had to visibly exist for the patronage and applause to be generated. National tastes and national artists somehow had to be brought forth at the same time. Peale's difficulties in getting musicians to perform in the museum symbolized the dilemma. A group of amateurs played, but only for "a short time for some of its active members leaving the City and no profit accruing for their trouble. The opportunity of practice only was not sufficient stimulus," he drily concluded, "therefore once after falling off it was given up." Hearing from his friend, Vaughn, "it is astonishing how much money Bowen makes by such arts in his triffley museum at Boston," Peale toyed with the idea of hiring a professional organist for the museum. Regardless of his success in solving these music problems, the dilemma remained. Patronage in America warranting artists to become professionals would not appear

until the artists had created a demand for their work by producing a large corpus, which, in turn, probably required full-time efforts. How aesthetic nationalists coped with this dilemma, how they envisioned the place of the artist in American life, requires a separate chapter.[40]

3. The Artist as Patriotic Leader

*A*mericans of the early national period assigned to artists a dual patriotic role. Not only would they foster an American aesthetic. By their very existence they would refute the evolutionary theories of such Europeans as the Count de Buffon and Abbé Raynal alleging "the tendency of nature to belittle her productions" in the New World. If, indeed, "America appears to hasten towards perfection in the fine arts," thereby disproving Buffon and Raynal and their followers, then first-rate artists had to be visibly in evidence. Defensive-minded Americans could agree with Jefferson that "our difficulties . . . when viewed in comparison to those of Europe . . . are the joys of Paradise." They firmly believed that "our own country . . . is a new creation; made on an improved plan." Aesthetic nationalists also welcomed Jefferson's observation that "in science the mass of [European] people is two centuries behind ours, their literati [merely] half a dozen years before us." Nevertheless, more impressive proofs of American cultural progress had to be found.[1]

Jefferson's *Notes on Virginia*, therefore, received a warm welcome from aesthetic nationalists. In general, it could be taken as a book-length refutation of the belief in New World devolution. Specifically, Jefferson vigorously responded to Raynal's exclamation, "One must be astonished that America has not yet produced a good

poet, an able mathematician, a man of genius in a single art or single science." Citing the stature of George Washington and David Rittenhouse, Jefferson proudly went on to assert, "As in philosophy and war, so in government, in oratory, in painting, in the plastic art, we might show that America, though but a child of yesterday, has already given hopeful proofs of genius." Magazine writers enthusiastically added that "the time is come to explode the European creed, that we are infantine in our acquisitions, and savage in our manners, because we are inhabitants of a new world, lately occupied by savages." The author of these "Thoughts on American Genius" triumphantly pointed to the success and fame of American painters in Europe as conclusive evidence of "peculiarly strong talents for painting" among their countrymen. The critical esteem for Benjamin West and John Singleton Copley could not be gainsaid. Younger men like John Trumbull, it was hoped, would maintain the exalted position established by West and Copley in Europe. Gilbert Stuart, Washington Allston, and other American painters also received occasional mention in the repeated assurance that "the seed is not the flower," and the United States would undoubtedly excel even more in the future.[2]

A few dissidents could be found. Latrobe, in one of his pessimistic moods, doubted "any operation on public taste to be within the power of any pen whatever." Alternatively, one could deny any cause for concern, as John Adams did in his inaugural address to Congress: "The existence of such a government as ours, for any length of time, is a full proof of a general dissemination of knowledge and virtue throughout the whole body of the people." That being the case, "what object of consideration, more pleasing than this, can be presented to

the human mind?" It was no accident that Adams, late in his presidential administration, opposed the emigration to America of "schoolmasters, painters, poets, &c." Glumly noting that all of them would be "disciples of Mr. Thomas Paine," he wrote to John Marshall, "I had rather countenance the introduction of Ariel and Caliban, with a troop of spirits the most mischievous from fairey land." The political dangers of imported artists reinforced some Americans' belief that the American landscape could compensate for underdevelopment in the arts. As one author, who took the ponderous pseudonym of "Philoenthusiasticus," put it, "The beauty and sublimity of nature in this western world far transcend the most celebrated description." The United States had the mightiest rivers, the highest mountains, and the most "verdant meads." Carping critics who still insisted on great American artists, therefore, should be dismissed as "shallow, chattering animals" and *literary foplings.*" The editor of the *Emerald Miscellany of Literature* serenely admitted that America had little or nothing of "that perfection in the fine arts, which ennobles the Italian school," but went on to explain that America had no need for those unreal likenesses "when nature has favored us with so many lively originals." Such interpretations continued, however, only as a very muted counterpoint to the dominant refrain of aesthetic nationalists.[3]

Americans were convinced, as we have already seen, that their new nation should have an elevated democratic taste. "A cultivated taste for the polite arts," the idea went, "improves our sensibilities for all the tender and agreeable passions . . . ; nothing is so improving to the temper," both individually and nationally, "as the study of the beauty either of poetry, eloquence, music or paint-

ing." Hence, alarm spread when foreigners observed
that "luxury in North-America always turns upon objects
of vanity; never to the productions of the fine arts." The
German tourist making this statement added that Ameri-
can indulgence in decadent sensual luxury belied the
notion that they were still too young a people to produce
a great artistic culture. John Quincy Adams grudgingly
acknowledged that the "continued libel upon the charac-
ter and manners of the American people" had "too much
of truth" in its contents. The German tourist's translator
felt that the fine arts could counteract the coarse inclina-
tions toward sensual luxury or at least, in the absence of
simplicity, act as a palliative. Artists had the crucial role
"to awaken taste . . . in order that our stately edifices may
not shock the eye of science, and remain lasting monu-
ments of self-sufficiency, and barbarism."[4]

The linkage of those two terms, self-sufficiency and
barbarism, indicated a widespread reluctance to trust en-
tirely to American resources. Magazine writers ran-
sacked the annals of every imaginable country and time
for useful examples from other nations to emulate. The
Dutch attracted special attention: they were a commer-
cial people, and presumably therefore of crude tastes,
yet they had produced an impressive number of great
artists widely appreciated by their countrymen. Ben-
jamin Austin, Jr., visiting Amsterdam in 1784, reasoned
that national pride guarded the Dutch from blindly
copying French or English styles. The practice of Dutch
merchants to subordinate the fine arts to commerce by
speculating in art works as in other commodities seemed
far better to moralistic Americans than throwing money
away on gambling, horse-racing, or other degrading
pastimes. The ownership of fine paintings, regardless of
the motives behind their acquisition, inspired Dutch chil-

dren with a refined taste. Why could not Americans fol-
low suit by owning one or two worthwhile paintings,
rather than several "bad prints displayed in costly
frames"? Upon closer analysis, the Dutch example
seemed less appealing. They had achieved a widespread
appreciation for painting, but "every amateur is aware
that the [Dutch] national taste has degraded the noble
parts of this art," by overvaluing high finishes and vul-
gar realism. There were also horrible examples of Dutch
obtuseness that threw their aesthetic awareness into seri-
ous question. What could one do, for example, with a
Dutch merchant, visiting London and taken to view St.
Paul's Cathedral, who contented himself with the dis-
covery that the cathedral clock showed that his watch
had lost only thirty seconds in fourteen days? Aesthetic
nationalists eventually concluded that their cause would
be best served by emphasizing domestic resources.[5]

Fortunately for the nationalists, American artists in
the last years of the eighteenth century had begun to
shed their anonymous craft connections and move toward
an awareness and pride in themselves as professionals.
This led to a dramatic and fundamental change in their
public visibility. As Alan Gowans has explained, the
quest for the names and credentials of architects prior to
the 1770s confronts the discouraging fact that architects,
as we understand the term, did not exist. Artisans and
designers collaborated, while "the man who at once in-
vents great ideas and gives them great tangible expres-
sion did not belong in this age." What this meant in
practice may be seen in a 1751 South Carolina news-
paper advertisement placed by Dudley Inman, "Carpen-
ter and Joyner, lately arrived from London." He
promised to "chiefly adhere to either of the orders of
architecture," adding that "he likewise gives designs of

houses according to the modern taste in building, and estimates of the charge." Though Inman told his readers that skill in building "is a talent (as all others) brought into the world with a man, and must be cultivated and improved with the same care and industry as such others," this immediately followed the announcement that he hung bells in the "best, neatest and least expensive manner." Both Inman's varied talents and his overly pretentious language—what did it mean, for example, to "chiefly adhere" to the classical orders?—proved him to be part of the older tradition of master builders, not an architect in the modern sense. The situation in the other arts was quite similar. Professional musicians filled the concert orchestras only after the Revolution. Colonial American painters readily shifted, as occasion required, from painting of faces to signs or carriages. John Winter, in 1771, advertised several of his paintings, including a landscape "representing the evening, painted after the manner of Pusine" (that is, Poussin), and "a fire piece, representing a large pile of buildings on fire, copies from one of the best pieces extant." The same advertisement noted the painter's ability to simulate interior stucco work, cut letters for printers' fonts, paint carriages, and clean pictures. Clearly, this was a level of versatility and competence that met the needs of an earlier America, but could scarcely satisfy the rather grandiose aims of aesthetic nationalists.[6]

The move toward professionalization of artists after the Revolution, giving some encouragement to the nationalistic hopes for a rapid achievement of American greatness in art and public taste, may be symbolized by the attitudes of Latrobe and Peale. In opposition to men like Dudley Inman and organizations like the Carpenters Company of Philadelphia, Benjamin Latrobe prided

himself on being "the first who in our own Country has endeavored & partly succeeded to place the profession of Architect and civil Engineer on that footing of respectability which it occupies in Europe." The key words here were "respectability" and "Europe." Trained in London and in continental Europe, Latrobe held throughout his American career an interpretation of professionalism that frequently identified it with the eighteenth-century European conception of a gentleman. His protest to his son-in-law, "I feel a kind of aversion to be a Whiskey agent as derogatory to my character as a professional man," revealed a class bias against a given activity at least as much as a professional's desire to protect his reputation. Similarly, Latrobe refused to charge more than his office costs for designs of churches, college buildings, and other structures for nonprofit institutions. Latrobe's professionalism, in short, had the not-quite-coherent, not-quite-modern flavor of Thomas Jefferson's humanistic notions of democracy.[7]

If Latrobe can be seen as the aristocratic dilettante becoming a professional, then Peale's career marks a converging movement from the opposite direction from the anonymous world of the craftsman. Starting his life as a saddlemaker and accidentally stumbling upon a market for paintings that he could satisfy, he changed crafts in the belief "that he possibly might do better by painting, than with his other Trades." Peale commonly referred to his art as "the business" and seemed to make no fundamental distinction between the art of a mechanic or an inventor and that of a painter. To draw only two of many possible examples from his correspondence, he could write about fire engines and cite "another artist by the name of Lyon [who] says a powerful engine . . . ," or, with regard to improvements in an early copying

tool, the polygraph, "if artists would take pains in form-
ing such Pins and give them a proper temper. . . ."
Peale's concept of the appropriate social status and mores
for an artist contrasted sharply with Latrobe's. Instead
of the noblesse oblige of the gentleman, so essential to
Latrobe, Peale took the stance of the modest workman.
He summarized his view by quoting his first patron:
"Mathias Bordley used to say, everything should be neat
about a Painter. I insist on it, that every action of them
should be good, in gratitude for the powers bestowed
on them."[8]

The different origins, ideals, and class affiliations of
the Latrobes and the Peales generated many difficulties
whenever American artists tried to organize for common
purposes. But that fact should not obscure an extremely
important unity of function. Whether drawn from the
upper class or the working class, American artists were
asked for, and happily supplied, a wide variety of ser-
vices, almost all of which reflected the nationalists' ef-
forts to raise the level of public taste. Significantly,
Latrobe generally referred to himself as an architect
and engineer. Thus he was involved not only in the con-
struction of the national Capitol and redecorating the
White House, but also in building a water system for
Philadelphia, designing towns for speculative land de-
velopers, and even fabricating river steamers in Pitts-
burgh. That he was engaged in such a variety of endeav-
ors resulted partially, no doubt, from the paucity of
regular architectural commissions, but it also indicated
Latrobe's willingness, shared by other architects of his
time, to enhance the American scene in every way pos-
sible, without being particularly worried about limiting
the range of his professional expertise. A very similar
patriotic readiness to help the new nation characterized

Peale. His museum was not the only "new kind of paint-
ing" that he tried. His illuminations for national cele-
brations held an equally important place in the eyes
of the public. Apparently, Peale's first illumination com-
memorated Maryland's signing of the Articles of Con-
federation. An elaborate design on a canvas nine feet
square, showing the "genius of America" dressed in
stars and stripes and wearing a headband urging "*Perse-
verance*," Peale painted and illuminated it at his own
expense. Baltimoreans found it so praiseworthy that they
exhibited it in front of their courthouse and paid its
creator two guineas. Subsequently, Peale constructed
many grandiose illuminations honoring the defeat of
Cornwallis, the adoption of the Constitution, Fourth of
July celebrations, Jefferson's second inauguration, and
so on. These rarely failed to please observers. Even
John Adams, who complained of an illumination in Paris
that the tallow would have been better used if distributed
to the poor and to war vessels, admitted that a com-
parable scene in Philadelphia "was the most splendid
illumination I ever saw," with only a "few surly houses"
remaining dark.[9]

Patronage patterns in the new republic, as Peale
learned in developing his museum and preparing illumi-
nations, and as other artists found in their work, re-
flected both the new aesthetic nationalism and older, less
sympathetic attitudes toward the artist. The demand for
versatile craftsmen sometimes gave artists interesting
opportunities to diversify their output. In addition to
the already mentioned examples from Latrobe's and
Peale's careers, one could cite John Trumbull's detailed
response to Rufus King's request for ideas in designing
American military uniforms, or the popular praise for
William Rush's "Masterly Chissel," evidenced by his

ship figureheads. On the other hand, the subservient status of artists could still be seen, for instance, in David Burn's advertisement of 1785, offering to teach "the five orders of architecture" and that "any gentleman may be attended at his own lodgings." American artists in the first decades of national independence, then, had to cope with an ambiguous patronage system at the same time that they struggled to become socially acceptable professionals.[10]

The unintentionally treacherous character of American patrons can be clearly seen in the correspondence of Jefferson. He repeatedly pledged his efforts to improve American taste by encouraging native artists, and those efforts were frequently and vigorously expended. Jefferson had high hopes for Trumbull, "a young painter of great and increasing reputation." Trumbull even received an offer to become Jefferson's private secretary, for "I fear much that our country is not yet rich enough to encourage you as you deserve." Yet Jefferson filled most of his letters from Paris to Trumbull in London with requests to run errands that would insult the pride of any competent craftsman, let alone a sensitive and insecure painter. In addition, Jefferson made no secret of his commissions for copying paintings to build his collection as cheaply as possible, arguing that "there are always men of good talents, who being kept in obscurity by untoward circumstances, work cheap, and work well." It never seemed to occur to him that his economizing might be one of the major "untoward circumstances." Consequently, Trumbull was not merely playing the rhetorical prima donna when he told Jefferson, "I do not aim at Opulence:—but I must not knowingly run into Embarrassment and Ruin."[11]

Other artists receiving Jefferson's attention had simi-

lar reasons for responding ambivalently. Latrobe enjoyed Jefferson's praise and friendship and willingly contributed a great deal of time and effort to help shape the first designs for the University of Virginia. But Jefferson had not entirely moved beyond a mid-eighteenth-century aristocrat's view of the place of his architect. Confident of his own architectural abilities, his suggestions while President to the Capitol architect frequently infuriated Latrobe. Blowing off steam, Latrobe once wrote to the construction foreman at the Capitol: "You and I are both blockheads. Presidents & Vice Presidents are the only Architects & poets & prophets for ought I know, in the United States. Therefore let us fall down & worship them!" Jefferson did not think of himself as a poet, but when he offered a commission to one, the ambiguities of late eighteenth-century American patronage appeared once again. In 1802 the President wrote Joel Barlow: "Mr. Madison and myself have cut out a piece of work for you, which is to write the history of the United States, from the close of the War downwards." The context strongly suggested that the work would have a significant role to play in the party battles then being fought. Though Barlow showed no great interest in the proposal, Jefferson persisted, writing eight years later, "You owe to republicanism, and indeed to the future hopes of man, a faithful record of the *march* of this government, which may encourage the oppressed to go and do so likewise." Nowhere in Jefferson's published correspondence with Barlow is there any evidence that the writer's independence and professional self-respect might be threatened. Jefferson, like many Americans of his time, welcomed the increasing visibility of native artistic talents, but had no full appreciation of their needs and interests. It could be little wonder that

artists became discouraged in this baffling milieu. Trumbull preferred to have his son become "a Butcher or a shoemaker" for, he wrote, "I regard my profession, in these times of Tumult, as little worth the attention of a man of Talent."[12]

Obviously, if the artists were to fulfill their patriotic duties as set for them by the aesthetic nationalists, substantial institutional support was required. Not surprizingly, magazine editors saw themselves playing a significant, pioneering part. According to the *Evening Fireside*, "Experience declares that the taste, the habits, and the morals of a people are essentially affected by their periodical publications." The *Columbian Phenix* felt that "a Magazine is the proper repository, for the noblest productions of genius," and John Quincy Adams welcomed the creation of the *Port Folio* "to take off that foul stain of literary barbarism which has so long exposed our country to the reproach of strangers, and to the derision of her enemies." Indeed, the periodicals did generate a market for American literature, and, to a lesser extent, for engravings and music. But the technological limitations of publishing prohibited any real help for the visual arts beyond urging readers to attend exhibits and support American artists.[13]

The creation of academies had much greater possibilities. Scholars have offered varied interpretations of the first efforts to found art institutions in America. Generally they argue that the dissension that soon characterized each one arose from conflicts between the wealthy laymen and the artists. "The layman made money, the artist defended the dignity of his profession." In addition, the first academies allegedly imitated too closely those of England, without the latter's richness of artistic talent and training, and their founders failed to make

up the difference with sufficient enthusiasm. Neil Harris has succinctly eliminated the first of these notions: "The intellectual and moral autonomy of American artists did not disappear under civic attack; it never existed. Artists were eager to rely upon majoritarian [i.e., lay] sentiments in everything except technical expertise." Since the laymen never attempted to intervene in technical questions, no real cause of dispute existed. As for the supposed lack of enthusiasm, the squabbles rending the academies showed all too much passionate concern by the large group of participants. The reference to imitation of the Royal Academy, however, does point to a major reason for the academies' troubles. Political and economic overtones of that model, not professional objections to lay control, provoked heated debate, secessions, and even dissolution of the American academies. They originated, after all, in an ideological context that demanded something much more specific than merely an art school and exhibition hall. The academies should foster American artists, with the primary aim of bringing into existence a distinctive national taste. Consequently, all of the beliefs, expectations, and fears discussed so far in this book impinged upon the formation and development of the academies.[14]

One of the first academies was organized in the early 1780s by Alexander Quesnay in New York City. His newspaper advertisements for public support illustrated many of the conditions and beliefs faced by his own and later efforts. First of all, as commentators never tired of saying, Americans had no ready-made and obvious source of support equivalent to the English Crown and aristocracy. That did *not* mean that adequate patronage could not be found in America, but it had to be discovered and approached. Quesnay showed his understand-

ing of this by making a public appeal through the press. To attract the widest possible interest, the aims of the academy were appreciably broadened to include "branches of foreign Languages, viz. French, Italian and German; Painting, in every Branch; Geography, Astronomy, Architecture, Fortification, and Surveying, Music, Riding, Fencing and Dancing." Later institutions would drastically pare down the list, but the temptation to gain students and contributors by expanding the variety of courses remained for decades. Quesnay's basic pitch would also sound increasingly familiar: "The genius of the inhabitants of these United States is susceptible of any improvement." Europe had already been astonished by West and Copley. Therefore, Quesnay's academy would serve the public interest "where the culture of the polite arts may be properly attended to." He made no distinction between the needs of young would-be professionals and the larger number of interested amateurs. Neither he nor most American artists at the time found such a distinction very important; the line between the talented amateur and the itinerant professional, either in terms of skill or productivity, might be extremely thin.[15]

Quesnay's academy survived briefly and then disappeared. The entrepreneurial approach to gaining American support for the arts would have to await the American Art Union of the 1840s to be a successful device. Quesnay's fate may also be explained by his failure to capitalize on the widespread belief in the nationalistic role of artists. Initially he had promised that "the most accomplished masters in the respective branches shall be sent for from Europe," implying that the United States had none of its own. Later he advertised "very great encouragement" to any American

teachers "according to their merit." A lingering moralistic distrust of art professionals showed through, however, in his requirement not only of "certificates of their good conduct and ability" but also that they "give sufficient security for their future conduct, that they will not raise any disturbance in the Academy." A friendlier tone would be a prerequisite for sufficient support either from the public or the artists.[16]

The Columbianum, or American Academy of the Fine Arts, sponsored by Charles Willson Peale in Philadelphia, offered an alternative way of organizing an academy. Though Peale took the leadership, the short-lived Columbianum was a cooperative venture of artists rather than an entrepreneurial enterprise. Twenty-nine founders met in December 1794, and pledged "our utmost efforts to establish a school or academy of architecture, Sculpture, painting &c. within the United States." The proposed curriculum was much less all-encompassing than Quesnay's, but still showed very catholic tendencies. The membership included engravers, jewellers, draftsmen, naval architects, and carvers as well as painters and sculptors. The lack of professional hostility to lay control is clearly shown in the first list of officers elected by this self-styled "association of Artists." For chairman, the members elected Burgess Allison, a Bordentown, New Jersey, clergyman. Major Richard C. Claiborne, also an amateur, became secretary.[17]

Like most early American art institutions, the Columbianum originated from a variety of felt needs and favoring conditions. Peale wanted a place for his sons, Rembrandt and Raphaelle, to be trained, while many members no doubt sought the companionship and mutual support of their peers. Robert Edge Pine possessed a collection of casts of classic statuary, presumably the

absolute prerequisite for any drawing class. James Cox had been running a drawing and painting school in Philadelphia. Finally, and most important, a large migration of artists from Europe, escaping the turmoil provoked by the French Revolution, supplied for the first time a sufficient number of potential members of an artists' association.

Almost immediately, an irreparable split among the members destroyed the organization. The two groups were soon hurling bitter accusations at one another. It turned out to be a contest between the recent immigrants and the native Americans, but it had nothing to do with technical, artistic issues. As Peale's biographer put it, "In America there was little or no parallel to European social conditions, and little or no partisanship in styles of art. There was only that patriotic spirit of emulation, the eagerness to prove that democracy's sons could match the best in old world culture." The immigrants accused the group led by Peale of "preventing and cramping the original idea of a National College into a contracted plan for an academical drawing school." They wished to match England's national institution with the king as patron by having President Washington become "the principal patron." Unless we remember how bitter and fearful political differences could be in the 1790s, we will fail to comprehend the virulence of the Peale group's reply. Starting with an invidious, xenophobic aside, they denied any presumption "to establish a national institution which would place similar institutions in other states in a subordinate position." The implicit Jeffersonian castigation of Federalist centralization and aristocratic snobbery then became explicit:

> Some gentlemen, who fancy themselves a better order of beings, imagine themselves equal to the most stupendous

projects, . . . but America is not the soil to foster seeds of such vanity and arrogance. . . . We will leave conceptions so profound as a National College . . . to those who started up from the hotbeds of monarchy, and think themselves lords of the human kind. . . . We are not in monarchical subordination here.

While Quesnay failed for lack of appreciation for the belief in the American artist as a patriotic leader, the Columbianum foundered on the divergent political affiliations arising from that patriotism. The artists, like the politicians, would eventually be able to agree with Jefferson's plea, "We are all federalists, we are all republicans," but it would take time to recognize that honest men could have political differences.[18]

The next art institution to be organized, the American Academy of the Fine Arts in 1802, represented an anachronistic variation of Quesnay's undertaking, but this time founded by a small, conservative, upper-class clique of "a few gentlemen, at the head of whom were Robert R. Livingston and Edward Livingston." Until after 1815 the American Academy made no great impression, primarily because its founders never reached beyond their own tight-knit group, centered in the Livingston family, and remained blandly unaware of the lessons to be learned from the earlier efforts of Quesnay and the Columbianum. It apparently was initiated by Robert Livingston, then American ambassador to France, who suggested to his brother Edward, then mayor of New York, that he should obtain "Casts in Plaster of the most beautiful pieces of ancient Sculpture now collected in the [French] National Museum." Soon a group of family friends opened a subscription to found, as their Articles of Organization phrased it, "a collection that may be the foundation of a school for

the fine arts and attract the attention of such of their admirers as have not the means or the leisure to visit the originals." The casual mood underlying this may be seen in Janet Montgomery's letter of May 29, 1802, to Robert Livingston, telling her brother that she had taken two shares "at I know not how many guineas a share." The first reports in the newspapers apparently repeated the founders' belief that this "gallery and school of sculpture" would be "the first established in the United States." Proof of their ignorance of Quesnay's difficulties came in the statement that the American Academy could be "honourable to our country, perhaps profitable, to the individuals who should support it."[19]

The American Academy unabashedly imitated European examples and ideas. The founders reiterated the usual pleas for an American art and taste to continue the examples of West and Copley, and repeated the need for taste to soften the passions, and so on. Yet their provincialism appeared unambiguously in their belief that "the reputation of our country is closely connected with everything that may introduce within it a germ of those arts once so highly cultivated in Europe, but not yet planted here." The directors of the academy set up temporary bylaws to be used until they could obtain a copy of the Royal Academy's. They sent flattering letters to Napoleon and other leaders and institutions in Europe. "We thought it might be worth (independent of the honor) some old pictures or Statues to us." However, Edward Livingston wrote his brother in Paris, the directors trusted the ambassador's discretion in presenting honorary memberships to "such painters and sculptors and their [patrons] as you think will lend most to our reputation and Emolument." Finally, the

directors sent John Vanderlyn to Italy in 1803 to make copies of the most famous paintings. They were so unaware of the removal by Napoleon of most of Italy's masterpieces to the Louvre that, even when Vanderlyn tried to explain to them the importance of that fact for his mission, they balked. Traditionally, Italy had been seen as the fount of the fine arts, and the directors refused to accept new realities, in Europe or in America. Robert Livingston worked for the greater glory of America by negotiating the Louisiana Purchase, but he and his friends remained unswervingly provincial in questions of taste.[20]

It should be no surprise to learn that the American Academy did nothing to create an appropriate institutional support for American artists, at least until 1816 when it was drastically reorganized. The founders presumably felt that their efforts would be welcomed by the artists. Robert Livingston wrote that the gallery "must be contrived as to give constant admissions to *artists* without expence or by a single subscription." Nevertheless, he and his friends envisioned what the Society of Artists later condemned, "*followers of followers and copyists of copyists.*" The members of the academy thought that their collection of plaster casts, differing from the originals only in the material, provided the opportunity for students to "pass [their] hours in uninterrupted study, cultivating [their] taste by contemplating the most correct modes of ancient sculpture." Without this stimulus and guide, "the strongest intellect may be fruitlessly or deviously employed." Similarly, the directors went Jefferson one better in an unintentional insult to the professional pride of a painter by sending Vanderlyn to Europe to make copies, naïvely assuming that this amounted to a generous act of patron-

age for Vanderlyn. He reflected their outlook when he wrote of several paintings by Rubens in the Luxembourg that "there are admirable parts to be taken out of them and which would make agreeable pictures." As an example, Vanderlyn mentioned "two Lions finely painted, which are rode by two Cupids [;] the rest of the picture is uninteresting." What that meant was perhaps implied by his marking out the word "unaccurate" and substituting "uninteresting." He concluded that such selected details from large paintings "may be looked upon as their cream (for colouring)." Neither Vanderlyn nor his patrons understood that they were not even getting accurate imitations, let alone any spark of creativity. Few American artists or aesthetic nationalists evidenced much interest in the American Academy's approach. Its collection soon found an obscure and dusty place in a public attic, where it remained, forgotten, for over a decade.[21]

Robert Livingston believed that his academy "does us so much honor in the eyes of Europeans that I wish it might be pursued with some scale," which would, at the same time, give Americans something to talk about besides party politics. Disliking the institution's being called the New York Academy, he urged Rufus King, just elected its vice-president, to preëmpt the word American, before competitors in Philadelphia "place you in the background by forming an 'American academy of arts,'" since that title "will be much more respected in Europe." Indeed, Philadelphians were not to be outdone by the New Yorkers, though they did not bother quarreling over names. The *Port Folio* reprinted a description of the American Academy from the *London Monthly Magazine*, disparagingly commenting that it "alludes to some faint beginnings in *New-York*." Livingston might urge his friends in New York to push

ahead, but his main contact, Edward Livingston, had sailed for New Orleans, after resigning his mayoralty the previous fall. The initiative went to Philadelphia, where the first continuously operative art institution in America appeared in 1805. It was another twenty years before New York regained the artistic limelight in the United States.[22]

The Pennsylvania Academy of Fine Arts has been strangely neglected by historians. Though it may be accorded several pages or, at most, a chapter in cultural histories, its value as a register of art development in the United States has never been fully shown. Rarely in the forefront of the history of American art and taste and never lapsing into the moribund conservatism of the American Academy's first years, the Pennsylvania Academy, from its beginning in 1805, has had a place in the mainstream of aesthetic opinion.[23]

In sharp contrast to the founders of the American Academy, the Philadelphians paid close attention, from the very beginning, to antecedents and to the variety of American aesthetic attitudes. Peale wrote Jefferson in January 1803, calling attention to newspaper accounts of the American Academy. Reluctantly, he confessed that "publick spirit is wanting for such encouragement" of the arts in Philadelphia. Recalling the difficulties encountered by Quesnay, from whom Peale had learned how to make illuminations, and his own disappointment in the Columbianum, Peale had no intention of trying to force the issue. The makings of an academy equal to New York's already existed in Philadelphia. A South Carolinian, John Allen Smith, had collected a number of casts in Europe and sent them to Philadelphia in 1800, "in the hopes that they might possibly be of some service to his countrymen when they should turn their

thoughts to the study of paintings & sculpture." Smith thought this aim would be better served in Philadelphia than Charleston, in terms of both location and population, but the casts lay in a warehouse for several years before Peale repaired them for the Pennsylvania Academy. Unlike the Livingston family and friends, Peale and the other Philadelphia founders awaited more than merely the possession of casts.[24]

By 1805 the time seemed ripe. Political passions, which had torn the Columbianum to pieces, had moderated to the point where Peale could readily accept an old political enemy of Revolutionary days, George Clymer, as the Pennsylvania Academy's first president. A large number of wealthy and powerful Philadelphians evinced their readiness to support the institution. Latrobe wrote Peale of his reaction to the patrons, perhaps speaking for many artists: "Among the names, I observe, those of a number of Men whom I did not suspect of any taste, or knowledge for any Art, but that of bookkeeping or cookery. I am glad however that they have come forward with that most essential support of all Art [—] Money." Also, they had contacts in Europe, including the current ambassador to France, General John Armstrong, who could be relied upon to generate gifts to the new academy. Not only Smith's collection of statuary replicas, but also a large collection of paintings owned by a Mr. Lichbeitner and another by Robert Fulton could be borrowed to start the academy's collection. Finally, the artists in and near Philadelphia proved their interest by contributing examples of their work upon election to membership.[25]

The founders of the Pennsylvania Academy carefully mapped out their plans. Presumably the American Academy had also done something of the sort, though Janet

Montgomery's statement was, typically, very vague: "We mean to begin with ten Statues and which will amount to a thousand guineas and if that *succeeds* go on." The Philadelphians' scheme, by contrast, left no doubt about their criteria of success. Believing that the public organizational meeting ought to be preceded by planning sessions where "the whole business should be ready cut and dried" since "large bodies can never do business well," a small group of men met several times at Peale's home. The plan, suggested by Joseph Hopkinson and approved by the others, was to open a gallery of casts purchased from the original subscriptions. Paintings would be exhibited for sale, and the twenty-five percent commission plus receipts from admission fees would soon provide a salary for a keeper. He would instruct students in drawing from the models, and, later, "from the life." The founders' subscriptions would also finance a building especially designed for the academy's needs. Subsequent income, it was hoped, would enable the academy to purchase individual works or even whole collections such as Benjamin West's. Instruction could eventually be offered in architecture, engraving, and other subjects besides painting and sculpture.[26]

The first collection of the Pennsylvania Academy blended the traditional aims of the American Academy with the innovative encouragement of American artists sought by the Columbianum. In July 1805 a committee made up of Peale, Hopkinson, and William Meredith wrote General Armstrong and Nicholas Biddle, asking for their help. The committee candidly stated their wishes:

> You have heard of a similar establishment at New York, which has received the patronage of Buonapart himself. That Institution has received from Paris very fine Casts of the

> most valuable ancient statues—We are desirous of procuring
> the same, and request your assistance to our design.

Not until late in 1810 did General Armstrong remit "a
case of Books & Engravings," but Biddle speedily sent
off a large number of casts. His conservative inclinations
could be seen in his long explanation for sending one
"altho' modern." But the founders' attitudes were more
fairly represented in their application for incorporation,
signed by the members in December 1805.

> The object of this association is to promote the cultivation
> of the Fine Arts, in the United States of America, by intro-
> ducing correct and elegant Copies, from works of the first
> masters, in sculpture and painting and by thus facilitating
> the access to such standards, and also by occasionally con-
> ferring moderate but honorable premiums, and otherwise
> assisting the studies and exciting the efforts of the artists
> gradually to unfold, enlighten and invigorate the talents of
> our countrymen.

They were cautiously but genuinely interested in sup-
porting American artists. The directors resolved, for
example, in their preparations for the first exhibition,
that "Paintings by American & living Artists shall always
have a preference over those by European or Antient
Artists." In addition, they accepted and displayed fancy
needlework and other craft productions as well as draw-
ings and paintings.[27]

The first building for the academy, completed in
1807, provoked ominous rumblings. Designed by the
Philadelphia auctioneer and speculative builder, John
Dorsey, it cost dangerously more than estimated, had
numerous structural faults, and appeared functionally
and aesthetically mediocre. Peale worried that the choice
of Dorsey as architect, which Latrobe took as a "public

affront put upon me as a professional man," clouded the successful development of the academy. Nevertheless, it managed to weather the storm, and within a few years even Latrobe could pass over the insult and praise the institution: "The intention is excellent, the members exceedingly respectable, & the success of their exertions far beyond what I expected."[28]

Before the Pennsylvania Academy could feel assured of its continued existence and activity two grave dangers had to be faced. The first, and more manageable, one arose from the possibility of public moralistic outrage at nudity, even when sanctioned by the most exalted of tastes. Americans would not tolerate any breach of what they very narrowly defined as common decency. Casts of ancient nude statues had to be bowdlerized with fig leaves and even separate exhibitions for men and women. As Robert Livingston had recognized, "tho these Statues are viewed by the most delicate women [in Paris] without a blush yet the modesty of our country women renders a covering necessary." The Pennsylvania Academy followed suit and timidly avoided controversy by quietly eliminating drawing classes using live models.[29]

All fears that public prudery might lead to a quarrel between the artists and the lay patrons disappeared with the outcome of the case of Adolph Wertmüller's *Danaë*. This Swedish emigré had painted in Paris a lushly sensuous nude reclining under a shower of gold. When he proposed that it be shown in the academy's 1811 exhibition, Peale had it "put out of sight," writing Jefferson that "we should guard against familiarizing our Citizens to sights which may excite a blush in the most modest." Latrobe agreed that "it is a *foolish* thing" to paint such a picture, which, if shown "sacrifices [the artist's] moral Character at the shrine of his Skill."

Wertmüller's independent showing of *Danaë* in 1814 provoked an almost unanimous howl of protest. "Iris" attempted to defend it, claiming that thousands "of the most virtuous and enlightened part of the community" had admired it. But the consensus was that "*such* paintings cannot be made decorous *thus*." The Society of Artists quickly met, repudiated the exhibition of any paintings tending to corrupt public morality and sent a committee to meet with the editors of the *Port Folio*, praising its efforts to maintain "a correct and chaste taste for the arts." Clearly, the Pennsylvania Academy would find no argument in its acceptance of popular notions of decency.[30]

The academy did experience, on other grounds, a major and angry secession of the artists that could have destroyed its value for aesthetic nationalists. The Society of Artists, organized in May 1810, threatened a separation, and, to quote Latrobe, "it is certain that the interests of the fine Arts would in great degree be sacrificed." If the split continued, "it would be the war of fashion, & influence, & family connexions, and superior wealth and leisure,—against professional knowledge and merit & skill." One should not, however, rest with such passionate statements and overrate the magnitude and the number of issues dividing the society and the academy. As Latrobe bluntly put it, in the same letter, "It is evident that the sentiments of the parties might be united, if either of them possessed tangible property. It is on this point that you divide. If both parties there," he concluded, "could consider the arrangements which respect the objects of art as settled (for upon them I do not see any great difference of opinion) all you have then to do is to agree about your money concerns." Indeed, at the society's organizational meeting, a commit-

tee was appointed to meet with the academy to discuss how the two societies might be "useful to each other, and the better to promote their common object." Consequently, Lillian Miller sums up the matter too baldly when she states: "The artists resented an academy run by businessmen and felt that the institution had done little for their direct benefit."[31]

There is only slender and inconclusive evidence to support the notion that the Society of Artists conceived of itself as appreciably more dedicated to the direct interests of American artists than the Pennsylvania Academy had been. In 1811 the society did appropriate $300 for a painting by John Trumbull "as a testimony of the estimation this Society holds [for] the Merits of that celebrated Artist." Its announcement of the Fourth Exhibition, in 1814, included the promise to devote half of the "nett proceeds" for prizes to exhibitors. "As the progress of the Arts in this country—depends more upon the exertions of Artists themselves than on particular patronage," the prizes would "encourage the works of living artists, and . . . promote a laudable emulation. . . ." And, in 1815, the rapidly declining society suspended classes because their cost encroached "too much upon the funds of the Society necessary to be appropriated to benevolent purposes." This last action may actually have resulted primarily from the teacher finding it "inconvenient to attend." In any case, neither any nor all of these characteristics warrant seeing the Society of Artists as a predecessor of later professional organizations with insurance and burial provisions and the like.[32]

Whatever the original reason for organizing the Society of Artists, and it may have been intended mainly as a lever to use in the artists' negotiations with the academy directors, efforts to unite the two were well under-

way within a year of the founding of the society. They jointly sponsored the annual exhibits that began in 1811, and, as we have seen, agreed in their aims. The committees that discussed unification found the only barrier to be the academy's fifty-dollar membership fee. According to George Murray's report to the society, the artists "contended, that the Talents and Exertions of the Artists, who are, (to use a familiar expression of one of our Members), '*The Bees that make the honey*' . . . ought to have much weight." Since "Artists from the nature of their pursuits, are seldom or ever rich," they ought to be given special consideration by the academy to the extent of foregoing the usual membership price, especially since the wealthy lay patrons "do profess to be enamoured with the Fine Arts." Insisting on payment by the artists of the standard fifty-dollar fee, the academy's committee argued that their institution would be endangered if control were permitted to "Gentlemen, however respectable, who had no interest or Ownership in that property, by contributing to its accumulation." This invocation of eighteenth-century ideas about suffrage accompanied another traditional American belief: "The Artists were neither men of business, nor acquainted with the world; and consequently very ill calculated to manage their own affairs." Although the idea that businessmen may best supervise financial arrangements has its merits, the society's committee angrily retorted that, since artists spent their lives pursuing truth, obviously they could not appear upon an equal footing "with *men of business and men of the world*." Such angry exchanges held up final amalgamation until 1820.[33]

The Pennsylvania Academy, however, did not await the society's acceptance of the financial settlement. During 1812 and 1813, the directors implemented a series

of measures that effectively eroded the meaningfulness of a separate Society of Artists. Thus, the directors demonstrated that the academy could overcome serious challenges that had been too much for the earlier art institutions. In March 1812 the academy created a body of "Academicians" as "a Body of Artists to be attached to the Institution." Promising young artists, like Thomas Sully, were elected to academy membership and given a share (thereby voiding the main grievance of the society) or, like Thomas Birch, hired as teachers for the academy art classes. When, by 1815, the hard-pressed Society of Artists could no longer afford to stage exhibitions, the academy proceeded to continue them by itself. By that time, few members of the society had any motive for continuing to belong, and the society's numbers, originally more than 130, gradually dwindled to zero. The Pennsylvania Academy had proven itself able to meet the needs and desires of the practicing artists as well as those of interested laymen. Deservedly, the academy is considered the oldest art institution in the United States.[34]

Popular reactions, evidenced by newspaper and magazine coverage, were not always favorable to the academies' efforts to support American artists and improve the public's taste. The newspapers generally applauded, and frequently the periodicals followed suit. On the other hand, as a long letter to the editor of the *Monthly Anthology* in 1806 exemplified, doubts remained. The frequent discovery of alleged American self-taught geniuses, "E.E." claimed, usually were only excuses to praise the unlearned mediocre. He found the New York and Philadelphia academies "extremely premature; and must inevitably prove futile and nugatory." Only after the minds of the people had been carefully prepared to

nourish the seeds of taste could schools be fruitfully developed. Americans did consider prints and pictures standard household furniture, but "the common and motley collections, we generally find, show plainly, that fashionable decoration is the only object; and that taste is neither consulted in the selection, nor gratified by the exhibition." This critic represented a significant minority of commentators who urged the primacy of increasing patronage, while "all unqualified pretenders should be universally discountenanced," in order to produce great American artists.[35]

The academies' answer came the following year in a speech by George Clymer, a prominent patron and president of the Pennsylvania Academy. America had already produced great artists, he observed, but had left their polishing to other countries. Therefore, it was neither chauvinistic nor futile for the academy to provide "what may make such excellence all our own"—a school for study, a field for competition, and an instrument "in diffusing a taste throughout, to ensure general encouragement, and particular patronage."[36]

Clymer had silently passed over the crucial question of whether a museum's function was really compatible with the aim of patronizing American artists. What would prevent a resurgence of the tradition-bound thinking of the American Academy founders? Self-appointed taste makers could propose such acquisitions as a collection of prints from ancient paintings by Trumbull and Bellori, conceding that the engravings "are devoid of [artistic] merit" but insisting that "they are extremely instructive on the subject of ancient art." If this typified acquisition policies of American art institutions, then they would serve American artists very poorly indeed. Without the academies, American artists

unable to study in Europe might, as the *Port Folio* said, "languish in obscurity, or abandon the attempt in utter despair"; yet the presence of the academies could become equally depressing.[37]

The effort to gain moralistic sanctions for the academies offered another threat to their utility for American artists. John G. Bogert, secretary of the American Academy, complained in 1813 that, though his institution was twelve years old, it had not yet attracted the attention that it merited. He attributed this neglect to "an idea . . . too generally entertained that this institution is designed merely for the amusement and gratification of a few individuals." Actually, since his academy worked "to inculcate a taste for virtuous employment, . . . and to bring into exercise all the finer feelings of our nature," it clearly played an important role in American development. After all,

> it is well known truth, that much of the difficulty and most of the obstacles to improvement in education, most of the vices in society and many of the violations of public law, originate in a corrupt and vulgar taste, a propensity to low gratifications, and an attachment to illiberal pursuits.

Perhaps not surprisingly, compared with its profound importance in countering these evils, the academy's function as a "school and nursery for genius" received only the most cursory attention. A writer (perhaps Rembrandt Peale) calling himself "A Lover of the Arts" curtly rephrased Bogert's tactful approach: "The arts, ornamental as they are, and useful as they may be, cease to be an object worthy of either interest or encouragement, unless they are subservient to the higher cause of morals." Reliance on copies of European works ignored the American artists' efforts, but the "cause of morals"

could produce self-righteous repression. Wertmüller's *Danaë* and most other nudes for decades thereafter were roundly condemned for descending "to rake, from the filth of mythology, a disgusting portrait of miserable licentiousness." Since they threatened "the foundations of public decency" they had to be "immediately and indignantly discountenanced." Jefferson put the case for censorship positively when, accepting an honorary membership in the Society of Artists, he wrote Thomas Sully and praised the organization: "It may be able to give an innocent and pleasing direction to accumulations of wealth, which would otherwise be employed in the nourishment of coarse and vicious habits."[38]

While firmly closing one door, the moralistic and nationalistic biases opened another. As John Adams put it during the War for Independence, American artists "ought to assist in publishing to the World, and perpetuating to Posterity, the horrid deeds of our Enemies." Postwar commentators recommended that American heroes should be immortalized by depicting their "principal actions," thereby encouraging posterity's laudable emulation. One magazine writer imagined a pantheon filled "with the choicest works of the statuary and the painter," to be paid for by a national subscription. Though the word pantheon reflected a persistent imitative impulse, the nationalistic note dominated: "This is OUR temple, dedicated to OUR God, and sacred to the memory of OUR heroes." It would supply attractive commissions for American artists, and, in addition, would build a bond of national union, a major consideration in the face of bitter political dissensions arising during the War of 1812. The academies, once exploded by political issues, now were seen as instruments to moderate them.[39]

America, it was generally assumed, remained the land of liberty in a generation that saw Europe suffering from the dislocations and tyranny of the Napoleonic wars. Aesthetic nationalists confidently assured themselves that their homeland was the obvious haven for the arts. They felt that this insured American artistic greatness, since the exiled artists escaping to the New World would catalyze a widespread elevation of artistic achievement and public taste. Edward Ingersoll declaimed at the 1808 University of Pennsylvania commencement ceremonies: "To question the genius that warms, or the vigour of native intellect that animates the American breast would be sacrilege against the deities of truth. . . . Our arts, nurtured in the lap of Liberty, must flourish." European troubles relieved many Americans of the fear that they would lose their artists to the traditional cultural capitals. On the contrary, the flow of talent was toward the United States. America's superiority as a home for artists appeared so secure that American study in Europe no longer augured expatriation. Orators dismissed alarm by telling their audiences that the lessons of history, exemplified in the early days of Rome, Greece, and Persia, proved that young nations should learn from older ones.[40]

Nevertheless, the possibility of European domination of American art and taste remained great enough for aesthetic nationalists to emphasize ancient examples, as useful here as they had been in the search for American aesthetic principles. The idea that classical Greece was the best model for America was a popular one. The most elaborate statement of this came from Latrobe, often called the "Father of the Greek Revival" in the United States, in his "Discourse before the Society of Artists" on May 8, 1811. He began by addressing himself to what

he conceived to be the major obstacle to the fine arts in America—the fear that they were incompatible with political liberty. The example of Periclean Athens would dispel all such fear, he argued. The rise and fall of Roman art reinforced the lesson. Latrobe justified spending half his speech on these considerations by proclaiming, "Indeed, the days of Greece may be revived in the woods of America, and Philadelphia become the Athens of the Western world." Since "a propensity to the fine arts is an instinctive property of human nature," the main concern for Americans really should be avoidance of all repressive influences, especially religious biases. Latrobe's flattered listeners, contemplating the glowing future, were assured that America's rise to its rightful position "will not be rapid, but it will be certain and durable." Latrobe concluded with the counsel that, as in the Revolution, we should "let our independence in the arts grow out of the conviction that, *united we stand, divided we fall.*"[41]

Public opinion, as seen in the magazines, agreed with this strategy for aesthetic independence. A few confirmed conservatives blushed when they called to mind how far America lagged behind Europe in the arts. The lack of ruins and antiquities in the United States, one traveler feared, restricted us to the contemplation of wigwams and beaver dams. More commonly, writers applied to the fine arts the dictum, "Among the greatest impediments to the progress of improvement in the useful arts, may be reckoned a blind and bigoted attachment to customs and processes, whose absurdity is [only] sanctioned by antiquity." Americans needed to cut loose from outworn traditions, that is, those of modern Europe. The craven Anglophiles had to be cast aside when they demanded that "British subjects [be] acknowledged to

have an exclusive claim to genius, invention and improvement. According to them, the sterile mind of an American can do little of itself." By comparison, ancient Greece was safely remote, especially since few travelers ventured east of Italy prior to the end of the Napoleonic wars in 1815.[42]

The first American academies mirrored the high value placed on Greek models by starting their collections with copies of ancient sculpture (or at least what they thought to be classical works). One curious, rather unexpected result came from the frequent association of great art with the democratic society of Greece by an American public which generally failed to notice the fundamental differences between Athenian and American types of democracy. A broadly democratic basis for judging the arts seemed to be the logical consequence. Aristocratic complaints lingered on for a time that "everyone pretends more or less to taste and judgment in painting, and especially in architecture." But these cavils were soon swamped by affirmations of the venerable motto, "Vox Populi, Vox Dei." Thus, Joseph Hopkinson's "Discourse to the Pennsylvania Academy" in December 1810 pleaded the need for beauty to please a wide public. "The object of the fine arts, in all their branches, is to please," and, speaking for the American Everyman, "we require no critic or connoisseur to tell us whether we shall be delighted with a play, or subdued by the powers of music." Similarly, the *Analectic Magazine* printed a long article in 1815 appraising artistic progress in the United States. The author puzzled over the early appearance in America of an artistic disease generally connected with a society's old age, "the pedantry, the cant and quackery of taste" dished out by connoisseurs. They preened themselves on their knowledge of the

old masters and those artists whom no one else bothered to remember. This was ridiculous, but worse still, also pernicious, for it needlessly cowed ordinary people into fearing to trust their own senses. Those pictures enjoyable only to the cognoscenti missed the crucial point: "The highest and most real excellence is that which pleases all classes, and in all ages."[43]

The American artist, supported by appropriate institutions, was a vital leader in emancipating the people from a dependence on European productions with their effete, antidemocratic admirers. National pride in the country's independence required the artists' aesthetic leadership. At a stroke, an elevated democratic taste would be fostered, quieting domestic political storms, banishing morally objectionable pastimes, and raising Americans to worldwide preeminence by proving, once again, the intimate connections between political liberty and aesthetic greatness. Latrobe had verbalized Americans' deep faith in the inevitability of their country's becoming the modern Greece in cultural achievements as in political liberty. It could only be a matter of time, one eagerly and impatiently awaited by all good patriots.

Hopeful as the American partisans of the arts tried to be, their expectations continued to be unfulfilled. The delay strained their patience. Latrobe, in the same speech that heralded the inevitable appearance of American artistic supremacy and warned that progress would be slow, could not refrain from bewailing his countrymen's avoidance in architecture of "that republican simplicity which we profess." Instead, he saw "some of the most magnificent situations in our country and in the world . . . already irrevocably occupied by structures copied from the palaces of the corrupt age of Diocletian, or the

still more absurd and debased taste of Louis the XIV."
The author of the 1815 *Analectic Magazine* article con-
demned American architecture for being poor copies
"from the common English books, with but little va-
riety, and no adaptation to our own climate or habits of
life." Unready to admit that their vision was either pre-
mature or erroneous, the aggrieved aesthetic nationalists
cast about for a more acceptable explanation of the pain-
fully obvious gap between the reality and their predic-
tions.[44]

In searching for scapegoats, frustrated critics did not
favor explanations most common in later histories of the
period. Only after 1815 did the frontier fiction became
the dominant defense to explain away the apparent fail-
ure of an adequate American patronage for the arts. The
Literary Magazine's use of a theory of cultural evolu-
tion was quite unusual in the first generation of national
independence. According to that interpretation, "when
its attendant arts, and commerce, have rendered [Ameri-
cans] comfortable in all respects, they will then natu-
rally aspire to and encourage works of ingenuity and
polite arts." Already, the argument continued, Ameri-
cans had developed from log houses to ones built of
stone or brick, achieving convenience and elegance. But,
although the primacy of conquering the wilderness could
be very persuasive to mid-eighteenth-century Americans,
it implied too passive a stance for most of their grand-
children half a century later. The development of the
frontier spurred aesthetic nationalists to calls for action
rather than lulling them into a serene readiness to await
the "sweet bye and bye."[45]

Even less frequently did they rely on analyses of
what might be called the immediate aesthetic infrastruc-
ture. Grandiose hopes were expressed for the academies

and coverage of the arts in the press, but the lack of institutional support other than government aid played no significant part in their search for the villain thwarting the American renaissance. Twentieth-century commentators on the arts in developing countries harp on social institutions, but the first generation of American aesthetic nationalists preferred to examine and to indict popular attitudes as the basic cause of their hopes being deferred.[46]

Had not Americans concentrated too much on the political disputes involved in gaining political independence? Factional hatreds had wrecked the Columbianum and continued to prejudice questions of taste. Joel Barlow's very stilted *Columbiad*, for example, won great praise from Peale, who agreed with the author's political position, while John Quincy Adams patronizingly shook his head: "Joel has nothing of his own, he takes his whole political creed from Tom [Paine], but having had a learned education and being a man of rhymes, he has sometimes given a grace of expression to Tom's specious doctrines." Jefferson and Trumbull's close friendship broke up over Trumbull's resentment of Jefferson's deism, which, very typical of the times, Trumbull quickly converted into a political opposition. By 1804 one observer thought he saw the arts and sciences "emerging from the gulph of politics, which have hitherto swallowed up every other pursuit." Though the fine arts remained distressingly crude, he proudly pointed to the vernacular tradition embodied in American ships, already unequalled for beauty, symmetry of proportion, or efficiency. Some periodicals explicitly turned away from politics to dwell on the arts, while conceding that "the general convulsion of our political system" continued to threaten the alienation of the artist and the

man of taste. The sectional jealousies rampant during the War of 1812 particularly alarmed aesthetic nationalists. "J.H." urged recognition of the "proud streamers of our *native banners*" by supporting original genius, in this case a young Bostonian named Henry Williams. Americans should avoid the accusation that "amid the distractions of party . . . the still small voice of patient merit is suffered to expire." Other writers felt that the still, small voice had, indeed, been ignored, thereby retarding American artistic maturity.[47]

A variant of this interpretation suggested that lack of governmental concern for the arts had grievously harmed American artists. In view of the generous support of artists by European governments and rulers, the lack of large-scale federal, state, or local American governmental commissions and grants seemed to be a dangerous stinginess rather than republican economy. One critic pleaded for Congressional appropriations to join private subscriptions to endow national museums. The Society of Artists made explicit their bid for public support when they elected Thomas Jefferson their president in 1812, one month after electing him an honorary member. The society published in *Niles Register* its belief that the nation's leaders would be very useful in uniting the country to form a "correct taste" by eliciting native artistic talent. Before Jefferson could write his modest acceptance of membership, Thomas Sully notified him of his election to the presidency. Jefferson need not fear being of little use, Sully assured him. His holding the presidency would help the society implement its conviction: "The artists in this country can never expect to be supported by individual patronage, it is to the public that they look for encouragement."[48]

Direct and substantial governmental support for the

arts is still, in 1974, a demand unlikely to be met. Little has changed in such demands other than the prose styles. Even Thomas Jefferson, surely the most avid friend of American art and taste ever to occupy the White House, adamantly stood in opposition. He insisted that "the Constitution has left these encouragements to the separate States." Equally important in his thinking was the opinion that the American educational and status systems "have long since produced an overcharge in the class of competitors for learned occupations," resulting in "great distress among the supernumerary candidates." The state legislatures, according to Latrobe, were dominated by men representing American "actual & political equality." He wrote to an Italian friend, "Of this state of society the solid and general advantages are undeniable: but to a cultivated mind, to a man of letters, to a lover of the arts it presents a very unpleasant picture." What hope existed for artists from a Pennsylvania legislature which not only "does not contain one individual of superior talents [but in which] superior talents actually excite distrust"? The main subterfuge for a long time would be the hiring of artists ostensibly to decorate public buildings. Latrobe, for example, pressed Congress in 1808 to appropriate $11,500 for decoration of the south wing of the Capitol. It would enable painting, minor repairs, and so on, "*but chiefly*, to keep the Italian sculptors at work." Rather than emphasizing their value in decorating the Capitol, Latrobe rested his case on the assertion that "they have planted the germ of the Arts here." Latrobe was, in short, looking for ways to gain governmental aid for artists in spite of the official refusals to do so.[49]

Aesthetic nationalists looked to the government not only because of European examples, but also because

they were dissatisfied with the volume of private patron-
age. They reasoned that a rampant commercialism domi-
nated American interests, and, unless redirected, it
would only get worse in time. In 1795 the editors of
the *New York Magazine* castigated the *"disregard of
any objects but those attached to the active scene of
business."* They did think that time would modify the
monomania. Some encouragement might be had in the
founding of the Pennsylvania Academy as evidence that
"we are not altogether occupied in these coarser crav-
ings" for material gain. A despairing exile in Philadel-
phia was unwilling to make any concessions to optimism:
*"Of stones it would be easier to raise up children to Abra-
ham,* than to inspire a taste for the Arts, where the
wharves, the banks, and the markets, are the national
museums and the temples of genius!" Worst of all, he
could see no reason for expecting a major change in
popular attitudes. Americans were guilty of "final im-
penitence." Few critics cut American pride so deeply,
but grumblings against the predominant commercial
spirit continued to be heard.[50]

Perhaps commercialism sprang from certain flaws in
the American social system. Some observers blamed the
loss of potential scholars and artists on the prevailing
nuclear family, early marriage, and the expectation that
men would seek their fortunes at an early age. The re-
sulting lack of great fortunes meant that Americans
could not expect to have lavish patrons so evident in
European history. Also, "such is the effect of our edu-
cation, which leads us to consider the *possession*, not the
expenditure of money, as the proof of nobility," in the
opinion of Latrobe, "that a man rather loses than gains
credit & reputation by the exhibition of *elegant* furniture,
of pictures, or of other productions of the fine arts."

Admittedly, vanity and the interest of friends produced a market for portrait painters, but, again, lack of education resulted in selection of the artist according to the dictates of fashion rather than informed opinion. Women did not, unfortunately, counterbalance these trends, since early marriage abbreviated their education and the demanding tasks of wife and mother left too little time for cultivation of taste. Consequently, Peale shrewdly advised his son: "I tell him that he must paint the Ladies very handsome and if he pleases them especially those that are beautiful his fortune is made. *They govern the World.*"[51]

Wealthy Americans, with leisure and money at their command, seemed especially culpable for failing to set a good example. Aesthetic nationalists assumed that the tides of taste were set by a very few persons, those Latrobe referred to as ". . . Astor & the whole tribe of those who having money, want to tell everybody so by the exhibition they make." Therefore, America would remain the Siberia of the arts, Eliza Anderson concluded, and "the *Tartarus of Taste*" until "our distinguished gentlemen patronize the arts and learn how to distinguish [masterpieces], from the signs which decorate the shops of the *barber*, the *tallow chandler*, or the *tailor*." Samuel F.B. Morse, arriving in London as a student of painting, marveled at the sight of genteel ladies and gentlemen at their easels in a gallery copying some of the pictures. "Since ladies of distinction, without hesitation or reserve, are willing to draw in public," he wrote his parents, they could plainly see "in what estimation the art is held here." By contrast, Jefferson's exploitation of young painters to do cheap copies for him and his purchase of "more or less third-class works" in Paris made a very poor figure.[52]

Other writers remained confident that wealthy patrons would appear, even if they were something less than Lorenzo de' Medicis. Sufficient numbers of well-to-do citizens, "Junius" claimed, were already becoming convinced of the importance of patronizing the arts. Money was already being spent on many works of art; it should be rechanneled, the Society of Artists resolved, to living American artists, "instead of running with the current of fashionable folly, in quest of the mouldy and wormeaten pictures of Europe—pictures, too, which are, at least, half a dozen of removes from originals."[53]

Nevertheless, many artists in the new nation continued to make invidious comparisons between levels of patronage in Europe and America. Writing of his son Rembrandt's trip to Europe, Peale conceded of "the first circles in Europe" that "it is a fact that if a Man possesses extraordinary tallents greater encouragement is given to them than in this Country." The aesthetic nationalist defense had to be put on other grounds. Latrobe wrote Rembrandt that he might find "European barbarism in government" more obnoxious than "our barbarism in the arts," or that the competition might be too stiff from those "struggling for bread, with more vigor, & more success." Potential artistic expatriates may also have become discouraged by European preferences for old masters. Furthermore, the American patronage scene was certainly not entirely bleak. Relying on friends and neighbors, a flood of obscure primitive painters enjoyed a stable income and social acceptance by their peers. English actors found pay in America far better than in England. Nevertheless, America had not by any means become the aesthetic Elysian Fields envisioned by the aesthetic nationalists.[54]

To sum up, nationalists in the early republic had repeatedly stressed the importance of great American artists as significant patriotic leaders. Their appearance and that of a refined democratic taste were seen to be thoroughly interdependent. When the desired quality and volume of art work and public interest failed to appear immediately, ingenious commentators searched for the cause, rejected the counsel of patience, and focused on the crucial question of money. Talk of the primacy of conquering the wilderness or of the cultural effects of early marriages satisfied few of these critics. They persisted in the faith that America's destiny was the artistic leadership of the modern world. Tardiness in achieving that position, the aesthetic nationalists kept chanting, could be eliminated if the government, the wealthy, all Americans simply spent more money for the works of American artists, who, in turn, would triumphantly lead public taste to unparalleled heights. The *American Review* started publication in 1801 by neatly summarizing the most acceptable view:

> . . . it is only the gradual influence of time, that, by increasing our numbers, and furnishing a ready market for the works of domestic hands and heads, that will, at length, generate and continue a race of artists and authors purely indigenous, and who may vie with those of Europe. This period is, probably, at no great distance.

Furthermore, American artists needed sympathetic applause, "and not the haughty ridicule of a coxcomb frown [which threw the artists into] a life of future inaction and chagrin." Americans had too long embraced "renegadoes, foreign convicts and imposters." Only when native sons received their countrymen's financial

and social rewards would bondage to transatlantic whims and conceits be ended. In the face of all discouraging evidence to the contrary, aesthetic nationalists reiterated their conviction that America would soon achieve world-wide artistic and aesthetic preeminence.[55]

4. Sculpture and the
Tyranny of the Greeks

———◄◆►———

*T*he first generation of American aesthetic nationalists were far more successful in enunciating theories and redefining vocabularies than they were in bringing forth an art and a public taste embodying their dreams. If nationalistic aesthetic theory remained disorganized and occasionally self-contradictory, its manifestation in the traditionally defined fine arts was heartbreakingly fragmentary. Achievement of the nationalists' hopes, or their frustration, varied considerably among the separate art forms. Ironically, but perhaps expectably, the art form which the museums and critics first thought about and studied remained the one most unresponsive to the demand for a distinctly American art.

Sculpture in the United States up to and long after 1815 remained more completely exotic and peripheral to American life than any other of the fine arts. The "literary" pioneers of a heavily neoclassical style did not flourish until mid-century, and a truly indigenous statuary came only in the closing years of the nineteenth century. As the *Boston Spectator* admitted in 1814, no American had ever attempted "to give in marble 'the human form divine,' " and so the nation could scarcely have many connoisseurs of statuary. Nevertheless, the editors printed a translation of some passages by "an

eminent German" to affirm their belief that sculpture
"is a sublime art, in which every person of elegant read-
ing cannot but feel a pleasing interest." The reason why
elegant *readers* were the presumed audience became im-
mediately clear. "It is but by imitating the ancients that
the sculptor can attain excellence," the German authority
pontificated; the ambitious artist had to become
thoroughly versed in ancient masterpieces like the
Laocoön. In case any American had the temerity to
hope for a homegrown school of sculpture, the translator
concluded with a dictum: "The most lively and best
disciplined imagination, will never supply the place of
reality." Since few Americans could hope to study in
Europe long enough to become intimately acquainted
with the ancient works, they could scarcely conceive of
a time when sculpture would be anything but a foreign
curiosity.[1]

The continuing domination of craven admiration for
ancient sculpture may be seen in the periodicals. This
partially explained the relative infrequency of such
articles—only 25 up to 1815, compared with 136 on
painting and 127 on architecture—since most editors pre-
ferred topics more congenial to American pride. Even
the catalog of the statues and busts in the Pennsylvania
Academy was compiled from "the best authorities." The
breathless admiration exuded in the catalog entries for
the American Academy collection showed the author's
"correct" attitudes, but stirred the interest of few Ameri-
cans: "The flow of youth enlivens [the Apollo Belve-
dere's] elegant person, in which nobleness and agility,
with vigor and elegance are sublimely blended, pre-
serving a happy medium between the delicate form of
Bacchus, and the more firm and masculine lines of Mer-
cury." If the magazine editors accurately estimated their

readers' taste, many Americans would just as soon hear
of the strange statues of Easter Island, an impressively
sentimental cemetery monument, or the efforts of the
admittedly backward Portuguese to erect statues, as to
read of the glories of ancient sculpture. In this regard,
Peale's Museum appropriately placed its 1,400 casts
from antique gems between the Mammoth Room and
the Chinese exhibits.[2]

The tactic of emphasizing ancient examples, which
had served American nationalists so well in other con-
nections, had a deadening influence on their interest in
sculpture. Nor could the game be reversed by playing
up modern trends, for the archaeological discoveries at
Herculaneum and Pompeii had produced "a new and
severer mode of study among the artists, with a more
diligent attention to nature and the antique." So said
John Flaxman, commonly considered the leading con-
temporary British sculptor. An occasional American tour-
ist might report from Europe that "you find an im-
mense number of ANTIQUE, clumsy, ill-designed,
worse executed statues, and but a very small proportion
of good ones"; his admiration for Michelangelo and
Bernini provided no real alternative for Americans, who
were nearly as remote in time and mood from the Ren-
aissance as from the ancient world.[3]

Some welcomed the lack of sculpture in America,
viewing the art as morally questionable. For a free,
Christian people to raise statues in tribute to any human,
living or dead, "is a sort of self-degradation; it is setting
up images to worship" and therefore blasphemous. If
one got beyond this objection, the fact remained that an
alarming number of statues were nudes. A self-styled
Bostonian visiting Venice was aghast at the indecency of

a reclining nude woman, even in marble, in a church. "It might have merit for its true imitation of nature," he conceded, "but nature is not always to be exposed, and particularly in a place of publick devotion." Typical of Americans for decades thereafter, he found it too embarrassing to examine the figure closely.[4]

Those who favored more statuary for the United States disarmed the moralists by the same gambit used in other connections: insisting on patriotic obligations to honor the heroes of the Revolution. Fortunately, the trend in Europe sanctioned modern dress for sculpted figures, and the question of a nude Washington, later to cloud Greenough's piece, did not arise. The several state and federal officers who almost immediately after 1783 began authorizing memorial statues of George Washington wanted "the work of the most masterly hand." The task of selecting and guiding the artist "would be a very pleasing employment for us," Virginia's Governor in Council wrote Jefferson, "if we had ever turned our thoughts that way or were adepts in the Science of devices, Emblems &c." Indicative of their colonial attitude, they wrote to state or national agents in Europe, asking them "to find out the best [sculptor] in any of the European States."[5]

And yet the apparent colonialism of such an approach was quite consistent with a certain kind of aesthetic nationalism cherished by Jefferson and popular among the most sophisticated and widely read Americans. What Gowans says of Jefferson's use of architecture holds equally for his ideas about sculpture:

> In Jefferson's mind, public buildings in the United States should be more than things of beauty; above all, they should state a creed. They should declare to the world the full mean-

ing of American independence, that what was created in
1776 was not just another political entity, but a basically
new way of life.

Consequently, he was as "willing to make some sacrifice
of convenience to the beauty of the form" in a tea-vase
as in a piece of monumental sculpture, but that did not
mean that he substituted indigenous formal criteria for
functional ones. What Jefferson wanted in all his public
and personal commissions was a symbolic rather than an
instrumental functionalism. For his purposes the attempt
to formulate new symbols ran needless risks. "Indeed
I have ever found it dangerous to quit the road of ex-
perience. New essays generally fail." Logically it fol-
lowed that ancient models in sculpture had the same
nationalistic value as they had for architecture. Their
use "will give unrivalled honour to our state," as he
wrote Madison about the architecture and sculpture for
the Virginia Capitol, "and furnish a model whereon to
form the taste of our young men." Unlike most aesthetic
nationalists, who sought new forms to mirror American
beliefs, those who followed the symbolic functionalist
path preferred traditional forms that could be "read" by
all civilized men.[6]

For a time Jefferson's views on sculpture also con-
tained an unclassical emphasis on phenomenological
rather than idealized reality. Thus, in the preparations
for Houdon to journey from Paris to America to do a
Washington statue from life, Jefferson agreed with
American friends that "an Exact *Copy*" of Washington's
figure and features should be the primary criterion. The
symbolic size, posture, expression and trappings of the
statue, required by neoclassical doctrine, would be sacri-
ficed "to enable them to transmit to posterity the form
of the person whose actions will be delivered to them by

History." Washington humbly accepted "whatever may be judged decent and proper."[7]

The critical consensus presumed by Washington to exist soon fragmented. The Columbianum and the American Academy both followed the practice of obtaining casts of classic sculpture, but the founders of the two organizations held widely divergent attitudes about the role the casts should play for American artists and American taste. Increasingly after 1800 it became impossible blissfully to follow Jefferson's course and hold in solution his contradictory beliefs about symbol and form in sculpture. Jefferson apparently recognized the problem. Toward the end of his life he moved ever closer to a purist position on symbolism, casting aside the claims of mundane realism. The result may be seen in a long letter of 1816 in which he advised the state of North Carolina on its plans for a statue of Washington. In his answers to the queries of Nathaniel Macon, Jefferson showed how far he had retreated into traditionalism. Ignoring the growing number of sculptors resident in the United States, he denied any awareness of "a single marble statuary" in the country. In any case, America had nothing to equal Carrara marble. "Who should make it?" Jefferson asked rhetorically. "There can be but one answer to this. Old Canova, of Rome. No artist in Europe would place himself in a line with him; and for thirty years, within my own knowledge, he has been considered by all Europe, as without a rival." He went on to cite "every person of taste in Europe" to justify his preference for a Roman costume since "our boots and regimentals have a very puny effect." Finally, Jefferson suggested Ceracchi's bust of Washington as a model, both because of Ceracchi's high reputation, and because "his style had been formed on the fine models of

antiquity in Italy." This traditional symbolism found favor with few Americans.[8]

A more widely held opinion was expressed by Latrobe in his advice to Macon about the same project. Latrobe felt that "the statue may be very admirably made in this country by Mr. Villaperta," an immigrant Italian with wide experience and impressive credentials. Furthermore, "we have in America marble" from new quarries in Maryland and Virginia "very superior in texture to that of Carrara in Italy." The national pride evident in these remarks came out most clearly when Latrobe reflected on the possibility of having the work done in Italy. He highly recommended Andrei, who had worked on the Capitol to Latrobe's satisfaction, to choose the artist because "he also has a perfect knowledge of the temper of our country, and would see that no Italian frippery should degrade the dignity of a figure of Washington." In contrast to Jefferson's reliance on conventionally approved artist and material, Latrobe vigorously supported the more popular kind of aesthetic nationalism. What Jefferson and a few other neoclassical dogmatists called "the fine models of antiquity" Latrobe cast aside as "Italian fripperies."[9]

Neither Latrobe nor those who shared his ideas about sculpture intended to repudiate all traditions. What they wanted was an Americanized imagery for traditional purposes. Latrobe was convinced that a monumental statue of Liberty for the federal Capitol "is indeed essential to the effect of my Architecture," and, generally, sculpture should convey a symbolic message. However, keeping one eye on public attitudes demanding comprehensibility of the symbolism, he had no intention of using a classical vocabulary too dependent on a mythology known only to those with extensive literary knowl-

edge. In drawing a seal for the Bank of Philadelphia, for example, Latrobe attempted a symbolic design that avoided the common pitfall: "The language of Allegory is like the Indian language of signs. It is *poor* in expression, & to those who do not understand it, appears nothing but ridiculous grimace." For similar reasons, Latrobe demanded representational accuracy. He accepted the indigenous symbolic value of the eagle to decorate the Capitol's Representatives Hall. But his Italian sculptors gave him "an Italian or a Roman or a Greek eagle, and I want an American bald Eagle." Requesting a drawing from Peale, Latrobe worried that "any glaring impropriety of Character would be immediately detected by our Western Members." Many Americans accepted Latrobe's blend of symbolism and pictorial realism in sculpture.[10]

Those who had any great interest in sculpture at all remained a small minority until long after 1815. The private market for sculpture in the United States, even by a recognized European master such as Houdon, may be fairly seen in the fate of the busts and other small works that he took to Philadelphia. Four years after Houdon's return to Europe, William Temple Franklin inquired of Jefferson what to do with "some Busts &c. belonging to Mr. Hudon." "I made him an Offer of Land for them as they would not sell here," according to Franklin, and ". . . we have no Person who understands packing such Things." As for public commissions, Peale perhaps spoke for most of his countrymen when he commented on sculpture in the District of Columbia: "I like not his Eagles or figures. . . . I would much rather see buildings without ornament than Sculpture badly executed: unnatural and without taste." If one may judge from newspaper comments on a Congressional bill

of 1801 to erect a mausoleum to Washington, a major cause of bad taste would be "that the means bear no proportion to the end—the fame of the man cannot be measured by the structure." A simple, undecorated statue or obelisk should be erected, with the simplest of symbolisms—a large and severely simple memorial to the austerely great leader. "Censor" voiced the widespread objection to raising a crumbling monument, pitiful in design, and disgraceful by contrast with the man whom it allegedly honored. Nevertheless, busts and statues of Washington, Franklin, Hamilton, Anthony Wayne, and the naval heroes of the war with Tripoli began to appear up and down the Atlantic coast. An emerging romantic nationalism, with its fondness for sepulchral mementos, was voiced by a New Englander visiting Mt. Vernon in 1813. He shed "a tear of sympathy over the Manes of departed greatness" and lamented that "no sculptured stone; no monumental brass, will tell the future wanderer where the Veteran lies."[11]

The fate of William Rush (1756–1833) illustrates the toll on American art taken by the contradictory and all too frequently unfriendly attitudes toward sculpture. Wayne Craven writes that Rush's work marked "the culmination of the native American wood carving tradition" and yet, at the same time, "was also its swan song." Crowds gathered at the wharves to admire his ship figureheads. Consciously ignoring neoclassical dogma, his carvings should have planted the seed of a virile and truly indigenous American sculpture. Unfortunately, the public had already been too thoroughly indoctrinated with the notion that "Art" in sculpture could only be in marble, and so they failed to see Rush's work as an American version of the traditional art of sculpture. Latrobe, one of the few in Rush's lifetime with the audac-

ity and perception to praise Rush's figureheads as great art, ranked him, "in the excellence of his *attitudes* and *action*, among the best sculptors that have existed. . . . There is a *motion* in his figures that is inconceivable. . . . Many are of exquisite beauty." For years thereafter, most Americans assumed that sculpture remained something in marble that one went to Europe, especially to Italy, to see, admire, and leave unrelated to American life. Accordingly, several generations of would-be American sculptors sedulously copied the styles and subjects of Europeans, leaving Rush's example for those anonymous craftsmen who decorated circus wagons and carved cigar-store Indians.[12]

5. Painting and Engraving:
Moralistic Neoclassicism Embattled

*A*merican attitudes toward and ideas about painting encompassed a far broader and more complex spectrum than for sculpture. Benjamin West's life (1738–1820) and work very conveniently illustrate the several major trends. Born and raised in Pennsylvania, first developing from a "provincial and literal-minded training" typical of the folk artist, West quickly moved on to study in Italy in the 1760s with an eager naïveté later so evident in his American students. Ultimately he settled in London, received the highest critical accolades for his correctly neoclassical historical paintings, and long served as president of the Royal Academy. The three stages in his career—self-taught folk painter, American student in Europe, and triumphant cosmopolitan—parallel the relative strength of the three main clusters of American responses to painting in the first generation of national existence. European neoclassical critical doctrine continued to dominate, though with decreasing force, partially because of European movement toward romanticism, but also because indigenous American genteel and vernacular developments showed growing strength. By 1815 America was ready for a distinctly national style of painting, which it soon received in the Hudson River School.[1]

West's American birth was a source of pride to his

countrymen, even though most of his adult life was spent in London and his championing of a European academic style of painting greatly complicated the task of aesthetic nationalists looking for a recognizably American school. Newspapers and magazines in the United States commonly referred to "the sublime pencil of the great American Artist." Samuel Morse spoke for most of West's American students: "As a painter he has as few faults as any artist of ancient or modern times." Equally important for both the American layman and artist, "in his private character he is unimpeachable." As an exemplar of American artistic talent and morality, West could not be surpassed.[2]

Many Americans also found West's art attractive, frequently for the same qualities held against him by modern critics. What Ellis Waterhouse rejects as his "natural banality of mind, coupled with an instinct for the facile imitation of old masters" and what Barker objects to as a facility for synthetic quotation producing monstrosities of moralism in his manufacturing plant of a studio, comprised West's primary virtues in the eyes of contemporary admirers. The sheer number and size of paintings continually pouring from his atelier amazed many Americans. They repeatedly praised "the *tout ensemble* arranged with perspicuity, as explains, at first view, the business of the picture, to the understanding of every beholder." According to the explanatory pamphlet accompanying *Christ Healing the Sick in the Temple*, the best encomium to convey "the extraordinary merit" of the picture would be the statement that the scene seemed real. Repeatedly, critics used such terms as "masterly conception," "most complete harmony," and "wonderful dignity." Rare and audacious indeed was the opinion that patrons ought to reject "the overgrown daubing

of Mr. West." As Flexner has put it, West found the key to his success in marrying the middle-class realism of Hogarth to the neoclassical dictates of Winckelmann. West made moralizing acceptable by delineating the sublimity of virtue rather than the ugliness of evil and by concentrating on such virtues as patriotism. West's widely heralded use of modern costume fit the neoclassical emphasis on archaeological accuracy, while his paintings' perspicuity and their noble subjects in dignified repose proved acceptable equally to neoclassical dogmatists and bourgeois spectators.[3]

Unfortunately for the aesthetic nationalists, West's artistic cosmopolitanism had little relevance to the search for a national taste. Using his historical painting as a critical guide, the reviewers of English exhibitions, for example, castigated the popularity of portraits which continued to dominate the shows. In viewing the 1808 display of the Royal Academy at Somerset House, "F.W." soon fell to yawning over the "endless, thick chop'd portraits" that apparently demonstrated the artists' contempt, "a catch-penny thing—that any thing will do for the vulgar mob." Candor required, he went on, the admission that portraits were "undoubtedly the most absolute reactions of a patron's orders." The fault lay in the distraction this caused the artists from subjects requiring deeper study, and mediocre historical paintings won attention by default.[4]

Only at its best, according to the critical doctrine based on West's paintings, did historical work embody the greatest qualities inherent in the art, qualities grouped under the four headings of "chastity," "correctness," "genius," and "imagination." Ideally, those four elements should be harmoniously combined, but this required great training, skill, and the finest models.

Otherwise, impulse would override truth, or, equally bad, "correctness" would remain coldly uninspired by fancy. To avoid such imbalances, painters had to study the Masters, who, it was generally agreed, had somehow found ways to balance the potentially conflicting criteria of great painting. The ambitious artist and the cultivated man of taste sought to discover the Masters' secrets of success. Using West's paintings as a critical guide, in short, had the result of deflecting American art and taste back toward the European models and theories which the aesthetic nationalists had worked so strenuously to minimize.

American magazines before 1815 published a large number of articles about painting. The commentators agreed that "the great desideratum of art" for painters was "the union or association of the Grecian style and character of design with all those lesser accomplishments which the moderns have so happily achieved." Such terms as composition, attitude, character, and grace referred to the Grecian excellence of classical repose and expression. If painters unimaginatively followed the critics' dicta, however, they provoked responses similar to that of a reviewer of the 1803 Royal Academy Exhibition: "There is nothing to astonish or to enrapture the spectator. . . . There is indeed study, labour, judgment, and, in many instances, composition and distribution." To get beyond this mediocre level, the painter, once again, must study the Masters and fathom their accomplishments.[5]

What prevented this critical canon from thwarting American painting, as it had thwarted a national sculpture? Unlike the situation in sculpture, neoclassicism in painting was, by the last years of the eighteenth century, fast losing its strength and coherence both in Europe

and America. The rising nationalism in art styles on both continents gained crucial leverage from the neoclassical habit of grouping artistic masterpieces into schools, geographically defined, focused in and derived from a particular master. Whereas all the greatest sculpture apparently fell into one school, the "antique," very little ancient painting was available for the modern critic to study. Consequently, the schools of painting had a multiplicity and a modernity quite different from sculpture. The four great schools, it was commonly asserted, flourished in Renaissance Italy. Opinions differed as to their relative rank, but most agreed that they were the Roman school led by Raphael, the Florentine school of Michelangelo, the Lombard school of Correggio, and the Venetian school of Titian and Paul Veronese. These, together, "seem destined to remain forever superior to human art and imitation." Nevertheless, even if on a distinctly lower plane, one might include the French school of Poussin and the Flemish school of Rubens and Van Dyke. Each of the Italian schools had its particular excellence: Roman correctness and elegance, Florentine strength and sublimity, Lombard lively naturalness, and Venetian coloring. Neoclassical critics viewed the other schools as derivative at best, Poussin following the Romans, and the Flemish concentrating on realism and color. Yet audacious Americans, searching for a synthesis of their own, might irreverently exploit the various schools. Rembrandt Peale, for example, wrote his father from Paris in late 1808:

> I have certainly profited greatly by the Voyage—independently of my health—I have seen and studied the Masterpieces of Rubens, Raphaelle, Titian, Vandyck, Corregio, Paul Veronese, &c. I have selected their beauties, noticed their defects, methodized their systems & have formed an

Union of their various excellences in the *Picture of my Brain* which is still to be my model, assisted by Nature—which I believe is sufficiently beautiful in America.

His approach, so drastically different from that of a young Benjamin West awed by Italian treasures in the 1760s, points up the weakness of neoclassicism's hold on American aesthetic opinion by the early nineteenth century.[6]

The cause of American aesthetic nationalism received support also from the changes then going on in European art theory. A subtle and gradual shift from neoclassical values to at least proto-romantic ones broke the grip of the older critical dogma without replacing it with an equally compelling newer one. Americans, like the Germans and other ambitious nationalities, took full advantage of the interim confusion in critical doctrines to push forward indigenous ideas and styles. On the other hand, the lingering power of neoclassicism necessitated the shaping of an aesthetic nationalism that was at least partially responsive to the ideas of the opposition.

The most extensive debate among neoclassical critics of painting pertained to the relative merits of Raphael and Michelangelo. The former disciplined his forms to maximize majesty, elegance, and grace, and seemed to be more purely Grecian in his taste. Michelangelo overwhelmed the viewers of his works with his "great *gusto*," using ideas not borrowed from previous masters. The gusto pleased many commentators, even if it lacked the elegance of Raphael or the ancients. The increasing popularity of Michelangelo over Raphael marked a declining interest in classic, restrained purity in favor of a freer fancy. In 1814 the *Boston Spectator*, for example, briefly described the works of the Florentine master as showing what marvels could be accomplished when

genius and industry united; Raphael received only faint praise, and that perhaps more in recognition of official opinion than from the writer's own enthusiasm.[7]

The dangers of indulging the taste for personal imagination could be clearly seen in the work of Henry Fuseli (1741–1825). The conservative critics found him particularly infuriating, for he had gone through all the proper steps of training and remained enthusiastic about the "unattainable superiority" of Greek art. But his love for Gothic horror and erotic frenzy without which, he claimed, beauty "fades into insipidity, and, like possession, cloys," betrayed terribly incorrect sympathies. Having gone to London as an able draftsman from his native Switzerland, having won the favor of Sir Joshua Reynolds, having studied in Italy for several years, and even having translated Winckelmann into English, Fuseli, to the bafflement of the neoclassicists, matured with a style of "impassioned energy and expression, or luxurious softness and grace." Rosenblum has even compared Fuseli with the Marquis de Sade in the "self-conscious exploration of erotic experience that approaches the bizarre, pornographic domain." Neoclassical critics found his work an "extravagance of fancy" unreconcilable with "true taste," or "nothing but a vile plaster of oil and ashes." Unbullied, Americans greatly admired Fuseli's paintings and lectures. Some of Latrobe's early, visionary drawings showed strong stylistic similarities to Fuseli. By 1802 the *Port Folio* calmly referred to him as "the celebrated Fuseli," endowed with the imagination of a poet and the genius of a painter. Americans continued to enjoy, as Charles Leslie summed up Fuseli's *The Lazar House*, ". . . one of the most tremendous exhibitions of appalling sights I ever beheld."[8]

Equally popular by 1815 and just as obnoxious to neoclassicists was the seventeenth-century Neapolitan painter of impassioned, stormy landscapes, Salvator Rosa (1615–1673). As the central figure of a genius cult which saw him as a "wild, free spirit of extravagant inventiveness" living an adventurous life, Rosa increasingly intrigued the various romantically inclined Europeans and Americans who avidly read Chateaubriand's *Atala*. Fuseli was quoted as believing "there was a general pervading grandeur, indescribable by words" in all of Rosa's work. Critical standards had been reduced to such a shambles, the redoubts of neoclassicism had been so breached by 1807, that the reviewer of the Pennsylvania Academy's first exhibition praised two paintings by West for their classic composition, and, in the next breath, complimented his son's painting for being in a style approaching that of Rosa. The "gloomy" master seemed to have an "irresistable talent of depicturing the horrible sublime," and an unusual flurry of excitement greeted the loan in 1811 to the American Academy of two paintings reputedly by Rosa.[9]

If Fuseli and Rosa threatened neoclassicism with an aristocratic variety of romanticism, the rising popularity of Rembrandt (1606–1669) and of Hogarth (1697–1764) augured an equally grave danger in the trend of middle-class tastes. By 1807 it could be said without fear of contradiction that "the name of Rembrandt is dear to all who are in the least acquainted with the fine arts." The magic effect of his colors seemed inexplicable, for he obviously owed little to examples from Greece or Italy. He was born in Leyden, and therefore presumably fell into the Flemish school, but that scarcely explained his appeal. Rejecting all ideal forms, showing actual antipathy for neoclassical notions of grace, elegance, or

grandeur, "with singular emphasis may this painter be said *to hold the mirror up to nature.*" Equally disturbing, Rembrandt remained ignorant of his art, viewed "scientifically," but he instinctively "commanded the whole empire of light and shade." Conservative critics could only shake their heads in wonder at this anomaly, and warn off the student by stressing the mystery of Rembrandt's communion with external nature. Relying on intuition and genius, violating all the lessons neoclassicists had been teaching, Rembrandt continued to worry the critics.[10]

The fundamental neoclassical doctrine of general nature was at stake. Rembrandt's critics could not deny that he drew his inspiration from nature, which, according to their theories, was a prime test of artistic greatness. However, Rembrandt's nature did not at all accord with that of the critics. Herein lay a fundamental problem for the increasingly strident defenders of neoclassical painting: their concept of nature tended to blur, fragment, and produce results abhorrent to conservative men of taste. Arthur Lovejoy has succinctly demonstrated the intellectual morass one falls into as soon as eighteenth-century meanings of nature are probed.[11]

Most American aesthetic nationalists before 1815 tended to construe "nature" in one of two widely variant ways. The first took a genteel position:

> Nature must be the foundation . . . but nature must be raised, and improved, not only from what is commonly seen to what is but rarely; but even yet higher, from a judicious and beautiful idea in the painter's mind, so that grace and greatness may shine throughout, more or less however the subject may happen to be.

While this did not correspond precisely with the conventional neoclassical doctrine, it led to similar critical judg-

ments. Adherents praised the Italian masters and spurned anything smacking of earthy realism, whether of the "German school" or the "vulgar lasciviousness" of Wertmüller's *Danaë*. Thus, a traveler visiting the Louvre concluded that the artist ought never lose sight of nature while he adorned it, and then rejected Flemish and Dutch genre pieces, "where low and disagreeable objects and scenes, drawn from the vulgar amusements of the coarsest peasants, are represented with disgusting fidelity." Obviously, a large element of class bias ran through the conception and critical use of ideal nature, thereby making it ideologically very suspect in America.[12]

An alternative definition of nature, more compatible with a democratically oriented art, though heretical in the eyes of neoclassicists, took a very simplistic tack:

> Painting is the art of representing to the eyes, by means of figures and colours, every object in nature that is discernable to the sight; and of sometimes expressing, by figures, the various emotions of the mind. . . . The different effect which the same objects of nature have upon different men, produce what is called the *different manners* of painters. . . . The painter of portraits should draw a faithful copy of nature in its minutest circumstances.

This was, in fact, an application to the theory of painting of the uniformity-variety interpretation discussed in Chapter 1. It meant that any man with adequate eyesight could trust his aesthetic judgment in following his own commonsense observation of the "truthfulness" of a painting. Equally important, it sanctioned the most humble efforts of untrained American limners who pleased their patrons. Since God intended scenery for man's contemplation, the painter blasphemed if he altered God's work in favor of his own ideas. As Leslie remarked of Westall's paintings, "His faults seem to

arise chiefly from a wish to improve upon nature, not knowing that what generally goes by the name of improving upon nature, is nothing more than being able to select all that is good from her, and that to obtain his end the artist cannot have too much intercourse with her." Landscape painters annoyed American critics, for example, by paying too little attention to the distinctions between morning and evening. Peale applied this interpretation to portraits, where he aimed "to produce a perfect illusion of sight, in such perfection that the spectator believes the real person is there." Consequently, Dutch realism, so obnoxious to the aristocratic traveler quoted above, found favor because of its accurate representation of mundane reality and because its subjects seemed more familiar (and therefore easier to judge) than Greek gods or Italian ruins. Followers of the commonsense definition of nature might, and often did, admire the Italian masters, but, in the neoclassicists' opinion, for entirely wrong reasons. Rather than praise the ideal beauty of Leonardo's Mona Lisa, they noted a believable portrayal of a beautiful woman.[13]

This simplistic conception of nature also reinforced the strong American distrust of connoisseurs and technical jargon. The asinine faux pas of pretentious art lovers proved to be one of the favorite fillers in American magazines. A typical article told of a dilettante in Paris viewing pictures at the Palais Royale who worked himself into an ecstasy over what he claimed to be Raphael's *St. John*. His friends listened in silent admiration. Finally a guide passed by and sneered at this "very wretched daubing" by some obscure copyist of the original in another room. Such absurd antics might easily be avoided, the editors frequently assured their readers. A painter should appeal to "men of tolerable good sense and in-

formation," and he had no need of "a few phrases of Italian connoisseurship to astound the amateurs of his native country."[14]

Eloquence developed as a corollary critical criterion from the emphasis on realistic treatment of nature when applied to human emotions. As one of the earliest articles on painting in an American magazine phrased it:

> . . . to have some celebrated Action, express'd with so much Force, that we see *Dignity*, or *Grief*, *Terror*, or *Love*, according to the Circumstances of the Story, and are moved as Strongly, as if the Persons represented were in Being, and before our Eyes. . . . is no longer a dumb Entertainment to the Eye, but a speaking Image to the Mind, that awakens every Sentiment in it.

This appeared in 1745. The emphasis on "celebrated Action" personifying idealized emotions showed the writer's kinship to neoclassical ideas, though the insistence on trompe l'oeil already implied an aberration from the doctrine of general nature. By the end of the century, American notions of pictorial eloquence threatened to break away completely from neoclassicism. Moralism easily seeped in when one argued that "*Emblematical Pictures* are a happy medium of conveying silent wholesome instruction to young minds." They were increasingly "read" with an orthodox literalness, as may be seen in Latrobe's analysis of Madame Plantou's *Peace of Ghent*. And, given romantic predilections, people used the same idea of eloquence to praise paintings not at all neoclassical or didactic in the traditional sense, for example Gautherot's *The Funeral of Atala* based on the story by Chateaubriand. The painting emphasized wild pathos, not classical or moralistic decorum. Neoclassical emphasis on nature and eloquence had provided

aesthetic rebels with eminently useful concepts with which to overthrow neoclassicism.[15]

No more striking evidence of that can be found than the preference of Americans for Hogarth instead of David as an alternative to West. Jacques Louis David (1748–1825), whose *Oath of the Horatii* (1785) marked a major turning point in art history, clearly held a far more central place in the development of neoclassicism than (according to conservative contemporaries) the rather vulgar cartoonist, William Hogarth. David's bourgeois, puritanical, ideological painting, "primarily a statement of political belief" rather than painting in the old sense of a "thing of beauty and a joy forever," should have been a very enticing model for American aesthetic nationalists. Yet the fact is that Americans remained singularly indifferent to David's life and work. Jefferson was virtually unique among Americans in saying, "I do not feel an interest in any pencil but that of David." In view of Jefferson's ideas about the function of sculpture, such a preference is not hard to understand. Much more puzzling was the reaction of John Trumbull, who actually saw the *Oath* in David's studio, and mildly noted "figures large as life, the story well told, drawing pretty good, coloring cold." Rembrandt Peale responded similarly, lavishing the highest praise for Rubens' paintings, as Trumbull had, and going on to dismiss David's: "Those I have seen are more remarkable for high finish, excellent drawing & great size than *general effect*, and alongside of Ruben's, where some are placed in the Luxembourg Gallery, dwindle down to the appearance of *Parchment* paintings." Perhaps these painters simply had no interest in the ideological implications of David's work, but neither did their countrymen. American periodicals published biographies of

many major and minor European painters, but not one appeared on David. The infrequent and brief mentions of David credited him as being a good colorist and a close student of nature, or gasped at the size of one of his huge canvases, but none showed any awareness of his real aims or significance. The first generation of American independence experienced a variety of French cultural influences, but David's example was not one of them.[16]

In sharp contrast, Hogarth's reputation could scarcely have been higher in early nineteenth-century America. Neoclassicists had never been very happy with his pictures or his theories. They felt Hogarth lacked skill in form and color and too often degenerated expression into caricature. His main merit was only a "coarse fidelity." However, by 1815 Americans had become accustomed to hearing his conception termed poetic and almost prophetic. The "quantity of thought" which Hogarth crowded into every picture alone served to *"unvulgarize"* whatever subject he treated. His forcefulness seemed "analogous to the best novels of Smollett or Fielding." George Murray even told the Society of Artists that Hogarth "may justly be denominated the Shakespeare of painting." In explanation, Murray very revealingly asserted that his paintings "tend equally to amuse, to delight, and to instruct." Certainly, David's paintings provoked few chuckles, and apparently they delighted no American other than Jefferson. Murray's summary of Hogarth's recipe for success suggested quite another trend than the grandiose history paintings of a David.[17]

From Hogarth to sentimental genre painting to anecdote turned out to be a very easy transition. Neoclassical critics had always objected to the unimaginative realism and trivial subjects of genre painters. By definition, they

failed to concern themselves with the "higher departments of the graphic art; such as invention, grandeur of design, and sublimity of expression." Artists of genre merely concentrated on details and coloring in portraying familiar scenes. For the same reasons, early nineteenth-century audiences with egalitarian and romantic (or sentimental) inclinations welcomed painters like Wilkie who aimed to delight and amuse, not to instruct or reform. They charmed the crowds with "the *justness* illustrating *that particular* story," with humor of incident rather than of character. Similarly, reviewers had moved a long way from strict neoclassical tenets when they praised Westall's painting for "the spirit and ingenuity of his rustic life." To say that his work was distinguished for classical taste meant little more than that people thought his paintings admirable. Anecdotes of humorous, ordinary scenes, or of picturesque landscapes, threatened to banish entirely serious concern for decorum, sublimity, or ideal nature.[18]

Interest in eloquent paintings reinvigorated the long-standing debate on the relative merits of poetry and painting. The enthusiastic partisan of anecdotal pictures who claimed that painting, in fact, was no more than poetry in pantomime unintentionally raised the question of painting's value. Photographic realism, if carried far enough, enabled poetry's defenders to argue that the painter overly concerned himself with the material world. By comparison, therefore, the poet using "the whole limits of the physical and spiritual creation" held a much more exalted artistic rank. For this reason, admirers of painting stressed the immediacy and intensity of impact that their favored art form had over poetry. That, in turn, increased the tendency to value the emo-

tional more than the intellectual, romantic rather than neoclassical responses to favored pictures.[19]

Nevertheless, in spite of all these influences working toward incipient romanticism, neoclassical theories of painting continued to keep a precarious hold on the official sources of art criticism before 1815. To recur to the parallel made at the beginning of this chapter, Benjamin West's position in London still symbolized official aesthetic doctrine. But the stances represented by the two earlier phases of his career—self-taught painter in the American woods and young painter ready to make a place for himself in the genteel art world—marked the wave of the not-very-distant future in American ideas about painting. The defenders of neoclassical theories were already feeling embattled and discouraged. Whether they looked at the growing taste for the genre of a Wilkie or Westall or for the unrestrained fancy of a Fuseli or Rosa, prospects were grim. In either case, the future would prove "the general doom which, in this country, awaits all who are bold enough to pursue the elevated walks of art." So said the discouraged reviewer of the British Royal Academy's exhibition for 1809. In spite of the neoclassicists' insistence on the formative importance of the old Masters, they feared Leslie was right when he wrote: "There is nothing more certain than that a young artist acquires his taste from the living artists that are about him much more than from the works of those who are gone." And if they had looked across the Atlantic, they would have found an even less promising prospect in the United States.[20]

The habit of contemporary critics of treating art history through biographies of masters and of national schools encouraged Americans to look for distinctive na-

tional traits in their artists, a search that ended in final rejection of neoclassical dogmas by the 1820s. The vaunted Italian schools, of course, served as exemplars of this critical approach. As could be seen in the case of Rembrandt, the national schools were sometimes defined simply by the birthplace of the artists, regardless of stylistic differences. Alternatively, artists were defined by their leaders, as when Guercino was called "another disciple of the Caracci school." Some critics modestly saw themselves as "too ignorant to be the pupils of any school, and guided by the mere impulse of natural feeling," but proceeded to set up a particular artist, rather than a school, as their test of greatness. The prevailing tendency remained, however, to define stylistic schools geographically.[21]

Self-conscious Americans readily accepted such an approach and looked for the rise of an American school. But who would be its leader? West continued to receive attention from the American press, but he could scarcely serve their needs. Admittedly, he had employed painting "for moral and useful purposes. His works are a silent, but impressive system of morality, piety, and patriotism." Yet the trouble with conceiving of West as an American exemplar could be seen in the fact that the *Port Folio* reprinted this tribute to West from a London publication. He had lived too long in England and played too important a part in English art for the defensively anti-British American public to accept his leadership. Even if one justified West's residence abroad by noting that had he stayed in the United States he would have had "the noblest and *amplest* opportunities of—giving away as many pictures as he pleased," the unsuitability remained obvious for all but a few Americans.[22]

Alternative candidates for the leadership of an Ameri-

can school of painting failed to find a broad enough con-
sensus among aesthetic nationalists. Among the older
generation, Gilbert Stuart's pioneering portraiture, with
its "eloquence personified," encouraged artistic conser-
vatives and nationalists. But even in portraiture he was
an imperfect master. Though Stuart painted "a most
exact likeness," Latrobe concluded that he "could not
paint any thing below the Chin & could not draw any-
thing correctly." And his capricious arrogance continu-
ally annoyed clients. As John Quincy Adams com-
plained, "Mr. Stuart thinks it the perogative of genius
to disdain the performance of his engagements." John
Singleton Copley's character had no such black marks
against it, but, to quote Charles Leslie, "his merits and
defects resemble those of West." Resident in England
since 1775, Copley could no more serve the needs of
American aesthetic nationalists than could West. Young
American painters seemed promising, but none had yet
established themselves sufficiently to win an indisputable
leadership above their peers.[23]

Failing to find a single, dominant star, perhaps Ameri-
cans would discover a constellation of native talent.
Magazine writers of the early nineteenth century ad-
vertised any and all painters in the United States hoping
thus to point to or prove the existence of an American
school. This led to the puffing of many obscurities. Take,
for example, the sad story of Otis Hovey, of upstate
New York, whose genius, "which if properly cultivated,
might have astonished the world . . . must now dwindle
to insignificance, or be content with the praise of the
vulgar, and the gaze of the rustic." Hovey, Jacob
Eicholtz (the tinware maker of Lancaster, Pennsyl-
vania, discovered by Thomas Sully), and many other
backwoods geniuses seemed to show that the American

forests were bursting with artistic potential that needed only a little cultivation to glorify their homeland. Anyone with the suggestion of talent tantalized American editors with the thought that he might be the unrecognized Michelangelo of their country. Urban amateurs like John Cogdell, the Charleston, South Carolina, lawyer, also received notice.[24]

Some European exiles seemed potential leaders of an American school. Francis Guy, living as a tailor in Baltimore, suffered from a lack of patronage that seemed a scandal to the *Observer*. His "dreams of reality," so charming to modern critics, seemed to his contemporaries merely evidence of a genius like a "wild plant." Frenchmen such as Denis Volozan and D.W. Boudet, and many other artist refugees failed to get any better response from the American public.[25]

The greatest attention went to the painters who have been most respected by later critics. Sometimes the artists pushed themselves forward with anything but modesty. Rembrandt Peale, in a letter to his father published in the *Port Folio*, bragged of his invention of "encaustic": "I have produced the most brilliant effects. . . . Beauty shall come to me for immortality." And the elder Peale took full advantage of his friendship with Jefferson and other national leaders to press his son's case. More typical was the boosting of Charles Leslie, who had the good fortune of being "discovered" while working for the publishers of the *Port Folio*. Leslie seemed so gifted, in his first sketches, that Philadelphia patrons, led by his employers, financed his trip to England for study with West. Thereafter, from 1813 on, numerous reports of his rapid rise to excellence and of subscriptions for commissions appeared in American

periodicals. Before long, they kept saying, he would be a brilliant ornament to his country.[26]

Leslie, Washington Allston, and Samuel F.B. Morse reportedly would serve the coming generation as West, Copley, and Trumbull had served the passing one. Allston's *Dead Man Restored to Life* (1813), according to the *Analectic Magazine*, showed that painter "soaring at once to the highest department of his profession." Nationalists and traditionalists alike cheered the productions of his "imagination teeming with splendid and beautiful ideas, and governed by a pure and classic taste," though Allston's work was at least as romantic in the European manner as that of Fuseli or Rosa. The correspondent reporting the widespread admiration of Morse's *The Dying Hercules* (1812) shown at Somerset House and awarded a gold medal, could not help but feel a patriotic glow at the thought of these young Americans reaching such prominence.[27]

But the American school of painting, prior to the 1820s, remained a potential rather than an actual development. Aesthetic nationalists had to decide upon criteria by which they could separate true members of the school from pretenders and unpatriotic followers of European styles. This necessity for critical choices broadened the differences between the vernacular and the genteel manners of painting evident in America by the early nineteenth century. Sidney Tillim has called this dichotomy "the great continuing tension in American art," the tug and pull "between provincialism and style, between secularism and High Art." His use of the word "provincialism" nicely symbolizes the problems for aesthetic nationalists. In the broad stream of Western art, primary concern for distinctively American values *was*

provincial; yet, for early American nationalists, the continued association of American artists with European recognition and theories—Allston's romantic, quasi-Italian landscapes; Morse's gold medal from the Royal Academy—almost surely meant the absorption of American art and taste into those prevailing in Europe. The nationalists' sympathy for genteel "cultivation" and fear of the vulgar, and egalitarian implications of the vernacular style made their critical task all the harder.[28]

Benjamin Latrobe was a good example of the genteel aesthetic nationalist. Always proud of his education, refinement, and social standing, he was repeatedly torn between his nationalistic fervor, with its innovative thrust, and his acceptance of traditional aesthetic criteria and prejudices. Aware that patronage patterns in the United States called for advice like that he gave to Boudet—"looking neither to the right nor left, you should *manufacture* heads"—still, he could not avoid lamenting that his friend "has sunk into a mere miniature painter." Portraits might be tolerable for a professional painter, Latrobe seemed to be saying, but miniatures were beneath the painter's dignity. Such a distinction reflected eighteenth-century English priorities, not nineteenth-century American needs.[29]

Where this genteel nationalism led may be seen in Latrobe's opinions on painting landscapes. In 1798, while recuperating from an illness in Richmond, he composed and illustrated a beautiful little manuscript entitled "An Essay on Landscape." In the form of an extended letter to Susanna Spotswood, whom he may have been courting at the time, the text verbalizes a mixture of "correct" Enlightenment attitudes with those soon to be popularized by Chateaubriand, Madame de

Staël, and other romantic writers. He began by running through the lessons to be gained from the old Masters, emphasizing Claude Lorraine, Rosa, and Poussin. He paid credence to "the Chain of being which peoples and cloaths this earth," dabbled in speculations about sundry topics of natural history, and otherwise showed himself to be a conventional "man of reason." Cheek by jowl with these, however, are romantic outbursts like the following:

> The World, indeed, is a great Cemetery;—every thing is composed, and is upheld by the decomposition, & destruction of something else; & the gay tapestry of every spring, viels the murders of all the preceding Seasons!
> What a glorious Subject for melancholy! How delightfully miserable might not a philosopher make himself by indulging Such a *cogitation.*

Similarly, he wrote a long entry in his journal which started out sounding like one of the many hymns praising the beauties of the American wilderness: "The whole landscape of America is most essentially different,—considered in the view of Art,—from that of Europe." But then he went on to express regret that it "consists of *Systems* of Landscapes that may be Classed under a few heads, and from which many of the most pittoresque kinds of Scenery, frequent across the Atlantic are absolutely excluded." America had a few glories, including the Hudson River Palisades and Niagara Falls, "but upon the whole they are beautiful but *tame* Subjects for the pencil."[30]

The nostalgia for Europe expressed by Latrobe verged too close on betrayal of the nationalist cause for it to be shared widely or for long in America. That Latrobe and his contemporary artistic peers frequently

conveyed these feelings in their art as well as in their letters and conversation separated them from the dominant mood of their countrymen. Emerson eventually wrote a patriotic indictment of Allston that summed up the grievance against him and like-minded artists long held by aesthetic nationalists:

> Allston is *adamas ex veteri rupe*, chip of the old block; boulder of the European ledge; a spur of those Apennines on which Titian, Raphael, Paul Veronese, and Michel Angelo sat, cropping out here in the remote America and unlike anything around it, and not reaching its natural elevation. . . . The times are out of joint, and so is his masterpiece.

Magazine writers, well before 1815, recognized that "identity—*what* is American—remained indeterminate until the sense of *place* had been established and fixed." They tended to agree that, since no antique examples were available for American painters to study, nor perhaps even informed praise to spur them on, necessarily "nature was their first teacher, her works their great academy." Foreign recognition had its attractions, but those staying abroad were soon crippled by "too artificial refinement upon the wild and vigorous stock of their own genius." Homebred artists might lack cultivated taste, but they were distinctive and unmatched for "acuteness of observation, in truth and accuracy, in short in the power of representing individual nature." Thus, portrayal of nature in the second sense discussed earlier in this chapter, with its democratic and antineoclassic implications, became the crucial test of the American school. Woe unto those who, like Allston, failed to understand this development and continued to paint esoteric historical subjects or Italian landscapes. Far better to be like Benjamin Trott, who, according to an encomium of the

miniaturist published in 1811, "may be called the un-
tutored child of nature, having drawn his powers from
his original genius."[31]

Those looking for criteria on which to base the Ameri-
can school of painting relied heavily, in fact, on the
values and techniques characteristic of American folk
painting. In effect, this meant that the first stage of
West's career, the untrained limner, became the pre-
ferred model of Americanism in painting. It gained
some sanction from the professional painters' emphasis
on the normative role of nature. Gilbert Stuart rein-
forced popular inclinations when he stated, "I will not
follow any master. I wish to find out what nature is for
myself, and see her with *my own eyes.*" But even with-
out such authorities to quote, the flood of folk painting
pouring out in early nineteenth-century America sug-
gested to aesthetic nationalists, as later scholars have
occasionally agreed, "what is peculiarly American about
art." Contrary to academic painting's emphasis on the
grand and the noble, the American vernacular domesti-
cated everything. Even when religious or patriotic scenes
were portrayed, the homey and familiar allusions re-
ceived strong emphasis. Artistic pretentiousness had no
place here. Rembrandt Peale mimicked the stance of
the American limner when he advertised his wares in
Baltimore by claiming that "the portraits . . . are, at
least, a handsome and genteel kind of furniture; and
as such certainly worth a few dollars!" Those painters
responding to popular tastes received eulogies regardless
of whether or not they fit traditional biases. Miniaturists,
spurned by a Latrobe, won lavish praise from the *Port
Folio* and other magazines. The writer of a biographical
sketch of Edward Malbone, whose sudden death in
1807 was widely lamented, found in his paintings of

female heads particularly "enchanting delicacy and beauty." A painting of an actor by a New York miniaturist named Wood "alone entitles its author to immortality." Trott got frequent mention side by side with Stuart and Copley as worthy of international fame.[32]

Proponents of an American painting based on the vernacular style applauded the public interest in landscapes. They were confident that the non-European traits of the American scene would speed the rise of a national taste if the artists focused on American topography. As one newspaper, commenting on Vanderlyn's panorama in New York, put it in 1818:

> Although it was not to have been expected that Mr. Vanderlyn would have left the higher department of historical painting, in which he is so eminent to devote his time to the more humble, though more profitable, pursuit of painting cities and landscapes—yet, in a new country, taste for the arts must be graduated according to the scale of intellect and education, and where only the scientific connoisseur would admire his Marius and Ariadne, hundreds will flock to his panorama. . . . This is to "catch the manners living as they rise," and with them catch the means to promote a taste for the fine arts.

And landscapes *were* popular, probably more in demand than portraits, except for those of Washington. The style of the landscape paintings, largely done by limners, differed markedly from Latrobe's prescriptions. Where the genteel English style of landscape painting, substantially followed by Latrobe, depended on an illusionism whose constituent elements had been carefully set down by theorists of the picturesque, "the style of the typical American primitive is at every point based upon an essentially non-optical vision." Rather than following perspective and all of the other academic techniques

developed since the Renaissance, the American folk painter had "a style depending upon what the artist knew rather than upon what he saw, and so the facts of physical reality were largely sifted through the mind and personality of the painter." Since he shared the prevailing ideas and beliefs of his clients, the folk painter unselfconsciously replaced European theories about the beauties of particular scenes with a search for a clear, energetic, and coherent expression of his, and his clients', perceptions. Thus, neither the genteel nor the vernacular style evidenced an unmodified search for photographic realism. Their most crucial difference lay in the source of the mental filter through which they strained visual data: aesthetic theories carefully worked out in Europe, based on the works of selected old Masters, versus the commonsense presumptions generally held by most Americans. Aesthetic nationalists, in short, had chosen well their criteria for an American school. Reliance on the vernacular style gave them a ready-made critical approach that was both usable and unavoidably populistic in its ideological implications.[33]

The best illustrations of the practical implementation of American attitudes toward the plastic arts are the reviews of annual exhibitions that became common after 1810. Although a number of public exhibits occurred earlier, including that of the Columbianum in 1795, the first magazine review appeared in 1807. For a time the reviewers concentrated on the old Masters shown and on those Americans, such as West and Stuart, who had safely established reputations. Other commentators merely set down their responses to a particularly impressive picture, praising Leslie's portrait of Mr. Cooke or marveling at Jarves' *Irving*. The first full review appeared in the July 16, 1811, issue of the *Balance*.[34]

The reviewers responded favorably to the conviction of the Society of Artists and the Pennsylvania Academy, which jointly sponsored the most important annual exhibits starting in 1811, that the range of selection should be as inclusive as possible. To the traditionally recognized arts of painting, engraving, sculpture, drawing, and architectural sketches were added such handicrafts as ladies' paintings on velvet and silk embroidery. The reviewers soberly appraised them all, making no invidious comparisons between arts and crafts. For those who sneered at miniatures as being no better than painting teacups, and therefore a waste of a Trott's talent, one reviewer angrily retorted by asking why teacup painting should not, after all, be considered a worthy art form. If miniatures and teacups were artistically inferior, he concluded, it could legitimately be so only because 99 out of 100 were poorly done.[35]

The positive criteria to be used received clear statement in the first major review. The writer first observed that the collection generally "does infinite credit to the artists, and to their country," rivaling not just the first, but the eighth or tenth, Royal Academy Exhibit. He particularly liked the paintings shown by Stuart, James Peale, and Volozan, as well as those of John Krimmel, the most influential painter of anecdote in the new nation. Francis Guy came in for hard knocks for allegedly basing his landscapes on foreign, colored prints. The critic objected to Guy's views of Baltimore as showing the "short and clumsy figures of the Dutch school, and the stunted oaks of European scenery" instead of tall Americans and our "infinitely variegated forests." Landscapists in general, this anonymous critic reiterated, ought boldly to aim at the simplicity of nature, distinguishing with accuracy the hours of the day, or the sea-

sons of the year. Thomas Birch had achieved this in his picture of the Schuylkill River. The nationalism, vernacular realism, and desire for familiar and anecdotal subjects evident in this review would remain the dominant criteria.

Reviewing the 1812 show, "G.M." (George Murray, one wonders?) proceeded cautiously. He believed that "indiscriminate praise is rather productive of evil than good," but the commentator ought also to avoid concentrating on "the *trickery* of art, [rather] than on the faithful and natural representation of real objects." He affirmed the democratic orientation that art necessarily had to have in the United States. Since the great mass of people were well informed and based their taste and criticism on "*common sense*," artists ought to break away from a servile imitation of European masters. American artists should "boldly pursue the same course as the ancient Grecians, who had nature only for their model, and genius for their guide." Thomas Sully's paintings rightfully gained great admiration, he felt, but his *Lady of the Lake* erred in showing no resemblance to Scottish terrain. Again, in his portrait of Mr. Cooke as Richard III, Sully "deviated from nature with a view to improve his picture," and destroyed the likeness. Krimmel's *View of Centre Square on July 4*, by contrast, "is so familiar and pleasing a representation. It is truly *Hogarthian*," according to Sully, though Krimmel still needed practice in "the mechanical part of his art." As for those city productions of landscape done from sketches, better called "scratches," G.M. claimed, "We had rather see a simple stump of a tree, with whatever weeds may happen to surround it, painted faithfully from nature, than the sublime garret views of cataracts, clouds, and mountains, painted by the trading artist or the travelling

amateur." Curiously, this demand for vernacular expression did not carry over into sculpture. Though the critic generally rejected European recipes for landscape painting he made an exception of William Rush's wood carvings for the new Schuylkill River Bridge. They produced a very bold and striking effect by "this truly American sculptor," but the reviewer hoped Rush would pursue the "higher branches" of his art, that is, neoclassical statues.[36]

Concern for anecdote and realism continued in the reviews of the Third Annual Exhibition in Philadelphia, but interest in something beyond photographic accuracy gained prominence in the commentaries. Rembrandt Peale's still life had great merit in its "accurate and minute resemblance . . . very near perfection," and Krimmel's *Quilting Frolic* pleased most viewers. "Everyone can sympathize with the cares or the pleasures of middling and rustic life," the *Monthly Recorder* commented, "for there all is natural." In addition, Bass Otis' having no identifiable manner seemed "a convincing proof of his close attention to nature." However, his painstakingly detailed portrayal of the *Constitution*'s battle with the *Guerrière* brought the complaint from one reviewer that "there is a wide difference between a *picture* and a *map* of a ship." Presumably, Otis tended to overemphasize representational accuracy for its own sake. In contrast, Trott's portrait miniatures deserved applause for their having "*soul* as well as *body*." Very tellingly, however, the same observer continued to endorse the dictum, "The object of painting is to represent nature." Rhetorically, he asked, "Is nature to be viewed through the medium of old cracked pictures [of the Masters]? we hope not." The strong implication remained that nature *should* be viewed through the eyes

and the inclinations of the contemporary American, not through some allegedly objective lens. The vernacular sympathies of this critic were further revealed in his final comment, which praised a black chalk sketch of the interior of Oliver Evans' foundry.[37]

Reviewers of exhibitions in 1814 and 1815 maintained the criteria used for the earlier shows. The reviews continued to be characterized by reliance on commonsense judgments combined with distrust for the technical jargon of connoisseurs, with favorable citation of the Dutch and Flemish schools to justify emphasis on accurate portrayals of nature. Reviewers did not change their predilection for American patriotic and anecdotal subjects. An exception might be inferred from one commentator's expressed wish that American artists would aim for a higher and bolder flight, rising from the cold delineation of individual nature, to the dignity and invention of the highest branches of the art. This suggested either a retreat to neoclassical formulae or the onset of a new gentility. The comment, however, was made only in reference to recent commissions celebrating heroes of the War of 1812. Being patriotic portraits, they marked scarcely any significant break, as yet, with prevailing American criticism. How far the American critics had departed from the language and interests of their English contemporaries may be seen by leafing through the newspaper and magazine reviews reprinted by William Whitley. A representative passage appeared in the *Sun* of May 4, 1817, praising Ibbetson's *Eagle Crag from Scandergile Force, Borrowdale. Effect of sunshine on a waterfall*:

The naked figures are drawn with the utmost ease, elegance and truth, and coloured with Polemberg's delicacy and sweetness, the clearness of water and the aerial perspective of the

whole, unrivalled by any artist, ancient or modern, and absolutely only to be equalled by Nature herself, in a camera obscura. The prismatic effect on the vapour, though hardly discernible and only noticed by acute observers, has a surprising effect.

From painting title to final phrase of the discussion, this notice, and most of the rest reprinted by Whitley, could have found no place in an American periodical of the same date. American criticism had achieved substantial autonomy.[38]

The same could not be said for graphics. Americans tended to accept engraving as a polite art, if only because it enabled dissemination of knowledge about great pieces of art work. Yet this subordinate and ancillary role rendered it vulnerable to the objection that prints inadequately represented the originals. Etchings could give no idea either of coloring or of "that charming part of the art [of painting], the chiaroscuro." On the other hand, "pictures scarcely going beyond mediocrity have produced very fine engravings" when the subject was striking, for defects in drawing and coloring "vanish before the graver." Since the engraver merely copied with unavoidable imperfection the creative work of another, he could gain no very high artistic rank in an era when "original genius" played such a major part in aesthetic judgments. Thus, even though no ancient examples existed to hound printmaking, and though it was a technological art readily adaptable to mass marketing, this medium had serious difficulties in gaining acceptance, in practice as well as in theory.[39]

A few engravers and their sympathetic publishers worked hard to build a market for American prints. The *Columbian Magazine* and a few others published landscapes and portraits fairly regularly. William Birch

o8.

ics,
nto
ght
the
odi-
ned
uro-
rent
tate
nly
and
tter
th-
the

tate
in a
of
, or
ote
the

ed.
th-
on-
he-
ng
an
ce
lar

as-

138

ing
its u
Sigr
ing
in A
tale
to r
gro
Am
tests
in A
ann
insp
the
awa

T
for
gen
Fra
the
be
the
by
eve
for
As
pic
anc
the
me
tha
des
hav
gar

could be gathered from the objection that "the eye is absolutely disgusted to see how miserably *flat*, and *awkward*, how hard and harsh, every artist has contrived" to make ladies' bosoms. Regardless of mundane realities, a bosom ought to be shown as soft, pleasingly curvaceous, and graceful. As this makes clear, unlike the vernacular style in painting, engraving had not yet freed itself from European theories. Such a dogmatic statement of the proper look of a feminine profile implied academic artistic attitudes far more than those of the vernacular. It should not be surprising, therefore, to learn that the greatest compliment Americans bestowed on their engravers was to say that their work would do credit to European artists.[42]

We may conclude that a superficial glance at the contents of American magazine articles up to 1815 would have conveyed the idea that neoclassicism prevailed completely. Certainly the numerous reports on Benjamin West and the traditional treatments of the European masters would support such a conclusion. Indeed, in sculpture Americans *had* so far failed to reveal any interest in breaking away from neoclassical dogmas. Engraving, too, suffered from a tendency to define the fine arts in restricted terms not entirely relevant to American needs and interests. In painting, however, Americans had capitalized on prevailing critical theories to justify a significant break with European trends and concerns in favor of encouraging an indigenous, distinctively American school. Rejecting a sense of inferiority and impotence arising from America's lack of elaborated art traditions, critics by 1815 had reconstrued that paucity into a fundamental advantage, enabling the growth of a democratic, naturalistic, and nationalistic style of painting.

6. Architecture and Interior Decorating: "Elegance and Convenience"

⬤

*A*mericans might debate whether they should encourage the arts of sculpture, painting, or music, but they had to have buildings. Once past the primitive beginnings of settlement, that is, by 1700 or earlier in most of the seaboard areas, some kind of architecture naturally appeared. Prior to national independence, however, American architecture seldom if ever sought consciously to avoid the examples set by the European, and especially the English, cultural centers. Provincial variations of those models, of course, did appear with increasing frequency. The resulting architectural scene in the new nation revealed a welter of conflicting tendencies. Talbot Hamlin distinguished three major varieties at the time of Latrobe's arrival in 1796: "the continuing English colonial traditions," opposed both by "the dominant classicism so strongly upheld by Jefferson" and by a "marked nationalistic trend" championed by Charles Bulfinch, Samuel McIntire, and Asher Benjamin. More recently Alan Gowans has argued that the prerevolutionary classical tradition broke down, after 1783, into the "Adamesque-Federal" style of classical decadence, the Empire or neoclassical style of Roman symbolism, and a variety of vernacular and Gothic preferences. Clearly, Americans in the new na-

tion had to choose not whether architecture ought to be accepted, but what kind of architecture they were to have.[1]

No more than in aesthetic theory could the need for choice of architectural style be evaded by reliance on imitation of European conventions. Mid-century classicism was rapidly losing its hold on European architectural opinion. Those in the United States who would nostalgically recur to an increasingly moribund neoclassicism soon exposed their critical bankruptcy. Backward-looking commentators ostensibly believed that, from the descent of Xerxes to the death of Alexander the Great, "we see the elegant arts cultivated to that high degree as to leave succeeding ages only the humble task of imitating what they could never equal." Imitation meant careful use of classical orders, a bias for stone rather than wood buildings, and heavy emphasis on proportion and symmetry. Yet the buildings and writings of Vitruvius, Palladio, Inigo Jones, and Sir Christopher Wren, rather than those of the ancient Greeks, served as the models for these neoclassicists. More importantly, the emphasis on imitation of the ancients accompanied a distinctly Baroque interest in prospects and axial lines. A short description of Monticello printed in 1803, for example, repeatedly drew attention to its magnificent prospect. A traveler in Paris about the same time complained that the view of the Louvre, like that of St. Paul's in London, was interrupted and obscured by surrounding buildings. Illustrations for articles on architecture in American periodicals often evidenced a strange misunderstanding between the critic and the engraver. An article praising the fine views to be seen from Dartmouth College, laid out with geometrical formality, had an illustration of the college, with boys playing ball,

without any sign of the vaunted prospect. Similarly, the description of a country villa near Philadelphia allegedly commanding a fine view of the city included a plate showing only the house and neighboring shrubbery. Whatever the reason for this divergence between text and picture, the emphasis on siting remained as evidence that American neoclassical attitudes toward architecture embodied relatively modern as well as classical concerns.[2]

The neoclassicists' remarkably limited critical vocabulary vitiated their ability to persuade their countrymen far more than did their rather muddled use of classical and Baroque ideas. This may have been partially attributable to the assumption that their readers were familiar with classical doctrine, and, therefore, that one needed only to say that Fanueil Hall composed "a uniform and consistent pile" or that a building in the style of a Greek temple presented "*A Plain But Stately Edifice.*" The chair maker's advertisement that his wares were "in the neatest manner" would seem to support such a hypothesis, but he immediately added, "and different fashions." A critic might justifiably fall back on enthusiastic use of words such as "sublime" or "grandeur and beauty" to praise an attractive structure, but all semblance of critical clarity had disappeared when a residence could be heralded as elegant, though "finished not altogether in the modern stile, nor yet in the Gothic taste."[3]

The trouble lay in the neoclassical emphasis on architectural expertise. Typically, architectural observers followed the cautious course of a traveler admiring the Flavian Amphitheatre in Rome who excused himself from giving a description since he had insufficient time and technical knowledge, and was not equipped with proper measuring instruments. Consequently, he and

many other tourists indiscriminately gushed about noble, magnificent, and elegant specimens of refined taste.[4]

The word *elegant*, in fact, became a convenient catchall term of praise. Americans here only reflected and compounded earlier British imprecision, evidenced in Samuel Johnson's definition: "rather soothing than striking; beauty without grandeur." The occasional American effort to sharpen the meaning got little further than to say that elegance "is distinguished from beauty, as the species from the genus." Writers could still praise the "elegance" of a massive church spire, of the New York Federal Building, and of Shellburne Light House. The term had been emptied of any significant content beyond registering some sort of approbation by the time it was used to characterize the Gill house in Princeton, Massachusetts, an odd combination of Greek Revival and Italian Renaissance architecture.[5]

The nostalgic neoclassicists tended to be as conservative on social issues as they were on aesthetic ones. They repeatedly urged the use of stone and brick instead of wood as the basic building material. They stressed the need for permanence, perhaps because of the example of ancient ruins, though not for the obvious reason of minimizing the devastation caused by the fires that plagued all American cities. The neoclassicists looked for ways to reduce physical and intellectual mobility in a new nation where change was the dominant watchword. As the writer of a description of Yale College in 1796 put it, "These valuable buildings are brick, and bid fair to stand as lasting monuments of the piety of their founders."[6]

Americans' persistence in building with wood, moving frequently, and departing from their ancestors' piety went far to explain the increasingly shrill imprecations hurled by neoclassicists at those who ignored or eclecti-

cally mixed classical models. In the face of the obviously declining American respect for classically pure architecture, its defenders harped on the sheer size of ancient monuments, attempting to bully their countrymen back to the true way. This paralleled a rather priggishly genteel accent increasingly evident in neoclassical architectural comment. One of the directors of the Pennsylvania Academy revealingly commented in his description of the Academy's edifice, "How grateful to avert the offended eye from the loathsome objects of common life, and to expatiate over all the charms of Grecian and Roman beauty." The zealous defender of architectural correctness, examining New York City's new Grace Church, could concentrate on "an appropriate ballustrade, subdivided by pannels, the beauty of which entirely atones for the want of taste so evident below." In a less charitable mood, he would bitterly indict a church in Baltimore that had the impudence to sport Ionic columns based on a ratio of nine times the diameter for their height, rather than the proper twelve or fifteen. The "monstrosity" also had flattened arches, which, he sneered, all men of taste knew could be used only for lower courts, stables, and coach houses. Regardless of these denunciations, most Americans blithely went their way restlessly asserting their nationalistic pride and looking for more inspiring forms than those dictated by the archaeologically purist pedants.[7]

The widespread popularity of the Greek Revival, by the 1830s, demonstrated that Americans were far from repudiating all interest in classical architecture. The nostalgic neoclassicists failed to win a wide following, not because of the forms they favored, but because of the *reasons* for using those forms. Correctness and formal purity for their own sakes held no attractions for

any but a tiny minority of the American people. At the same time, extensive American use of classical styles for their symbolic value, politically or socially, or for their functional qualities would continue through much of the nineteenth century. The difference in tone between the neoclassical critique and one more acceptable to the American public may be seen in a newspaper article of 1803:

> The Americans have a taste in architecture, not corrupted, but suspended in its progress. The moment they see what is truly beautiful, they acknowledge its ascendancy. Hitherto, they have but little attended to this branch of the fine arts. In reaching at perfection, they will not have to travel thro' the rubbish of Gothic whim and caprice; the Grecian model is open to them; and they ought to adopt its models in all their severe and elegant simplicity. Their present style is slovenly in the highest degree; they may, however, step from this situation to the highest attainments at a stride. . . .
>
> . . . Here we recur to first principles, with ease, because our customs, tastes and refinements, are less artificial than those of other countries. . . .

Here are the egalitarian, optimistic, and nationalistic sentiments so popular in early nineteenth-century America. They could find attractions in the "Grecian model" quite as easily as did the snobbish, elitist, convention-bound neoclassicists. The issue remained one of motive, not of form.[8]

Americans of the generation following the Revolution generally stated their basic criteria for excellence in architecture in terms of elegance and convenience. But this apparent consensus disguised different attitudes at least as much as it expressed commonly held ones. As we have already seen, the signification of the word *elegant* had been so broadened as to render it almost meaning-

less. Furthermore, the relative weight to be given to the two criteria—whether elegance should be bent to the needs of convenience or vice versa—and, indeed, the very meaning of the word *convenience* remained open to question. A convenient building, one would imagine, functioned well. But what functions were most important? Greek Revival porticos for banks obviously served an important symbolic function, suggesting stability and dignity. Romantically picturesque country villas could generate a pleasantly escapist feeling, far from uninspiring American realities, thus serving an emotional function. Or a house might be built primarily to maximize the physical comfort of the residents. All three of these varieties of functionalism found their partisans in early republican America.

Thomas Jefferson was the most important proponent of symbolic functionalism. Those scholars and tourists who have emphasized the ingenious gimmicks that Jefferson devised for Monticello and the charmingly quaint quadrangle at the University of Virginia have failed to understand Jefferson's aim. He did enjoy playing the inventor and repeatedly indulged his interest in mechanics, but that inclination never stood in the way of his quest for a symbolically satisfying design for his residence. As Karl Lehmann has persuasively argued, the siting of Monticello on a hilltop three miles from the village of Charlottesville did not represent either the traditional practice in Virginia or Jefferson's search for the most convenient location. It marked his effort to revive the "very framework of ancient life," in this case following the precedent of the Roman practice in locating villas. And for its form, Gowans has succinctly stated Jefferson's reasons for remodelling Monticello:

There was nothing 'wrong' with the original Monticello, physically or aesthetically speaking; Jefferson's family was no bigger, his periods of residence were shorter, and as an example of a cultivated Virginia planter's home the 1770s building had been advanced enough in style to be perfectly acceptable still. It was the architectural "language" that was wrong. Now that Jefferson was no longer an English squire in the provincial plantations, but one of the most prominent citizens—and indeed, as President, first citizen—of a republic in which the values and virtues of ancient Rome lived again, Monticello must be made an appropriate architectural symbol of them.

In Jefferson's eyes, if American architecture were to move beyond the "rude misshapen piles" that he denounced in *Notes on Virginia* it had to express an acceptable symbolic language. Defending the design of the University of Virginia campus, its Board of Visitors enunciated Jefferson's principal concern: "We had, therefore, no supplementary guide but our own judgments, which we have exercised conscientiously in adopting a scale and style of building believed to be proportioned to the respectability, the means and the wants of our country, and such as will be approved in any future condition it may attain." The primary aim was "respectability," not "correctness."[9]

Classical forms admirably served Jefferson's desire for an architecture to symbolize the meaning and message of the United States. Since the Renaissance, Western man had praised the democratic liberty, simplicity, and dignity of Periclean Athens and republican Rome. Jefferson shared Latrobe's expectation that America would become the modern Greece. In 1812 he reassured Latrobe that the Capitol in Washington embodied a

design "worthy of the first temple dedicated to the sovereignty of the people, embellishing with Athenian taste the course of a nation looking far beyond the range of Athenian destinies." A quarter of a century earlier, when Jefferson first had the opportunity to shape the course of public architecture, he had already settled his views. The state of Virginia had decided in 1785 to build a new capitol in Richmond, and the commissioners for the project wrote Jefferson, then ambassador in Paris, requesting a plan which would "unite economy with elegance and dignity." Unhesitatingly he searched out "an architect whose taste had been formed on a study of the antient models of this art." Equally indicative of Jefferson's concern for symbolism was his explanation to James Madison for the delay in forwarding the plans and scale model: "Much time was requisite, after the external form was agreed on, to make the internal distribution convenient for the three branches of government." His claims for the convenience and economy of the Virginia capitol could not set aside the fact that the design had been selected for its external appearance rather than its internal accommodations. Most important of all, in Jefferson's opinion, was the need for "a morsel of taste in our infancy promising much for our maturer age." After all, he asked rhetorically, "how is a taste in this beautiful art to be formed in our countrymen, unless we avail ourselves of every occasion when public buildings are to be erected, of presenting to them models for their study and imitation?"[10]

Jefferson found the ideological implications of classical forms eminently acceptable, but the fact that they had "the approbation of near 2000 years" further enhanced their value. A "respectable" architecture not only said the right things but said them in the right way.

Jefferson was painfully aware that when an architect undertook a new solution, "experience shews that about once in a thousand times a pleasing form is hit upon." In selecting a design for the Virginia capitol, as in all of his other architectural concerns, he preferred "not the brat of a whimsical conception never before brought to light, but [one] copied from the most perfect model of antient architecture remaining on earth." This also dovetailed nicely with the aesthetic nationalist tendency to counter contemporary European example by recurring to venerable tradition rather than by repudiating America's place in Western civilization. Thus, insistence on classical symbolism in architecture paralleled the emphasis placed upon national schools in painting. In both cases, Americans freed themselves from European aesthetic domination by turning the European theorists' ideas against their proponents.[11]

To the very end of his life Jefferson held fast to the architectural beliefs that he had voiced in the 1780s. The campus of the University of Virginia, his last and perhaps greatest architectural work, demonstrated his preference for classical symbolism in much the same way as had Monticello, the Virginia capitol, and Washington, D.C. His beloved "academical village" no more aimed to maximize pragmatic convenience than did his own home. Lewis Mumford might grow ecstatic over "Jefferson's insight into the human needs that these buildings serve . . . for example, in the very intimate scale of the colonnades." Its founder repeatedly asserted that "this village form is preferable to a single great building for many reasons, particularly on account of fire, health, economy, peace and quiet." No doubt those were important considerations, especially if one were struggling to gain funds from a dubious legislature or

to persuade suspicious Europeans to emigrate and make up the faculty, but they were held within the limits set by classical symbolism. The visual evidence for this interpretation has been thoroughly set forth in Gowans' *Images of American Living.* Nothing in the written records suggests need for major changes in Gowans' interpretation. When it came to questions of siting, Jefferson turned Latrobe's protests aside with the argument that "the range of our ground was a law of nature to which we were bound to conform." Less than two months later, however, the Board of Visitors (dominated by Jefferson) resolved "that the ground for these buildings should be previously reduced to a plain, or to terraces as it shall be found to admit with due regard to expense." If the "law of nature" permitted large-scale grading and filling, why should it not allow directional realignment of the quadrangle? The answer would seem to be that the former responded to symbolic needs, the latter merely to considerations of climate. For when Latrobe had suggested the need for a central pavilion to tie the quadrangle together, Jefferson immediately recognized its symbolic value and incorporated it into his plan. Ultimately the location of the library, this central pavilion gained such importance in Jefferson's thinking that, as he wrote George Ticknor in 1823, it would be "the principal ornament and keystone, giving unity to the whole." Needless to say, Jefferson used the word keystone advisedly. The campus, it was hoped, would serve the everyday needs of a collegiate institution, but it had to be visually coherent in its symbolically classical statement. The nostalgic neoclassicists' arid pedantry had been recast by Jefferson into an architectural style with long-lasting appeal for many Americans.[12]

Both symbolic classicism and nostalgic neoclassicism

tended to underemphasize interior design in favor of architectural exteriors. Characteristically, American magazines up to 1815 published 127 articles on architecture but only four specifically on interior decorating. The architectural articles, as well as reports from travelers, paid only infrequent and fleeting attention to interiors. The ornate, paneled rooms of Herculaneum received extended notice, but produced only the conclusion that "one cannot but admire the elegance of the Ancients." Details of the interiors of American buildings got such brief treatment as to suggest that the writers denied the aesthetic significance of interior decorating. One article might mention Harvard Hall's library, with a rich carpet and walls ornamented with paintings and prints. Yet no systematic analysis appeared that was even remotely equivalent to those of exteriors. Typically, the interior arrangements of Charles Bulfinch's Tontine Crescent in Boston, except for mention of their dimensions, received only the comment, "The rooms are spacious and lofty, and attention is paid to procuring all possible conveniences for domestic use." The growing American preference for an instrumentally functional aesthetic gained scant attention from the varieties of neoclassicism that ignored or harshly subordinated interior design in favor of external appearances.[13]

Latrobe's preëminence among American architects in the first two decades of the nineteenth century was at least partially due to his insistence that neoclassical elegance could be combined with everyday convenience. He proudly reiterated that "my principles of good taste are rigid in Grecian architecture. . . . Wherever therefore the Grecian style can be copied without impropriety I love to be a *mere*, I would say a *slavish* copyist." Unlike Jefferson, however, Latrobe argued that "the *forms* and

the *distribution* of the Roman and Greek buildings which remain, are in general inapplicable to the objects and uses of our public buildings." The differences between Mediterranean and American climates particularly impressed Latrobe. Therefore, he always demanded that "good arrangement" should be the primary design criterion, even ahead of durability and assuredly far above the desire for "a magnificent piece of Scenery." Comfort-loving Americans could not fail to be impressed.[14]

Latrobe justified his "license in detail" in order to fit neoclassical forms to American needs by referring to the practice of the ancient Greeks. Contrary to the inflexible pedantry of Palladio and other Renaissance theoreticians, Latrobe argued, examination of the greatest pieces of classical architecture proved that "the Greeks knew of no such rules,—but having established *general* proportions and laws of form and arrangement, all matters of detail were left to the talent and taste of individual architects." Unlike Jefferson's and the nostalgic neoclassicists' academic rigidity, Latrobe preferred to concentrate on Grecian principles. Once again we see how Greenough's functionalism played a significant part in American aesthetic opinion well before the era of the Transcendentalists.[15]

Whenever the commission permitted, Latrobe preferred to start his design by analyzing the requirements of the client. Generally this resulted in a finished building recognizably neoclassical in shape, decoration, and detail. But if the requirements could not be satisfied by any reasonable variation on classical examples, Latrobe had few qualms about using a Gothic or other style. Thus, he submitted both a Roman and a Gothic design to the bishop and the building committee of Baltimore Cathedral. After discussing the relative merits of the two,

he confessed that his *"habits"* inclined him toward the Roman, "while my reasonings prefer" the Gothic. In the case of the Baltimore Library, he sent classical and Gothic designs, denying any preference for either. At least one residential work, the Markoe house in Washington, had no external merit at all, in the eyes of its architect, being entirely "created by *interior*" needs.[16]

The William Waln house (1805–1808) in Philadelphia may serve to show how Latrobe's functional classicism varied from that of Jefferson's or of the nostalgic neoclassicists. From the single remaining illustration, one does not immediately see how the motives involved in its design differed from those of many other houses of the same period. Far from straining for startling innovations or for a stereotyped Greek Revival appearance, Latrobe clearly tried to attain classical restraint, dignity, simplicity, and detail while incorporating what he named, in his fifteen-page letter to Waln, as the major criterion for an American house, "the greatest possible compactness, and convenience for the family, expressed in the very comprehensive word, *comfort*, and moderate means of entertaining company." Yet anyone studying the house and Latrobe's long letter would soon recognize that this architecture was not meant to be *read* in the way intended for Monticello or the University of Virginia quadrangle. That the Waln house had no porticoed porch, or that it did have a Palladian fanlight, was of no crucial importance. In order to correct the poor house designs in America, based on English precedents but in an incompatible climate, Latrobe wanted to blend a French floor plan, with its convenience and privacy, with an English "neatness, and elegant cleanliness." When Latrobe itemized his working ideas in designing the Waln house, the ideology so important

to Jefferson was as noticeably absent as were the nostal-
gic neoclassicists' unyielding demands for archaeological
accuracy. All of the program referred to functional
needs: (1) Avoid back buildings; (2) give light, air,
and easy access to the kitchen and "offices" without re-
moving them *below* the convenient inspection of the
lady of the house "by placing them in the cellar"; (3)
reserve the best rooms for the main entry facade; (4)
"gain a suite of good rooms including the Lady's apart-
ment on one floor"; and (5) fit the house on the 102-by-
175-foot lot while leaving in reserve "a valuable build-
ing lot in front." To achieve all of these requirements
within a severely classical container quite obviously re-
quired imagination and careful study. It was little won-
der, then, that Latrobe lost patience when builders copied
his designs without understanding the reasoning behind
them. They merely borrowed what he once called "the
coeffure of Architecture" while ignoring, and therefore
violating, the functional considerations he deemed so
essential.[17]

Typical of Latrobe's interest in interior decorating
was his insistence on designing all of the furniture for
the Waln house. Repeatedly, he wrote letters to clients
and friends, urging them to think carefully through
their intentions for furnishings and decoration. Conve-
nience required separation of public, private, and ser-
vants' areas in a home. Comfort dictated keeping the
number of windows to a minimum, even when the house
was correctly aligned for seasonal variations, if the
housewives were not to "engage in interminable warfare
against the glaring light and hot air" in summer and
drafts in winter. In decorating the rooms, "there should
be a regular gradation from the plain Hall to the orna-
mented Drawing room, and the Lady's boudoir," while

avoiding everywhere "quirks, and beads, and all sorts of overdone whims." Latrobe was always ready to set forth his ideas about interior design, whether on the proper angle of interior moldings to get "the beautiful effect of broad and clear shadow" instead of "a muddy penumbra," or the theory and practice of meaningful symbolism in the decoration of the Capitol. He made no invidious distinction between interior and exterior design, nor between the smallest detail and the largest facade. He consistently worked for an instrumentally functional classicism to achieve the greatest elegance and convenience.[18]

The popular demand for instrumental functionalism in architecture may be seen in the way even the nostalgic neoclassicists occasionally gave a functional gloss to their dicta. As one periodical put it, though classical rules necessarily placed much of architectural planning "under the jurisdiction of mathematicians," nevertheless, nothing should appear "stuck on" or superfluous in a building. "The great art," the same article continued, "consists in turning that which is necessary, or convenient in a building, into ornament. . . . The distinction of an edifice ought to determine its natural character." This neoclassicist tended to isolate some structural concerns as the prerogatives of the builder, not the architect, but many of his contemporaries applied functional, even organic criteria to all phases of design. Thus, the dome of the Hollis Street Meeting House in Boston found favor from the *Massachusetts Magazine* for its fine acoustic qualities as well as for its classical forms. Similarly, the Liverpool Lyceum could be termed magnificent by a writer in the *Port Folio* because it combined classical simplicity and correctness with a convenient, functional interior. The French legislative hall's chaste symmetry and order, on the other hand, "dwindles

down into something very frivolous and childish," according to one tourist, "when we recollect that the functions of this numerous body, are those merely of puppets." Classical dignity for trivial function could yield only absurdity, just as surely as did noble function embodied in petty, incoherent design.[19]

The force of aesthetic nationalism, as we have seen, could be encompassed within classical forms along the lines set by either Jefferson or Latrobe, but it might, with equal ease, strengthen the growing American preference toward romanticism and away from neoclassicism of any kind. Opponents of the trend bombastically, if ineffectually, defined the new movement:

> The word *romantic*, . . . is now become of vague and undefined application in the mouth of every dunce, male and female. . . . [It is] defined to be, *an ascendancy of the imagination over judgment* . . . [caused by] an affected appetite for the *vast* and *grand*, despising all the common and ordinary duties and relations of life. . . . The best means of correcting this romantic disposition are—an appeal to the dictates of *past experience*; and resignation to the will of God.

Americans' unwillingness passively to follow tradition and the will of God equalled the strength of their gradual movement toward romantic attitudes that frequently had nationalistic, or even chauvinistic, overtones.[20]

Nationalistically inspired coverage of architecture appeared in the earliest magazines and increased steadily. The first illustrated article (1760), for example, dealt not with noble and ancient models, but with Princeton's Nassau Hall. A critic of 1791 agreed with Jefferson that "the genius of architecture has shed maledictions over our land," but went on to assert the optimistic claim that Americans were less confused in their ideas of pro-

priety than any other people on the globe. We acted more from the impulse of "an enlightened nature, than from the coercion of the fashions," imposed by the opulent in Europe, that trifled with nature. Each era and climate, he felt, had its own proper taste. Though the writer ended by reaffirming neoclassical ideas such as the need of stone rather than wood as the basic building material, the implications of his argument clearly suggested an American architecture noticeably different from that of ancient Greece and Rome.[21]

Indicating the emerging professionalism of American painters and the increased public visibility they consequently attained, architects of praiseworthy buildings were carefully named in the contemporary press. During the years from 1790 to 1795 alone, laudatory descriptions appeared in periodicals of: Samuel Vaughn's improvement of Philadelphia's State House Square; Bulfinch's Triumphal Arch and Hollis Street Meeting House in Boston; Robinson, Moore, and Smith's Government House in New York City; and the Court House for Salem, Massachusetts, by "the ingenious Mr. Samuel M'Intire." All of these, to be sure, were more or less neoclassical designs, but the nationalistic pride in indigenous architects could equally well strike at the roots of older conventions in favor of new, romantic concerns. Owen Biddle's *The Young Carpenter's Assistant*, written by a young man particularly attracted to "picturesque and natural objects," adapted itself "to the style of building customary in the United States."[22]

The emerging interest in architecture having picturesque and storied associations marked the first major step away from neoclassicism toward romanticism, or, at least, unabashed eclecticism. The leading modern authority on the picturesque point of view, Christopher

Hussey, has listed its major architectural characteristics: "soaring, irregular masses, crumbling surfaces, masses of shadow, and prodigious [Baroque] 'movement.' " This might lead to a coherent, romantic style, but in itself was rather a way of combining styles than a style per se. Consequently, interest in the picturesque played a role in American aesthetic nationalism similar to the idea of national schools in painting. Though examples from Europe might still be closely observed, the result tended to emancipate Americans to search for equivalents, not merely reiterations of Old-World trends. Anticipated in England by Vanbrugh, and appearing full-blown with Robert Adam's *Survey of the Arts in England* (1778), concern for the picturesque had made serious inroads on American loyalty to neoclassicism by the 1790s. The latter's emphasis on the long, varied history of ancient monuments and their spatial location added substantial impetus to the drift toward an incipient, eclectic romanticism. The historic events occurring in Fanueil Hall, or the picturesque location of Vice-President John Adams' "Country Seat" outside New York City, soon began to overshadow interest in the symmetry and formal correctness of the buildings. Henry Livingston's estate on the Hudson River might have a mansion of no particular merit, but the "rural beauties" of its gardens and surroundings gave it extraordinary interest. Philadelphia's classically designed statehouse of 1735 had become "a spacious and venerable structure" by 1798. From this, it was only a short step to the eminently romantic attitude of looking for a "venerable and classick appearance," noting "a melancholy pleasure in contemplating the remains of the works of past ages." Following one of the aesthetic "transformations" traced by Rosenblum, the reflective observer

could take neoclassical architecture as a stimulus for romantically melancholy reveries about the transience of life, sealing it safely away in the historical and emotional distance and out of the way of important imitations. The emphasis on rural beauties brought with it an insistence on consulting "the genius of the place" instead of busying oneself with "regular Grecian designs." American taste had soon gone so far down the road toward massive, unrestrained irregularity that the assessment by the *Literary Magazine* in 1804 of Eddystone Lighthouse could no longer be thought exceptional:

> The solitude of this mansion, ascending amidst the waste of the waters . . . the dreary uniformity of the surrounding scene,
>
>> "Dark, illimitable, waste, wild"
>
> all conspire to feed and harmonize with melancholy and ferocious passions. The gloomily sublime, and the awfully magnificent are no where so amply and terribly unfolded as in the appearance of Eddystone in a storm.[23]

The picturesque point of view prepared the way for a Gothic Revival in America, evident soon after 1800. It might be presumed that the Americans simply picked this up from England, where Gothic Revival architecture had flourished as a vigorous alternative to the Georgian style since the mid-eighteenth century. Most contemporary observers thought otherwise. As Bülow, a German traveler, put it, "The American architecture falls into the gothic style, when they are left to their own ideas," citing houses in Philadelphia with round turrets and "the most fantastic caricature shapes." Certainly the manner in which the word *gothic* was used by American newspapers showed little awareness of European antecedents. A stucco worker advertised his

ability to work "either in the Modern or Gothic Taste," and the New York *Commercial Advertiser* soberly reported the arrival of "some very elegant Casts of Gothic Statues—amongst which is, a beautiful Cast of a Dying Gladiator." Clearly, the word *gothic* was used so loosely in late eighteenth- and early nineteenth-century America as to defy any efforts to trace its origins.[24]

Whether an indigenous growth or an imported style, Gothic irregularity, with elaborate decoration and massiveness, brought an enthusiastic response from early nineteenth-century Americans. Where the Amsterdam Stadt House seemed only a huge, ungainly curiosity to an American traveler in 1784, it had become a noble monument of Dutch industry and opulence by 1802. Other travelers wrote home of their pleasure at seeing the "magnificent portico" of Westminster Abbey, "Gothic and extremely beautiful." American receptivity to "Gothic grandeur" continued to the point where the *Free Masons Magazine* reprinted a long passage from Madame de Staël's *Corinne* that used St. Peter's Cathedral, that great exemplar of Renaissance classicism, as subject matter for romantic reveries. This enthusiasm soon brought to Philadelphia all sorts of buildings at least reminiscent of Gothic architecture, including the exterior of an oilcloth factory. By 1816 Latrobe ruefully confessed, "I have several Mortal Architectural sins to answer for. . . . One of them is, poisoning the taste of the towns by a morbid tendency to Gothic Architecture."[25]

The trend seemed particularly appropriate for church architecture. The European cathedrals, with their great age and tendency to fill the mind with sublime, solemn, and religious sentiments, persuaded some American commentators that the Gothic style for churches far surpassed "the more light finical one of Greece." The lat-

ter might catch the eye and tickle one's fancy, but it failed to make "an impression upon the heart and manners" at all comparable to that made by Gothic architecture. Consequently, Gothic churches received praise for their correct taste; in other words, from an instrumentally functionalist point of view, Gothic worked better than classical.[26]

Traditionalists might choke over the application of their favorite phrase to describe such irregular buildings, but that illustrated only one of many drastic changes in the American critical vocabulary and architectural values. Mt. Vernon, formerly thought to be so elegant, now seemed "extremely plain," though with a most beautiful site. Boston's Federal Street Meeting House, one of the many new Gothic churches, more properly deserved the appellation "elegant" under the new dispensation. "A Lady," swooning over the beauties of Roslin Castle, apparently felt no contradiction in calling its chapel "a very chaste and elegant piece of Gothic architecture. It is a ruin," she panted, "but the most perfect ruin that can be seen." Terminology had become the utter despair of philological purists; the *Port Folio* saw "Dorsey's Gothic Mansion" in Philadelphia, with its balustrades, buttresses, niches, "Saracenic tablets," and antique window, as "a correct and chaste specimen of the Gothic order . . . a model of beautiful and correct architecture."[27]

Dorsey's Mansion indicated an eclectic appetite for colorful, exotic, and romantic decoration that had been developing in America for some time. As early as 1791, Helen Maria Williams started her tour of Paris with the Bastille, "feeling a much stronger desire," she explained, "to contemplate the ruins of that building than the most perfect edifices of Paris." This interest in ruins

and any "ancient and magnificent, though gloomy edifice," derived from a fundamental change in tourists' attitudes which will be examined in Chapter 9, fed American tastes for new and different ideas for decorating exteriors and interiors of all kinds of buildings. Careful descriptions of strange ornaments gave hints to readers aspiring to follow the latest architectural fad. Magazine articles ranged ever further afield to find the exotic, describing "Mahometan Temples and Mosques," the Russian Czaress' Hermitage, the Pagodas of Hindustan, and the legendary land of Persia. An author telling of some Spanish hermitages clearly revealed the major motive—a quest for the titillatingly different: "The hall was neat, large, and stately; but being plain and unadorned with no more than decent decorations suitable to such a society, I hastened [on]."[28]

When attention turned back to European buildings, the quest for the exotic led to concentration on "the most romantic avenues" and rustic tower of Le Petit Trianon, not the neoclassical glories of Versailles. Old castles served admirably to bring forth delighted murmurs of "vestiges of ancient grandeur . . . gloomily magnificent . . . barbarously magnificent." Editors were especially happy to publish "particular descriptions" of such structures as the new Exchange-Hall in Hamburg. Not only had its architect included "everything that can contribute to convenience and utility," but he had provided rooms for every mood, including the Arabic Saloon and the Grecian Saloon, "in the pure Grecian style, with Caryatides." Thus, classical decor had become little more than additional grist for the insatiable eclectic.[29]

In their escape from the dead hand of neoclassicism, Americans seemed to have rushed from the picturesque to a giddy, romantic eclecticism, commonly called Gothic

and apparently no more American than Greek temples. The idea that Americans proved their nationalistic taste by the very fact of their unusually restless use of a motley variety of everchanging architectural decorations pleased the first generation of aesthetic nationalists no more than it has subsequent partisans of an "elevated" American taste. The despairing critic of the 1814 Pennsylvania Academy exhibit saw no other alternatives than a rank romanticism and loyalty to neoclassicism. Heralding Joseph Ramée's designs for Union College, he hoped that "the genius and talents of this artist will have a tendency to *check*, if not to *destroy*, a semi-barbarous taste (which seems to gain ground amongst us) for a mongrel Gothic architecture, where *novelty*, *whim*, and *caprice* are substituted for fitness, beauty, and elegance." Many Americans agreed with his indictment without feeling compelled to return slavishly to the "chaste simplicity of Grecian architecture." They sought a truly American architecture which, like folk painting, drew upon and symbolized their own experience, needs, and aims.[30]

The essence of the evolving vernacular tradition was the emphasis on functional simplicity as the way to achieve an attractive "elegance and convenience." John Kouwenhoven, the leading student of this style, has pointed out that it depended on the joy of creating beautiful useful things by stripping away all but the instrumentally essential parts and forms. Diametrically opposed to the "Beaux Arts ideal" of conventional, applied ornament, this tradition, according to Kouwenhoven, tended to be one ignored by most writers, then and since. Certainly few American aesthetic nationalists before the twentieth century had the wit or courage to champion the vernacular in architecture, even to the extent that they

did in painting by 1815. Kouwenhoven may be right in calling Horatio Greenough its "first important defender," though, as we have seen, Greenough had been explicitly anticipated in the early years of the nineteenth century. But by 1815 many American journalists commenting on architecture, and especially on bridges, revealed their commitment to and endorsement of the vernacular tradition.[31]

Writers of this persuasion tended to suggest convenience as the primary criterion of good building, in place of romantic appeal or correctness, either neoclassical or Gothic. Defenders of architectural gentility sometimes narrowly skirted this approach, as when "X." specified that an elegant table required neatness and "a certain genteel disposition." A European critique of American architecture noted that "those private houses which they build are commodious and well-finished, and the brickwork in Philadelphia is not to be excelled anywhere. The United States," the article concluded, "have many works of utility, but exhibit very few specimens of architectural taste." The partisans of the vernacular rejected this dichotomy between utility and taste. The presence of the first, they contended, necessarily proved the existence of the second.[32]

Concern for comfort and convenience early appeared most strikingly in reports from tourists traveling abroad. Americans found in English inns the "*reality* of a comfort, of which other countries have scarcely an *idea*." The public baths of Paris, according to Mr. Pinkerton, proved far superior to those of London in their convenient and healthy arrangement. London did have, however, the Wapping docks, designed by John Rennie, who "has most sedulously aimed at blending, and has succeeded in the accomplishment of a work, which at once

united simplicity and grandeur of appearance" with convenience. The roof lines of the three tobacco warehouses displayed the "most admirable simplicity" while being strong enough to withstand hard usage.[33]

At home, the same attitude led to castigation of continued imitation of European memories and tastes by American masons and carpenters which resulted in "irregularity, confusion, nooks and corners for dust." Cutting loose from European styles, it was asserted, led to design of elegantly convenient homes built by craftsmen. This populistic bias against experts, Latrobe explained in a letter to Count Volney, meant "that an Engineer is considered only as an *overseer* of men that dig, and an Architect as one that watches others that hew stone and wood." It was not only that "with us the labor of the hand has precedence over that of the mind." Americans uninterested in Latrobe's classicism saw no reason to pay him, or other architects, for designs. They demanded the elimination of the disparity in American homes between "a pretty good style of architecture, *on the outside*" and inconvenient, expensive interiors. Furthermore, they thought that home-grown, self-reliant craftsmen could maximize interior and exterior elegance through functional utility better and more cheaply than could trained and proud architects.[34]

The developing clarity of this vernacular aesthetic could best be seen in the many magazine articles on bridges. Craftsmanship of useful things other than bridges obtained no substantial aesthetic appraisal in the American periodical press before 1815. At first even the decoration of bridges—Gothic tracery, railings, and lamps—received attention as something distinctly separate from the engineering aspects. Moving one step away from this distinction between "art" and "science,"

one critic wrote that the Connecticut River Bridge had stone piers and abutments "handsomely faced and pointed," but the bridge as a whole received no aesthetic judgment. A bridge was termed an "elegant structure" for the first time in 1804, though the description was based on mathematical rather than aesthetic considerations. Within the next year, Philadelphia's new Schuylkill Bridge obtained aesthetic critical judgment as a whole: "The design is more simple, its strength is greater, its parts are better combined and more assistant to each other, and there is no useless timber, or unnecessary complexity, in any part." This description by one of its builders straightforwardly linked aesthetic approval with simple, functional design. The ideal had also been achieved in the bridge at Springfield, Connecticut, "one of the best of its kind in America; combining elegance and neatness, with strength and durability." Here was the embodiment of elegance and convenience, organically developed from the requirements of site and use, paying little heed to extrinsic considerations of style.[35]

Thereafter, in the many articles on new bridges, there were temptations to regress from the endorsement of beauty in function. The *Port Folio's* report on the Schuylkill Bridge, for example, asserted that "all that could be spared for ornament, was expended on the exteriour, as the interiour neither admitted nor required it," thus once again separating design and decoration. Others doubted the possibility of seeing beauty in a bridge, regretting Baltimore's Gay Street Bridge as a needless, unnatural destruction of the stream's attractiveness, or feeling that the Pawtucket Bridge diminished the "charming and romantic" falls.[36]

Nevertheless, the prevailing attitude persisted that

beauty in bridges came from functional simplicity, that "the beauty, strength, and cheapness of framed bridges depend upon the judicious distribution of the forces" in the trusses. The mile-long bridge over the Susquehanna represented, according to the *Philadelphia Gazette*, a unity of form and function "exciting the ideas of great strength and durability, and the whole presenting as complete a specimen of architecture on as great a scale as any perhaps to be found in any other country." The vernacular critic's disregard for precious distinctions between fine and useful arts, as well as his requirement of elegant convenience, came out in his judgment that the bridge "may be justly considered the proudest monument of the arts ever erected in the United States." The contrasting, genteel approach is illustrated in "very handsome bridges" on the National Road in western Virginia, which, according to Latrobe, were "constructed much more with a view to appearance and at a much greater expense than with skill or judgment." Proponents of the vernacular aesthetic would have found such an opinion incomprehensible. Lack of skill and excessive expense remained, for them, proof of bad taste.[37]

Magazine writers occasionally applied this aesthetic to houses and public buildings as well as to bridges and docks. Women were counseled that a main hall should be kept "plain, neat, and always clean, to convince the world that you attend more to utility, than ornament." By the same token, churches ought to be small enough for the minister to be heard by all the congregation, and the surroundings ought to be planted with trees that served as windbreaks and absorbents of "the noxious qualities of the atmosphere." The editor of the *American Register*, commenting on the arrangement of the Representatives' Hall in the national Capitol, was sur-

prised "that any architect ever imagined it would be fit for the purpose of public debate." *Niles National Register* added that its magnificence and splendor seemed extremely poor compensation for the expense and poor acoustics.[38]

The embattled neoclassicists attempted to incorporate the vernacular criteria. They insisted that the best examples of their favored style did, in fact, combine utility and elegance. As noted earlier, the traditionalists had always stressed the compatibility of classical correctness with the dictates of nature. Developing that idea further, George Tucker, writing for the *Port Folio*, argued that "there are certain principles of *utility* and convenience, which, regulated by the uniform laws of matter and the no less uniform nature of man, lead always to the same results in building." Therefore, he reasoned, Greek laws of architectural proportion and symmetry remained equally valid for nineteenth-century Americans. In practice, justification for this neoclassical functionalism frequently strained all plausibility. London's rebuilt Drury Lane Theatre, for example, could legitimately have a green Corinthian column with a gilt capital on the stage since "performers still wear embroidered dresses, and consequently require the adjacent objects to be uniform with their costume and character." Similarly, at least one enthusiast applauded Bulfinch's effort to build a church uniting "the massive simplicity of the Grecian temple, with the convenience of a Christian church." Though he claimed that "a purer taste appears to banish superfluous ornament," such efforts persuaded many partisans of the vernacular that the neoclassicists really did not understand their opponents.[39]

The roots of the vernacular aesthetic lay in a proud nationalism that pointed to the rapid emergence of the

United States from a land of primeval forests to one of large cities as proof of the value of functional adaptation. Since progress had produced material success, why should it not be also the key to artistic greatness? As William Short lamented in a letter to Jefferson, Virginia's plans for a new capitol were sharply conditioned by the reluctance of the authorities to "believe it is possible to build a more magnificent House than the W[illia]msburg Capitol. It seems impossible to extend their Ideas of Architecture beyond it." Americans took special gratification in the account of the traveler in Kentucky, who told how he passed log huts and descended a hill into Frankfort, to "behold (rising as it were by enchantment) an elegant three story" statehouse. The glories of American growth, however, deserved something better than what "The Perambulator" saw in New York City —"the strange admixture of elegance and meanness in our streets and buildings" exemplified in "the barbarous front of the theatre . . . resembling a miserable barrack." At the other extreme, the better country houses tended to be too pretentious. "While we despise or overlook the humble beauties and snug comforts of the cottage," the *Analectic Magazine* complained, "we but seldom attain to the grandeur of the *chateau* or the *villa*." Mimicking ancient or modern European styles produced, at best, ponderous stateliness and cumbrous magnificence incompatible with republican simplicity. For all of these ills the antidote prescribed by the vernacular aesthetic was to achieve elegant convenience by cutting away all sham and foreign nonsense. Thus, "L.M." jeered at the lavishly expensive fluted columns, stuccoed walls, and carved mantletrees for the President's mansion. Only they "who inherit power, and may probably be dolts or changlings, need these artificial decorations, to preserve them from

contempt." The egalitarian and populistic implications to be seen in this critique based on vernacular values typified the ideological significance of architectural theory and criticism in the first generation of the United States' existence.[40]

The search for an American taste in architecture continued long after 1815 before any recognizable consensus began to emerge. At the end of the "Second Revolution" all seemed smoke and confusion in the battle of aesthetics among archaeologically purist neoclassicists, symbolical classicists, functional classicists, romantic eclectics, and the admirers of a craftsmanlike, unpretentious vernacular. The architectural scene was one of flux, as it had been for a generation. Latrobe's discourse before the Society of Artists in 1811 represented the closest thing to a consensus to be reached for years to follow. He had, in effect, pleaded the case for using the concern for republican simplicity to transform a foreign, meretricious neoclassicism into a genuinely American Greek Revival. Rather than lapsing into the querulous elitism of some neoclassicists, Latrobe praised such virile evidences of Philadelphian growth and taste as the Schuylkill Bridge. He urged Americans to reject the decadent and deadening veneer of European luxury and return to the ideals of republican Greece for useful, appropriate models on which to build the Greece of the modern world. This would stop the distracted search for foreign decorations and exotica. Taking the noble, simple forms of ancient Athens and combining them with American demands for convenience could lead to a truly great American architecture. But that would take more time, thought, and talent than had been expended by the first generation of aesthetic nationalists.[41]

7. Music and Dancing:
The Rise of Genteel Romanticism

------◄◆►------

O pinions about music during the early national period in America had very little to do with contemporary European developments in the art. Apparently, they had little more relation to concert life in America. The late eighteenth century saw the rise of the modern symphony with the success of Haydn's works in Paris and London during the 1780s. The period marked the emergence of Viennese classicism and the drift toward romanticism in European art music. The wide popularity of Handel's oratorios got extensive notice and approval in the United States, but there was little or no mention of Haydn, Mozart, or the revived interest in Bach's Passions. According to older historians, churches and colleges, where the music was almost entirely vocal and devotional, served as the primary institutional supports of American musical expression. However, Sonneck, the most learned scholar of the subject, carefully studying and collating extant programs and other documents, has insisted that outside New England sacred music "was cultivated . . . neither so steadily nor so intelligently and progressively as secular music." He found, in fact, a striking parallel between European and American concerts in substance and quality, when allowance was made for the greater difficulties to be overcome in America.[1]

The changing post-Revolutionary American taste in music seems puzzlingly unrelated to other expressions of aesthetic opinion unless one recognizes that, in music far more than in any other art form, colonial America had developed an autonomous folk expression, ostensibly religious in character, but also serving as entertainment and as a motive for social gatherings. Commonly known as "fuguing tunes," these indigenous creations of American self-taught composers, most importantly William Billings, showed recollections of old English and German Reformation music, but the recollections of a folksinger rather than of a trained musician. Admired today as the first signs of a uniquely American music, with a "guileless truth" akin to that of Cooper's Natty Bumppo, the fuguing tune came under heavy attack by the time Billings died in 1800. The battle between proponents of the fuguing tunes and of "regular" music, with the latter winning decisively by 1815, epitomized the shift in American musical taste away from a lively and lusty vernacular toward a solemn, even pompous, and heavily moralistic respectability.[2]

This change resulted from two concurrent developments. First, and unlike the situation in painting, Americans generally welcomed the many professional musicians who emigrated from Europe during the Napoleonic wars. They rapidly found positions with orchestras, choral groups, and other music organizations previously filled largely by American amateurs. The European professionals promptly introduced a much greater emphasis on technical correctness and emotional propriety in musical performances. The reason for the ready acceptance of the European musicians, and, therefore, probably the more fundamental of the two developments producing a major change in American musical

taste, was the appearance of a critical theory that synthesized the strong forces of moralism and gentility in the new nation. Suggestive of a modified musical romanticism, the critical doctrine found the fuguing tunes intolerable and frowned them out of respectable existence. Not until the late 1960s would the vernacular composers' reputations begin to recover from the onslaughts of the friends of regular music.[3]

Perhaps because of the importance of music in religious services, the moralistic bias in American taste during the early national period dominated musical theory far more effectively than it did any of the other arts. The result may be seen in a series of articles published in 1807 by the *Literary Tablet* which clearly stated the prevailing presumptions about the nature and value of music. Among the rational and refined pleasures provided man by God, the author affirmed, "there is not one which engages the soul more intimately, or seizes the affections more forcibly, than MUSIC." The Almighty had perfectly arranged voice, ear, and lungs as musical instruments. The Mosaic code certified the value and correctness of music for "the only church." Music served a number of secular functions, according to this view, including healing of the sick, but "the richest quality in the nature of music, consists in its power of exciting reverential ideas of the Almighty, in the temple of his holiness." Typical of prevailing American discussions of music, the author of the *Literary Tablet* series not only emphasized vocal, religious music, but only off-handedly noticed that it played some part in social life. "The affections are softened," as he put it, and "the heart is purified." As one might guess from such a statement, "purity" frequently reflected a quest for respectability as well as morality. The consensus held that music

had such elevating effects because of its unparalleled impact on human passions.[4]

Three crucial questions arose from this theory of music. First, could secular, especially light, music be defended on moral grounds? Clearly, learning to sing or to play an instrument cost a great deal in time and money. Perhaps the doctrine of stewardship required the expenditure to be made for more useful purposes. The major difficulty in answering this question, the Reverend John Bennett claimed, lay in the fact that "the passions of mankind . . . have very much debased and profaned this art." He found so many popular songs indecent that he recommended avoiding the danger of soiling the purity of a youthful mind by restricting the choices to sacred numbers. Others objected particularly to the mischievous effect of drinking songs on the young. The defenders of popular music, such as a hit of 1806 entitled "Send the Bowl Round Merrily," countered with the assertion that music was merely "an innocent sensation." Taking care not to make any distinctions as to type of music, such proponents denied the possibility of music doing harm, while suggesting that it might, indeed, be "the divine restorer and harmonizer of the soul."[5]

The second major issue revolved around the fact that music compounded melody and harmony. Which was more important? Some commentators heatedly insisted that "the first essential, and without which all others are of no consequence," was the tune, air, or subject. Harmony might be granted second place in importance, "but [it] receives from air more consequence than it communicates." On the other hand, some observers argued that harmony had primacy since it lulled tensions and aroused the imagination. Melody came merely from a simple succession of tones, the partisans of har-

mony pleaded, while their favorite displayed "a combination of various sounds, delicately and imperceptibly blended together." This really amounted to a quarrel over the relative importance of sentiment and meaning in music. The defender of melody believed that music "reaches the highest pitch of excellence" only when wedded to poetry, while the other side dismissed poetry as a very weak mate, since reading took more attention than listening. The melodists saw music as a pleasing accompaniment to the message of poetry; their opponents replied, "Music, in order to produce its fullest effect, must prompt the audience to feel forcibly, to think impetuously, to have their imaginations hurried into action with a tumultuous violence, a turbulent delirium of extasy." This incipient romantisicm, however, included no interest in exotic cacophonies. Travelers repeatedly complained of the noise of clanging church bells or the "*melodious warblings* of hand organs." All would have agreed readily with the tourist in Amsterdam who thought the authorities should stop "these itinerant murderers 'of the music of sweet sounds,' as public nuisances." In contrast, popular musical taste especially appreciated a scene, such as a Harmonic Society concert in Philadelphia, where "the charms of melody were accompanied by the no less delightful charms of conspicuous beauty." Whether the beauty referred to the harmony or the young ladies in the choir the *Port Folio*'s reviewer left conveniently unstated.[6]

Music critics debated the issue of ancients versus moderns as vigorously as had the aesthetic theorists, with much the same results. In this context, the question became: Since the charms of melody had been so thoroughly cultivated in ancient times, had there been any real progress in music since, or had the march of

music history in fact been one of decline? As with similar debates, the stakes were real and high. Nationalistic Americans asked, in effect, how they could ward off the aesthetic pressures of contemporary Europe without either repudiating America's European heritage or lapsing into a reactionary bondage to ancient forms and examples? Fortunately, what might have seemed a grave problem—the fact that no large amount of ancient music remained—turned out to be a godsend. The overpowering effect of classical sculpture had no counterpart in music, while sufficient literary evidence remained, unlike the case for painting, so that the ancients could be compared to good effect with modern European musical trends. Citations from classical authors were taken to prove the "prodigious effects of the ancient music." Yet references to inconvenient ancient tastes, such as that for the random sounds of the aeolian harp, could simply be left aside. The ancients-versus-moderns debate, thus, resulted in a highly satisfactory stance for American music theorists. One picked and chose the preferred characteristics to form a new, nationalistic musical tradition: "The music of the ancients was more pure, expressive, and simple than our's; which, on the other hand, possesses excellencies unknown to the ancients—harmony, fugue, and imitation; excellencies which it is folly to deprecate."[7]

Applying this musical theory, Handel's oratorios served as the very touchstones of excellence. His music satisfied all of the criteria: simple to follow and, hence, susceptible of widespread popularity, most acceptable in religious themes, and emotionally satisfying in the powerful but eminently respectable blendings of melody and harmony. In addition, the oratorios sanctioned the American bias toward religious choral music. Though

an occasional bow went to "the divine strains of Haydn," that composer suffered greatly in the eyes of American critics from never having gone to Italy. If he had, "there can be no doubt, that, with his excellent ideas of singing and harmony, he would have acquired great reputation as a composer of operas." That Haydn had been the founder of the modern symphony, or that Vienna had replaced Italy as the center of musical creativity, received no attention at all. Handel, and particularly the *Messiah*, remained the exemplar and model for Americans throughout the early national period.[8]

The proponents of "regular" church music, meaning that music consistent with the oratorios of Handel, obviously could find no excuse for tolerating the fuguing tunes popular for so long in America. They were hopelessly and perniciously irregular. But this involved far more than a technical quarrel over alternative musical styles. There were obvious and immense differences between the lively, polyphonic fuguing tunes and a homophonic, dignified "regular" music. But a purely musicological issue could hardly have generated the widespread concern indicated by the fact that, in Massachusetts alone, more than one hundred choral societies were founded between 1785 and 1840 dedicated to "Improvement in sacred music." The importance of the musical controversy lay primarily in its ideological overtones. The crucial difference in attitude between the partisans of the fuguing tunes and the proponents of regular music may be symbolized in the fact that Billings was an intimate friend of Samuel Adams, with whom he sang politicized hymns, while the leaders of the choral societies were Federalist ministers. Samuel Adams, the radical patriot, loved the fuguing tunes that the conservative John Adams rejected as "the *Old Way*, as

we call it—all the drawling, quavering, Discord in the World." Both men were Revolutionary heroes, of course, but, logically enough, they differed as much and as heatedly over their musical tastes as in their preferences for post-Revolutionary governmental organization. The issues, indeed, were nearly the same.[9]

William Billings' introductions to his various music publications voiced an irreverent and almost utopian populism very similar to the biases expressed by the left wing of the Revolutionary pamphleteers. The latters' suspicion that all pretense to authority merely disguised an unscrupulous desire for "personal power and grandeur" paralleled Billings' theory of composition:

> *Nature is the best Dictator*, for all the hard dry studied Rules that ever was prescribed, will not enable any Person to form an Air any more than the bare Knowledge of the four and twenty letters, and strict Grammatical Rules will qualify a Scholar for composing a Piece of Poetry, or Properly adjusting a Tragedy, without a Genius. It must be Nature, Nature must lay the Foundation, Nature must inspire the Thought . . . as I don't think myself confined to any Rules for Composition laid down by any that went before me, neither should I think (were I to pretend to lay down Rules) that any who came after me were any ways obligated to adhere to them, any further than they should think proper.

If anyone suggested that such a lack of discipline would lead to musical chaos, Billings evinced no more dismay than had the radical political democrats when accused of proposing mob rule. As he put it, in his dialogue between the Scholar and the Master in *The Continental Harmony*, "What is *one* man's *meat* is *another* man's *poison*," and so the only criterion of excellence would be this: "As music is nothing more than agreeable sounds, certainly that sound which is most pleasing is most musi-

cal." "One man, one vote" served Billings as well in defining his audience as it had served the anonymous author of *The People the Best Governors* in describing the American polity. Billings placed his defense of his fuguing tunes squarely on their popular appeal: "*Variety is always pleasing*, and it is well known that there is more variety in one piece of fuguing music, than in twenty pieces of plain song, for while the tones do most sweetly coincide and agree, the words are seemingly engaged in a musical warfare." The public's acceptance, according to the egalitarian democrats, remained the only relevant test.[10]

Musical populists held out against their more respectable and sober opponents little longer than the radical democrats against their conservative critics. The ratification of the Constitution in 1789 marked the culmination of the latter struggle, with the conservatives successfully cutting off the more radical political and social implications of the Revolution. The forces for regular music got their attack fully underway about 1800 and, within fifteen to twenty years, utterly routed the fuguing tunes from the field. Though a number of composers in the older idiom were active in the late eighteenth century, the critics aimed primarily at Billings. Tactically, it proved advantageous to refute and vilify the most outspoken defender of the vernacular style.

The commentators who urged the need for regular music quickly gained control of the magazines and used this forum without stint. The fourth edition of Andrew Law's *The Art of Singing and the Musical Primer* (1803) provided the occasion for the widely respected *Monthly Anthology* to enter the lists against Billings. Praising Law's simple and useful system of singing instruction, the reviewer went on to confess that "the

tones of our singers are generally harsh and dissonant." This, he thought, was because choirs were too often filled with singers trying to out-sing their neighbors. The lamentable effect had been "to banish good compositions from our churches. The works of Handel," he concluded, "have been sacrificed to the inartificial and contemptible strains of Billings, and of others, who were infected with his taste." Typically, Billings was blamed for fostering a vicious taste rather than for responding to a folk movement. As we have already seen in several other contexts, American cultural elitists found it dangerous to oppose popular tastes directly. Hope of success required a flanking movement—in this case, by attacking fuguing tunes as incompatible with Christian worship.[11]

By 1808 the *Monthly Anthology* happily observed that much progress had resulted from the efforts of Law and others of similar persuasion. Hymnals now had a much greater proportion of "solemn and finished musick" replacing the "fugues and fol de rols [which had] threatened to banish simplicity and grandeur from the choir." Billings' presumably "unfinished musick," according to this view, had shown a lack of the training required to achieve grandly simple sacred numbers. Consequently, the science of sacred music had to be taught more widely, and hymnal compilers had to stop "rushing into composition before they know anything of its science." The best works of European masters were too often entirely neglected, according to the *Churchman's Monthly Magazine*, or, even worse, "mangled and distorted by the licentious presumption of our domestic composers." The *Monthly Anthology*, on the other hand, tended to think that works devoted exclusively to European masters were too often "compli-

cated and artificial," learned with great difficulty and forgotten with little regret. Since in most churches a set of tunes was sung which the congregation could not follow, "we therefore wish that the ballad-like and indecorous compositions of many ignorant modern composers" be banished in favor of noble traditional melodies. The forces of respectability, in other words, had to come to grips with the public insistence on congregational singing.[12]

A concern for religious propriety motivated much of this pressure for regular church music. Francis Hopkinson, one of America's first composers and an invariable voice of gentility, claimed that "heart, voice, and instrument should unite in adoration of the great Supreme," since that had been the original idea for liturgical and organ music. The organist only indulged his vanity by showing off his virtuosity, or his giddiness by aiming to entertain the congregation. All should be subordinated to the sobriety and humility of the worship service. As for congregational singing, according to another critic, "most of our modern pieces would better suit the fiddlers of a ballroom, than the choir of our churches." Revivalistic enthusiasm found no friends among the proponents of regular music. Music was the language of the passions, they insisted, and it should be disciplined to enhance feelings proper in the presence of God; when music provoked "gaiety, levity, and the licentious passions, it is called profane, or secular music," obviously inappropriate for churches. Propriety demanded solemn and sublime church music, not that "gingling together of a frolicksome succession of sounds into a sort of psalm-tune bewitched."[13]

By 1815 church music commentators had carefully worked out plans to achieve "a rational, correct, and

devout performance of sacred music." Every pew should be supplied with sufficient hymnals, and everyone who was able ought to be taught to sing. Each church should select a small number of tunes for various occasions, thereby familiarizing the congregation with the usual selections. Another device would be to scatter specially trained singers throughout the congregation. Objections that general singing led to bad timing and irregular harmony—that is, a return to the vernacular style—could not be admitted if singing were considered a religious duty and safeguards like those just described were instituted. Ironically, the reformers urged the organization of choral societies to regularize church music, though one of the pioneers in such efforts had been none other than William Billings. Undaunted, they reiterated their belief that regular singing would completely differentiate the music of Christian churches from the "shouting and howling" so characteristic in synagogues and in churches using fuguing tunes.[14]

What, precisely, was the function of music in church? A variety of answers appeared during the first generation of national existence, but they can be clustered under either one of the competing headings of mood and message. If American periodical coverage fairly represents contemporary opinion, we may conclude that, surprisingly, the articles emphasizing the value of music in creating devout feelings predominated by 1815, rather than the adherents of a more austere emphasis on the message conveyed by the lyrics. The shadow of ascetic puritanism, at least in this regard, had significantly dimmed. A few commentators objected to "jingling terminations" in the lines because they altered "the sublime words of the psalmist into the weak singsongs generally used." More commonly, those asserting

the primacy of the lyrics spoke ambiguously about improving the heart, and that could all too easily be interpreted to mean mood music. The importance of message became even less clear if one went along with E.S. Ely, who argued that the music often attracted many to church who might not otherwise have gone. He did not explain how that fitted with the need to educate the soul through music.[15]

The proponents of religious mood music frequently used arguments suggestive of the idea of religious instruction. Thus, the *Christian Disciple* set the stage for devotional exercises by calling forth pure and spiritual thoughts in the minds of the congregations. Yet the same article praised "plaintive and melancholy airs" inducing feelings of contrition, reverence, and awe.[16]

Others forsook this doctrinal fence-straddling, asserting that church music relieved the weariness of long attention and cheered the mind. One might even be well advised to "imitate the perfume of the Jewish tabernacle." While relaxing the mind, great oratorios might very well produce a greater religious impact than the most eloquent sermon. Americans had certainly moved a long way from Quaker and Puritan fears of popery when a commentator on Milton could say with little fear of being mobbed or deported:

> Surely nothing can more elevate the soul above the cares and anxieties of the world, than the awful solemnity of the cathedral worship when performed in one of those majestic structures. . . . Indeed Milton's soul was too great to be cramped and fettered by the narrow prejudices of the bigotted associates of Cromwell.

Following that line of thought, travelers in increasing numbers visited Roman Catholic churches and enjoyed

the music with few qualms that their pleasure might be tainted with heresy. A tourist visiting South America praised the solemn yet sprightly music of Catholic services with its tendency to make music popular among the people. John Adams lauded the "perfect Skill and Judgment" of a Protestant choir in Middletown, Connecticut, but found a Catholic service in Philadelphia so "awful and affecting" that he concluded his long description to his wife with the observation, "Here is everything which can lay hold of the eye, ear, and imagination —everything which can charm and bewitch the simple and ignorant. I wonder how Luther ever broke the spell." Though Adams' response was ambivalent, Abigail, on a later occasion, wrote Jefferson that hearing the *Messiah* in Westminster Abbey "was sublime beyond description," able to transport her "amongst a higher order of Beings." Similarly, Latrobe grumbled about the cacophony of "the old Psalmody" in a Presbyterian church in New Orleans and the "villainous taste" of a Catholic service because, in both cases, he had gone to hear "good and affecting music." Religious mood music had become thoroughly entwined with a genteel, respectable, and frequently secularized taste.[17]

Critics of church music did agree, whatever their other differences, that the association of ideas played a crucial role in one's enjoyment of music (this was apparent long before Alison's theory of associationism had any wide currency in America). Therefore, "it works confusion in the breast of a man, who has heard the same strains in a circle of bacchanalians, or connected with love ditties from the piano of his mistress," and then in church. How a godly man ever found himself in a "circle of bacchanalians" was left unasked. Instead, the critics strove to draw firm distinctions between secular and

sacred music—in itself an act of moralistic compart-mentalization that tacitly conceded control of secular music to the ungodly. That fuguing tunes blurred these distinctions had been a major part of the critical indict-ment of Billings. Part of the magical spell cast by church music, according to Billings' opponents, derived from its sharp separation from mundane affairs. This theory of association, however, stopped appreciably short of denying the presumably inherent physical distinction between music and discord. For example, a traveler in Lisbon complained of the "insufferable annoyance" of the constant ringing of the Franciscan convent bells near his hotel. No doubt he objected to the intrusion of church bells in the workaday world, but from his com-plaint that "the discord is everlasting," it is clear that it made no difference to him whether the bells had a religious or secular connotation. He and most other Americans of his time remained too convinced of the validity of hard-and-fast categories to admit that in-discriminate bell-ringing was music. Because of this habit of inflexibly categorical thinking, along with the prevalence of associationism, disagreements over the na-ture of church music paled by comparison with those over secular music.[18]

Formulating an American aesthetic relevant to mu-sic, as we have already seen, could be immensely com-plicated, if not actually thwarted, by the doubts and fears of the moralists allied with the incipient senti-mental romanticism of the upper class. In the case of church music the forces of the moralists had repudiated and suppressed an indigenous vernacular style. When attention turned to secular songs and concert music the alliance broke down, and music critics spent most of their efforts up to 1815 countering the moralists. They

started with the widely acceptable belief that music held an exalted rank among the fine arts. Many Americans would have agreed when "Juvenal" pontificated, "Music is universally acknowledged to be the most pleasing, the most engaging, and the most captivating of all arts." The extended discussions dealing with church music took as much for granted. Nevertheless, its captivating quality raised serious questions of moral and social policy. The only way to deëmphasize moral didacticism in answering those questions, it seemed, was to replace it with a rather humorless and priggish filiopietism.[19]

The transition from moralism to patriotism as a basis for appraising secular music may be followed in Noah Webster's essay of 1788 on the place of music in education. The pressure for psalm-singing schools showed, he felt, a burgeoning desire for an understanding of music "as an article of education, *useful* as well as ornamental." Thus, though he started with the regular music–choral society movement, involving religious issues, his notion of utility implied social values rather than religious ones. The doctrine of stewardship, which pertained to social conduct as much as to moral standards, served as his intellectual bridge. He preferred vocal music over instrumental because of its power to employ children's minds "in leisure hours, when idleness might otherwise open the way to vice." Again, it soon became clear that Webster's opposition to vice arose more, perhaps, from his concern for civilizing America than from traditional religious beliefs. His invidious comparison between instrumental and vocal music in the schools hearkens back to the ideas about the relation between the arts and civilization. Whereas music from instruments provided only an agreeable amusement, pleasing the ear but leaving no impression upon the heart, singing could have

an admirable and powerful effect on society by working to "correct and soften the rougher passions." Webster felt he had made a strong case for "the utility of cultivating music, as a science."[20]

Untrained voices might produce discordant noise rather than sweet music, but serious instruction involved equally disturbing dangers. The fashion for recitals displaying the performer's virtuosity caused at least one writer to grieve, "It is not now sought as a repose for the mind after its fatigues; but to support its tumults." Recitals also corrupted the children by playing upon their vanity. To avoid these pitfalls children and adults ought to concentrate on good old simple music and not waste their time and banish their serenity practicing difficult "and consequently not very good music." After all, the science of music had been "established on the most sublime parts of mathematical truths." It followed that harmony and the other principles of music set by the Author of Nature "are the same with those which are beautiful to the eye in architecture." In neither case could abstruse complications unamenable to the taste of men of common sense be defended. A further danger of sacrificing "sentiment, feeling, and expression" for mere rapidity of execution came with the need to employ music teachers. Since music stirred the passions, parents concerned for their daughters' virtue should not leave them alone with their teachers. Indeed, Handel's works and the chastity and dignity of Corelli sonatas had been too much neglected in considering the moral safety of youngsters, for the "more bewitching style of the Italian school." In short, "decency and propriety in every kind of music must above every other consideration, be attended to, or our morals must inevitably suffer."[21]

The operative terms—decency and propriety—could

easily be secularized into an insistence on recurring to natural simplicity. Unembarrassed by actual examples of ancient music, critics supplied their own interpretations of classical styles to oppose the needless and dangerous complexity of modern music. The *Port Folio* reflected: "Instead of embellishing modern music, with beauties unknown to the ancient [world, we] have lost the principles of that music, without discovering others equivalent." To recover those principles, American musicians needed only to stop worrying about European trends and follow the dictates of nature, which taught that music must be "the handmaid of sense, to enforce, enliven, or sweeten sentiment." Modern music, typified by Italian opera, had degraded the mistress to servility— "harmony triumphs, with very little regard to sentiment." The "dark and mysterious" science of modern music could safely be ignored, for its effect was to diffuse music's impact into vagueness and generality. As one admirer of simple melody complained, "If I experience from it impressions of joy or grief, they are wild and indefinite; . . . the effect of the art is perfect only when it is specific and individual." What was being called for here was a tidy, respectable sentimentalism. Modern musical elaborations, like those heard by John Adams at a concert in the Tuilleries overwhelmed the listener with complicated, technical displays. "There was too much sound" for him, and too little sentiment. Relying upon nature and the recovery of ancient principles, Americans could, according to this viewpoint, create a truly great and truly national music. It would combine a restrained populistic appeal with a quiet gentility paralleling the "Democratic Definitions" being worked out by the aesthetic nationalists.[22]

Francis Hopkinson's "six easy and simple Songs for

the Harpsichord" nicely fit the specified pattern. Interestingly blending the stance of the aristocratic dilettante with that of the impassioned romantic composer, Hopkinson wrote Jefferson that "both Words and Music were the Work of an hour in the Height of a Storm." He intended the songs for the widest possible audience: "Any Person who can play at all may perform them without much Trouble, and I have endeavour'd to make the melodies pleasing to the untutor'd Ear." Though his biographer hesitated to call them either beautiful or important, and noted that the songs dwelt in "an untrue Arcadia, populated with over-sentimental shepherds and shepherdesses, or with jolly tars, veritable models of sobriety and good behavior," Jefferson enthusiastically lauded their "pathos." His daughter had been moved to sympathetic tears, he reported. It is less important that we find the lyrics mawkish and vapid than to note that many of Hopkinson's contemporaries probably did not share his standards. His compositions smacked too much of the drawing room and had too little robust vigor to serve as persuasive models for an American popular music.[23]

Consequently, a persistent lament arose from music critics dismayed by the "decay of simplicity in our songs." Why, they asked, could we not have more songs like "Blue Bells of Scotland," "the most charming effusion of simplicity, uncontaminated by thought."? If the author intended any irony here, it was lost on many of his readers. They agreed that modern music came from an "overcultivation of the ear," producing a search for oddity "by the redundancy of variations and graces; nature is outraged . . . and the ear is perplexed, if not lost, in a crowd of harmony [or by] . . . everlasting repetition." Franklin felt that "in composing for songs the

reigning taste seems to be quite out of nature, or rather the reverse of nature, and yet like a torrent, hurries ... all away with it." An article in the *Literary Magazine* chimed in by averring that the modern system of harmonics was unnatural and made tolerable only by repetition. "Since nature has given us a delightful harmony of her own," it wondered, "why should we destroy it by the additions of art?" Latrobe angrily retorted, "Wretched, as to music, must be that country that knows no higher enjoyment than a Scotch song," and thumped for "the exquisite Italian Airs." Jefferson occasionally sent to Europe for "anything new and good in the musical line" to add to his large library. Nevertheless, these remained eccentric variants from the dominant critical consensus in their America.[24]

Latrobe, Jefferson, and a few other American connoisseurs of music had no chance of dissuading most Americans from their distrust of, or even contempt for, expertise. Most commentators of the time held that music theory and uncommon technicalities were both needless (except, possibly, as comic relief) and dangerous. An extremely popular characterization of "A Musician" by "Timothy Catgut" expressed the prevalent populistic and patriotic bias: "A Musician is like an echo, a retail dealer in sounds. . . . He runs after an Italian air, open mouthed, with as much eagerness as some fools have sought for the philosopher's stone." He could import a tune from Europe, this heavy-handed definition continued, and think it all the better for being farfetched. Like an experienced hound smelling out his game, the musician smelled out Handel and Corelli. "There is no medium in him, he is either on a flat or a sharp key, though both are natural to him." Editors of many periodicals reprinted "Timothy Catgut" as late as

1810. Along the same line, "Anthony Evergreen" had fun in *Salmagundi* parodying his friend Snivers, with his "cogniscenti phiz," able to tell during a concert "a crotchet at first sight," and who grieved at the "confounded scraping and scratching, and grating of our fiddlers." The silliness of dwelling on sharps, flats, diacritical marks, scales, and the like seemed to be the main lesson to be learned from the occasional magazine articles dealing with the vocabulary of music.[25]

Though one could laugh away the connoisseur's interest in foreign exotica, his harping on technique and the mechanical perfection of music ran the danger of muddling or perverting proper musical values. At best, very learned music produced only "mimicry," while musical genius demonstrated true "inspiration." Some genteel critics reluctantly admitted that the self-taught Billings deserved credit for refusing to be shackled by the rules of "artificial composition." The famous British music historian, Charles Burney, was approvingly quoted in the *New York Magazine*: "Music that leaves us on the ground, and does not transport us into the regions of imagination beyond the reach of cold criticism, may be correct, but is devoid of genius and passion." That seemed to sanction the congenial notion that the critic could evaluate only the irrelevant and unimportant question of correctness. The editor saw no reason to warn his readers that this statement scarcely typified Burney's ideas. Typical of American attitudes was the account published in the *Port Folio* of the musically inclined orphan girl. Feeling that practice sufficient to perform publicly cost more time than it was worth, she hit upon the happy solution of playing hymns to herself every evening in solitude. She never worried about set forms, took whatever tunes had pleased her and improvised, be-

lieving it better to compose badly than merely to repeat the finest of another's compositions. That this worked directly against the aims of the advocates of regular music only points up the success of the drive to isolate church music from secular concerns. The orphan girl's motive, after all, was entertainment, which she admitted to be "comparatively selfish, worthless and fleeting." Neither she nor most other Americans interested in music had yet managed to come up with a stable and coherent theory of the place of all music in American life and thought.[26]

Public doubts and fears concerning music connoisseurs did not extend to their dilettantish interest in the mechanics of musical instruments, even though that interest often went hand in hand with the type of music they favored. Thus, Charles Willson Peale made himself a guitar and learned to play French romantic songs "of nymphs and flowers and of the sleeping shepherdess awakened with a kiss." Musical technology may well have seemed more amenable to popular inclinations than a sophisticated, Europeanized musical taste. In that regard Jefferson was less out of touch with American attitudes when he busied himself with the details of ordering a piano or an organ than when he sent for European music scores. Writing his daughter of his purchase of a spinet-sized piano, Jefferson dwelt on the size, shape, and construction—"fixes his 3. unisons to the same screw" and so on—without saying anything about its tone qualities. Some years earlier he had ordered a harpsichord from a London craftsman. Virtually his whole letter of instructions concerned types of stops and the like. His only specification as to its appearance revealed his preference for functional simplicity: "the case to be of mahogany, solid not veneered, without any

inlaid work but deriving all its beauty from the elegance of the wood." Jefferson relied heavily on such authorities as Charles Burney for appraisal of the musical qualities of the instruments he purchased. All of this had very little to do with public concerns, in any case, since Peale's guitar and Jefferson's piano were for their private use. Reticence was the keynote even in Peale's Museum "Orchester." As he wrote John Hawkins to inquire about technical improvements in his clavioles, the performers could "play without being seen, if they chuse it, and also out of the way of being interrupted by impertinent visitors."[27]

The frequency of concerts in post-Revolutionary America had by no means discouraged the many critics who held grave moralistic doubts of their acceptability. Travelers to Bethlehem, Pennsylvania, often praised the excellent public concerts they heard, but still pondered the propriety of their being given in a church. Did that not violate the mood of veneration expected in church? Since the concerts often were staged for profit, did that not put money changers back into the temple? When "Philo-Musices" raised these rhetorical questions, arising from the drive to separate the church from society, he apparently expected all good Christians to see that the answers were self-evident.[28]

The moralists held sway in the periodicals until at least 1815, even when concerts were moved out of the churches. "Timotheus, Jr." expressed the dominant reservations when he asserted that spending money on concerts revealed a poor sense of stewardship, threw one into contact with evil characters, and led to an exhilaration unsuitable for reading the scriptures and saying one's prayers. A persistent minority cheered on the cause of public concerts, regardless of the moralistic opposi-

tion. Reviewing the annual Ladies' Concert of the Co-
lumbia Anachreontic Society, the *Port Folio* hoped that
"an institution so honourable to the taste and manners
of our city, may continue to receive the electric applause
of *Beauty* and Fashion." One editor went so far as to
beg for patronage of an upcoming concert "to banish
from our memories that we are here, *in the very Siberia
of the arts.*"[29]

It must have seemed gratuitous cruelty for the embat-
tled minority to be confronted also by secular opposition
like that from "A.L.B." He criticized modern concerts
for losing sight of the ancient connection of music with
drama to produce catharsis. Instead of stirring, suspense-
ful music, the orchestras gave "some frantic *Italian* air,
as licentious as the genius of its country, and as dis-
cordant to the mournful feelings." What conceivable
merit, he queried, could there by in playing "Yankee
Doodle" except cravenly to flatter the galleries? This
may have seemed like rubbing salt in the wounds of those
striving to free American concerts from moralistic
critiques.[30]

Actually, "A.L.B." expressed a position that aesthetic
nationalists exploited to good advantage. In their opin-
ion, the fault of an indiscriminate endorsement of secular
music lay in the strong likelihood that it would lead
either to an imitative acceptance of European ways—
hence, the castigation of "some frantic *Italian* air"—or,
equally unfortunate, to emphasis on catering to "the
mob" with such things as "Yankee Doodle." The basis
for thinking that these were the most likely trends could
be found in the repertoires of American concerts and
musical theater productions in the late Colonial era and
that tended to continue after 1783. The aesthetic nation-
alists wanted to counter moralistic distrust of secular

music with a patriotic style that neither remained be-
holden to European leadership nor wholly accepted
American populism. Just as in their search for an Ameri-
can aesthetic vocabulary, they wished to emancipate
America from European cultural domination without
cutting the ties with Western civilization; at the same
time, they wanted an indigenous style responding to
popular egalitarianism while "elevating" it through the
aesthetic nationalists' leadership. Achieving these ends
involved a harsh critique of prevalent European art
music, a tentative exploration and popularization of folk
music, and (perhaps especially to win popular support)
encouragement of the art of the dance.[31]

In view of American preferences for simple vocal
melodies, much of late-eighteenth-century European
music seemed impossibly contrived and unappealing.
"Instrumental music is only an extravagant imitation of
vocal sounds," and symphonic music found few Ameri-
can admirers even among such connoisseurs as Jefferson.
Italy, home of the opera, naturally interested such a
people. But, alas, the very home of excellent vocal music
had strayed far away from the true path! It seemed
obvious that "if singing has any power over our souls, it
must arise from its assisting sentimental expression; if
the music be too complicated, the sense is confounded,
and the effect destroyed." Yet travelers seemed to con-
cur in their condemnation of the baffling and meaningless
Italian opera. As one shocked American reported,
eunuchs were commonly used, though "opposed to every
principle of decency and humanity." The tedious operas,
"in which every principle of common sense and nature
is violated," did not even have the splendid scenery or
the taste and beauty of French operatic ballets. In Rome,
one heard only endless recitatives with "the same dirty

scenery." Americans continued to refer to Italy as "the seat of the fine arts . . . that land of musical taste," but that opinion reflected habit and the desire to fend off consideration of Vienna and symphonic music rather than any respect for silly "Italian warblings." Nor did most Americans find opera much better in other parts of Europe. Charles Leslie spoke for many when he concluded a description of a London performance with the generalization, "Fine music always carries me into other regions, but at the opera I felt chained down to the earth."[32]

This hostility to European art music, especially opera, involved an attitude far different from the proudly anti-intellectual populism conveyed in, for example, Mark Twain's *Innocents Abroad*. The aesthetic nationalists were looking for sentimentally appealing, respectable, and not-too-overpowering models for an American musical style. What they found, in a variety of relatively obscure places, were folk songs. Thus, a traveler writing of his "Tour through Jamaica" told of an old Negro sitting outside his hut playing a Koromantee flute. The observer responded, almost in spite of himself, to the scene and to the music of this African instrument with "the sweet mellowness of its tone, and the simplicity of its execution." It contrasted very favorably with so much of European music since the Renaissance with its "offensive pedantry, . . . ostentation of difficulty and puerile contrivance." European folk songs, on the other hand, could be very appealing. Spanish *sequidillas* "have something so natural, so attractive, so inspiring," according to *Niles Register*, "that they seem to revive the golden age," a combination nearly irresistible to Americans who wanted a simple, natural, vocal music. These and many other examples found by travelers overseas confirmed

the aesthetic nationalist's argument that "the progress of musick depends much upon the temper and disposition of a nation." Americans ought to foster bards who sang of our freedom. Unfortunately, American musical character had scarcely emerged, and "Yankee Doodle" seemed all too typical of those "fugitive unsubstantial things, which fill the ear and starve the mind." By 1813 the *Port Folio* moved to rectify the insult to our national honor evidenced by the lack of an American "traditionary music." The editors promised two prizes of $100 each for the best naval songs submitted in the following three months. The goal would be "national songs, in which the value of our institutions, the blessings of our condition, the peculiarities of our manners, and the triumphs of our arms, embellished by the graces of poetry, could be familiarized to our ordinary amusements."[33]

One of "our ordinary amusements" that had long been connected with music was dancing. To the great scandal of the moralists, dancing had been an integral part of American theatrical productions from their first appearance in the mid-eighteenth century. And the dancing master often preceded the musician in the American towns. A fairly typical advertisement of a music teacher that appeared in Philadelphia in 1730 concluded with the information: "His wife teaches Writing and French. *Likewise Singing, Playing on the Spinet, Dancing, and all sorts of Needle Work are taught by his sister lately arrived from London.*" The moralists remained convinced that this was all giddy nonsense. "I never knew a good Dancer good for any Thing else," John Adams testily snapped. The aesthetic nationalists would have their hands full overcoming moralistic objections to admitting the dance into the genteel world of the arts.[34]

There were two compelling reasons for them to try.

In the first place, the widespread fondness for the dance meant that, if it were not brought under respectable control, it would continue to flourish sub rosa. That, in turn, would mean abandoning all concern for one of the most popular expressions of and influences on American taste. The aesthetic nationalists simply could not have their laboriously constructed aesthetic structure kicked aside by an art that reinforced the trends they had endeavored to alter. Persistent unimaginative borrowing from the Old World—to be seen in American ballet in the 1790s —and pandering to the most unelevated aspects of popular enthusiasms—evident in the circus of the same years —threatened to cancel out whatever gains the aesthetic nationalists made in shaping popular songs and concerts. In addition, the folk songs they had found so charming frequently involved folk dances. Not all of them caught their fancy. Latrobe sneered at the Negro dancing he saw in New Orleans: "I have never seen anything more brutally savage, and at the same time dull and stupid, than this whole exhibition." As for the seamen dancing on deck during John Adams' voyage to Europe in 1778, "there is not in them the least Ray of Elegance, very little Wit, and a humour of the coarsest Kind." Nevertheless, the same logic that led to the use of folk song as a model for American music frequently suggested the relevance of dancing for any effort to "elevate" American taste in entertainment.[35]

The aesthetic nationalists had remarkable success in winning popular acceptance of dancing's respectability. A heated debate staged in letters to the editor of the *Repository* during the first months of 1802 revealed the conflicting considerations. "O. . . ." condemned plays, dances, and musical training on the traditional grounds that "this important season of youth [is thereby] pros-

tituted to idle and useless purposes." He grudgingly conceded that dancing taught elegance and grace of carriage, but he thought the same results could be achieved in easier ways. "J.I.H." responded that such entertainments were necessary for growing youth to relax their "tender minds" after the severities of study. However, he agreed that too much time was spent on dancing. "Frank Liberal" cast aside such "canting regret" as unworthy of serious consideration, which, in turn, caused "Senex" to label Mr. Liberal "a bold champion for dissipation." "Verus" ended the discussion by warning parents that dancing initiated their children "in the rites of dissipated assemblies." The upshot appeared to be that dancing itself had merit, at least in small quantities; only the associations proved objectionable. Manners as well as morals were threatened: "A strange rage for imitating low life seems to be the epidemical malady of the age." The class bias underlying such a view may be gathered from the same author's examples. The graceful minuet and the elegant cotillion had been displaced by the Scotch step, Irish shuffle, and partridge waddle.[36]

Travelers in Europe gasped at what they felt to be the gracelessness and indecency of European ballroom and stage dancing. Neapolitan ballet dancers seemed more anxious to show off their gymnastic skills than to convey "those graceful, characteristic movements, which form the excellence of this act." In the ballrooms French officers had introduced "a lascivious dance called the *waltz*"; fearing American inclinations to copy European fashions, the observer trembled at the thought of this new vice migrating to the United States. He comforted himself with the thought that manners had to lapse into an advanced stage of corruption before the waltz could be adopted, and so his homeland was safe.

Meanwhile, others found various folk dances far more attractive, thus matching tourist reactions to European art and folk music—whether the folk dancing in Austrian Dalmatia, the graceful *fandango* in Spain, or the rustic festivals in France. In any case, the conclusion drawn from European dancing closely followed that pertaining to European music.[37]

Americans were becoming increasingly impressed with the idea that "dancing is the exercise of vigour, spirit, and activity"; at the same time, they worried less about the dangers to manners and morals. An American in Paris in 1812 found the "splendour and taste" of a formal ball dazzling and the waltz truly enchanting. He dismissed any lingering doubts with the comment that many of the better sort of people actually spent two or three hours a day dancing. He would still have been considered distinctly *outré* by many of his countrymen, but only a rapidly waning minority would have challenged his moral character. Charles Willson Peale expressed the growing consensus: "Youth is the time of lively feelings, of mirth and happiness, and while the spirits are spritely, they require the endulgence of mirth and happiness, and, if properly directed, will not produce remorse. Care has not yet soured their tempers." Scarcely an endorsement of bacchanalian happenings, it is true, but Peale's moderate position represented a major change from dour disapproval of all dancing.[38]

The aesthetic nationalists had not succeeded in developing an American style of dance prior to 1815 any more than they had secured a distinctly American secular music. It could even be argued that the movement away from the fuguing tunes to regular music and choral societies marked a retrogression from the search for a national taste. Nonetheless, they had freed dancing and

secular music from the blanket of moralistic disapproval evident in 1783. Further, they had begun to mark out some guidelines for an indigenous style in those arts. Their achievements here were far greater than in the case of sculpture, less chaotic than in architecture, if less fruitful than in painting. The aesthetic nationalists had carefully picked their way between the reefs of chauvinism and colonial imitation of Europe, in music and dance as in all the other aesthetic interests that they had considered. The bias towards vocal music continued, but the erosion of moralism, as evidenced by the growing approval of dancing, matched a burgeoning patriotic zeal. The artist had an obligation to memorialize the glories of America while winning public approval, whether he be architect, poet, painter, or musician. A potentially deadening moral didacticism, in short, had been curbed and the search for an American taste was well under way.

8. American Town and Country: Regularity, Rural Felicity, and "a Degree of Wildness"

*W*hatever the subject of discussion on aesthetics, Americans of the early Republic drew upon faithfulness to nature as a primary norm of excellence. In architecture this led to utilitarian functionalism; in music, demands for simple melodies; and in painting, folk realism. When critics turned their attention to the comparative merits of landscapes, "art" suffered from invidious comparison with "nature." Precisely what nature meant to these writers changed with time and never amounted simply to the forest primeval. Still confronting a country largely of untamed wilderness, the commentators tended to place their emphasis on *rural*, rather than frontier or primitive, felicity, which had a carefully subordinated element of wildness about it.[1]

The untamed West, in fact, had very few American admirers before 1815. That region's limitlessness might be sublime, but certainly it was also frightening, and pleasurable sublimity came only with a safe vantage point. Thus one tourist typically praised "the wild uproar and awful sublimity of the tumultuary cataract" at Niagara but timidly avoided extensive viewing around the base of the falls. Those sights, he claimed, would certainly be sublime, but the whirlwinds and spray

created real dangers of being blown off. Similarly, reviewers of Pike's *Exploratory Travels* occasionally noted Indian curiosa but hastily passed over the "dreary progress" to Sante Fe as having little interesting information. It seemed somewhat easier to accept these massive spaces if one saw rock formations that at least suggested ruined buildings, conveying the feeling that the hand of civilization had touched the area in some distant past. Then the explorer could dismiss fears of the unknown with romantic reveries about the passage of time.[2]

Fearful dislike of the unbounded and unpopulated West characterized most reviews of exploratory travels before 1815. Reviewers of Paul Allen's edition of Lewis and Clark's *Journals* (1810) repeatedly referred to the "desert and barren" country with its "dreary nakedness." The *Western Gleanor* explained to its readers: "There is, indeed, nothing in the work that can excite wonder and astonishment, or carry along the reader by the charm of an increasing interest. The scenes of the wilderness are cheerless and monotonous, as those of savage life are more or less uniform." Other than some bits of "curious information," according to a review in the *Analectic Magazine*, the only parts of real interest were a few acceptable scenes like the waterfall on the Columbia River which "combined all the regular elegancies which the fancy of a painter would select." Magazines reporting on travel books about the Missouri, the Mississippi, and the Louisiana Territory conceded that the river banks were eminently beautiful, and even boasted that the Mississippi was "the Nile of America." Still,

> however majestically the muddy Missouri may roll its waters through the wilderness, there is still no doubt, but that the little yellow Tiber, for instance, . . . will furnish the

traveller with scenes, feelings, and ideas, which the former can never present. . . . After all that may be said of the awful beauty of wild nature, it is the presence of man only and his works that give a real value even to the most enchanting landscape.

The rare article enthusiastically praising the "noble rivers and majestick mountains," such as the *Baltimore Repository*'s review of Pike's expedition, affirmed that "here the eye of the observer dwells with rapture, and exhausts itself in discerning new objectes in the variegated scene." Nevertheless, the same author concluded by dreaming of the future when the area would sparkle with towns, cities, and even new nations. Apparently the only way to overcome the fear of and repugnance toward the West was to envision the time when it would be thoroughly settled. Only thus could most Americans before 1815 feel comfortable about and even enjoy the beauties of Western landscape beyond the agricultural frontier. In other words, the emergence of "The American West as Symbol and Myth," recounted in Henry Nash Smith's *Virgin Land*, did not occur until the second generation of national independence.[3]

Before Americans could accept and glorify the American wilderness they had to discover a desirable differentness between American and European terrain. Prior to the Revolution, the fact of differentness was inescapable. Its desirability, however, remained in question. The nationalistic fervor of the Revolutionary period generated a conscious need to see America in the most favorable light. At about the same time, the growing popularity, in the Old World and the New, of a proto-romantic, sentimental admiration for pastoral settings and carefully isolated bits of untamed wildness provided a conceptual framework for treasuring the more or less

settled American landscape. The result was a strong rural bias, most remembered of Jefferson but equally typical of many of his fellow Americans. Thus Jefferson wrote a visitor to America in 1809 that he should get "beyond the confines of our cities. These exhibit specimens of London only; our country is a different nation." As early as 1763, John Adams had written in a similar vein, "I mount this moment for that noisy, dirty Town of Boston, where Parade, Pomp, Nonsense, Frippery, Folly, Foppery, Luxury, Polliticks, and the soul-Confounding Wrangles of the Law will give me the Higher Relish for Spirit, Taste and Sense, at Weymouth, next Sunday." Whether viewed from Jefferson's Monticello or from Adams' Braintree, the early American city was seen from a rural perspective, not from one in the unbounded, unsettled West.[4]

With this aesthetic stance Americans were prepared to take pride in what had formerly been cause for provincial embarrassment. Reflecting on the different appearances of Richmond in England and in America, Benjamin Latrobe noted "the want of finish in the American landscape"; yet he ended by asserting "the perfection of cultivation in the first instance, in the second, the grandeur of Nature." A few years earlier John Adams had written, "I am situated on the majestic banks of the Hudson, in comparison of which your Thames is but a rivulet, and surrounded with all the beauties and sublimities of nature." He and his fellow Americans took pleasure in their connection with a well-tamed nature, whose face revealed how thoroughly it had been mastered:

> Consider, for one minute, the Changes produced in this Country, within the Space of 200 years. Then, the whole Continent was one continued dismall Wilderness, the haunt

of Wolves and Bears and more savage men. Now, the Forests are removed, the Land covered with fields of Corn, orchards bending with fruit, and the magnificent Habitations of rational and civilized People. Then our Rivers flowed through gloomy deserts and offensive Swamps. Now the same Rivers glide smoothly on through rich Countries fraught with every delightful Object, and through Meadows painted with the most beautiful scenery of Nature, and of Art. The narrow Hutts of the Indians have been removed and in their room have arisen fair and lofty Edifices, large and well compacted Cities.

Clearly, Americans were ready to tour their country with a confidently critical eye. Emancipated from a colonial dependence on European standards and from a provincial defensiveness, the time had come, soon after the conclusion of the War of Independence, to develop autonomous criteria for environmental design as part of the search for an American taste. Those criteria would come first and most importantly from travels in America. Foreign travel played a later and supplementary role.[5]

The easiest and most generally accepted criterion concerned villages and well-populated countrysides. Given the interest in rural settings and the need for evidences of human control, American travelers in the first generation of national independence almost instinctively hit upon the recipe for aesthetic success. Crossing to Long Island from Manhattan in 1792, Charles Willson Peale admiringly noted that the ten miles to New Town "was so thick settled that it appeared to me almost like a Village, the Houses appeared to be neat and snug habitations." Traveling in mid-June, when "the fields were loaded with grain" and freshly cut hay, occasionally highlighted by "several hansome seats" as well as small tidy towns, Peale could rest assured that most Americans

would have enjoyed the trip as much as he had. The historian could pick comparable appraisals almost at random. Ellen Randolph Coolidge wrote Jefferson in 1825 of the beauties of rural Connecticut. Viewed from Mount Holyoke, "the whole country as you look down upon it, resembles one vast garden divided into its parterns." She delighted in the "air of neatness and comfort" she found in journeying through the farming towns. "The houses have no architectural pretensions, but they are pleasing to look at, for they are almost all painted white, with vines about the windows and doors, and grass plats in front decorated with flowers and shrubs." It was easy to enjoy these scenes because they differed so little from comparable ones in Europe. Appropriately enough, Mrs. Coolidge believed that "here *New* might, I should think, almost challenge *Old* England, in beauty of landscape."[6]

American cities were quite another matter. It seemed obvious that they had no hope of competing with European ones unless new criteria were found. Contemporary reports may generally be summarized as an extended and inconclusive debate between those using unflinchingly utilitarian criteria, whose watchword was "regularity," and the more self-consciously aesthetic proponents of "variety," who were using essentially the same stance for cities as for villages. This dichotomy tended to parallel the divergence in architectural opinion between the symbolic functionalists and the instrumental or vernacular functionalists, but the anti-aesthetic views implied by the latter became much clearer in the proponents of urban regularity.

Philadelphia, with its grid-patterned streets, served as the critical touchstone among American cities. Perhaps a few Americans viewing Philadelphia would have

combined aesthetic expectations with approval of its functional arrangement, as in John Adams' remark, "The Uniformity of this City is disagreeable to some—I like it." The more common attitude received full statement by Noah Webster in a New York magazine article of 1788. He began by admitting that everyone he knew, other than Philadelphians, "was disgusted with its regularity." But Webster proceeded to negate the relevance of such an attitude. Citing Lord Kames' doctrine of relative beauty, he argued that a city's attractiveness depended entirely on utilitarian considerations. "The single question, therefore, with respect to a town or city, is this: *Is it planned and constructed for the greatest possible convenience?*" If so, then the plan was quite acceptable; especially in a place like Philadelphia, "built for the express purpose of accomodating men in business," according to Webster, variety could be tolerated only when it did not interfere with commercial convenience. Applying the same principle to New Haven, he found it perhaps the best designed small town in America, even though its central green bulked so large as to give the place "an appearance of solitude or dullness." Latrobe's castigation of Norfolk, Virginia, showed a negative application of the same idea: "Norfolk is an illbuilt, unhealthy town. The streets are *irr*egular, *un*paved, *du*sty, or *dirty* according to the weather, *crook*ed, *too nar*row where they should be widest, near the river, & accompanied by an innumerable retinue of narrow & filthy lanes and alleys." Later observers of Philadelphia interpreted the trend toward a grid pattern and away from crooked, intricate streets either as proof of the progress of civilization in America, because of the grid pattern's commercial advantages, or else that "Philadelphia is the

most dull, monotonous, uninteresting city on the face
of the globe."[7]

The opposite in city planning, Boston, provoked a
comparable division of opinion. That city's *Columbian
Magazine* emphasized the most appealing features:
"The buildings in Boston are in general good, the streets
are open, spacious, and well paved." The view from
Beacon Hill "is one of the finest prospects, the most
beautifully variegated, and richly grouped, of any, with-
out exception that I have ever seen." Unpersuaded by
such artistic phrases, "A Pennsylvanian" replied that
"the streets and lanes are peculiarly disgustful, as they
are laid out by no plan at all"; most were crooked, and
even the town green had a dogleg shape. Boston's defend-
ers granted the irregularity of its plan, but stressed the
view from Beacon Hill, or argued, "As it lies in a
circular form around the harbour, it exhibits a very
handsome view" from the sea.[8]

The appeal of a panoramic view was one that few
Americans, then as now, could forego. Whenever a tour-
ist found an elevated spot from which to look out and
down, he was sure to praise the scene. The baroque geom-
etry of Annapolis, seen from the top of its statehouse,
pleased Charles Willson Peale and any number of other
tourists. The quite different form of New York City,
seen by John Adams from "the new Dutch Church
Steeple," drew much the same kind of praise.[9]

Seen at street level New York City apparently dif-
fered so greatly from what Americans considered to be
an efficient or beautiful town that it got little more from
its magazines than a decent silence, and it seldom re-
ceived praise from observers. In an expansive moment
John Adams maintained that "the Streets of this Town

are vastly more regular and elegant than those in Boston, and the Houses are more grand as well as neat." Most travelers objected that the medieval Dutch streets, crowded together near the Battery, made the long, straight, commodious Broadway only a pleasant exception. The old front-gabled buildings "were probably once thought handsome, but tastes are *strangely altered*." The same writer repeatedly complained that the streets composed a labyrinth so dense that he had to buy a "plan" of the city to find his way.[10]

The demands of convenience enunciated by Webster required not only a tolerable regularity but also well-paved streets and clean, pleasant buildings. Albany, retaining much of its Dutch flavor, was clean enough, but its streets, on the side of a steep hill, often became muddy, and its buildings "are both inconvenient and clumsy." Pittsburgh had some handsome buildings but on crooked, ill-paved streets, and the ever-present dirt from the use of coal fires provoked Latrobe to write, "I hate the dirt & mire, & smoke, & gossiping, & goiture of Pittsburgh." When European travelers complained about the American utilitarian attitude, as revealed in the removal of an ancient Indian mound from the town center of Chillicothe, Ohio, a patriotic reviewer sardonically wrote in *Niles Register*: "This clearly proves the vulgarity and depravity of their taste. Any other people in the world, that is, civilized people would have suffered 'so beautiful, so antique, and so interesting an *ornament*' to have remained."[11]

Admirers of smaller towns also joined the debate between regularity and variety. Mirroring the aesthetic approval of Boston, an enthusiastic citizen of Poughkeepsie, New York, claimed that his town could be compared to a beautiful girl: "Although her features are not

perfectly regular, nor her form perhaps altogether in symmetry, yet, take her all in all, is exquisitely lovely." Huntingdon, Pennsylvania, on the other hand, preened itself on being a smaller version of Philadelphian regularity. The town's curbed and graveled streets "gives them an uniformity, cleanliness, and beauty seldom seen in the villages of the Western country," at least in the eyes of a Huntingdon editor. For tourists, especially those from New England, the most fascinating small town was the Moravian community of Bethlehem, Pennsylvania, which exercised an attraction similar to that of Shaker crafts for modern Americans. Located in a verdant valley, with buildings of rough stone "put together in the simplest manner," Bethlehem's neat cleanliness impressed "Secretus" in 1784 as it had John Adams seven years earlier. Other visitors saw in the town's dignified simplicity, showing the "greatest order and unanimity," their ideal of what urban, simple and yet gracious living ought to be. The only other American place at all comparable, judging from contemporary travel accounts, was Nantucket, with its primitive simplicity. It reminded Joseph Sansom of a Moravian settlement with its small town friendliness, "abstracted, but not wholly withdrawn from the world." Unfortunately, Nantucket's "monotonous plain" could not compete with Bethlehem's picturesque location.[12]

Even the most uncompromising proponents of urban regularity and convenience agreed that attractive towns and cities had to have suitable sites. Ideally, an urban center should have a "commanding situation," though not "naked," allowing numerous fetching views. Building on the edge of rivers or other bodies of water provided beautiful and majestic approaches, to be seen at Boston, New York City, and Philadelphia. One theorist

dogmatized, "Water is one of the grand accompaniments of landscape" with the most pleasing views being at the edges of rivers, lakes, or seacoasts. Inland towns could comfort themselves with the notion that the finest locations gave prospects like that of Concord, Massachusetts, "the rivers meandering through the meadows, and the distant hills rising above one another." Farm lands interspersed with water, with hills bounding the view—this was a sure recipe for successful town location.[13]

Horrible examples existed to warn the wary. Milton Springs, for example, existed "totally destitute of natural advantages. In a dreary and marshy hollow, surrounded by high and barren hills. . . ." Latrobe could only shake his head in amazement at a wealthy lawyer in New Castle, Delaware, who built his "enormous house, in bad taste . . . close by the water,—of which to enjoy a scanty view he sacrifices a range of the most valuable lots in town, . . . & he has then planted a range of Lombardy poplars, which exclude the prospect as effectually as a brick Wall." Both St. Louis and Pensacola appalled visitors by the lack of respect shown the potentialities of water. St. Louis, seen from the Mississippi, was attractive enough, but, on closer inspection, it proved to be made up of patches of crooked, narrow streets with no attempt to use views of the river. "Z." felt the only hope to be a fire like the one that destroyed early Detroit to give a chance for complete rebuilding. Pensacola, beautifully situated on a commodious bay, strangely turned its back on the view, showing only backyards to approaching ships. The one-story buildings on sandy streets in a small town without noteworthy public buildings seemed to illustrate how not to build a town. Boosters in such places were forced to indulge in the kind of local bombast parodied by *Salmagundi*'s "Jeremy Cockloft":

"Trenton . . . only wants a castle, a bay, a mountain, a sea, and a volcano, to bear a strong resemblance to the bay of Naples."[14]

New Orleans offered a baffling challenge to all the aesthetic categories so carefully built up by American travelers. The Louisiana Purchase in 1803 signaled the need for information on the area's capital, and a number of observers responded. New Orleans' strategic commercial location was most noble, according to one early report, but the prevailing one-story buildings seeemed more like "miserable sheds" than proper examples of urban architecture. The city continued to strike Americans as a collection of contradictions as late as Latrobe's visit in 1819. "Everything has an *odd* look," he confessed. The public square "has an admirable general effect, & is infinitely superior to anything in our Atlantic cities as a water view of the city," yet part of it was closed by "very mean stores covered with most villainous roofs." A month later Latrobe still pondered, "A curious town it is." The public buildings around the square, including the cathedral, "are as bad as they well can be" in architectural detail, but as a group they "produce an admirable effect when seen from the river or the levee." Other writers trying to assimilate New Orleans emphasized the crescent sweep of the Mississippi past the city, the levee with its "handsome broad walk," and the use of "Penn's plan" of grid-patterned streets. Nevertheless, the prevailing opinion for some years tended to be negative. One tourist went so far as to say:

It deserves rather the name of a great straggling town, than of a city. . . . In fact, the mind can, I think, scarcely image to itself a more disagreeable place on the face of the whole globe; it is disgusting in whatever point of view it be contemplated . . . [with its] wild brutish . . . suburbs.

Only with the growing interest in Gothic Revival architecture did Americans find the context within which they could take pleasure in the "venerable" buildings of the city.[15]

Equally indigestible for many Americans, and far more controversial than New Orleans, was the nation's new capital. Philadelphians' disappointment at losing the honor and the economic advantages of their city's remaining the capital, of course, generated many aspersions on the wisdom of the choice of the new location. "Presto" claimed that the site was noted mainly for its extreme inconvenience, while the first buildings served speculators rather than the ultimate grandeur of the city. Six months later the *Literary Magazine* printed another article which claimed that "Washington wears, at present, rather a grotesque, than picturesque appearance. . . . Fruits forced in a hothouse," it went on, "answer very well the purpose of those who bring them first to market, but they have not the substance of more natural productions." The author had to admit that the new city's plan had such regularity that when all vacant lots were filled, "it must form the grandest piece of architectural uniformity in the world." Some felt that that eventuality could only remain a vain, childish dream. The plat's gigantic scale, according to this view, thwarted any possibility of it ever being filled. Perversely, the critics of the new capital also asserted that, if by some mischance the city did fill out, "the number of the *idly rich* will multiply . . . and an overgrown capital will be the consequence." That most of these critics urged the return of the capital to Philadelphia, and complete abandonment of Washington, suggested the partisan source of their critiques.[16]

The numerous and probably incompatible motives be-

hind the planning of Washington certainly laid it open
to criticism. Starting with "the idea of creating a new
city,—better arranged in its local distribution of houses &
streets,—more magnificent in its public buildings, & su-
perior in the advantages of its site to any other in the
World," as Latrobe summed it up, Jefferson and L'En-
fant, nonetheless, carefully studied the plans of Amster-
dam, Paris, Milan, and even ancient Babylon. Hoping
to combine Philadelphia's grid-patterned regularity
with visual variety and monumental prospects, thereby
avoiding Philadelphia's "disgusting monotony," Jef-
ferson and L'Enfant mapped out a plan which, in La-
trobe's opinion, "has in its contrivance every thing that
could prevent the growth of the city." Actually, the
early dismissal of L'Enfant, and President Washing-
ton's premature decision in April 1792 to fend off all
alterations in the plan to encourage "the public
opinion on the thing as stable & unalterable," ex-
onerates L'Enfant from accusations of an inflexible
and unworkable design. Jefferson and the City Commis-
sioners overoptimistically assumed that they could en-
courage rapid development while specifying extremely
restrictive architectural and zoning controls. In addition,
they hoped that the rapid development would cause
land prices to rise enough so that sale of choice lots would
pay for public buildings and urban improvements. Fi-
nally, they expected Washington quickly to become a
major commercial as well as political center, despite the
strong lead held by Baltimore and Alexandria. When
land sales lagged, the controls had to be relaxed, and
trade patterns did not dramatically refocus on Wash-
ington; the result was an extremely patchy, poverty-
stricken, and impossibly zoned city. Early Washington,
in short, experienced most of the difficulties of any other

overly ambitious, speculatively built city, exaggerated by the grandiose expectations of it as a national capital.[17]

Though outnumbered by the antagonistic critics, the admirers of the new national capital vigorously countered their arguments. In November 1800 President Adams calmly termed Washington "beautiful and commodious," while his successor rather bravely wrote a friend that "everybody is well satisfied with the place, and not a thought indulged of ever leaving it." Some friendly magazine editors had already been hard at work drumming up approval of Washington. A widely reprinted article praised the location as "exceeded, in point of convenience, salubrity, and beauty by none in America." Including a map as a frontispiece, the author felt that the street pattern contained "some important improvements upon that of the best planned cities in the world, combining, in a remarkable degree, convenience, regularity, elegance of prospect, and a free circulation of air." Basing his judgments solely on L'Enfant's plan, since nothing had yet been built, he foresaw many buildings having the most extensive prospects, with the capital commanding a complete view of the city. Substantially the same text appeared in the *New York Magazine*, with the added observation that the plan removed "that insipid sameness that renders Philadelphia and Charleston unpleasing," proving the exalted genius of L'Enfant. A writer in 1794 expected the buildings to be of beautiful white stone, showing "a stile of architecture, chaste, magnificent, and beautiful." These enthusiastic anticipations all came before the start of actual construction. The best that could be mustered thereafter was Latrobe's cautious note that "upon the whole the city *'looks up'* considerably" or Jefferson's equally restrained comment in a letter to Joel Barlow: "This may be considered as a

pleasant country-residence, with a number of neat little villages scattered around within the distance of a mile and a half, and furnishing a plain and substantially good society." For those with less of a vested interest in Washington's appearance, disappointment and disillusionment carried the day.[18]

Though the first generation of national independence saw hundreds of other new towns and cities platted throughout the United States, aesthetic nationalists apparently preferred to concentrate their attention on existing urban areas, for few discussions appeared in print or in letters on the aesthetics of the new settlements. The aesthetic nationalists may have concluded that, since the new towns were generally modeled on Philadelphia, with a few copying Washington, the greatest effect could be had by focusing on the prototypes. More importantly, they could not have failed to recognize that any opinions that did not reinforce the real-estate speculators' search for maximum immediate profits were completely ignored. Jefferson could take little comfort from his attempt at embodying ideology in Washington. He gained a far smaller following for his "checkerboard towns" designed to counter the yellow fever epidemics that devastated Philadelphia in the 1790s. Latrobe doubted the wisdom of creating new capitals, but the newer states showed no interest in his ideas. When he tried to persuade developers to align their streets in conformity with climatic conditions, pleading that "it is surely better to sacrifice the form of half a dozen houses in a part of the town in which form is of little or no consequence, than to ruin the aspect of all the houses in the town," Latrobe got nowhere at all. In fact, as late as 1810 he complained that even Washington did not have a plan carrying "the *force of a Law*." Aesthetic consider-

ations, in short, gained a much wider hearing in existing cities, with their diverse publics, than in the new towns where economic or political interests were so firmly entrenched.[19]

Those aesthetic considerations frequently involved urban parks and gardens. The history of these environmental arts in America remains so largely unwritten that it is very difficult to be sure even of the basic chronology. Perhaps the story of New Haven Green may be taken as typical. In the first decades of settlement, trees were gradually removed until, by the late seventeenth century, scarcely any remained. Prior to about 1783 the area was known as the Market Place. Sometime after the mid-eighteenth century, the wilderness had been pushed back so far that New Haven residents began to replant the area, and the British invaders of 1779 found the town "too pretty to burn." The pace of development varied in other towns, but the pattern remained much the same —early clearing, a period of stark bareness, and then growing pressures for more trees, at least by the 1790s when New York City landscaped Battery Park.[20]

The American penchant for combining aesthetic and utilitarian values can be clearly seen in the appeals for increased use of trees and gardens in city plans. Greater numbers of trees seemed to be the primary need. Not only did they provide the shade so essential in the days before air-conditioning, more importantly, it was commonly believed, they substantially reduced the chances of contagion. Philadelphia had followed the same pattern as seen in New Haven. Then the devastating yellow fever epidemic of 1793 "brought into vogue notions of the salubrity of verdure, foliage, and shade." By 1804 nearly every house had at least one tree, and a writer in the *Literary Magazine* could "joyfully anticipate"

the time when a double row bordered every street. The dread of yellow fever also encouraged Philadelphia to build parks. State House Square gained its graveled, serpentine walks, "where the Citizens, especially Invalids & Children may walk to inhale fresh air," according to Charles Willson Peale, "and amuse the mind when diseased by too much care." Center Square (now the site of City Hall), with Latrobe's neoclassical waterworks, "introduced into the very bosom of the city" streams, fountains, and groves, "which constitute the highest pleasure of the country." Other cities also began to show concern for their parks and public walks, fencing them, planting more trees, laying out paths, and so on. The Lombardy poplar enjoyed particular popularity both because of its "spiry form" and because it grew rapidly and transplanted easily.[21]

Ideally, according to Americans of the early nineteenth century, trees should be planted to provide public walks, combining some of the characteristics of what we now call parks and boulevards. Boston's mall, for example, was described by those defending that city's aesthetic merits as "a very beautiful public walk, adorned with rows of trees, and in view of the common." Strollers used the mall much as they did Paris' later boulevards. But, many complained, Americans did not sufficiently avail themselves of these opportunities. Philadelphia's Center Square seemed to be mostly a place where men sat on the fences and watched the ladies, while New York City's Battery walk tended to be "not quite genteel. . . . everybody walks there, and a pleasure, however genuine, is spoiled by general participation." Consequently, when Peale petitioned the Philadelphia city government for aid in improving State House Square, his wish to put it "in a better dress" included physical

improvement and also raising its reputation so that "Ladies of respectability" might use it, confident that "no indecent behaviour will be overlooked as heretofore." We can see that ideas about urban landscaping, no less than attitudes toward fashionable dress, involved a genteel class bias. An article on Philadelphia's State House Square, describing it before Peale's projected improvements had been made, succinctly expressed the American image of an attractive urban walk:

> It was in form of a beautiful lawn intersperced with little tufts of flowering shrubs and clumps of trees, borders of flowers, serpentine walks, etc. at present it is laid down in a grass platt, divided in the middle by a spacious gravel walk, lined with a double row of large native and exotic elms, which form a cool shadowy retreat [with a good supply of benches] . . . the only spot in this populous city appropriated to the necessary and refreshing uses of exercise and air.

Combining the criteria of utility, regularity, and variety, State House Square drew together the carefully planned "naturalness" of eighteenth-century English gardens and the more formal patterns and purposes of classical French landscaping.[22]

American towns and cities had not yet grown so large that urban gardening had become terribly expensive, either on an individual or a public scale. Foreign travelers visiting the United States in the 1790s embarrassed patriotic citizens by noting the paucity of gardens "in a country capable of furnishing all the ornaments, which taste can invent." Instead, they asserted, the giddy pursuit of dissipation and gaming usurped interest in the bucolic pleasures of gardening. Touching on a theme long to persist in unfriendly European critiques of American attitudes, these tourists concluded that, because of the hustling spirit of the new nation, what gar-

dens existed were for use rather than ornament. Americans apparently contented themselves with what the woods afforded, since most of the wealthy had country houses and were "fond only of what succeeds well when left to itself." Some domestic critics reinforced this view. The examples of classical writers like Cicero and Epicurus, as well as the need to maintain one's moral stature, suggested the dictum, " 'Better is a handful with *quietness*, than both hands full, with travail and vexation of spirit'. . . . The streams of pleasures in cities are like their common sewers. . . . *'Go forth unto the field, and lodge in villages.'* " Those forced to remain in cities could at least bring a bit of the field and village with them by tending a garden.[23]

It is difficult to decide how much weight these opinions deserve as anything more than additional evidence of the ruralistic bias against urban areas. Ornamental gardening certainly received little notice in the American press before the 1820s. The first American book on gardening, Bernard McMahon's *The American Gardener's Calendar*, did not appear until 1806. The first magazine to devote considerable attention to horticulture did not see print until 1822. Nor were horticultural associations organized before the 1820s. Nevertheless, contemporary documents and the evidence presented in Alice Lockwood's *Gardens of Colony and State* do not confirm the opinion that Americans ignored their gardens. Every city had at least a few elaborate residential gardens that would compare favorably with the "beautiful hanging Garden" seen by Charles Willson Peale in Annapolis. Jefferson's perennial efforts to improve Monticello's landscaping could have been matched by many other Americans "of the better sort." Although a great deal more research is needed here, what was

happening in ornamental gardening may have paralleled the changing American attitude towards trees. Latrobe included in his impressions of his 1796 visit to Mt. Vernon the observation that the formal parterre, the first he had seen since touring Germany, represented "the expiring groans I hope of our Grand father's pedantry." He immediately followed this by noting that "towards the East Nature has lavished magnificence, nor has Art interfered but to exhibit her to advantage." Perhaps what European tourists and some American aesthetic conservatives took to be indifference to residential gardening actually involved a new, more informal style.[24]

The morally cleansing influence of nature could also be combined with fashionable pomp and entertainment in the pleasure gardens in or near American cities. They first appeared in the 1760s but became numerous only in the 1790s. More or less consciously modeled after such famous English entertainment spots as Vauxhall, the pleasure grounds incorporated large gardens interspersed with statues, paintings and illuminations, genteel romantic arbors and walks, concert and refreshment rooms. The pleasure garden offered an entertainment "brilliant while chaste, and delicate while entertaining. . . . [it] affords in the day time a pleasing recreation to those who have no gardens of their own, and an elegant and instructive amusement in the evening." So popular had these become by 1801 that the *Lady's Monitor* reviewed five then flourishing in New York City alone. English example competing with American pride showed in their names: Columbia, Vauxhall, Ranleigh, Mt. Vernon, and United States.[25]

The design of the pleasure gardens lends weight to the idea that American criteria for gardening were going through a major change in the generation before 1815.

Those in New York, some of them dating from the mid-eighteenth century, were far more formal and relied far more heavily on European examples than such popular later ones as Gray's Gardens in Philadelphia. New York's Vauxhall, for example, was originally laid out in 1740 by Jacob Sperry, a Swiss florist. When Peale saw Vauxhall in 1798, he summed up the appearance: "small, but neatly fitted up with boxes and seats, walks divided by small beds of flowers." Some years later a writer for the *Whim* praised Vauxhall's "order and neatness in the arrangement of the gardens" and "the general effect of regular arrangement." This type of pleasure garden, in short, expressed the themes of restraint, balance, and order, so much a part of eighteenth-century rationalism. In sharp contrast, Gray's Gardens, the most popular of those laid out after the Revolution, evoked a whole range of sentimentally romantic feelings. Rather than careful tidiness, the dominant mood of Gray's Gardens was expressed in Manasseh Cutler's description: "We observed a small footpath; we followed it, and it conducted us along the declivity of a hill which on every side was strewn with flowers in the most artless manner." The watchword here was "artless," whereas Vauxhall's had been "order and neatness."[26]

"Constantia" gave a careful description of Gray's Gardens in 1791. After crossing the Schuylkill River from Philadelphia and ascending a flight of stone steps, she came to a graveled wall bordered by "beautifully shorn grass." She then noticed the hewn-stone banqueting house with white columns, backing up a "superb orchestra" ornamented by a fine portrait of the "immortal Handel." The house contained a ballroom and a greenhouse of "prodigious size." Strolling through the gardens, Constantia enthusiastically responded to the varied

views to be seen from the many graveled paths. There was a romantic summerhouse with a full-length portrait of George Washington in front, and beyond, a garden of exotic lemon, orange, and pomegranate trees in full blossom. Then serpentine walks led over a "neat Chinese bridge" into a "wilderness full of romantick views, momentarily changing." An excavated cavern, arbor seats, nightly illuminations, transparencies, and fireworks rounded out the gardens' wonders. This "little Eden" shrewdly coordinated many of the elements most appealing to Americans—patriotism, exotica, technical virtuosity somewhat like an eighteenth-century Disneyland, variety—all within a framework of carefully planned rural felicity. Constantia neatly summed it up: "By the bounteous hand of nature the scene is apparently moulded, though we cannot admit the deception as to exclude from our idea, her hand maid art."[27]

The ideological implications of Gray's Gardens had already been voiced by a writer in the *Universal Asylum*. He pointed to three leading reasons for cherishing such pleasure gardens. In the first place, "an agricultural people, as we are, should be fond of gardening and ornamental farming; but in this we have hitherto been deficient." This new institution would educate Americans to "a taste so natural and noble," thereby reinforcing patriotic fervor. Rural entertainments also strengthened republican manners and had salutary effects on public liberty. Finally, and not at all surprisingly, they had a positive influence on public morals. The love of beautiful nature, encouraged by Gray's Gardens, "softens, refines, and elevates the human mind," as proven by the amazing lack of vandalism in the Gardens. Pleasure gardens, in other words, embodied a didactic, moralistic nationalism, drawing on nature as a normative

source, that was at the very heart of the aesthetic nation-
alists' search for an American taste.[28]

The idea of combining undistorted with carefully
planned nature to achieve an American style in garden
design received considerable attention from magazine
editors. Severely formal gardens requiring trained gar-
deners proved terribly vulnerable to the American hostil-
ity to "sacrificing Comfort to Taste." On more theoreti-
cal grounds, "a degree of wilderness" in gardens gained
sanction from the widely held notion that "Nature,
'when unadorned, [is] adorned the most.' " "Art, as-
sisted by Taste and Simplicity," it followed, "may be
said sometimes to improve upon Nature; but to produce
that improvement Invention can only revert to Nature
herself." Achieving greater naturalness in gardening
through an eclectic use of natural examples also seemed
to be the basic aim of English proponents of picturesque
gardening. The renowned Lord Kames, in his extensive
correspondence with Mrs. Montague, partially reprinted
in the *Monthly Anthology*, enunciated their goal: "a
mixture of sweetness and liveliness, which makes fine
harmony in *gardening*, as well as in *life*." Too few
articles in American magazines, however, revealed any
serious interest in English doctrines of the picturesque to
support an argument that that was the major source of
American ideas on gardening. As in their search for
democratic definitions, editors merely used prestigious
English names and concepts when they served American
purposes and calmly ignored foreign theories when they
did not.[29]

Magazine writers paid more attention to the integra-
tion of art and nature to be found in Chinese gardens.
Like skillful painters, according to one writer, Chinese
gardeners collected from nature the most pleasing ob-

jects and then tried to form them into an "elegant and striking whole," creating perfection from the number, beauty, and diversity of the scenes. Americans should move beyond such simple imitations as putting an occasional Chinese bridge in a pleasure garden, though they had to realize that Chinese landscaping principles were "exceedingly difficult, and not to be attained by narrow intellects." Interest in Oriental technique may have been another indication of the American effort to emancipate themselves from artistic bondage by emphasizing remote examples, just as partisans of an American music praised the merits of ancient melodies. Editors took pleasure in reprinting Lord McCartney's comment that what the English considered their own invention in gardening had flourished for ages in China. Perhaps the flanking movement around English dogmatists had served its purposes by 1811, and cutting loose from Chinese examples had become desirable. At any rate, "Proclus" in that year devoted a long article to the thesis that the Chinese were culturally retarded, especially because of their "absurd devotion to established rules [and] . . . a great dread of innovation."[30]

Certainly Americans had no dread of aesthetic innovation, as may be seen in the rise of botanical gardens after 1800. John Bartram's had been established as early as 1732, but, just as in the case of pleasure gardens, the multiplication and elaboration of botanical gardens occurred only in the 1790s. Here, truly, could be seen a realization of American wishes to unite utility and beauty, scientific research and rural felicity. Two of the most renowned were William Hamilton's Woodlands near Philadelphia on the Schuylkill River and David Hosack's Elgin Gardens located in New York where Rockefeller Center now stands. Jefferson was so im-

pressed with Hamilton's botanical collection that he tried to lure him to Monticello to advise on its gardens. Woodlands, at the same time, had all the virtues of a pleasure garden—architectural elegance, collections of fine paintings and statues, and extensive walks with variegated prospects. Hosack's garden may have been somewhat more narrowly scientific, effectively serving as Columbia College's arboretum, but it gained widespread praise for its reclaiming of a rather rocky and barren hillside. Within a few years, unfortunately, Elgin Gardens lapsed into disrepair and deterioration after Hosack finally persuaded the state of New York to take over the gardens.[31]

Shortly after 1800 American patriots no longer needed to fear travelers' sneers at the lack of gardening in the United States. Samuel Miller's *Retrospect of the Eighteenth Century* took heart at "the superior taste which has of late years been shown in landscape gardening," and John Dunbar declared in 1810 that Philadelphia had a number of flower gardens "which VIRGIL would not disdain to describe." The efforts to bring nature into the city had produced substantial results. Eclectically borrowing from Europe and Asia, and combining these importations with indigenous technological ingenuity, the aesthetic nationalists were well on their way toward an American style of gardening. Yet their arguments in favor of urban gardens and public walks could all too easily be turned against them in favor of escaping the city entirely. Rural serenity rather than urban sophistication remained the ideal for many if not most Americans before 1815.[32]

The belief in the moral superiority of country life over that in the city, what I have called the rural bias, rested on a fully developed rationale. "It is only the

powerful and secret charm of the country," the typical justification began, "which has a constant and universal influence over the heart of man." Reiterating the moralistic fears discussed in earlier chapters, the rural rationale suggested that in the cities the arts, "perhaps too refined in our time, pursue their niceties of form, to attract and please, for a moment the sorrowful eye of the wealthy." Those artificial, ephemeral pleasures could not compare with the genuine joys and the simple greatness of the humble, self-confident husbandman. Those who could not enjoy rural scenery merely proved their own "vitiated taste." After all, how could one develop any art work "equal to the ravishing pencil of Nature? . . . Alas, how puny and weak are all the exertions of the greatest copyists, [compared] to the great original, Nature!"[33]

Strive as the artist might to obey critical counsels and follow nature, he could be no match, proponents of the rural bias contended, for all the wondrous beauties of Nature which so readily and properly evoked thoughts of "that all-bountiful and omnipotent BEING" who had created all. In his faulty copy of nature the artist could never reach such exalted moral heights; he had to content himself with his audience's marveling at the genius and perseverance of man in even making the effort. The *Juvenile Magazine* taught its young readers that human beings were imperfect and limited, while the natural world reflected its Maker with pristine purity. Necessarily, therefore, nothing man-made could equal the perfect functionalism of all natural objects fitting into a harmonious whole. In human art, "pictures of delight are minute, confined, vivid, and variegated. Solemnity is inspired by a boundless, wild, unshapely scene." Only God's Nature provided a picture that "can

strike as well as charm," causing us to adore and fear Him at the same time. The transcendent loveliness of the natural world also served the great moral purpose of revealing the abominable ugliness of vice.[34]

This line of thinking finally led some writers to see the American wilderness in its natural simplicity as far superior to the artificial complexity of European gardens. As William Penn had once written, the flowers in the Pennsylvania woods surpassed the finest in London gardens for color, greatness, figure, and variety. An admirer of "American Prospects" conceded that Americans had little to compare with Europe's "elaborate arrangements of art," but for picturesque views of "the face of uncultivated nature" the United States could not be surpassed. Another magazine writer saw no reason for American travelers to "expatiate with so much enthusiasm" on the beauties of Switzerland, Scotland, or Germany. Niagara Falls was only one of the many "scenes which we have no need of going to Europe to behold." Besides, as Jefferson asked in his effort to persuade Maria Cosway to visit America, "Why go to Italy? You have seen it, all the world has seen it, and ransacked it thousands of times." In contrast, he offered Niagara, the Natural Bridge, and "our own dear Monticello." "Where has nature spread so rich a mantle under the eye?" Responding to this blend of nationalism and moralistic love of nature, the editors of the *Port Folio* in 1809 began a monthly series of illustrated descriptions entitled "Sketches of American Scenery." Clearly voicing the pride in the American landscape evident here, the *Observer* proclaimed that nature in America, more than anywhere else, lavishly "presents herself in her primitive garb—in her native grandeur."[35]

Many of those propounding the rural bias, however,

found such romantic primitivism quite repelling. A self-confessed "Rustic" writing in the *Port Folio* argued that the lack of cultivation and "rural embellishments" in America called for more formal gardens than those in England. How revolting, he exclaimed, to have an artificial wilderness in the midst of a virgin forest! Confrontation with, and constant efforts to conquer, the American wilderness heavily influenced these commentators' reactions to the alleged beauties of nature in her "primitive garb" far more than did nationalistic pride. Europe might be settled and urbanized enough to idealize primitive nature; Americans, they felt, were too close to that state to glorify it. What they sought was the rural felicity, as they so often called it, of cultivated fields, pastures, villages, and elaborate country estates, such as the ornately decorated mansion and grounds of Harman Blennerhassett on his island in the Ohio River. An occasional illustration in contemporary American magazines praised an "elegant rural prospect" of log cabins in a forest; much more frequently editors directed their readers' attention to villas of the wealthy, like Henry Pratt's Lemon Hill near Philadelphia. Yellow Springs, Pennsylvania, as portrayed by the *Port Folio* could be taken as an example of what many Americans thought constituted rural beauty. "This seat of health, hilarity, and rural elegance" was surrounded by distant forest-crowned mountains. The valley contained carefully tended farms, with large and comfortable houses perched on the mountainsides or in the midst of the verdant hills. It composed "a perfection of landscape calculated to gratify the most fastidious taste"; if the efforts of art were added with "improved taste," a traveler could be truly enchanted.[36]

Improved taste, as the term was used here, depended on sensibility which bridged neoclassical and romantic attitudes toward landscape. The "refined sensibility of the soul" responded to the beauties of nature, according to both mid-eighteenth and early nineteenth century theorists. Americans were especially resentful of any suggestions, like those of Thomas Ashe, that they were insensible to the finer points of beautiful landscapes, even though, on other occasions, they chastised their fellow citizens for being insensitive. Many authors worked very hard to show their poetic sensibilities, often with disastrous results. "J.W.'s" hymn to the beauties of Bedford Medicinal Springs typified an all too common style: "Here amid the mazy forest, or rugged landscape, they steal the roses of youth from the zephyrs of the mountains and vallies, and purify their feelings, whilst they lave their bodies in the translucent streams, sparkling with the richest gems of Hygeia." Their ventures into verse often came to no better end, as Eugene Huddleston has shown.[37]

The scenes most interesting to men of sensibility varied greatly, ranging from the "gloomy woods" of Pahaquarrie, New Jersey, to the "pleasing melancholy" to be enjoyed in "A Rustic Cemetery," or from Lake George to the Dismal Swamp. Generally, each of those scenes could be placed within at least one of the three basic aesthetic categories of the time—the picturesque, the sublime, and the beautiful. Any or all three might be implied by the word "romantic." Many Americans took their meaning of picturesque from William Gilpin, "the high priest of the picturesque," as the *New York Magazine* called him. His emphasis on "the simplicity of nature . . . in her most usual forms" easily fit prevail-

ing American ideas about nature. And, unlike later theorists, Gilpin indulged in no esoteric reasonings about aesthetic terminology. That also was very congenial to American predilections. According to Gilpin and his followers, a scene was picturesque if it composed well in a drawing and was harmoniously colored. Scenes of rural felicity commonly involved that sort of attractiveness.[38]

The experience of sublimity included many emotions, but rarely did Americans find gloomy settings sublime. It might be acceptable for the environs of well-cultivated and settled Boston to have blue mountains in the distance, "in gloomy grandeur, adding a tinge of sublimity to the whole scene." But the United States in the early nineteenth century still had too many virgin forests and untamed mountains for most Americans to take pleasure in their "dull uniformity." Nor were ruined, desolate towns, like Martinsburg, Maryland, tolerable to those looking forward to a nation of villages and fields in blossoming prosperity. A traveler in 1810 viewing Lake Cayuga's "handsome sheet of water" typically concluded that the day *would* come when "these shores, now dark and gloomy with the tall and impervious forest, shall be lighted up with villages, and towns." Farther west, one escaped the gloom through the imagination: "It is true, the abrupt termination of the ridges presents a bleak and cheerless front, but I have been on several ridges where one might forget that he was on a mountain." Gloomy scenes were tedious and boring, whereas sublimity dazzled the spectator.[39]

Many travel writers would have agreed with the notion that "when sublimity is united with beauty, the effect is the genuine picturesque—a massy rock—a grand mountain, or a tremendous cascade." The theoretical

pansion of civilization while feeling that "all nature droops and pines under the destructive influence of human art." The same mood appeared in some appraisals of exploratory expeditions to the West. "U." thrilled at the commercial and agricultural possibilities of the new land and affirmed the primacy of America's claim over that of Spain or Russia. Yet he urged establishment of garrisons and government trading posts at the same time that he bewailed the sad fate awaiting the Indians of the area.[43]

The resulting crisis of "Nature and the National Ego," to use the title of Perry Miller's essay, has increasingly troubled Americans right up to the present, when we build more and more skyscrapers and sprawling suburbs at the same time that we enact "wilderness acts." Nevertheless, the early nineteenth-century debate between the admirers of untouched wilderness and the proponents of rural felicity masked the crucial fact that Americans by 1815 had generally achieved an acceptance of the American landscape that had been so noticeably lacking forty years earlier. Few, on the other hand, yet evinced much pleasure in the unbounded West as such. For exotic scenes and enchanting views, most Americans before 1815 still went east, not west. Consequently the replacement of neoclassical by romantic values in tourists' attitudes, rather muted in accounts of travel in the United States, appeared much more strikingly in accounts of Europe. In the waning years of the eighteenth century, foreign travel meant not simply excursions in Europe, but primarily on the Grand Tour circuit. Within a few years that would drastically change. In the process, new aesthetic criteria would gain precedence which enhanced the attractions of the most non-European parts of America.[44]

9. From the Grand Tourist to the Romantic Traveler

*T*he fundamental shift in American aesthetic values, away from neoclassicism and toward romanticism, may be seen most clearly in the foreign travel accounts published in American magazines in the generation prior to 1815. Focusing on that source rather than on the more commonly used travel books and collections of letters has the advantage of using a perspective midway between the interesting observations of individuals and the very general patterns found by such scholars as Neil Harris and Paul Baker. The magazine articles, in other words, enable us to trace chronologically the changes in aesthetic opinions concerning travel in the crucial thirty or forty years between neoclassicism in its prime and a well-developed romantic outlook.[1]

In the process of that change American travelers evidenced a growing national self-confidence which kept foreign attractions in their place, for increasingly they conceived of foreign travel as a form of entertainment, as a temporary vacation from American realities rather than an escape from them. As early as 1771 Abigail Adams set the mood. "From my Infancy I have always felt a great inclination to visit the Mother Country as tis call'd." But, she continued, "tis natural I believe for every person to have a partiality for their own Country. Dont you think this little Spot of ours [i.e., Massachu-

setts] better calculated for happiness than any other you
have yet seen or read of [?]" She would eventually
travel to Europe, and live there for four years in the
1780s. Though she regaled friends and relatives at home
with extended commentaries on the sights, her national-
istic attachments remained unshaken. Returning home,
she noted in her diary, "I do not regret that I made this
excursion since it has only more attached me to America."
Similarly, Jefferson might conform completely to
French styles while he resided in Paris, but his belief
that Americans ought to pay close attention only to
European examples having immediate relevance at home
may be seen in his "Hints to Americans Travelling in
Europe" (1788). Gardens, he felt, were "peculiarly
worth the attention of an American, because it is the
country of all others where the noblest gardens may be
made without expence." Painting and statuary, on the
other hand, were "too expensive for the state of wealth
among us. . . . They are worth seeing, but not studying."
Occasionally Americans found the sight of European
artistic riches so dazzling that they had to retreat into a
moralistic critique like that of John Adams' conclusion
about English aristocratic estates: "A national Debt of
274 millions sterling accumulated by Jobs, Contracts,
Salaries and Pensions in the Course of a Century might
easily produce all this Magnificence." More commonly
tourists from the United States luxuriated in foreign
exotica without fearing for their patriotic virtue.[2]

Americans traveling in Europe during the 1780s and
1790s generally followed, as they had in previous de-
cades, a pattern and set of responses long since firmly
established as the Grand Tour. William Mead, the lead-
ing scholarly authority on the Tour, has characterized
the English participation in this fashionable finishing

of an upper-class education as being hasty, thoroughly conventionalized, shaped to touch a few major cities with the most direct routes between, and generally restricted to Great Britain, France, Italy, and the Low Countries. Germany was largely *terra incognita*, Spain remained inaccessible by road, and Switzerland offered little beyond romantic landscapes that stirred few imaginations before 1800. "The chief aim, indeed, of most people of fashion," Mead concluded, "was to waste time as gracefully as possible." Using the numerous tourist guidebooks even then available, English and American followers of the Grand Tour, and those writing in American magazines for the armchair tourists, revealed aesthetic preconceptions very similar to those discussed in the preceding chapter. Regularity, variety, and convenience remained the criteria in judging cities; landscapes received praise to the extent that they exemplified rural felicity; and thinking in conventionalized categories thwarted favorable responses to anything strikingly different.[3]

Regular city plans, convenient and pleasing walks, and cleanliness distinguished attractive cities for the Grand Tourist, whether he spoke of Edinburgh in 1745 or of Florence in 1799. Even Venice received demerits for its narrow and winding streets, dangerous bridges, and inescapable stench. Streets at their best were not only straight, wide, curbed, and laid in a grid pattern but also had "very neat and handsome" buildings. Glasgow, for example, boasted one whole street of buildings of wrought stone, each about fifty feet high, with columns from the basements and with pediments "after the best Grecian and Italian models." Rome, on the other hand, ought to have been more uniform and its plan more regular. Americans frequently praised the prevalence in

properly laid out European cities of commodious walks, "well gravelled, [with] flowering shrubs, parterres, etc." What constituted an ugly town might be illustrated by Lyons, with its "very narrow, dark, and dirty streets: of high, strait, and excessively dirty houses"; by English factory towns filled with tiny cottages built in scattered confusion, without any apparent order or plan; or by a small Silesian village, reminding John Quincy Adams of an American one, with its houses "scattered over an extent of several miles square, and the houses are all strewed about in spots." These three examples, of course, suffered doubly from being decidedly off the beaten track of the Grand Tour. But John Trumbull's crusty dismissal of Liège showed how conventionally sanctioned cities might also be condemned: "The town is old, large, ill built and dirty, containing more beggars and fewer pretty women than any other of equal size I ever saw."[4]

The substitution of bourgeois for aristocratic values in the opinions of Americans on the Grand Tour appeared in their frequent discussions of the relative virtues of London and Paris. The issue seemed to be one mainly of convenience versus elegance. As early as 1745, but especially around the turn of the nineteenth century, invidious comparisons were made between the comfort so evident in London, and Paris' noble architecture and general splendor in a squalid setting. As an American woman succinctly put it, while Paris had many magnificent buildings, they were in narrow, ill-paved streets without sidewalks, and had "a dunghill before every door." Typically, when "Mr. Pinkerton" described recent "Improvements in Paris" in 1806, he praised the beauty and elegance of the new public buildings and squares but concluded that the happiness of England lay

in the fact that "the ease and comfort of the people have been studied; and that idle splendour has been sacrificed to lasting utility." Only rarely did American magazine readers get the French point of view. In their private letters diplomats like John Adams and Thomas Jefferson condemned London's smog and the architecture which Jefferson termed "the most wretched stile I ever saw." American editors, however, found the appeals to comfort and convenience more impressive than the French emphasis on architectural elegance and correctness.[5]

The puritanical, bourgeois, and democratic notions of Americans revolted at the sharp contrasts between great, showy wealth and poverty so commonly found on the Grand Tour. Entry into Paris required passage through the squalid, poverty-ridden suburbs. Frederick Hall was equally distressed by London, "that miniature of the pomp and bustle; the activity and sloth; the virtue and wickedness of the world." Tourists might strive to overlook such faults in a London or Paris, but Dublin could not be forgiven the fact that its "streets are filled with wretchedness and grandeur, idleness and extravagence," any more than they could forgive the great, irregular city of Cairo where "the excessive opulence of those who bear the rule, [clashes] with the frightful poverty of the most numerous class."[6]

Vacationing Americans did not, on the other hand, find much pleasure in purely commercial cities, regardless of their convenience or regularity. Indicative of this preference for diversion from life commonly found in American cities was the offhand dismissal of Bremen as "a great city, a rich city, and a commercial one; but I cannot say I think it very agreeable." Similarly, anyone not dominated by a desire for gain and "a corrupt taste"

was warned away from Amsterdam, which would "render the mind callous to every impression of the sublime and beautiful." The Grand Tourist bound for the certified beauties of Florence might, in passing through the seaport of Leghorn, admit that it was "constructed on the most refined principles, of which the spirit of commerce is capable." But, after all, Leghorn lacked "the charms which the remains of antiquity inspire, with but one solitary imperfect monument of the arts." Admirers of commercial cities like Liverpool sometimes tried to counter such biases but probably with scant success.[7]

Foreign travel accounts showed much more flexibility in their appreciation of a city's size and location. Though, as for American cities, magnificence (often synonymous with massive dimensions) and noble prospects served as primary criteria, writers quite readily accepted cities off the usual Grand Tour route if they fulfilled these requirements. The water approaches to Montreal and Algiers and the fabled, ancient Babylon received favorable mention for their beauty. Of course, the more usual sights, especially the Bay of Naples, gained the largest share of attention. Few would have disagreed with the observer who announced, "I know not of any prospect more extensive, more varied, or more striking, than that of Naples and its environs, seen from the top of Mount Vesuvius."[8]

Americans at the end of the eighteenth century followed the usual guidebooks and tried to appreciate the approved sights, but many could not escape, even for a holiday, the moralistic outlook then so dominant in the United States. There constantly recurred in their travel letters an unresolved conflict between the claims of taste and those of morality, particularly with regard to dancing, music, and religious art. We have already noticed

the frequent complaints against operatic performers and the indelicacy of the female dancers. One visitor regretted to observe the Genevans, a people fond of dancing, cast aside their native folk dances and succumb to "the rage of the waltz." Another dour American in Paris castigated the feminine fashion, in spite of the cold winter, of being not just *à la grec* but *à la sauvage*, with flesh-colored drapery of clinging bodices without any underlinen. These tourists' position became clearer when the former praised the morality of medieval statuary in contrast to "the irregular gods and naked goddesses of Ancient Greece, at the Louvre." More of a problem than allegedly lascivious fashions and dances was the inescapable fact that the Catholic Church had traditionally been a leading patron of the arts, and so the churches had become major repositories of art masterpieces. Virulently Protestant Americans usually dealt with this by touring the churches while penning blasts against "monkish superstition." What a relief to get away into a Protestant region like Silesia! There one could admire the excellent pipe organs in the churches and even praise the large amount of singing in Lutheran services, wishing with John Quincy Adams that the practice were adopted in the United States. Compared with Catholic masses, the Lutheran ritual seemed only a minor variation of that used in a sound New England meetinghouse.[9]

Observing the landscape outside major cities also served as a relief for actual and armchair followers of the Grand Tour. Their expectations ran to evidences of rural comfort and variety, with no great interest in massive, dark, or awe-inspiring scenes. A book reviewer in 1791 quoted the typical view:

> Holland is a perfect garden; but a continued sameness presents no new object for the imagination to rest upon.

England and France are more diversized and romantick,
and in general richly cultivated - here and there an arti-
ficial forest - venerable castles - majestic country seats - large
populous inland cities - charming roads; and many in-
teresting objects, to engage the particular attention of an
American.

What especially engaged American attention most often
involved the long-established, well-planned, and fruit-
ful look of the countryside in Europe. Southern France
seemed "so elegantly laid out and planted, as to give
the appearance of a rich demesne to extensive districts."
The prevalence of large chestnut and walnut trees en-
hanced the notion of great age. The environs of Brussels
suggested to a tourist in 1796 an improved New Eng-
land, without its rocks, stones, and enclosures. Especially
noteworthy, he felt, were the Dutch canals bordered by
the carefully planned straight lines of lofty trees,
planted in double, triple, and in some instances quintuple
rows. The thoroughly cultivated fields and meadows
proved man's successful development and control of
nature, to be seen, for example, in a road seven miles
long, perfectly straight, tree-bordered, and producing
"a vista as striking as it is novel."[10]

The opposite of smiling nature—"dismal unifor-
mity," agricultural barrenness, or gloominess—repre-
sented the major negative features of Grand Tour land-
scapes. Thus, Jefferson wrote from Marseilles in April
of 1787: "From hence my inclination would lead me
no further Eastward as I am to see little more than a
rocky coast. But I am encouraged here," he went on,
"with the hopes of finding something useful in the rice
fields of Piedmont, which are said to be but a little way
beyond the Alps." Writers of the time often used words
like *desolation* and *desert* not only for Saharan barren-

ness, but also for any area without sufficient visual variety and signs of human occupation at a prosperous level. The scenery of Sweden, for example, "is very desolate and dreary . . . one continued rock of granite, covered with fir," improved only by poor, scattered cottages in a few, distantly spaced forest clearings. Not even the most hallowed parts of the Grand Tour escaped criticism on the grounds of dreariness. One traveler complained that the country around Rome "is in the most deserted, forlorn, and miserable situation," while "nothing can equal the dull, tiresome uniformity of a French road" in contrast to the "charming" ones of Great Britain. French scenery, according to this view, remained so similarly patterned that soon one became bored. Gloominess could no more be tolerated than tedium, whether in architecture, city planning, or landscape. In the days before romantic interest in old castles appeared, the common opinion asserted that "an ancient castle . . . must be at best a cold and gloomy habitation," with no more appeal than "a large, old-fashioned gloomy place" like Toulouse. Consequently, conventional Grand Tour routes and attitudes became seriously undermined when tourists began making invidious comparisons between the rugged seacoasts of Great Britain and the "apparent gloom" mixed with "magnificence, hypocrisy, and sadness" to be found in Rome.[11]

The dichotomy between smiling nature and gloomy uniformity illustrated the Grand Tourist habit of thinking in quite rigid categories, rejecting out of hand all things that did not snugly fit one's mental pigeonholes. Exotic places proved unmanageable for such minds and were cast aside for being unlike familiar parts of Europe. The dirt and stench of Madeira, its people in strange clothing, and "the most miserable contrived mince pye

gardens you can imagine" alienated rather than intrigued late eighteenth-century visitors. "The Streets and Houses in the City of Morocco," Thomas Barclay wrote from Tangier in 1786, "are despicable beyond belief." The only interest his contemporaries could muster for Oriental cities concerned commercial opportunities, as in the case of Canton; the beauties of European quarters, like those in Calcutta; or in revealing the empty pretentiousness and general inferiority of famous capitals. In all cases, the writers presumed an inflexible standard based on the Grand Tour, without asking whether there might be other, different beauties in the world.[12]

The same dogmatic approach applied to Europe itself. Gothic or other "old fashioned" styles of architecture not showing a reverence for classical formulae or a concern for modern comforts suffered arrogant dismissal. Instead of beautiful estates between Bordeaux and Tours, one letter writer complained, there were only "a few ruinous *chateaux*," unbearable to live in, and some *maisons bourgeoises*, representing comfort if not elegance. A similar condescension appeared in the admission that, considering the year of its erection (1560), Antwerp's city hall was "a superb house." Nor were such notable early examples of the Gothic Revival as Walpole's Strawberry Hill or Claremont by Vanbrugh likely to receive favorable mention. Jefferson passed over them with a curt entry in his notes—"Nothing remarkable." Furthermore, indigenous folk architecture commonly gained no more than a polite yawn. Such structures showed, according to one tourist, no signs of "either taste or grandeur. They appear to me just what you might expect *village* architects to produce." Their style seemed unable to avoid the "mean and vulgar." Village fashions in dress were equally spurned. At best,

folk costume might be "singular." The American seeing the peasants in Basle averred that he had never seen such odd figures, that they "had carried eccentricity of dress to its highest pitch." He no doubt felt himself to be quite generous and broad-minded in describing them as "singularly picturesque."[13]

Nothing so clearly indicated the Grand Tourist's cranky humorlessness whenever confronted with a novel situation as his rejection of all sounds he did not consider harmonious. He understood harmony to be perfectly embodied in the rather ponderous oratorios of Handel. By that standard, the elaborate musical ritual heard in an Amsterdam synagogue could only be called "shouting and howling." Even when the sounds were simple, if they were not sufficiently "sweet" they should have been banned as public nuisances, whether they were the cacophonies of church bells or of organ-grinders. Wherever they heard the discord of bells, the travelers moaned about "disagreeable or detestable" noise.[14]

But a broader, less doctrinaire approach to the pleasures of travel already was emerging. The Grand Tour never really recovered from the disorganizing influences of the French Revolution. Old fashions lingered on for a few years after 1789, but, increasingly, they would be pushed aside in favor of travel as an adventurous discovery of new, rather than traditional, conventional aesthetic pleasures. Therefore, the closing years of the eighteenth and the opening years of the nineteenth centuries marked a transitional period in the history of tourism, when many travelers still followed the approved routes, while increasing numbers found new areas to enjoy for new reasons.

Emancipation from the straitjacket of Grand Tour guidebooks did not, of course, occur all at once. As the table shows, the process was recorded by an increasing

volume of articles and reviews pertaining to foreign
travel in American magazines after 1800 involving a
gradual diversification of areas covered, with a persistent
but relatively waning interest in Europe throughout the
period.

ARTICLES AND REVIEWS IN AMERICAN MAGAZINES ON FOREIGN TRAVEL

Subject Area	To 1800	1801– 1805	1806– 1810	1811– 1815	Total
Grand Tour Europe	13	26	25	14	78
Other parts of Europe	1	10	14	12	37
Mediterranean	5	11	9	30	55
New World	2	0	4	18	24
Elsewhere	5	2	5	7	19
Total	26	49	57	81	213

The areas not generally seen extensively on the Grand
Tour began to attract much more attention during the
transitional years early in the century. Along with an
awakening interest in picturesque landscape, especially
in Switzerland, the articles on previously ignored parts
of Europe indicated the movement away from the
Grand Tour and toward a search for the picturesque.

The older fashion's predilection for cities carried over
into the new century, though with numerous and drastic
changes in point of view. London no longer received
praise for its comfort and convenience; the very things
most unpleasant for earlier visitors now became its vir-
tues. The shroud of smoke hanging over the city, changed
by the wind in color and direction, presented, it was now
felt, "a grand and gloomy scene. . . . It is pleasing to
observe the black streams which issue from the different
manufactories." Gloominess had gained a positive,
though limited, connotation, for in November the smoke
gave "an effect dismal and depressing." A comparable

ambivalence lurked in the reaction to the city's "gay and ambitious" chatter of crowds made up of those who had no love for lawns, groves, or rivers, and who lived under skies darkened by smoke and "cloudy vapours." Tourists had only partially broken free from the antipathies of the Grand Tour style toward gloominess and lack of urban parks and walks.[15]

Willingness to view parts of Europe previously ignored and to accept them on their own terms came more quickly. Amsterdam received increasing notice, with favorable mention of that city's vigorous musical life, though with some persistent doubts concerning the quality of Dutch taste for the arts. A significant blow was struck at American ignorance of Germany by John Quincy Adams' "Tour through Silesia," serialized during the years 1801 to 1802 in the *Port Folio*. His many enthusiastic responses were seconded by translations of German works, which began to appear in American periodicals. The transitional quality of those responses may be seen in their praise for little-known cities like Dresden in conventional Grand Tour terms. In the same way, travel writers began to write of the fringes of Europe, admiring highly romantic views while castigating unfamiliar objects. Thus, the Welsh village of Llanberis had an ivy-covered church, at first mistaken by the tourist as an old cottage, "the most ill-looking place of worship I ever beheld." At this stage of evolving criteria, the would-be admirers of the picturesque found it much easier to enthuse over such standard beauties as the sunsets, gardens, prospects, and architecture of Palermo or the ancient wonder of Babylon. While cautiously exploring new tourist areas, writers apparently clung to tried and true responses, or else retreated to an informational level that hazarded no aesthetic appraisal. Jef-

ferson, who sometimes sounded like the prototypical Grand Tourist, succinctly expressed in a letter of 1787 the newer mood:

> I am constantly roving about, to see what I have never seen before and shall never see again. In the great cities, I go to see what travellers think alone worthy of being seen; but I make a job of it, and generally gulp it all down in a day. On the other hand, I am never satiated with rambling through the fields and farms, examining the culture and cultivators.[16]

Discovering new aesthetic responses, on the other hand, most frequently occurred on the conventional travel routes. Appreciation of previously spurned Gothic architecture appeared early in the nineteenth century. An American visiting England in 1803 wrote home that Battle Abbey, the first Gothic structure he had ever seen, greatly pleased him. It was becoming increasingly fashionable to describe one's feelings of awesome mystery upon entering a Gothic cathedral, especially if it avoided "the barbarity which characterized and disgraced the architecture of that period." Tourists maintained, in other words, an anachronistic, neoclassical vocabulary when they began praising the neglected beauties of Gothic architecture. A striking example of this came from a visitor to Palermo who described the "singularly superb" interior of that city's cathedral. Impressed with the exceedingly rich decor and pervasive feeling of enchantment, he concluded, "The chasteness of its design; the neatness, beauty and elegance of its execution, cannot be excelled." Either through conscious use of old words to describe newly experienced things, or merely using what words of acclaim were ready at hand, such reports redefined or muddled the current critical vocabulary beyond a neoclassicist's recognition. At this stage in the

evolution of a new travel aesthetic the only alternative to such misuse of the old terminology may well have been silence. As Robert Livingston wrote to his sister in 1801, "It would be idle to attempt to describe a Gothic building, no one part is like another, & nothing but a good drawing could give an idea of one." By 1809, however, a traveler who often mirrored typical Grand Tour attitudes, such as the opinion that all castles were gloomy, could laud the ruins of an old fort that added picturesqueness to Geneva and casually refer to "that solemn and stately air which distinguishes the best specimens of Gothic architecture" to explain his admiration for Notre Dame in Paris.[17]

Concurrent with the growing interest in Gothic architecture appeared a thinly disguised indifference to the wonders of Renaissance art. Many travelers dutifully followed the Grand Tour, but with rapidly waning enthusiasm. One, able to stay only four days in Florence in 1803, made verbal obeisance to the belief that really four months were needed to see the sights properly. Revealingly, however, he thought the Pitti Palace not worth the trouble, since the French soldiers had carried off most of the good pictures, and he had interest in only "the most capital works." When John Quincy Adams scanned the statuary collection of the National Museum in Paris, he confessed, "The Apollo, the Venus de Medicis, and the Laocoön—I had seen so many and such excellent copies of those that I was unable to discover any new excellence in the originals." As for the paintings from the Pitti Palace and other Italian collections, "the gallery of pictures was immense, but so much accumulation of excellence is rather unfavorable to the proper estimation of every separate masterpiece." An American visiting Florence in 1806 candidly wrote, "I do not

however . . . admire much the architecture, although it has been much praised." In fact, "the round of churches, with pretty pavements and pretty ceilings, I had neither courage enough to make" nor knowledge enough to describe, even though they were often the major depositories of the arts. He did visit the famous Gallery of the Fine Arts, filled with valuable antiques. Despite Winckelmann's eulogies, nonetheless, this American did not think even the celebrated *Niobe* group particularly good. He concluded his account of the various masterpieces simply by listing the "most admired ones."[18]

Boredom with the approved sights and growing interest in neglected aspects of Europe produced a taste receptive to architecture outside Europe previously thought much too strange. This and the concomitant American interest in novel ideas for architecture and interior decoration brought at least an ambiguous, constrained interest in Moorish and Egyptian architecture. The older hostility might be seen in John Ledyard's letters to Jefferson in 1788. He found Alexandria "as remarkable for its base and miserable Architecture as I suppose the place once was for its good and great works of this kind." Cairo was even worse, "a wretched hole, and a nest of vagabonds." By the 1790s, however, magazine writers recounted with pleasure, if not quite yet with full approval, examples of "the Arabian taste" in areas unacquainted with the profusion of "fantastic novelties" brought forth by European industry, luxury, and caprice. Some articles persisted in calling attention to Cairo's dirt and irregularity, to its houses with the external appearance of prisons and interiors of "ill-contrived" rooms. Others asserted that they had "pleasant saloons," terraces that were "charming places," while the city was picturesquely ornamented with many minarets and

trees. Cairo, formerly condemned for its irregularity and non-European appearance, was on the verge of winning approval for those same characteristics. Complete revision of eighteenth-century aesthetic criteria for cities, however, took many years and much effort to be accomplished.[19]

Landscapes, of only minor concern for Grand Tourists, proved to be readily reevaluated by the partisans of the picturesque. As B.H. Bronson has clearly shown, neoclassical landscaping sought "to compose three-dimensional paintings not from devotion to the charms of nature but according to an intellectual conception as classical as the modeling of antique sculpture." Simply by suppressing the latter part of this formula, one easily moved from the old guidebooks' concern for rural felicity to bucolic raptures very near a full-fledged romantic view of nature. Popularity for the raptures to be experienced in England's Lake District had, in fact, soon become commonplace, with a proliferation of new guidebooks to lead the unimaginative.[20]

Looking about for less hackneyed examples of the picturesque, writers found them in all sorts of places. The environs of Dublin, for example, held several cottages nestled by a pleasant brook that embodied simplicity and rural innocence, where one could enjoy "a purer gale than the choked city can afford." The threat of gentlemanly "improvement"—plans to level the cottages and force their inhabitants back into the city—provoked one defender to outrage: "Shame upon thee, unfeeling grandeur! . . . Cottages, my friend! in the present day, are considered as the warts of the landscape."[21]

Those cottages may well have been endangered by plans for a large-scale picturesque garden. Repelled by the "vegetable distortion" of Dutch and French formal

gardens, followers of the picturesque found Blenheim Park the epitome of their desires. Grand Tourists had found it very unimpressive: "It is not laid out in fine lawns and woods, but the trees are scattered thinly over the ground, and every here and there small thickets of shrubs . . . and flowers." But for travelers of the picturesque point of view Blenheim Park appeared quite otherwise. The "sublimity of aged oaks and elms, the beauty of a spreading lake, the swell of hills and lawns, the continual softness of a velvet turf," the "sportiveness" of deer, goats, and horses, and the massive grandeur of Vanbrugh's architecture—all of these came together in "one coup d'oeil."[22]

Creating more Blenheims in England might require displacement of cottages, but the continent held many places, as John Quincy Adams discovered in Silesia, where one could be dazzled by "ornamental forms" and picturesque vistas. The most fruitful area seemed to be Switzerland, formerly perceived largely as a rugged barrier on the Grand Tour between France and Italy. Now it was fast becoming a tourist's playground. Americans were charmed by a country with villages peeping out of every valley, high hills cultivated to their very summits, where "nature seemed to smile on every side" and the Swiss moral rectitude and sturdy democracy gladdened the hearts of the newly independent Americans. As John Rutledge, Jr., put it, "Everything here is gay chearful and happy." Switzerland had "the grandest as well as the most rural scenes of nature," where one might stare at massive mountains and glaciers, enjoy the quiet pleasures of a well-tilled land, or indulge in melancholy reveries at the "enchanting little spot" where Rousseau had lived. "The beauties of Switzerland are so various," in short, with "such an extraordinary com-

bination of the grand and wild features of nature, of the sublime and lovely." The simple, rustic life there far surpassed the attractions of pomp and ceremony in Rome. Within a few years after 1800, a visitor could forego descriptions, since "twenty books of travel" did it for him. The author so audacious as to publish another provoked a reviewer to cry that "no book was ever less wanted." Picturesque terrain as seen in Switzerland had, indeed, taken the Western world by storm.[23]

The nostalgic beauties of Swiss peasant life exemplified the temptations toward idealization that frequently overcame the tourist in the first years of the nineteenth century. When he looked to the Orient, he did not, as did those with Grand Tour biases, focus on the dirt, irregularity, and disparity between luxury and poverty. Instead, he preferred to see, for example, India's Coromandel coast as a green theater backdrop for white sand and a multitude of beautiful seashells. It bordered a tropical paradise: "The whole surrounding country delights the eye with neverfading verdure" and cities "magnificently decorated" with "very curious sculpture." Travelers' accounts displeased reviewers if they expressed lordly disdain for the exotic sights, or if, on the other hand, they had tiresomely "minute descriptions" of things outside Western notions of the appealingly strange. Readers wanted to learn about the East, but they retained preconceptions almost as demanding as those of the Grand Tour.[24]

The emerging partisan of the picturesque concentrated on two emotions: the "sweet melancholy" induced by ruins, and the quiet ecstasy of romantic prospects. The first was succinctly described by an American touring Scotland. Confessing his greater enjoyment of "the irregular heaps of an old ruin, than the most stately

edifice of recent erection," this gentleman found many opportunities to "indulge the train of melancholy reflections" thereby evoked. Europe's multitudinous ruins, from Rome's Baths of Titus to Wales' Pontcycyltty Aqueduct, were duly ranked by such travelers according to their relative power to impress the viewer. Not content with that harvest of sentiment, enterprising and imaginative landowners constructed their own ruins, like the "Helicon" in Hirschberg, which John Quincy Adams felt "discovers an uncommon sensibility for what is truly beautiful, and," with its archaeological correctness, "the highest refinement of taste." Here, the old and new fashions, reverence for classical antiquity and pleasure in ruins, joined together in what Robert Rosenblum has called the Neoclassic Archaeologic.[25]

The fragments of ancient wonders to be found in the Mediterranean area also attracted great interest. Seven articles describing Pompey's Pillar in Egypt appeared in American magazines between 1804 and 1811, affirming, for example, that "nothing can equal the majesty of this monument. . . . On a nearer approach, it produces an astonishment mingled with awe." Ingenious editors dredged up breathless accounts of the Theban ruins, the Pyramids, the Tower of Babel, and ancient Babylon. Popular appetite seemed insatiable in spite of these turgid reprints.[26]

Magazine readers proved equally receptive to enraptured murmurings over wide-sweeping landscape views. Scotland's "gloomy crags, and thick wooded steeps," or Cornwall's rocky shores, "projecting their craggy fronts, in wild irregularity, into the broad bosom of the Atlantic," gave prospects admirably suited to contemporary tastes. Though articles sketched the views from numerous spots, including Mount Olympus and the Alps from

Turin, the Bay of Naples handily dominated the choice of romantic prospects. Not only was the city better built and "more uniformly convenient" than Rome, but also it was surrounded by water, islands, mountains, and all of the other components of a perfect picturesque landscape. With its Roman and Greek ruins at Pompeii and Herculaneum, the Neapolitan region offered "the most interesting classick recollections . . . with the fantastick, the wonderful, and beautiful appearances of nature to excite alternately the most delightful sensations, or plunge the mind into the most pleasing reveries."[27]

The Bay of Naples, in fact, symbolized the transitional stage in the American aesthetic of travel during the first years of the nineteenth century. While striving to develop new areas of interest and new emotions, travel writers still relied heavily on conventionally acceptable tourist attractions. The movement toward a thoroughly romantic travel aesthetic had some distance to go when the observer last quoted could finish his eulogy on the Bay of Naples by complaining of the distracting sight of numerous beggars. When they had become invisible to the writer, or scarcely observed bits of quaintness, only then could it be said that the tourist had completed his repudiation of the Grand Tour.

It has long been recognized as very difficult—some scholars would even say impossible—to date turning points in cultural history. Deciding when romanticism became the prevalent intellectual and emotional stance depends on so many elusive variables as to be a virtually hopeless task. Nonetheless, if we narrow our inquiry to the shift as perceivable in American magazine articles dealing with foreign travel, we may conclude that romanticism effectively supplanted the Grand Tour attitude by 1815. As shown in the table on page 247, this

revised outlook was marked by the sudden emergence of a predominant interest in the Mediterranean area and in Latin America at the same time that a full acceptance of romantic responses characterized the great majority of articles. By 1815 only a few diehard defenders of eighteenth-century ideas remained, and even they had been seriously infected by that which they steadfastly, if ineffectually, opposed.[28]

Articles on the Iberian Peninsula, an area largely ignored or contemned by followers of the Grand Tour but gaining approval by 1809, dramatically illustrated the changed geographical focus of the romantic traveler. John Adams' diary entries logging his journey through Spain in 1779 typified the traditional viewpoint:

> I see nothing but Signs of Poverty and Misery, among the People. A fertile Country, not half cultivated, People ragged and dirty, and the Houses universally nothing but Mire, Smoke, Fleas and Lice. Nothing appears rich but the Churches, nobody fat, but the Clergy. The Roads, the worst without Exception that ever were passed, in a Country where it would be easy to make them very good.

As late as 1806 an Englishwoman's "Sketch of a Journey in Spain" conveyed much the same mood. Harshly criticizing the countryside near Madrid as a "savage and unseemly wilderness," and Valladolid as "one of the most gloomy, desolate, and dirty towns, that can be conceived," this conservative tourist found only the industrious peasants and rural beauties of the Bay of Biscay worthy of commendation. Only they fit her hackneyed requirements for rural felicity. By 1809, however, "A Bostonian" journeying from Cadiz to Seville lauded the latter's Gothic cathedral and even conceded that an ancient Moorish palace might be "very singular" if not

actually handsome. Still, he was not yet able to avoid the old plaint: "The streets [of Seville] form a complete labyrinth." Within a few years a reviewer would casually remark that "of course" an author devoted much attention to the Alhambra, and articles emphasized with a pleasurable shudder "the frightful mountains" and "immense plains" of Castile. The stage had been set for Washington Irving.[29]

Portugal, especially Lisbon, experienced a similar rise in popular esteem. The usual picture, even in 1810, had been one of "nasty streets and dirty houses . . . meretricious dances and obscene songs." By 1813, "B." spoke for many when he concluded, "You cannot conceive a more beautiful sight of the kind, than the city of Lisbon illuminated," and praised the very romantic location of a convent twenty miles away that he had just seen. What had annoyed previous visitors remained in evidence, but now those features were ignored or tolerated, while attention turned to objects and sights with romantic appeal.[30]

The Holy Land and, to a lesser extent, all of the Near East became the most fascinating parts of the Mediterranean after 1810. An occasional earlier article had appeared, typically denigrating Medina or the Aegean Islands as "indeed, intrinsically charming," but so poverty ridden as to have no decent lodgings for tourists. A reviewer in 1811 went far toward accounting for the rise of interest in the eastern Mediterranean:

> Since Switzerland, Italy, and Sicily, the countries which formerly engaged the attention of tourists, have been so frequently visited, and so fully described, the traveller who is ambitious of novelty must direct his steps elsewhere. Greece has accordingly become of late years an object of great attraction. Although it is devoid of that interest arising from

modern works of art, which rendered Italy so inviting, and is inferiour to Switzerland in the stupendous objects of nature, it has, notwithstanding . . . the variety of its natural beauties . . . [and] the vestiges, still apparent, of its ancient grandeur.

Undoubtedly this explained the sudden appearance of articles and reviews of travels on such hitherto offbeat places as Rhodes, the Isle of Cos, and Baghdad.[31]

Most of the articles, however, concerned Palestine and were often either reviews of or extracts from published accounts of Chateaubriand's or Edward D. Clarke's travels. Of the eleven articles (often series) appearing between 1811 and 1815, six arose from Chateaubriand's *Travels in Greece and Palestine*, four from Clarke's *Travels*, leaving only one extract from another source. Therefore, while great interest in the area was not uniquely American, it probably evidenced something more than merely a search for novelty. Chateaubriand made it clear that his concern was not primarily aesthetic. In vain he tried to "court the illusions of fancy" in Greece while encircled by "the sad reality of woe and want." Moving on to Jerusalem, he observed that "the whole city resembles a cemetery in the midst of a desert." What really excited him was "the sight of the places commemorated in the Gospel." Clarke enjoyed the terrain and cities of Palestine, but, again, nonaesthetic considerations predominated in his own mind and, presumably, in those of his readers. As one religious magazine's reviewer phrased it, "One corner of the world is quite enough for us. . . . Even amidst the most splendid monuments of Pagan glory, the *Christian Observer* pants for that 'hill of Zion which he loves.' " Already we can see the close tie between romanticism and a rejuvenated Christian fervor that remained so characteristic of American thought until the Civil War.[32]

The Near East and the Iberian Peninsula by no means exhausted interest in faraway spots. Unlike the lethargy of a John Quincy Adams who lived for years in Russia "almost without passing beyond the bounds of St. Petersburg," enterprising editors sought out stories about Easter Island, Baku, Timbuctu, or the strange beauties of Van Diemen's Land. The preferred tone can be gathered from the American consul's description of the Azores, published in 1812: "All strangers are struck with astonishment at the grandeur and beauty of the views and scenery on this island." He found it "surprising how little is known of these islands," for they impressed him as being "the most magnificently romantic spot" in the world.[33]

A variety of features made up the romantic appeal. It might be the surprisingly civilized appearance of a Hottentot village in southern Africa, the great age of the ancient monuments in India, or the un-European curiosities of the Kremlin. The architectural irregularity of Moscow had now become a positive attraction: "Here a pagoda, there an arcade! In some parts richness, and even elegance; in others barbarity and decay. Taken together," according to a travel report of 1813, Moscow "is a jumble of magnificence and ruin . . . [that] make it, perhaps, the most novel and interesting sight of Europe." The emotional pitch of these accounts also varied widely, descriptions ranging from the quiet beauty of the cottages in Majorca to the breathtakingly dashing adventures of a sailor in the Fiji Islands suggestive of Melville's later *Typee* or *Omoo*.[34]

Romantic tastes for tropical sites of ruined grandeur encouraged the publication of articles on Latin America, an area entirely outside the ken of the Grand Tourist. Americans surely took pleasure in the fact, as stated in

a selection reprinted from the *Edinburgh Review,* that
"in proportion as the prospect becomes more gloomy
in the old world, our attention is naturally excited by
those little known and immense regions, which are
slowly rising into power on the opposite side of the At-
lantick." While the Napoleonic Wars gave cause to seek
less war-torn travel routes, the tourist evinced less in-
terest in geopolitical analysis than in such romantic sights
as a Jamaican grotto. A traveler describing a coffee plan-
tation in Surinam, typically, did not dwell on production
figures or agricultural techniques. Rather, he argued,
"nothing can exceed the beauty of the walls planted with
coffee trees, from their pyramidal shape, and from their
glossy dark green leaves shining with great brightness,
amongst which are hanging the scarlet coloured berries."
The ancient ruins of Mexico, the rustic and picturesque
appearance of Jamaican cottages ensconced in lush, tropi-
cal vegetation, and the bloody history of revolutions in
Haiti— these typified the major attractions for travelers
south of the Rio Grande.[35]

Wherever the romantic tourist ventured he demon-
strated an acceptance or imitation of what may be called
a fully romantic aesthetic. Gothic architecture, maligned
by the Grand Tourist, misunderstood in anachronistic
neoclassical terms by the admirer of the picturesque,
now received appreciation on its own merits. The "an-
cient, dark, and reverend pile" of Litchfield Cathedral
or of York Minster, struck the romantically inclined
visitor, standing "in mute astonishment at the magnifi-
cence around" him. Repeatedly, the impression was
summed up as one of "venerable grandeur." No longer
were castles unavoidably and unpleasantly dark and
gloomy. Warwick Castle, for instance, "presents a ven-
erable and massive pile," a "spacious and superb man-

sion." So impressive, in fact, did Gothic architecture now appear that it threatened to induce a new provincialism among Americans visiting Europe. The Wye River seemed preferable to the Hudson for scenic beauty, one American averred, since the former had those "*gothic* appendages which give to it all the additional and powerful influence over the fancy that belong to 'wizard time and antique story.' " He concluded that "an admixture of the soft with the savage features of the landscape," adorned with Gothic ruins including Tintern Abbey, made the Wye River valley inescapably appealing. Other tourists found equal gratification in Portugal's "fine old gothick castle of Belem," with its "striking and singular . . . mixture of the Arabick and Norman gothick" design, or in the seemingly Elizabethan windows in Pernambuco. Clearly, the dogmas of neoclassicism had been shouldered aside.[36]

Travel writers found it harder to avoid equivocations when studying Moorish architecture. An 1805 article praising the splendidly picturesque grandeur of Constantinople's walls remained for several years an isolated example of wholehearted acceptance. The lingering ambivalence may be observed in a description of a Moorish palace in Portugal as "spacious and richly furnished, though low and without regularity of design," or in another, of the royal seraglio of Morocco—"Nothing is wanting to render this a complete, terrestrial paradise, but liberty, the deprivation of which must embitter every enjoyment." Such reservations had largely disappeared by 1815. By that time the Moorish castle seen as one entered Lisbon was pronounced "a fine looking structure, and with its towers and battlements has quite an imposing appearance." The magical effect of the "light and elegant varieties of Arabian architecture" brought one

reviewer to exclaim, "No sight can more strongly impress on the mind the combination of feudal grandeur, with elegance and good taste, than a Persian nobleman on horseback."[37]

Romantic ideas were not restricted to architecture and landscape. Folk music and dance, occasionally thought quaint or curious but generally ignored by eighteenth-century tourists, gained increasing attention and approval in the first years of the nineteenth century. Often this necessitated the listener's entirely putting away his former notions of what constituted good harmony and rhythm, and that could be too great a task for some to accomplish. Thus, though a traveler of 1805 in Austrian Dalmatia carefully set down his impressions of indigenous dances and music, he found them to be little better than "disagreeable bawling." The dances, on other occasions, outraged conventional moral standards. On the Polynesian island of Tongatabu a large group performed "their complicated evolutions with a promptness and regularity not to be exceeded," but the climax was licentious. Nevertheless, editors kept printing such descriptions, and doctrinaire moralistic objections gradually subsided. By 1815 some writers and their readers refused to boggle at even the most exotic and morally suspect folk dance and music. A Jamaican playing a Koromantee flute, the "inventive but romantic genius" of Spanish operas and fandangos, or the ease and grace of French folk dancing—all won plaudits. In view of the strong American doubts about the good taste of opera and the moral acceptability of most dancing, this marked a significant lowering of barriers against varied aesthetic experiences.[38]

Preconceptions remained, however, and travel writers were forever complaining that anticipated exotica failed to overreach the ordinary. Smyrna, gateway to "the

Spicy East . . . did not answer my expectations." Or, arriving at Gibraltar, "the grand and classical impression . . . somewhat suffered upon entering the town, which at first, in some of its objects, not a little resembled Portsmouth Point." To hear that Nazareth was in the most wretched state of indigence and misery put a strain on Christians' sense of propriety. Equally disheartening for romantics dreaming of tropical paradise was the discovery that the relatively unchanging climate became very tiresome, and that the lush vegetation took on a "sickly and dull" appearance. Probably the prize example of such disappointments came from the melodramatic effort to explore the seraglio, the harem, and the "most secluded haunts of the Turkish sovereign." Gaining entry by means of a devious plot, the curious adventurer found himself confronted, as he had fully expected, "by a wild and confused assemblage of great and interesting objects." But, during a thorough tour, he became increasingly appalled at the tawdriness of it all, with the Dutch-like gardens filled with "very common flowers," and a great hall looking like "an old lumber-room" cluttered with "shabby bureaus of the worst English work" and littered with empty candy boxes. What a fraudulent hoax it all seemed to be! Having fully taken up the ecstatic search for romantic thrills, the one thing the romantic traveler could not tolerate was to find his never-never land filled with commonplace or shabby realities.[39]

There remained throughout the period, of course, a large number of articles on foreign places written mainly to give factual information. These often resembled encyclopaedia entries in scope and style of presentation. The great bulk of such articles by 1812 concentrated on Canada, previously rarely mentioned in American maga-

zines, but now terribly important as the major scene of
the early battles of the War of 1812. Even with such im-
mediate, military motives, aesthetic appraisal of public
buildings, city plans, and picturesque landscapes domi-
nated the discussions of Canadian cities and countryside.
Thus, the editor of *Olio* reprinted the description of
Upper Canada from Jedidiah Morse's *Geography* with
the explanation, "At this interesting crisis, when our
brave soldiers have taken possession of the capital, . . .
some account of the territory they are expected to con-
quer will not be unacceptable to our readers." Yet the
account did not appraise the economic and military
aspects of the province as much as it gave thumbnail
sketches of the various cities, Quebec having houses "al-
most universally of stone, small, ugly and inconvenient."
Americans had become thoroughly accustomed to travel
stories focused on aesthetic concerns. The description of
Halifax's barracks was characteristic: "Large and com-
modious, [they] are placed in an airy situation where
elegance and convenience are united, in an eminent de-
gree, with cleanliness and health." Fascination with loca-
tion and design had completely crowded out any com-
ment on the military considerations of defensibility or
strategic value.[40]

A few diehard defenders of the Grand Tour attitude
persisted to 1815, but not without unconscious acceptance
of many elements of the newer, romantic outlook. "A
Bostonian" might still quarrel with the morality of a
female nude statue in a church, but he found Venice
handsomely laid out and "beautifully improved."
"Emily" responded, in 1815, to the beauties of Versailles
largely in an outmoded, Grand Tour way; she also
lovingly described a romantic Parisian garden with a
grotto and shaded bowers "entwined with woodbine and

passion flowers." Only very rarely did articles appear that showed no evidence of the writer's having been infected with romantic notions.[41]

In conclusion, we see that the aesthetics of travel underwent a revolution between 1783 and 1815. From a time when tourists obediently followed the unimaginative, time-worn paths set by Grand Tour guidebooks, taste had moved through a transitional period of infatuation for the picturesque, to a full acceptance of romantic passion for exotic places, novel ways of life, and a concomitant dislike for the ordinary and the conventional. Obviously, the patterns so strongly crystalized during the eighteenth century did not completely disappear. Informational, distinctly unromantic descriptions of politically, economically, or militarily important places continued to be published. Certain key elements of the Grand Tour attitude, especially the demand for urban regularity, would not down. Thus, the traveler in Jamaica who swooned over "the scenes of Arcadia" that he discovered there still felt that Kingston's streets were "unfortunately so irregular as to destroy their beauty." While these persistent biases indicated a certain continuity in the travel aesthetic throughout the period, what changed strikes the latter-day observer far more forcefully than what remained the same. Indeed, regardless of which manifestation of aesthetic judgment one may care to follow through the first thirty-two years of American national independence, the impression of drastic change prevails.[42]

10. Conclusion

————◆———

hat, then, have we learned from this analysis of early American aesthetic opinion as a case study of cultural nationalism? Without parallel case studies from other nations—both similar ones, such as Australia, and distinctly different ones, such as Italy and Brazil—it would be foolhardy to attempt any definitive generalizations about the role of taste in nationalistic movements. Yet it might be a suggestive and interesting way of summarizing the argument of this book to try and formulate some working hypotheses for further study of cultural nationalism. The hypotheses would be more persuasive if they were initially tested against other American materials. Consequently, after offering my tentative generalizations, I will glance at the history of literature and of literary tastes in the first generation of American national existence to see if these generalizations cast new light on those already thoroughly studied subjects.

The actual desire or consciously felt need for aesthetic nationalism, at least in English-speaking new nations, has commonly been provoked by a growing sense of the desirably different appearance of the new land experienced by their residents. Colonials failed to recognize the differentness; provincials saw it but took it as evidence of the inferiority of the new areas as compared with the old homeland. In some new nations this stimulus to cul-

tural nationalism came with a new means of communication, such as the transcontinental railroad in Canada. It could appear intermittently over a long period, again as was the case in Canada as well as in New Zealand, before it effectively spurred a full-fledged nationalistic fervor. Or, on the other hand, it might follow the pattern in Australia and appear very rapidly. In America, nationalistic pride in landscape accompanied a strong rural distrust of both cities and primeval wilderness, but there seems to be little reason to predict such a connection in other countries.[1]

Efforts to verbalize that nationalistic pride led to a search for a new vocabulary to express new aesthetic values. Where does the aesthetic nationalist find his new critical vocabulary? He begins, if he is to have any chance of success, by recognizing that the purely eclectic route is just as fruitless as efforts to dream up entirely new terms. By the time a country has existed long enough to pass from a clutch of raw settlements to a nation it has surely developed some traditions, no matter how neglected or despised they may have been during its colonial period. The successful aesthetic nationalist searches them out, polishing and reshaping their indigenous elements while deemphasizing those most derivative of the mother country. In the United States, the pervasive moralism, the inclinations toward social and political democracy, and the primacy of the middle class had long been recognized as unfortunate variants from the British norm. Their aesthetic ramifications—vernacular realism, easily intelligible symbolism, utilitarian functionalism, and an overriding genteel moralism—were not invented by the new nation's cultural leaders. Rather, they only reversed the emotional valence, praising what had been spurned because of the provincial

inferiority complex. Similarly, at the heart of Australian nationalism was "the assumption that the vulgar could think—and like it," in spite of (or perhaps even because of) the violence that attitude did to formerly prevailing Victorian assumptions.[2]

A crucial difficulty is faced in a new nation's search for a national taste. It must have resident professional artists to create an art conveying the new values; yet those artists are dependent upon a favorable patronage pattern which, in turn, can scarcely be expected to appear before the artists are there. The leadership of the mother country in matters of aesthetics prevents the development of an autonomous art life during the colonial period. Within a short time thereafter, however, it must appear if the aesthetic nationalists are not to lapse into frustrated, embittered theorizing. The United States, Australia, and some other new nations have had the good fortune of producing generous, sophisticated patrons and the first generation of nationalistic artists just at the time when national needs called for them. It was sheer good luck, for example, that Thomas Jefferson as president was eager to build the Capitol just when Benjamin Latrobe desired to show what a professional architect could do for his country. The patchy, faltering history of the arts in New Zealand illustrates what can happen in the absence of such good fortune.

After having begun to formulate a new aesthetic vocabulary and to gain a tolerable number of professional artists supported by adequate patronage, aesthetic nationalists may still face a number of challenging problems. In the effort to banish lingering provincialism there is the constant danger of falling into a barren and self-defeating xenophobia. The history of the first American art institutions serves as an excellent example. The

quarrel between the provincials and the chauvinists destroyed the Columbianum. The American Academy under the Livingstons' aegis retreated, in effect, into an anachronistic and arid provincialism. Finally, with the Pennsylvania Academy, the partisans of an American art hit upon a formula that neither repudiated nor cowered before European traditions. The example of the Pennsylvania Academy led, soon after 1815, to a reinvigorated American Academy, demonstrating Lillian Miller's observation that competition for prestige among localities significantly aided the national cultural interest.[3]

Redefining the new nation's relationship with tradition in order to provide for a national culture nourished by historical roots is only one aspect of a broader problem—how to counter the great attractions of the established cultural centers without completely cutting the new nation off from useful foreign examples and resources. The first generation of American aesthetic nationalists found two strategies particularly useful. Americans stressed the nationalistic implications of European customs, as in clothing, or the history of painting, to argue that they sanctioned American independence in such fields. Alternatively, ancient European forms, as in music, were used invidiously against contemporary attractions. The latter strategy could have the unfortunate result, as we have seen in sculpture, of merely replacing one foreign tyranny with another. Later national movements had the advantage of being able to select a more distant cultural center to restrain the magnetism of culturally or physically closer ones. Thus, Canadians stressed British models to check American influences, while Australians did just the opposite.[4]

The best defense against foreign cultural attractions, of course, is to build a sturdy domestic consensus. In fact,

this turns out to be the central task of aesthetic nationalists. The consensus may be achieved, as neoclassical purists in sculpture clearly proved, at the disastrous cost of making whole art forms little more than insignificant exotics. Alternatively, American opinion pertaining to music, dancing, and instrumentally functional architecture exemplify the successful efforts of aesthetic nationalists.

Success or failure in gaining a national consensus—in itself a strong indication of a national taste—greatly depends on how the aesthetic nationalists have dealt with indigenous precedents. William Rush's wood sculpture suggested a virile American tradition, if contemporary commentators had only had the wit and courage to claim it. As for architecture, one could either castigate American predilections, following the example of Jefferson's denunciation of the buildings at Williamsburg as "rude misshapen piles," or the aesthetic nationalists could go along with Latrobe's willingness to capitalize on his clients' demands for comfort and convenience. In painting, unyielding insistence that Americans follow the European hierarchy of genres would have blocked the emergence of an American style, whereas acceptance of the vernacular soon contributed to the rise of the Hudson River School. In some media, such as music and dancing, aesthetic nationalists rejected certain local traditions (notably the fuguing tune) and reinforced others (folk dancing) to gain a new and viable synthesis.

The decision to foster or suppress indigenous precedents commonly involves the question of how extensively and in what particulars the conventional list of acceptable art media and forms will be revised. If no changes are made, the result is likely to be that of the fate of sculpture in nineteenth-century America. Since

the older cultural centers generally rate artistic endeavors according to their own values and achievements, new nations will unquestioningly accept that heirarchy only at their grave peril. Hence, American critics showed sound instincts when they asserted their preference for a good miniature over a poor history painting. Americans had little hope of outdoing European masters on their own terms. The cause of nationalism would be enhanced, however, if American artists were encouraged to follow their own inclinations in spite of, or even because of, the opinion of Europeans that the results were trivial or frivolous.

Aesthetic nationalists can not avoid working in a national and international context that may either handicap or reinforce their efforts. Americans at the end of the eighteenth century found a milieu quite favorable to a search for a national taste. The hegemony of neoclassicism in Europe was rapidly falling before the onslaughts of a moralistic and incipiently nationalistic romanticism. The European cultural scene was fluid enough, as we have seen in Chapter 9, to give Americans an excellent opportunity to pick out their own way. Furthermore, to the extent that romanticism substantially replaced neoclassicism, Americans found the new *Zeitgeist* congenial to their search for cultural independence. In place of neoclassical dogmatism about ideal nature, what could be better than the romantic quest, pointed out by René Wellek, for "the reconciliation of art and nature, language and reality"? That notion fit precisely what American critics by 1815 had already specified as a primary goal of art in the United States.[5]

Although contemporary commentators feared that the lack of numerous examples of great works of art in America would gravely retard the achievement of an

elevated American taste, in retrospect it seems clear that the opposite was true. Native artists found themselves free to search out new themes and new forms, not held back by the dearth of museums and private collections. The well-intentioned importation of casts of classic sculpture had a deadening influence on that art in America for decades. We can be thankful that American architecture and painting did not have to overcome such a barrier.

New nations often have difficulty sloughing off provincial doubts of the value or moral acceptability of art. We have seen how American aesthetic nationalists were repeatedly challenged by moralistic doubters who cited religious duties, or, like John Adams, expressed ideological fears. The creative artist in a newly independent country frequently feels he is "out of tune with the world." In a milieu unused to the patterns of artistic life he is forced to face down conventional doubts about his life style. As one twentieth-century New Zealand writer has complained:

> Where almost everybody goes off at fixed hours to employment in the city, or remains close to his farm work in the fields, the man who sits at home over his typewriter for three hours after breakfast, and thereafter is to be seen in the streets, the bookshops or the libraries or - ultimate laziness! - sunning himself in the parks, is clearly an outcast, an unstable person of doubtful moral outlook who should be sent about his business if he dares to seek a small loan until the next cheque arrives, who should hunt himself a job, even if it be with pick and shovel, and remove the blot of idleness from an honest bourgeois family.

Another New Zealander explained this obloquy as showing a "dominant characteristic" of his country's culture, "a kind of debilitated Puritanism, divorced from its

initial religious energy and watered down into forms of disapproval of, or indifference to, artistic activity, and a determined worship of the practical man and the success-ful money-maker." Without denying the influence of an austere Protestantism on the thought of Americans or New Zealanders, we may safely guess that artists in Catholic, Buddhist, or Moslem countries will find com-parable suspicions confronting them. The eagerness of newly independent peoples to develop their respective countries, along with the lack of familiarity of the way artists work (since in the colonial era artistic hopefuls went "home" to London, Paris, or Cairo), will suggest to many that artists are only social parasites.[6]

The lingering influence of provincial attitudes may also be seen in another limiting condition facing aesthetic nationalists—the reluctance of their compatriots to make the changes in aesthetic vocabulary and in the preferred hierarchy among the arts and styles so necessary to the growth of an independent taste. Anyone who glances through histories of the arts in new nations will soon discover that the lack of museums is a standard lament. That in itself reflects a provincial assumption. Since the former mother country has museums, the implicit argu-ment goes, *ipso facto* we must also have ours. The danger that this may firmly batten down a continuing provincial taste is poignantly exemplified in the Toronto *Mail*'s proud announcement in March 1880 of the opening of the Canadian Academy of Arts:

> Tonight the first exhibition of the Canadian Academy of Arts was opened by His Excellency the Governor-General in presence of a brilliant company. No more auspicious circumstances could have surrounded the initial public effort of the institution. Its patron is the Queen's representative. Among its warm supporters is H.R.H. the Princess Louise,

from whom a welcome message was received tonight. . . . The Academy has, moreover, been honoured by receiving an intimation from the Queen, through His Excellency, that Her Majesty will be a purchaser from the walls of the Exhibition. . . . His Excellency, Her Royal Highness and suite, sent a most interesting collection. . . . The task of nominating the first Academicians devolved upon His Excellency as patron.

With such an "auspicious" beginning of Canada's official art institution it should not surprise us to learn that it took another thirty to forty years for Canadian painting to find a recognizably national style.[7]

Even if aesthetic nationalists successfully avoid similar cul-de-sacs, their task of weaning their new countries away from provincial critical habits is an immensely challenging one. Colonists necessarily follow many of the tastes customary in the mother country, just as their legal systems, business practices, and moral codes derive from the homeland. This may be less true, for example, in the newly independent African states, where European traditions are rejected in favor of African ones. But for those many nations founded by and largely populated from Great Britain, France, or Spain, the nationalists have no strikingly different alternative culture to replace their European heritage. For Americans to adopt Indian ways or Brazilians to model themselves after Amazon headhunters was out of the question. Therefore, the aesthetic nationalists had to reinterpret traditional ideas rather than simply cast them aside. To appreciate how subtle an enterprise that could be, one should read Nikolaus Pevsner's charmingly discursive *The Englishness of English Art* (1955), and compare English notions of common sense, or English preferences for artistic linearity and utilitarianism, with the

American opinions discussed in this book. Little wonder that American aesthetic nationalists occasionally failed to adjust their countrymen's tastes.[8]

Certainly the most well-known failure of the first generation of American aesthetic nationalists was in the field of literature. Prior to the 1820s the call for an American taste brought forth neither notable indigenous writers nor a popular demand for them. Most literary historians have felt it necessary to attempt an explanation of the tardiness of effective literary nationalism. The social setting has been faulted by pointing to the repressive effects of our early copyright laws and the small size of our population. The pioneer fiction has been invoked, at times by citing some contemporary appraisal. Thus, David Humphreys wrote Jefferson in late 1788 that "as much attention is paid to the cultivation of literature as can be expected in a country that is so young and whose inhabitants are obliged to apply themselves to some profession for a maintenance." Whatever their explanation for the delayed appearance of an American literature, every literary history that I have come across placidly assumes that literature was either the vanguard in American artistic development or, at the very least, typical of the state of the arts in the new nation. Since we now should realize that literature could be matched for backwardness only by sculpture, perhaps we can test the generalizations made in this chapter by venturing a more persuasive interpretation of the literary scene in the new republic.[9]

Looking through the detailed studies of literature and literary criticism contained in American periodicals of the period, we soon find that, quite unlike most other manifestations of American taste, reading habits were extraordinarily slow in moving beyond colonial attitudes.

Though the periodization varies somewhat from one monograph to another, the authors would probably agree that colonialism in literary tastes remained the American norm until about 1800. As H.L. Flewelling has put it, "Most of the American writers themselves wrote in the English manner of a generation or more earlier." Critical opinions were formed, to borrow William Free's descriptions of the *Columbian Magazine*, "on the corpse of neoclassicism embalmed by Scotch common sense realism." With the founding of the *Port Folio* (1801), *Literary Magazine* (1803), *Monthly Anthology*, and *Literary Miscellany* (1805), "editors kept themselves in much closer touch with contemporary British writings." This literary provincialism continued for nearly two decades. Only with the publication of Irving's books and Cooper's early novels in the 1820s, and their enthusiastic reception in the United States, may we say that America was truly ripe for literary nationalism. That was at least a generation later than the appearance of professional artists and receptive audiences for painting, architecture, or music. American literary tastes, in short, could not possibly have become nationalistic in the 1790s, since they had not even moved beyond colonialism at that time.[10]

Even if proudly American authors had appeared before the 1820s they would have found an overwhelmingly hostile reception from the critics. Though periodical editors occasionally voiced hopes for new stars in the American literary firmament, they continued to assume that the new stars would and should be the same in style and form as those in England. Consequently, "English forms and content were tortured into confessing American ideals; American content was forced into English forms and made to express the universal ideas of

neoclassicism." American literary criticism doggedly turned its face away from any significant change in values or vocabulary, raising to a first principle the dictum: "Literature Must Not Condone Rebellion Of Any Kind Against The Existing Social And Economic Order." The aesthetic implications of such a position may be seen in the persistent critique of the novel as a literary form with a related prose style since the novel was thought to be subversive of the social order. Latrobe lamented *"the avidity with which English Novels are Sought after and read,"* on moralistic and ideological grounds rather than notably nationalistic ones:

> They settle every etiquette of visits, balls, & tea parties, give the true tone & manner to small talk & gossipping, point out to our young coquettes the most modish airs to our fops, the fashionable swing of folly, and establish the whole phraseology of that *talk* which is So conducive to the exercise and health of our lungs, which takes up So much of the business of our lives, & which has so very little meaning.

Jefferson bluntly denied his youthful acceptance of a variety of fictional forms and argued that the result of novel reading "is a bloated imagination, sickly judgment, and disgust towards all the real businesses of life." If such humane, enlightened, and sophisticated men as Jefferson and Latrobe thought in these terms it should occasion small wonder that the hopeful American author, like Charles Brockden Brown, felt insecure in the United States.[11]

Nor were leading Americans at all sure that even in such accepted forms as letters and public address should any major stylistic changes be tolerated. The magazines relied heavily on "standards of correctness and elegance based on the authoritarian grammar and rhetoric of late-

eighteenth-century England." Judging from contemporary correspondence we may assume that informed public opinion unsteadily vacillated somewhere between, on the one extreme, the repressive pole to be seen in John Adams' proposal for an American academy "for refining, correcting, improving, and ascertaining the English language," and, at the other, Jefferson's preference for "*Neology*" and disgust for "*Purism*" in language. Neither of these men, however, consistently held to those positions. As usual in Adams' works, his dogmatic theory often varied appreciably from his own expressed tastes. Thus, the academy suggested very pompous oratorical preferences, but, in fact, he favored what might be called a vernacular plain style. "Flashes of wit, curruscations of imagination, and gay pictures, what are they?" he asked William Wirt. "Strict truth, rapid reason, and pure integrity are the only essential ingredients in sound oratory." Jefferson so frequently praised classic models of "fine composition" that we must question how literally we should take his stated willingness to accept usage as the basis for the rules of language.[12]

The lingering power of literary provincialism may also be seen in the feeble and ambiguous efforts made to aid American authors. Aesthetic nationalists who had demonstrated zeal and ingenuity to gain commissions and recognition for a Latrobe or a Peale were utterly unable to create a worthy place for a Freneau, a Dwight, or a Barlow, while they seemed scarcely aware of the existence of a Brown or a Brackenridge. John Adams spent a day in April 1786 visiting London booksellers searching for a publisher for Dwight's *Conquest of Canaan* and Barlow's *Vision of Columbus*. Hearing that they could expect only a "cold reception," Adams pursued the matter no further than to inform the authors

of his findings. Jefferson's dubious commission for Barlow to write a Jeffersonian history of the new nation has already been mentioned. Freneau did receive a minor sinecure while Jefferson was secretary of state, but "the clerkship for foreign languages in my office" could scarcely impress Freneau as magnanimous support.[13]

Perhaps the best evidence of the aesthetic nationalists' inability to cope with the great weight of literary tradition would be the remarkable paucity of the references to literary subjects in their private papers. Peale exerted himself to enhance the quality of taste in America in a wide variety of ways, but his voluminous diaries and correspondence contain very few comments on literature. There is nothing in Jefferson's papers pertaining to the arts of language at all approaching the great quantity of material on architecture, sculpture, painting, or even the crafts. He devoted more letters to his (ultimately unsuccessful) effort to purchase a new kind of teapot in London than to the professional fate of Joel Barlow. Much the same may be said of the papers of Latrobe, Robert Livingston, and John Adams.

These men were fully aware of a vast spectrum of literary examples that might have been used to emancipate the United States from a continued bondage to current and recently past trends in London. One might emphasize the ancients—every educated man in eighteenth-century America had read Homer, Virgil, Tacitus, Thucydides, and Cicero. Alternatively, there were the classics in English, including Shakespeare and Milton. Aesthetic nationalists had the option of reclaiming an indigenous literary tradition, reaching back to William Bradford, unmatched in richness and scope by any other art form in America. If none of these did the trick, a number of continental European writers—Rousseau,

Madame de Staël, and Chateaubriand to name only three authors well known in the United States—could be turned against contemporary English tastes. That this strategy, used so successfully in painting and music, was not applied to literature before 1815 strongly suggests that Americans in the first generation of national independence were still so fully under the sway of literary provincialism that they were not yet seriously looking for ways to gain a national literature. It would therefore be pointless to demonstrate in detail that proponents of an American taste had no meaningful chance of gaining a national literature until much later.[14]

Indeed, most American literary historians date the achievement of a distinctively national literature somewhere between 1823, when Cooper published *The Pioneers*, the first of his Leatherstocking Tales, and the 1850s, the highpoint of the "American renaissance" that saw the publication of Hawthorne's *The Scarlet Letter* (1850), Melville's *Moby Dick* (1851), and Whitman's *Leaves of Grass* (1855). Few would quarrel with the editors of *The Literary History of the United States*, who gave to the section on Emerson, Thoreau, Hawthorne, Melville, and Whitman the title "Literary Fulfillment," with the justification that "American literature here for the first time sloughed off provincialism."[15]

One finds, to be sure, bits and pieces of the theories and critical canon developed by the aesthetic nationalists reflected in contemporary literature. The prevalent sentimental tales portrayed women as sweet, delicate, and unworldly, an image consistent with the antifeminist bias seen in discussions of clothing fashions. Critics and connoisseurs of literature were looked upon with the same distrust or scorn as those of other media. Complaints of the adverse effect on literature of commercial-

ism and the lack of patrons reflected the concerns of partisans of American music. But the point should not be missed that these were only disjointed fragments of a full-scale campaign for aesthetic nationalism. Sue Greene's conclusion about the literary critics writing in the *Monthly Anthology* applied to most literary opinion in America before the 1820s: "The Anthologists did not voice any ideas about the nature of literature that had not been stated before by eighteenth-century British critics. On the contrary, they played out parts that had already been created." Hence, a nationalistic American literary taste awaited the replacement in England of neoclassical by romantic criteria, a process that took far longer to complete in literature than in most other art forms.[16]

Contrary to the impression given by most historians, the successful campaign for an American taste occurred in the first generation of national existence rather than the second, belatedly completed by literature rather than initiated by it. By 1815 the ground had already been well prepared for an American art. The time is long overdue for the aesthetic nationalists to receive scholarly recognition of their work.

✍§ Notes

*Full titles of all periodicals
with the abbreviations used
in the notes may
be found in the Bibliography.*

PREFACE

1. See, for example, Seymour Martin Lipset, *The First New Nation: The United States in Historical and Comparative Perspective*, and Louis B. Hartz, ed., *The Founding of New Societies*.

2. Russel Ward, "The Social Fabric," in A.L. McLeod, ed., *The Pattern of Australian Culture*, p. 20; "Introduction," ibid., p. 1.

3. A.L. McLeod, ed., *The Commonwealth Pen: An Introduction to the Literature of the British Commonwealth*, "Introduction," p. 8.

4. A rare exception is the first-rate work of Bernard Smith on Australia, especially his *Place, Taste and Tradition: A Study of Australian Art Since 1788*.

5. Notably, Walter Jackson Bate, *From Classic to Romantic: Premises of Taste in Eighteenth-Century England*, and Robert Rosenblum, *Transformations in Late Eighteenth Century Art*.

6. See, for example, Frederick B. Artz' chapter, "Neo-Classicism and Romanticism, 1750–1830," in his *From the Renaissance to Romanticism: Trends in Style, Literature, and Music, 1300–1830*.

7. Russel B. Nye, *The Cultural Life of the New Nation: 1776–1830*, pp. 277–278.
8. Louis B. Wright et al., *The Arts in America: The Colonial Period*, p. 3.
9. Barbara Novak O'Doherty, "The American 19th Century, Part I: New Found Land," p. 31.
10. For a fuller statement of this interpretation, see J. Meredith Neil, "American Indifference to Art: An Anachronistic Myth."
11. Lyman H. Butterfield, ed., *Diary and Autobiography of John Adams*, vol. 3, pp. 185–186.

CHAPTER 1

1. See, for example, Eleanor D. Berman, *Thomas Jefferson among the Arts: An Essay in Early American Esthetics*, especially pp. 255–256.
2. John Steegman, *The Rule of Taste from George I to George IV*, pp. xi–xvii, 16–17, 105–106; Rémy G. Saisselin, "Some Remarks on French Eighteenth-Century Writings on the Arts"; Tony Evans, "Equalitarianism in the American Periodical Press, 1776–1801"; Lillian B. Miller, *Patrons and Patriotism: The Encouragement of the Fine Arts in the United States, 1790–1860*, pp. 221–224; Ruth M. Elson, *Guardians of Tradition: American Schoolbooks of the Nineteenth Century*, pp. 222–242.
3. See, for example, René Wellek, *A History of Modern Criticism: 1750–1950*, vol. 1, pp. 18–27; *Phila. Repert.*, February 16, 1811, pp. 331–332; "Thoughts of a Hermit —On Simplicity in Ornament," *Port Folio*, July 15, 1815, pp. 82–91.
4. *Am. Gleanor*, July 4, 1807, pp. 181–182; "Beauty, and Venus de Medici," *Lady's Wkly.*, February 4, 1809, pp. 234–235; "The Standard of Beauty," *Lit. Mag.*, September 1805, p. 228; Jefferson to Horatio G. Spafford,

May 14, 1809, in Andrew A. Lipscomb and Albert E. Bergh, eds., *The Writings of Thomas Jefferson*, vol. 12, pp. 280–281.

5. "The Collection: No. 1," *Mass. Mag.*, January 1789, p. 53.

6. "An Essay on Beauty," *Boston Mag.*, July, August, September 1784, pp. 363–366, 429–432, 463–466 (the second and third parts were reprinted as being "From the New Encyclopaedia Britannica," in *Christ. Schol. Mag.*, June–July, August–September 1790, pp. 227–230, 347–351); "on the Difference between Grace and Beauty: An Allegory," *Royal Am. Mag.*, February 1775, pp. 43–45.

7. John Kouwenhoven, *Made in America: The Arts in Modern American Civilization*; Nikolaus Pevsner, *The Englishness of English Art*, pp. 28–29; Leonard W. Labaree and Whitfield J. Bell, Jr., eds., *The Papers of Benjamin Franklin*, vol. 6, p. 328; Philocles, "Of the Refinements of Taste and Elegance," *Univ. Asylum*, November 1792, pp. 304–306; "The Ladies' Toilette, or, Encyclopaedia of Beauty," *Lady's Wkly.*, December 10, 17, 1808, January 1809, pp. 102–104, 116–119, 183–186; Charles R. Metzger, *Emerson and Greenough: Transcendental Pioneers of an American Esthetic*; Voltaire, "Beauty, Beautiful," *Boston Mag.*, February 1785, p. 40. The most accessible collection of Greenough's writings is his *Form and Function: Remarks on Art, Design, and Architecture*, edited by Harold A. Small; see especially pp. 69–86.

8. Lester J. Cappon, ed., *The Adams-Jefferson Letters*, vol. 2, pp. 560–562; Julian P. Boyd, ed., *The Papers of Thomas Jefferson*, vol. 7, p. 126; Dr. Blair, "On Beauty," *Gent. Mag.*, February 1789, p. 39; Edmund Burke, "On the Sublime and Beautiful; Vastness; Infinity," *Lit. Tab.* 2 (1804): 18; "Distinctions between the Beautiful and the Picturesque," *Lit. Mag.*, June 1806, pp. 439–440.

For contemporary British and European thinkers, see Samuel H. Monk, *The Sublime: A Study of Critical Thinkers in 18th-Century England*; Christopher Hussey, *The Picturesque: Studies in a Point of View*; and Walter J. Hipple, Jr., *The Beautiful, the Sublime, and the Picturesque in Eighteenth-Century British Aesthetic Theory*.

9. Theodore Sizer, ed., *The Autobiography of Colonel John Trumbull, Patriot-Artist, 1756–1843*, p. 236n1; Charles Coleman Sellers, *Charles Willson Peale*, pp. 100–101.

10. "Memoirs of Edmund Burke, Esq.," *Tablet*, May 26, 1795, pp. 6–7; *Port Folio*, September 1813, pp. 255–278.

11. *N.H. Gaz.*, May 18, 1786, pp. 107–108; *Mo. Reg.* 3 (1807): 230–243, 307–320; William Wizard, "On Style," *Salmagundi*, April 18, 1807, pp. 152–159. For a modern appraisal, see Hipple, *Eighteenth–Century British Aesthetic Theory*, pp. 122–132.

12. *Halcyon*, March 1812, pp. 137–139; *Gen. Repos.*, January 1813, pp. 189–222; "Thoughts of a Hermit—On Beauty," *Port Folio*, February, March 1815, pp. 149, 227; William Charvat, *The Origins of American Critical Thought, 1810–1835*, pp. 30, 48–51. Very useful on this subject is Terence Martin, *The Instructed Vision: Scottish Common Sense Philosophy and the Origins of American Fiction*.

13. Lipscomb and Bergh, *Writings of Jefferson*, vol. 14, p. 140; *Christ. Obs.*, February 1812, pp. 91–105.

14. "On Beauty," *Gent. Mag.*, May 1789, pp. 166–167; October 1740 entry in *Poor Richard*, reprinted in Labaree and Bell, *Papers of Franklin*, vol. 2, p. 252.

15. "Observations on Physiognomy and Beauty from the *Fool of Quality*, Vol. II, Written by Mr. Brooks," *Royal Am. Mag.*, May 1774, pp. 179–182; Miss I., "Thoughts on Female Beauty, Addressed to the Ladies," *Phila. Min.*, September 9, 1797; "on True Beauty," *Columbian Mag.*,

February 1790, pp. 87–89; "Personal Beauty Produced by Moral Sentiment," *Univ. Asylum*, May 1792, pp. 311–313; "Wit and Beauty: An Allegory," *Am. Museum*, October 1790, pp. 160–162; February 24, 1819, diary entry, printed in Samuel Wilson, Jr., ed., *Impressions Respecting New Orleans by Benjamin Henry Boneval Latrobe: Diary and Sketches, 1818–1820*, pp. 53, 54.

16. Charles Francis Adams, ed., *Familiar Letters of John Adams and his Wife Abigail Adams, during the Revolution*, with a Memoir of Mrs. Adams, pp. 339–340, 218–219; Jefferson to Anne Willing Bingham, May 11, 1788, in Boyd, *Papers of Jefferson*, vol. 13, pp. 151–152; Jefferson to his daughter Martha, November 28, 1783, ibid., vol. 6, p. 360. Valuable background material may be found in Evans, "Equalitarianism," pp. 57–74.

17. Sterne, "Beauty," *Phila. Min.*, May 13, 1797; Spirit of '76, in *Casket*, February 22, 1812, pp. 137–138; "On Beauty," *Am. Museum*, September 1790, pp. 128–129.

18. "Reflections on Female Beauty," *Boston Wkly.*, August 25, 1804, p. 173; Knox, "The Want of Personal Beauty, a Frequent Cause of Virtue and Happiness," *Observer*, July 30, 1809, pp. 183–185; W., "An Eulogy on Ugliness," *Am. Mag. of W.* 1 (1809): 26–27.

19. S., "The Lucubrator, No. 7—Beauty," *Repos.*, October 29, 1803, pp. 347–348; "Letters Addressed to Young Women (Married or Single) by Mrs. Griffith; Letter VII: On Oeconomy—Domestic Amusements, Music, etc.," *N.Y. Wkly.*, August 19, 1795, pp. 60–61; "Female Beauty," *Int. Regale*, January 21, 1815, pp. 148–149; "Taste," *Juv. Portfolio*, April 3, 1813, p. 99.

20. Jefferson to James Madison, September 20, 1785, in Boyd, *Papers of Jefferson*, vol. 8, pp. 534–535.

21. "Sensibility," *Mo. Anthol.*, March 1804, pp. 227–228; "Imagination," *Lit. Tab.*, February 4, 1807, p. 27; "The

Man of Taste," *N.E. Mag.*, August 1758, p. 28; "General Reflections on Taste," *Am. Museum*, June 1792, pp. 283–285.

22. "Criticism," *Something*, January 20, 1810, p. 145; "On Fancy," *Mo. Reg.* 2 (1807): 311–318. A convenient summary of neoclassical ideas about nature may be found in Bate, *From Classic to Romantic*, pp. 59–92.

23. "The Gentleman at Large: No. IV," *Col. Phenix*, July 1800, pp. 402–404; "On the Standard of Taste," *Lit. Mag.*, October 1806, pp. 291–295.

24. *Gen. Repos.*, January 13, 1813, p. 211; extract from Goldsmith, writing on taste and art, in *Port Folio*, June 1, 8, 1805, pp. 165–166, 171–173; diary entry for April 8, 1819, in Wilson, *Impressions Respecting New Orleans*, pp. 121–122.

25. T., in *Lit. Mag.*, February 1807, pp. 143–144; "Taste: An Old Dialogue with a New Varnish, to Suit the Present Fashionable Style," *Polyanthos*, May 1807, pp. 111–113.

26. Egbert, "Rover—No. III: Letter to Mr. Candid," *Casket*, April 4, 1812, pp. 207–208; "The Remarker, No. 7," *Mo. Anthol.*, March 1806, pp. 124–127.

27. "On the Standard of Taste," *Lit. Mag.*, October 1806, pp. 291–295.

28. "On Genius *and* Taste—from Reynolds' Academical Discoveries," *Boston Mag.*, March 1784, pp. 169–171; "Truth and Taste," *Columbian Mag.*, October 1787, p. 682; "Fashion and Taste," *Lit. Mag.*, July 1805, pp. 6–7; X., "The Pleasures of Taste," *Toilet*, February 1814, pp. 34–36.

29. "Beauty," *N.Y. Wkly.*, June 29, 1796, p. 412; "Artificial Taste," *Lit. Mag.*, October 1806, pp. 267–268; G., "On Taste," *Companion*, February 16, 1805, pp. 121–122. For common uses of the word *genius*, see, for example, the 1771 newspaper article praising Mrs. Wright's waxworks,

quoted in William Kelby, ed., *Notes on American Artists, 1754–1820,* pp. 9–10; and Francis Hopkinson to Jefferson, January 4, 1784, in Boyd, *Papers of Jefferson,* vol. 6, p. 445.

30. Manuscript, unpaged, in the Charles Willson Peale Papers, American Philosophical Society (hereafter cited as Peale Papers); "On the Legitimate and Fashionable Uses of the Word Style," *Repos.* October 22, 1803, pp. 340–341; "Admirable Works of Some Artists," *Omnium,* February 1810, pp. 122–124. See also, Thomas J. Tracy, "The American Attitude toward American Literature during the Years 1800–1812," pp. 58–92.

31. Elizabeth M. Manwaring, *Italian Landscape in Eighteenth Century England,* pp. 25–27; "Criticism," *Something,* January 1810, p. 145; "The Connoisseur," *Juv. Portfolio,* January 21, 1815, pp. 10–11; "Reflections on Taste," *Lit. Mag.,* June 1806, pp. 408–409; "Connoisseurship and its Pleasures," ibid., May 1806, pp. 365–366; J.Q. Adams to Thomas Boyleston Adams, July 10, 1811, in Worthington Chauncy Ford, ed., *Writings of John Quincy Adams,* vol. 4, pp. 135–136; J.Q. Adams to Alexander Hill Everett, April 10, 1812, ibid., pp. 312–313.

32. Harris, "Advice to a Beginner in the Art of Criticism," *Mass. Mag.,* February 1789, p. 112; Thaumastes, "The Fine Arts," *Nat. Mus.,* December 4, 1813, p. 28; M.K., "Rules for Judging of the Beauties of Painting, Music and Poetry; Founded on a New Examination of the Word 'Thought' as Applied to the Fine Arts," *N.Y. Wkly.,* August 31, 1796, p. 65.

33. "The Fine Arts," *Halcyon,* January 1812, pp. 19–21; Richard Chamberlain, "What Ought to Be the Object of the Arts," *Emerald Mis.,* May 7, 1808, pp. 340–343; "Genius and Taste Contrasted," *Phila. Repert.,* May 26, 1810, pp. 27–28; Sue Neuenswander Greene, "The Con-

tribution of *The Monthly Anthology, and Boston Review* to the Development of the Golden Age of American Letters," pp. 90–94.

CHAPTER 2

1. Lillian B. Miller, *Patrons and Patriotism*, p. 17; Neil Harris, *The Artist in American Society: The Formative Years, 1790–1860*, p. 13.
2. An Observer, "Observations on Faces," *Pa. Mag.*, July 1775, pp. 303–305; "On the Fine Arts," *Mass. Mag.*, May 1795, pp. 105–106; Abigail Adams diary entry for July 9, 1784, in Butterfield, *Diary and Autobiography of John Adams*, vol. 3, p. 165. For European ideas, in addition to the works previously cited, see David Irwin, *English Neoclassical Art: Studies in Inspiration and Taste*; Northrop Frye, ed., *Romanticism Reconsidered: Selected Papers from the English Institute*; and Rémy G. Saisselin, "Neo-classicism: Virtue, Reason and Nature," in Henry Hawley, ed., *Neoclassicism: Style and Motif*, pp. 1–8.
3. "A Dialogue on this Question—Have the Moderns Excelled the Ancients in the Cultivation of the Arts and Sciences?" *Mass. Mag.*, June 1792, pp. 370–373; Jefferson to Joseph Priestley, January 27, 1800, in Paul Leicester Ford, ed., *The Works of Thomas Jefferson*, vol. 9, pp. 102–105; Jefferson to John Brazier, August 24, 1819, in Lipscomb and Bergh, *Writings of Jefferson*, vol. 15, pp. 208–211; Karl Lehmann, *Thomas Jefferson: American Humanist*, pp. 75–76, 128.
4. Barca, "On the progress of the Arts and Sciences," *Wkly. Visit.* February 8, 1806, pp. 41–44; Thaumastes, "The Fine Arts," *Nat. Mus.*, December 11, 1813, p. 28; "The American Lounger, No. 81," *Port Folio*, February 11, 1804, pp. 41–42.
5. Jefferson to William Ludlow, September 6, 1824, in

Lipscomb and Bergh, *Writings of Jefferson*, vol. 16, pp. 74–75; J.Q. Adams to Benjamin Waterhouse, October 24, 1813, in W.C. Ford, *Writings of John Quincy Adams*, vol. 4, pp. 526–527.

6. Visconti, "On the Influence of Religion upon the Fine Arts," *Lit. Misc.* 2 (1806): 143–149.

7. "On the *Causes* that Have Promoted or Retarded the *Growth* of the *Fine Arts*," *Mass. Mag.*, April 1795, pp. 43–45; *Emerald Mis.*, May 2, 1807, pp. 207–210; "Present State of the Arts in England, at the Close of 1805," *Lit. Mag.*, August 1806, pp. 106–108.

8. "The Fine Arts," *Repos.*, February 16, 1805, p. 51; "The Fine Arts," *Halcyon*, June 1812, pp. 262–264; Abigail Adams to John Adams, May 9, 1776, in Adams, *Familiar Letters*, pp. 170–171.

9. "On the Country of Beauty," *Lit. Mag.*, April 1807, pp. 264–268; Y., "Why Did Greece Excel in the Arts," ibid., May 1806, pp. 370–372.

10. "Grecian Pictures and Statues," *Mo. Anthol.*, July 1809, p. 28; T.W., "On Beauty and Grace," *Am. Museum*, November 1790, pp. 235–238; "The Fine Arts," *Halcyon*, July 1812, pp. 316–320.

11. Idler, "On the Progress of the Arts," *Mass. Mag.*, April 1789, p. 240; "Progress of the Arts," *Mo. Anthol.*, May 1806, pp. 235–236; Elson, *Guardians of Tradition*, pp. 233–234; Rev. John Bennett, "Letter X: Present State of Literature and the Fine Arts in England; Remarks on the Augustan Age of that Country," *Am. Museum*, October 1792, pp. 234–236. A careful and thoroughly documented description of American anti-aesthetic biases and their consequences may be found in Harris, *The Artist in American Society*, especially pp. 28–55.

12. "Letter of Jeremiah Listless from Robert Rustic," *Eye*, September 22, 1808, pp. 136–140; "The Power of Beau-

ty, and the Influence the Fair Sex Might Have in Reform-
ing the Manners of the World," *Boston Wkly.*, March 3,
1804, pp. 73–74; Mary Black and Jean Lipman, *Ameri-
can Folk Painting*, p. 205; Carl W. Dreppard, *American
Pioneer Art and Artists*, pp. 21–42; Rita Suswein Gottes-
man, *The Arts and Crafts in New York, 1800–1804:
Advertisements and News Items from New York City
Newspapers*, pp. 3, 9–10, 12; Adams, *Familiar Letters*,
pp. 333–334.

13. "Origin of the Fine Arts," *Balt. Wkly.*, July 18, 1800,
p. 97; Hume, "Delicacy of Taste," *Lit. Mirror*, June 4,
1808, p. 63; H., "Influence of the Fine Arts," *Lit. Tab.*,
December 18, 1805, p. 25.

14. "Use of the Fine Arts," *Lit. Mag.*, May 1806, pp. 360–
361.

15. Priestley, "Morality—On Excellence in the Arts," *La-
dies Wk. Mus.*, February 20, 1813, p. 168; "Morality
—Ornamental Accomplishments; From Barrow," ibid.

16. Cynic, "A Ball-room Dress," *Mo. Mag.*, December
1800, pp. 497–498; Onesimus, "A Dialogue: Principal-
ly on the Gratification of Taste," *Evan. Intel.*, October,
November 1805, pp. 471–476, 510–520; Pilgrim, "The
Essayist, No. XII: The Pleasures and Advantages of
Taste Vindicated," *Lit. Cab.*, August 1, 1807, pp. 129–
131; "Of Taste," *Pioneer*, July 7, 1812, pp. 201–212;
"Morality the Results of Good Taste," *Polyanthos*, June
1813, pp. 149–150.

17. "Essay on Civilization," *Mo. Anthol.*, June 1804, pp.
345–346; "Moral and Physical Sublimity Compared,"
Lit. Mag., May 1806, pp. 363–364.

18. Martin Archer Shee, "The Poet and Painter Compared,"
Port Folio, October 1809, pp. 363–367; see also "Poetry
and Painting Compared," *Lit. Mag.*, January 1806, pp.
17–19.

19. "On Poetry, Music, and Dancing," *Lady's*, June 1801, pp. 351–353; A., "On Poetry, Music, and Painting," *Companion*, June 21, 1806, p. 267; The Rambler, "On Fashion," *Guardian*, March 5, 1808, pp. 62–63.

20. B., "On Beauty," *Lady's Wkly.*, November 1, 1806, p. 3; *Eve. Fireside*, September 21, 1805, p. 321.

21. "Clio," in *New York Commercial Advertiser*, July 24, 1804, reprinted in Gottesman, *Arts and Crafts in New York*, p. 377; Jefferson to B.S. Barton, February 26, 1815, in Lipscomb and Bergh, *Writings of Jefferson*, vol. 19, pp. 223–224.

22. "The Drone—No. IX," *N.Y. Mag.*, November 1792, pp. 643–645; "Modern Fashion Defined," *Ladies Wk. Mus.*, December 23, 1809, p. 2; "Anecdotes of Fashion," *N.E.Q. Mag.*, April–June 1802, pp. 249–252; L., "The Microcosm of Man as He Is—No. III," *Nightingale*, May 26, 1796, pp. 85–88.

23. "Female Dress," *Wkly. Visit.*, August 23, 1806, p. 339; "An Essay on Ideal Beauty," *Lady's*, December 1801, pp. 338–339; "Dress and Fashions," *Ladies Wk. Mus.*, December 19, 1801, p. 2; "On Fashions," *Lady's*, January 1802, p. 38.

24. An Observer, "To the Ladies," *Nightingale*, June 14, 1796, pp. 184–186; "On the Properties of Female Dress, etc.," *Christ. Obs.*, February 1810, p. 87. For the interpretation of late eighteenth-century American political life as one of deferential democracy, see Charles S. Sydnor, *Gentlemen Freeholders: Political Practices in Washington's Virginia*, and J.R. Pole, "Representation and Authority in Virginia from the Revolution to Reform."

25. "On Dress," *Mass. Mag.*, July 1790, pp. 407–409; "The Visitant—No. VIII: Remarks on the Dress of the Ladies," *Am. Museum*, January 1789, pp. 65–68.

26. "Simplicity of Dress," *Juv. Portfolio*, August 27, 1814, p.

135; Knox, "On the Influence of Fashion," *Observer*, November 4, 11, 1810, pp. 13, 17.

27. Rev. John Bennett, "On Dress," *Am. Museum*, March 1792, pp. 93–96; "The Visitant: No. X—Remarks on Dress," ibid., June 1789, pp. 584–587; "The American Spectator," ibid., February 1790, pp. 93–95; Mary Muslin, "The Mischiefs of Fashion," *Free Masons*, February 1812, pp. 356–359.

28. A.M., "The Fashion," *Ladies Wk. Mus.*, September 22, 1792, p. 3; "On Fashion," *Wkly. Mon.*, November 17, 1804, p. 128; "Dress," *Repos.*, July 14, 1804, p. 219; Sincerity, "Fashion," *Eve. Fireside*, December 14, 1805, p. 395; *Christ. Obs.*, August 1806, pp. 472–476; Philander, "On Dress," *Va. Rel. Mag.*, May–June 1807, pp. 180–187; "The Beholder," *Emerald*, February 23, 1811, pp. 200–202.

29. Modestus, "On the Dress of Women," *Ladies Vis.*, February 7, 14, 1807, pp. 38, 42; Eugenia, "On Female Dress," *Wkly. Visit.*, May 12, 1804, p. 253; "The Revolution of Fashions," *Free Masons*, September 1811, pp. 430–433; *Port Folio*, February 20, 1802, p. 51.

30. "Remarks on Female Dress," *Lit. Mag.*, October 1803, pp. 74–75; "Female Clothing," ibid., July 1806, pp. 22–23; "On Female Fashions—From the French," *Ladies Wk. Mus.*, October 21, 1809, p. 2; "Fashion," *Lit. Mag.*, June 1806, pp. 409–410; Smollett, "The True Use of the Senses Perverted by Fashion," *N.Y. Mag.*, April 1795, pp. 206–209; N., "On the Reasons of the Influence of Fashion with Practical Uses," *Theol. Mag.*, August–September 1797, pp. 415–422.

31. Moranda, "The Vigil—No. 7," *Balt. Repos.*, June 1811, pp. 295–299.

32. Ralph Izard to John Adams, September 28, 1778, in Charles Francis Adams, ed., *The Works of John Adams*,

vol. 7, pp. 50–51; *N.H. Gaz.*, October 5, 12, 1786, pp. 261–263, 270–274; Edmund S. Morgan, "The Puritan Ethic and the American Revolution."

33. Titus Blunt, Letter to the Editor, *Am. Mag.*, December 1787, p. 39; An Admirer of the Sex, in *Port Folio*, January 30, 1802, pp. 25–26; Samuel Saunter, "American Lounger, No. XLVII," ibid., February 19, 1803, pp. 57–58.

34. "On Dress," *Wkly. Visit.*, July 12, 1806, p. 291; "On Dress and Fashion," *Wkly. Mag.*, February 10, 1798, pp. 51–52; "Thoughts on an Economical Association, and a National Dress for Americans," *Am. Museum*, March 1789, p. 238.

35. Daniel J. Boorstin, *The Lost World of Thomas Jefferson*, pp. 19–21; Peale to Benjamin West, November 17, 1788, quoted in Sellers, *Charles Willson Peale*, vol. 1, pp. 273–274; Peale to Citizen Geoffrey, April 30, 1797, in Peale Papers. Sellers' excellent biography remains the basic published source for any discussion of Peale; for Peale's Museum, and its creator's character, see vol. 1, pp. 8–15, and vol. 2, pp. 3–10, 225–262.

36. Sellers, *Charles Willson Peale*, vol. 2, pp. 234–242; Diary of Manasseh Cutler, entry for July 13, 1787, ibid., vol. 1, pp. 259–262.

37. Advertisement for Waldron's Museum in the *New-York Gazette and General Advertiser*, January 11, 1802, reprinted in Gottesman, *Arts and Crafts in New York*, pp. 22–23; Peale to his children in London, December 12, 1802, in Peale Papers; Peale to Mr. Parkinson, December 30, 1800, in Peale Papers; draft of Memorial from Peale to the Select and Common Councils of Philadelphia, July 1816, in Sellers, *Charles Willson Peale*, vol. 2, pp. 307–308; Peale to William Findley, February 18, 1800, ibid., vol. 2, pp. 113–115.

38. Peale to Edmund Jennings, December 28, 1800, in Peale Papers; Peale to Sarah Lane, November 29, 1807, Peale Letterbooks, in Peale Papers.

39. Peale to Jonathan Dickinson, March 22, 1799, in Peale Papers; Jefferson to G. C. De La Costa, May 24, 1807, in Lipscomb and Bergh, *Writings of Jefferson*, vol. 11, pp. 206–207. See also Peale to Jefferson, January 12, 1802, in Sellers, *Charles Willson Peale*, vol. 2, p. 150.

40. Peale's manuscript Autobiography, in Peale Papers; Peale to his son, Rembrandt, August 30, 1802, in Peale Papers; Peale to John J. Hawkins, September 30, 1802, in Peale Papers.

CHAPTER 3

1. J.Q. Adams to John Adams, May 21, 1786, in W.C. Ford, ed., *Writings of John Quincy Adams*, vol. 1, pp. 23–24; Jefferson to Dr. Walter Jones, March 5, 1810, in P. L. Ford, *Works of Jefferson*, vol. 10, pp. 138–139; Jefferson to Angelica Schuyler Church, February 7, 1788, in Boyd, *Papers of Jefferson*, vol. 12, p. 601; Jefferson to Charles Bellini, September 30, 1785, ibid., vol. 8, pp. 568–569; on Buffon, see Jacques Barzun, *Darwin, Marx, Wagner: Critique of a Heritage*, pp. 40–43. For an excellent discussion of the evolution-devolution controversy, see Ralph N. Miller, "American Nationalism as a Theory of Nature."

2. Adrienne Koch and William Peden, eds., *The Life and Selected Writings of Thomas Jefferson*, pp. 213–214; "Thoughts on American Genius," *N.H. Gaz.*, February 1, 1787, pp. 380–381, and reprinted in *Am. Museum*, March 1787, pp. 209–211.

3. Latrobe to Miss E. Anderson, December 27, 1806, in Benjamin Henry Latrobe Collection, Maryland Historical

Society (hereafter cited as Latrobe Collection); Adams, *Works of John Adams*, vol. 9, pp. 107–108; Adams to John Marshall, August 11, 1800, ibid., vol. 9, p. 73; Philoenthusiasticus, "Reflections on America," *Mass. Mag.*, December 1795, pp. 559–560; "American Literature Reviewed: Epistles, Odes, and Other Poems, by Thomas Moore," *Mo. Reg.*, 3 (1807):91–106; "To the Public," *Emerald Mis.*, January 3, 1807, pp. 1–3.

4. A Lover of the Fine Arts, "Influence of Taste upon Manners," *Am. Museum*, June 1792, pp. 282–283; The Translator, Review of *Letters Concerning the United States of America*, in *Port Folio*, August 14, 1802, pp. 249–250; "To Readers and Correspondents," *Observer*, February 7, 1807, p. 94; J.Q. Adams to Abigail Adams, May 7, 1799, in W.C. Ford, *Writings of John Quincy Adams*, vol. 2, pp. 418–419.

5. [Benjamin Austin, Jr.], "Amsterdam," *Boston Mag.*, March 1784, pp. 188–189; "On Collections of Paintings," *Lit. Mag.*, May 1805, pp. 374–375; Mr. Holcroft, "A View of Amsterdam; with Observations on the Manners of the Dutch," ibid., February 1807, pp. 106–110; "Dutch Taste," ibid., August 1805, p. 148.

6. Alan Gowans, *Images of American Living: Four Centuries of Architecture and Furniture as Cultural Expression*, p. 225; advertisement in the *South Carolina Gazette*, May 6, 1751, reprinted in Alfred Coxe Prime, ed., *The Arts and Crafts in Philadelphia, Maryland, and South Carolina, 1721–1785: Gleanings from Newspapers*, p. 256; advertisement in the *Pennsylvania Chronicle*, June 1, 1771, ibid., pp. 13–14; Julian Mates, *The American Musical Stage Before 1800*, pp. 84, 85.

7. Talbot Hamlin, *Benjamin Henry Latrobe*, pp. 146–147; Latrobe to Henry Ormond, November 29, 1808, and La-

trobe to N.I. Roosevelt, January 30, 1814, in Latrobe Collection. For a fuller treatment of the subject see J. Meredith Neil, "The Precarious Professionalism of Latrobe."

8. Peale's manuscript Autobiography, in Peale Papers; Peale to Jonathan Muir, January 22, 1804, to Jefferson, February 26, 1804, and to his son, Rembrandt, September 9, 1811, all in Peale Papers; Sellers, *Charles Willson Peale*, vol. 1, p. 15. It should be noted that much of Harris' *The Artist in American Society* focuses on professionalization and related issues, though the great bulk of his material is drawn from the 1820s and following decades.

9. For Peale's illuminations, see his manuscript Autobiography in Peale Papers, and Sellers, *Charles Willson Peale*, vol. 1, pp. 17–18, 212–233, 268–271, vol. 2, pp. 177–190. For Adams' reactions, see Adams to Abigail Adams, July 5, 1777, in Lyman H. Butterfield, ed., *Adams Family Correspondence* vol. 2, p. 275, and Adams, *Familiar Letters*, pp. 349–350.

10. Trumbull to Rufus King, March 8, 1788, quoted in Sizer, *Autobiography of Trumbull*, pp. 327–331; *Philadelphia Daily Advertiser*, June 5, 1799, quoted in Henri Marceau, *William Rush (1756–1833): The First Native American Sculptor*, p. 73; *South Carolina Gazette*, July 18, 1785, reprinted in A. C. Prime, *The Arts and Crafts*, p. 293.

11. Jefferson to Thevenard, May 5, 1786, in Boyd, *Papers of Jefferson*, vol. 9, p. 456; Jefferson to Trumbull, June 18, 1789, ibid., vol. 15, p. 199; Jefferson to Trumbull, October 4, 1787, ibid., vol. 12, p. 207; Jefferson to Philip Mazzei, October 17, 1787, ibid., vol. 12, p. 245; Trumbull to Jefferson, June 11, 1789, ibid., vol. 15, pp. 176–179.

12. Jefferson to Latrobe, July 12, 1812, in Lipscomb and Bergh, *Writings of Jefferson*, vol. 13, p. 179; Latrobe to John Lenthall, January 7, 1805, and to William Jones,

April 21, 1813, both in Latrobe Collection; Jefferson
to Joel Barlow, May 3, 1802, in P.L. Ford, *Works of
Jefferson*, vol. 9, p. 372; Jefferson to Barlow, January
24, 1810, ibid., vol. 10, pp. 131–132; Sizer, *Autobiogra-
phy of Trumbull*, pp. 291–292.

13. The Editors, "To the Public," *Eve. Fireside*, January 4,
1806, p. 1; "To the Public," *Col. Phenix* 1 (1800):5–6;
J.Q. Adams to Thomas Boylston Adams, March 21,
1801, in W.C. Ford, *Writings of John Quincy Adams*,
vol. 2, pp. 521–525.

14. Oliver Larkin, *Art and Life in America*, p. 114; Harris,
The Artist in American Society, pp. 90–97; Lillian B.
Miller, *Patrons and Patriotism*, p. 88. For the early history
of the Royal Academy, see Sidney C. Hutchison, *The His-
tory of the Royal Academy, 1768–1968*, pp. 21–92.

15. Advertisement in *The New-York Gazeteer, and Country
Journal*, November 6, 1804, reprinted in Kelby, *Notes on
American Artists*, pp. 19–20.

16. Advertisement in *The New -York Gazeteer*, December 30,
1784, ibid., p. 24.

17. Charter agreement, December 29, 1794, in Archives of
the Pennsylvania Academy of Fine Arts (hereafter cited
as PAFA Archives).

18. Sellers, *Charles Willson Peale*, vol. 2, pp. 65–75; James
T. Flexner, "The Scope of Painting in the 1790's." For
the contemporary lack of tolerance of political differences,
see Marshall Smelser, "The Federalist Period as an Age
of Passion."

19. The basic sources of information used here are the Papers
of the American Academy and the Livingston Family
Papers, both in the New-York Historical Society (all un-
published materials referred to in this chapter and not
otherwise identified are from these sources); Alexander
J. Davis, 1836 report on the Academy's history; Articles

of Organization (ca. 1803); Janet Livingston Mont-
gomery to R.R. Livingston, May 29, 1802. See also the
newspaper reports in *Morning Chronicle*, October 27,
1802, and January 22, 1803, reprinted in Gottesman,
Arts and Crafts in New York, pp. 81–82, 82–83. A good
account, with a somewhat different emphasis, may be
found in Miller, *Patrons and Patriotism*, pp. 90–102.

20. Minutes of Meetings, December 28, 1802, and March,
1803; Edward Livingston to R.R. Livingston, December
24, 1803; John R. Murray and Joseph Browne to John
Vanderlyn, August 1, 1804.

21. R.R. Livingston to Janet L. Montgomery, August 1,
1802; John Vanderlyn to John R. Murray, January 10,
1804; *Morning Chronicle*, December 20, 1803, reprinted
in Gottesman, *Arts and Crafts in New York*, pp. 84–85;
for the Society of Artists, see George Murray's speech
reprinted in J. Meredith Neil, " 'Plain and Simple Prin-
ciples' for an American Art, 1810."

22. R.R. Livingston to Rufus King, April 27, 1804; *Port
Folio*, April 30, 1803, p. 143.

23. Typical of the treatment of the PAFA in recent studies are
Lillian B. Miller, *Patrons and Patriotism*, pp. 103–110,
and Harris, *The Artist in American Society*, pp. 94–97,
275–278.

24. Peale to Jefferson, January 28, 1803, in Peale Papers;
memorandum, July 4, 1800, in an extract of a letter from
John Allen Smith to Jonathan Vaughn, July 31, 1804, in
PAFA Archives. See also E.P. Richardson, "Allen Smith,
Collector and Benefactor."

25. Sellers, *Charles Willson Peale*, vol. 2, pp. 192, 205–206;
Latrobe to Peale, July 17, 1805, Latrobe Collection;
Peale's manuscript Autobiography, in Peale Papers.

26. Janet Livingston Montgomery to R.R. Livingston, May
29, 1802. Peale's description of the founding of the PAFA

may be found in his Autobiography and in two letters, one to his son, Raphaelle, June 6, 1805, and the other to Jefferson, June 13, 1805. The two letters were printed with many inaccuracies in *Pennsylvania Magazine of History and Biography* 9 (1885):121–123.

27. Peale, Hopkinson, and Meredith to General Armstrong, July 8, 1805, and apparently a rough copy of the same to Biddle, in PAFA Archives; John Armstrong to the President of the Academy of the Fine Arts, December 28, 1810, in PAFA Archives; Nicholas Biddle to Hopkinson, Meredith, and Peale, November 20, 1805, in PAFA Archives; application for incorporation, quoted in Charles Coleman Sellers, "Rembrandt Peale, 'Instigator' "; Minutes of the Academy Directors, April 22, 1811, in PAFA Archives.

28. Latrobe to his father-in-law, Isaac Hazelhurst, July 21, 1806, and to Count Volney, July 28, 1811, both in the Latrobe Collection.

29. R.R. Livingston to Robert G. Livingston, December 23, 1802; William Rush to Benjamin West, March 13, 1812, in PAFA Archives.

30. Peale to Jefferson, August 3, 1811, in Peale Papers; Latrobe to Peale, July 17, 1805, in Latrobe Collection; *Port Folio*, August 1813, pp. 122–141; ibid., January, February 1814, pp. 35–38, 155; *Nat. Mus.*, February 26, 1814, p. 107. For the resolution of the Society of Artists, see the Society Minutes, February 2, 1814, in PAFA Archives. For biographical data on Wertmüller, see Michael Benisovich, "The Sale of the Studio of Adolph-Ulrich Wertmüller."

31. Latrobe to George Murray, November 16, 1811, in Latrobe Collection; Society Minutes, May 28, 1810, in PAFA Archives; Lillian B. Miller, *Patrons and Patriotism*, p. 107. See also Harris, *The Artist in American Society*, pp. 95, 97.

32. Society Minutes, June 5, 1811, and Draft of Public Announcement, April 1814, in Society of Artists Records, in PAFA Archives; Society Fellows' Minutes, December 28, 1814, in PAFA Archives; Society Minutes, January 4, 1815, in PAFA Archives.

33. For the respective committee reports, see Society Minutes, November 27, 1811, and [Academy] Directors' Minutes, December 16, 1811, both in PAFA Archives. For the final moves to dissolve the society, see John Vallance, Bery Tansur, and William Strickland to Matthew Carey, January 16, 1820, in Matthew Carey Papers, Historical Society of Pennsylvania; also, William Kneass to Society members, February 23, 1820, clipping in PAFA Archives from *The Old Print Shop Portfolio*, February 1949.

34. [Academy] Directors' Minutes, March 13, April 13, July 16, 1812, and January 13, 1813, in PAFA Archives; extract from the minutes of a special meeting of the Society of Artists, February 24, 1813, made by William Kneass, and Society Fellows Minutes, March 18, 1815, in PAFA Archives.

35. E.E., Letter to the Editor, *Mo. Anthol.*, June, August 1806, pp. 300–302, 414–416. For a typical piece of favorable press coverage, see "The Pennsylvania Academy of the Fine Arts," in *Poulson's American Daily Advertiser*, November 26, 1807.

36. *Mo. Anthol.*, April 1807, pp. 216–219, and widely reprinted. See also the review of Joseph Hopkinson's address of November 13, 1810, in *Balt. Repos.*, January 1811, pp. 42–50.

37. T.S., in *Port Folio*, June 1812, pp. 537–542; "Pennsylvania Academy of Fine Arts," ibid., June 1809, pp. 461–464.

38. John G. Bogert, in *Mo. Rec.*, April 1813, pp. 40–43; A Lover of the Arts, in *Port Folio*, January 1814, pp. 35–38,

reprinted in *Nat. Mus.*, February 26, 1814, signed by Rembrandt Peale; Jefferson to Thomas Sully, January 8, 1812, in Lipscomb and Bergh, *Writings of Jefferson*, vol. 13, pp. 119–120.

39. Adams to Abigail Adams, April 27, 1777, in Butterfield, *Adams Family Correspondence*, vol. 2, p. 225; "Desultory Remarks on the Fine Arts in the United States," *Mo. Anthol.*, January 1804, pp. 109–110; "Valley Forge," *Mo. Mag.*, May 1812, pp. 5–9; R., "Plan of a National Burial Ground," *Port Folio*, October 1813, pp. 384–390.

40. Edward Ingersoll, "An Oration on the Encouragement of Genius in America, Spoken at the late Commencement in the University of Pennsylvania," *Port Folio*, September 3, 1808, pp. 150–153; R. Smith, "An Oration on the Advantages of the United States," ibid., September 10, 1808, pp. 168–171; "The American Arts—from the Aurora," *Balance*, December 24, 1811, p. 416.

41. The full text of Latrobe's Discourse was printed as a thirty-two-page appendix to *Port Folio* 5 (1811).

42. "American Letters from Europe," *Mo. Anthol.*, January, November 1808, pp. 22–25, 585–590; "Useful Arts," ibid., June 1809, pp. 429–430; A Real American, "American Genius," *Theophil. Essays.*, no. 9 (1810), pp. 372–375.

43. B., "On the Encouragement of the Fine Arts in America," *Observer*, November 29, 1806, pp. 10–12; "The Pennsylvania Academy of Fine Arts," *Port Folio*, December 1810, Appendix, p. 29; "Remarks on the Progress and Present State of the Fine Arts in the United States," *Anal. Mag.*, November 1815, pp. 370–371.

44. *Port Folio* 5 (1811), Appendix, p. 27; *Anal. Mag.*, November 1815, p. 372.

45. "Why the Arts Are Discouraged in America," *Lit. Mag.*, July 1806, pp. 76–77.

46. See, for example, William Colgate, *Canadian Art: Its Origin and Development*, pp. 39–40, 41, 46, 63–64, 66; Graham McInnes, *Canadian Art*, pp. 43–44; S.A. Dale, "Sculpture," in Malcolm Ross, ed., *The Arts in Canada: A Stock-Taking at Mid-Century*, pp. 34–36; A.L. McLeod, *The Pattern of Australian Culture*, "Introduction," pp. 1–4, 6, 8; Bernard Smith, *Place, Taste, and Tradition*, pp. 103–104; John Russell, "Melbourne: The National Gallery of Victoria"; Montague H. Holcroft, *Discovered Isles: A Trilogy*, p. 40; Eric H. McCormick, *New Zealand Literature: A Survey*, p. 84.

47. Peale to Joel Barlow, February 21, 1808, in Peale Papers; J.Q. Adams to William Vans Murray, April 2, 1799, in W.C. Ford, *Writings of John Quincy Adams*, vol. 2, pp. 400–401; Sizer, *Autobiography of Trumbull*, pp. 173–175, 241; "The American Character," *Lit. Mag.*, July 1804, pp. 252–257; The Editors, "To the Public," *Eve. Fireside*, January 4, 1806, p. 1; "Native Genius," *Something*, January 13, February 24, 1810, pp. 141, 237–239; J.H., "American Genius," *Polyanthos*, March 1813, pp. 321–323.

48. "Remarker, No. 21," *Mo. Anthol.*, May 1807, pp. 243–245; "Plan for the Improvement and Diffusion of the Arts, Adapted to the United States," *Lit. Mag.*, March 1805, pp. 181–183; "Interesting Correspondence," *Niles Reg.*, March 21, 1812, pp. 49–50. Jefferson remained nominal president of the Society of Artists until 1816, when he was succeeded by John Trumbull.

49. Jefferson to Doctor Maese, January 15, 1809, in Lipscomb and Bergh, *Writings of Jefferson*, vol. 12, pp. 230–232; Jefferson to David Williams, November 14, 1803, ibid., vol. 10, pp. 428–431; Latrobe to Signor Mazzei, December 19, 1806, and Circular D, April 23, 1808, to the Senators of the United States, both in Latrobe Collection. For

calls for government support of the arts then and now, compare, for example, John Trumbull's letter to President John Quincy Adams, December 25, 1826, and speech before the New York Academy, January 28, 1833, quoted in William Dunlap, *History of the Rise and Progress of the Arts of Design in the United States*, vol. 2, pp. 68–69, and vol. 3, pp. 125–126, with Joseph J. Akston, "Editorial," *Arts Magazine* 42 (September–October 1967): 3.

50. "Preface," *N.Y. Mag.*, 6 (1795): iii; R., "Pennsylvania Academy of Fine Arts," *Lit. Mag.*, August 1805, pp. 129–130; D., "The Fine Arts," *Observer*, February 28, 1807, pp. 131–133; review of Joseph Hopkinson's Discourse, in *Balt. Repos.*, January 1811, pp. 42–50.

51. Jefferson to Thomas Appleton, January 14, 1816, in Lipscomb and Bergh, *Writings of Jefferson*, vol. 19, pp. 229–230; Latrobe to D.W. Boudet, July 29, 1810, in Latrobe Collection; Peale to Raphaelle, June 6, 1805, in Peale Papers.

52. Latrobe to N.I. Roosevelt, October 28, 1808, in Latrobe Collection; "Pernicious Effects of Fashion in Some Cases," *Am. Museum*, August 1790, pp. 73–74; [Eliza Anderson], "Painting," *Observer*, May 30, 1807, pp. 348–349; Morse to his parents, August 24, 1811, quoted in Samuel I. Prime, *The Life of Samuel F.B. Morse*, p. 36; Lehmann, *Thomas Jefferson: American Humanist*, pp. 26–27. See also Marie Kimball's articles, "Jefferson, Patron of the Arts" and "Jefferson's Works of Art at Monticello."

53. Junius, "The Arts and Education," *Nat. Mus.*, January 8, 1814, pp. 50–52; Resolutions of the Society of Artists, printed, with editorial comment, in *Port Folio*, June 1814, pp. 611–612.

54. Peale to John J. Hawkins, July 3, 1808, in Peale Papers; Latrobe to R [embrandt] P [eale], April 29, 1808, in Latrobe Collection; John Hayes, "British Patrons and

Landscape Painting"; 5: The Encouragement of British Art," *Apollo* 86 (November 1967):358–365; William T. Whitley, ed., *Art in England, 1800–1820*, p. 233; Black and Lipman, *American Folk Painting*, pp. vi, 16–17; John Wilmerding, *A History of American Marine Painting*, p. 27; Mates, *American Musical Stage Before 1800*, p. 107.

55. "Preface," *Am. R.* 1 (1801): iii–iv; The Censor, "On American Patronage," *Toilet*, February 7, 1808, pp. 28–30; "Progress of Arts," *Halcyon*, August 1812, pp. 383–384.

CHAPTER 4

1. "Ancient Sculpture," *Boston Spect.*, March 5, 1814, pp. 38, 42. For the history of nineteenth-century American sculpture, see Margaret Farrand Thorp, *The Literary Sculptors*, and Wayne Craven, *Sculpture in America.*

2. "Catalogue of Statues and Busts in the Pennsylvania Academy of the Fine Arts," *Port Folio* June 13, 1807, pp. 369–375; "Account of Statues, Busts, etc. in the Collection of the Academy of Arts, New York," *Lit. Mag.*, December 1803, pp. 185–190; "A Description of the Character, Manners and Customs of the Inhabitants of Easter Island," *Juv. Mag.* 1 (1802): 7–13 and frontispiece; "Tomb of Madame Langhans," *N.Y. Mag.*, January 1791, p. 3 and plate; "On Portuguese Sculpture—from Murphy's Travels in Portugal," *N.E.Q. Mag.*, April–June 1802, pp. 212–214; "A Guide to the Philadelphia Museum," *Port Folio*, November 7, 1807, pp. 293–296.

3. J. Flaxman, "Cursory Strictures on Modern Art, and Particularly Sculpture, in England, Previous to the Establishment of the Royal Academy," *Mo. Anthol.*, October

1807, pp. 526–531; "An Account of the Ancient City of Herculaneum," *Am. Moral Mag.*, July 17, 1797, pp. 70–76; "Remarks on the Past and Present State of the Arts in England," reprinted from *The Reflector*, in *Anal. Mag.*, December 1814, p. 506; "Letters from an American in Europe," *Mo. Anthol.*, August 1809, pp. 95–100.

4. Letter to the Editor, in *Timepiece*, November 15, 1797, pp. 1–2; A Bostonian, "Some Account of Venice, and the Splendid Entrance of Buonarparte into the City, in December, 1807," *Mo. Anthol.*, August 1809, pp. 95–100.

5. Jefferson to George Washington, August 14, 1787, in Boyd, *Papers of Jefferson*, vol. 12, p. 36; Benjamin Harrison to Jefferson, July 20, 1784, ibid., vol. 7, pp. 378–379. The same process may be seen in the 1802 decision of the Society of Cincinnati to obtain a bronze equestrian statue of Washington for New York City. See Minutes of the Society, printed in *Lady's Misc.*, December 18, 1802, p. 87; and Edward Livingston to R.R. Livingston, November 29, 1802, and Nicholas Fish to R.R. Livingston, April 15, 1803, both in Livingston Family Papers.

6. Gowans, *Images of American Living*, p. 245; Jefferson to Trumbull, May 18, 1788, in Boyd, *Papers of Jefferson*, vol. 13, p. 178; Jefferson to Trumbull, July 17, 1788, ibid., vol. 13, pp. 376–377; Jefferson to James Madison, February 8, 1786, ibid., vol. 9, p. 267.

7. St. John de Crevecoeur to Jefferson, September 1, 1784, in Boyd, *Papers of Jefferson*, vol. 7, pp. 413–414; Jefferson to Washington, December 10, 1784, ibid., vol. 7, p. 567; Jefferson to Benjamin Harrison, January 12, 1785, ibid., vol. 7, pp. 599–601; Jefferson to the Virginia Delegates in Congress, July 12, 1785, ibid., vol. 8, pp. 289–290; Washington to Jefferson, August 1, 1786, ibid., vol. 10, p. 186.

8. Jefferson to Nathaniel Macon, January 22, 1816, in Lipscomb and Bergh, *Writings of Jefferson*, vol. 14, pp. 408–412.

9. Latrobe to Nathaniel Macon, January 9, 1816, in Latrobe Collection.

10. Latrobe to Signor Mazzei, April 12, 1806, to James Todd, October 26, 1804, and to Charles Willson Peale, April 18, 1806, all in Latrobe Collection.

11. William T. Franklin to Jefferson, December 17, 1789, in Boyd, *Papers of Jefferson*, vol. 16, pp. 36–37; Peale to Rubens Peale, June 5, 1809, in Peale Papers; [N.Y.] *Spectator*, January 24, 1801, [N.Y.] *Temple of Reason*, December 20, 1800, and *Commercial Advertiser*, January 4, 1800, all reprinted in Gottesman, *Arts and Crafts in New York*, pp. 74–75; Censor, "The Mausoleum of Washington," *Mo. Anthol.*, April 1804, pp. 243–246; *Lit. Repos.*, August 1813, pp. 308–309. For reports of various monuments, see *Port Folio*, October 3, 10, 1807, pp. 214–215, 239; *Lit. Mag.*, November 1807, p. 265; *Balance*, June 18, 1811, p. 196; *Mo. Mag.*, June 1812, pp. 129–131; *Niles Reg.*, March 20, 1813, p. 56.

12. Craven, *Sculpture in America*, pp. 20–25; *Port Folio* 5 (1811), Appendix, p. 24n; Marceau, *William Rush*.

CHAPTER 5

1. Rosenblum, *Transformations in Late Eighteenth Century Art*, p. 42. A convenient biography of West is Grose Evans, *Benjamin West and the Taste of His Times*. Barbara Novak's brilliant study, *American Painting of the Nineteenth Century: Realism, Idealism, and the American Experience*, appeared after I had finished this chapter. It adds important new light on many of the topics dealt with here.

2. *The New York Gazette and General Advertiser*, October

30, 1801, reprinted in Gottesman, *Arts and Crafts in New York*, p. 16; Samuel F.B. Morse to a friend, 1811, quoted in S.I. Prime, *Samuel F.B. Morse*, p. 37.

3. Ellis K. Waterhouse, *Three Decades of British Art, 1740–1770*, p. 62; Virgil Barker, *American Painting: History and Interpretation*, pp. 201–203; "Somerset Place, Royal Academy Exhibition, 1786," *N.H. Gaz.*, July 6, 1786, pp. 165–166; "West's Pictures," *Gen. Repos.*, July 1813, pp. 79–91; "Notes Relative to the Paintings of Mr. West," *Port Folio*, February 11, 18, 1804, pp. 45–46, 52–53; T.C., Letter to the Editor, ibid., June 1812, p. 537; James T. Flexner, *American Painting: The Light of Distant Skies, 1760–1835*, pp. 10, 33–36.

4. F.W., "Exhibition at Somerset House," *Mo. Anthol.*, September 1808, pp. 470–472; "Exhibition of the Royal Academy, 1812," reprinted from the *Literary Panorama* in *Port Folio*, February 1813, pp. 166–167.

5. "Barry's Celebrated Picture, The Victory at Olympia," *Port Folio*, November 1811, p. 456; Rev. John Bennett, "On Painting," *Am. Museum*, October 1792, pp. 232–234; *Port Folio*, November 25, 1803, pp. 380–381.

6. M., "The Schools of Painting and the Masters," *Mo. Anthol.*, September 1806, pp. 449–454; West, "Anecdotes of American Painters," *Port Folio*, October 1809, pp. 316–322, reprinted in *Halcyon*, December 1812, pp. 576–577; Rembrandt Peale to Charles Willson Peale, October 27, 1808, in Peale Papers.

7. "Life of Raphael," *Port Folio*, March 1812, pp. 248–259 and plate; "Michael Angelo Buonaroti," *Boston Wkly.*, February 11, 1804, p. 62; "Michael Angelo," *Repos.*, April 27, May 4, 1805, pp. 130–131, 138; "Biographical Sketch of Michael Angelo," *Ladies Wk. Mus.*, November 14, 1812, p. 110; "Life of Michael Angelo," *Port Folio*, February 1812, pp. 134–141, with two plates;

"Michael Angelo" and "Raphael," *Boston Spect.*, April 16, 1814, p. 63. For the parallel change in England and France, see Monk, *The Sublime*, pp. 167–193.

8. Irwin, *English Neoclassical Art*, pp. 44, 46; David Antin, "Fuseli, Blake, Palmer," pp. 110–111; T.S.R. Boase, *English Art: 1800–1870*, pp. 6–7; *Repos.*, March 15, 29, 1806, pp. 97–98, 113–114; Rosenblum, *Transformations in Late Eighteenth Century Art*, p. 8, 8n; "Royal Academy Exhibition," *Port Folio*, November 25, 1803, pp. 380–381; F.W., "Exhibition at Somerset House," *Mo. Anthol.*, September 1808, pp. 470–472; Hamlin, *Benjamin Henry Latrobe*, p. 541; *Port Folio*, May 15, 1802, p. 152; Leslie to Miss Leslie, December 12, 1816, in Charles R. Leslie, *Autobiographical Recollections*, p. 202. For Fuseli's transitional place in art theory, see Lionello Venturi, *History of Art Criticism*, p. 173.

9. Richard W. Wallace, "The Genius of Salvator Rosa"; Manwaring, *Italian Landscape in Eighteenth Century England*; "Life of Salvator Rosa," *Port Folio*, September 1812, pp. 282–287; *Lit. Mag.*, November 1807, pp. 263–265; "Letters from an American in Europe," *Mo. Anthol.*, January 1809, pp. 9–12; "American Academy of Arts—From the N.Y.E. Post," *Balance*, September 10, 1811, p. 289, and reprinted in *Phila. Repert.*, September 21, 1811, p. 144.

10. "Rembrandt," *Emerald*, November 1807, p. 34; "Life of Rembrandt," *Port Folio*, December 1812, March 1813, pp. 610–618, 293–294 and plate.

11. Arthur O. Lovejoy, *Essays in the History of Ideas*, Chapter 5, " 'Nature' as Aesthetic Norm," pp. 69–77.

12. "Rules for Painting Founded on Reason," *Gent. Mag.*, November 1789, pp. 530–531; "The German School of Painting," *Lit. Mag.*, December 1804, pp. 666–667;

T.C., Letter to the Editor, in *Port Folio*, June 1813, pp. 537–542; "Letters from Geneva and France . . . Addressed to a Lady in Virginia," ibid., December 17, 1808, pp. 389–393.

13. "An Analytical Abridgment of the Principal of the Polite Arts; Belles Lettres; and the Sciences—Painting," *Christ. Schol. Mag.*, December 1789–January 1790, February–March, April–May 1790, pp. 595–598, 719–722, 80–83; advertisement of Charles Peale Polk, in *Key*, January 13, 1798, p. 8; Leslie to Miss Betsie, September 14, 1812, in Leslie, *Autobiographical Recollections*, pp. 181–182; "On the Cultivation of a Taste for the Beauties of Nature," *Lit. Cab.*, July 18, August 1, August 15, 1807, pp. 125–126, 133–135, 139–142; "Picturesque Description," *Merrimack*, June 14, 1806, p. 174; Charles Willson Peale, manuscript Autobiography, in Peale Papers.

14. "The Connoisseur," *Polyanthos*, April 1806, pp. 35–37; "Some Remarks on Mr. West's Picture," *Port Folio*, January 1812, p. 21.

15. "Of the Knowledge of Painting," *Am. Mag.*, March 1745, pp. 114–117; Ephebos, "Some Observations on Pictures: With A Proposal," *S.C. Mus.*, June 3, 1797, pp. 677–678; Latrobe diary, June 18, 1819, reprinted in Wilson, *Impressions Respecting New Orleans*, pp. 102–105; "The Funeral of Atala . . . by Gautherot," *Port Folio*, September 1813, pp. 296–297 and plate.

16. Alan Gowans, *The Restless Art: A History of Painters and Painting, 1760–1960*, pp. 18–30; Friedrich Antal, "Reflections on Classicism and Romanticism," *Burlington Magazine* 66 (1935):160; Jefferson to Madame de Bréhan, March 14, 1789, in Boyd, *Papers of Jefferson*, vol. 14, pp. 655–656; Sizer, *Autobiography of Trumbull*, pp. 108–109, 114; Rembrandt Peale, in Paris, quoted in

Charles Willson Peale to Angelica Robinson, September 8, 1808, in Peale Papers; T.C. Brunn Neergaerdt, "Present State of the Art of Painting in France," *Mo. Anthol.*, August 1807, pp. 408–416; "David's Grand Picture," *Sel. Rev.*, June 1809, pp. 418–419. For some inconclusive speculation about American painters' lack of interest in David, see Edgar P. Richardson, *Painting in America from 1502 to the Present*, pp. 88–89, 120, 137.

17. "Remarks on the Past and Present State of the Arts in England," reprinted from *The Reflector*, in *Anal. Mag.*, December 1814, p. 494; "On the Genius and Character of Hogarth . . . ," ibid., February 1815, pp. 150–167; "Hogarth," *Port Folio*, January 1815, pp. 71–75; ibid., September 19, 1807, pp. 177–178.

18. "Life of Bartolomeo Manfredi," *Port Folio*, September 1812, pp. 291–294; "Illustrations of the Graphic Art; Exemplified by Sketches from the National Museum at Paris," ibid., December 1811, pp. 568–575 and plate; untitled, anonymous letter on painting and painters, in *Gen. Repos.*, October 1812, pp. 317–320.

19. Smelfungus, "Account of Paintings in the Louvre," *Mo. Anthol.*, August 1805, pp. 399–402; R., "The Vigil, No. 4—Comparison of the Poet and Painter," *Balt. Repos.*, March 1811, pp. 126–131; "On the Superiority of Painting to Poetry—From Bronley's History of the Fine Arts," *N.Y. Mag.*, October 1795, pp. 600–602; "On the Coalition Attempted by Some British Artists Between Poetry and Painting," *Lit. Mag.*, February 1807, pp. 135–138; Butterfield, *Diary and Autobiography of John Adams*, vol. 3, pp. 191–192.

20. "Exhibitions of Paintings," reprinted from *Ackerman's Repository*, in *Mo. Anthol.*, October 1809, pp. 273–280; Leslie quoted in Dunlap, *Arts of Design*, vol. 3, p. 79. In-

teresting evidence of the lingering power of neoclassical predilections may be found in Paul R. Baker, *The Fortunate Pilgrims: Americans in Italy, 1800–1860*, pp. 140–153.

21. "Life of Guercino," *Port Folio*, July 1812, p. 73; "Life of Michael Angelo," ibid., February 1812, pp. 131–141; "West's Portrait of Lord Nelson," reprinted from *La Belle Assemblée*, in *Emerald*, August 23, 1806, pp. 198–199.

22. "Biographical Sketch of Benjamin West," reprinted from *London Universal Magazine*, in *Port Folio*, November 9, 1805, pp. 347–348; "The Fine Arts," ibid., November 7, 1801, p. 355; *Companion*, September 27, 1806, pp. 382–383; "Mr. West's Picture," *Lit. Misc.*, June 1811, pp. 118–120.

23. "Full Length Portrait of Washington," *Port Folio*, December 17, 1801, pp. 405–406; B., "On the Encouragement of the Fine Arts in America," *Observer*, January 1807, pp. 19–22; Adams to John Singleton Copley, April 29, 1811, in W.C. Ford, *Writings of John Quincy Adams*, vol. 4, p. 71 n1; quotation from Leslie, in Dunlap, *Arts of Design*, vol. 1, p. 145.

24. Bayard, "Anecdotes of American Painters," *Port Folio*, June 1809, pp. 474–477; Russel, "Eichold the Painter," ibid., April 1811, pp. 340–342; E.P. Richardson, *Painting in America*, p. 124; "Sacred and Historical Paintings," *Christ. Visit.*, August 26, 1815, pp. 100–101; Earle Newton, "Jacob Eichholtz."

25. [Eliza Anderson], "Music," *Observer*, June 20, 1807, pp. 388–391; B.I., "Encouragement Given to the *Fine Arts*—Their Rapid Progress Among Us," ibid., November 7, 1807, pp. 302–303; Barker, *American Painting*, pp. 284–285, 291–292; Flexner, *American Painting*, p. 121 and plates 46, 51; J. Hall Pleasants, "Four Late Eight-

eenth Century Anglo-American Landscape Painters";
Latrobe to [D.W.] Boudet, September 26, 1810, in
Latrobe Collection.

26. "Original Letters from Paris," *Port Folio*, September 1810,
pp. 275–279; Rembrandt Peale, Letters to the Editor, ibid.,
January 1811, pp. 12–15; Charles Willson Peale to Jef-
ferson, February 21, 1808, quoted in Sellers, *Charles Will-
son Peale*, vol. 2, pp. 209–211; *Anal. Mag.*, August 1814,
p. 173; "American Artists in London," ibid., June 1814,
pp. 523–524; "Master Leslie," *Mo. Rec.*, April 1813,
pp. 30–31; "Mr. C.R. Leslie," *Port Folio*, September
1813, pp. 306–307.

27. "Literary Intelligence," *Anal. Mag.*, October 1813, Jan-
uary 1814, pp. 350, 88; note on Allston's "Dead Man
Restored to Life," ibid., August 1815, p. 173; *Port Folio*,
July 1814, pp. 88–93. For an extended modern critical
appraisal, see Edgar P. Richardson, *Washington Allston:
A Study of the Romantic Artist in America*.

28. Wilmerding, *History of American Marine Painting*, pp.
3, 4, 7; Sidney Tillim, "Three Centuries of American
Painting."

29. Latrobe to [D.W.] Boudet, September 26, 1810, and to
Bishop Carroll, July 27, 1810, both in Latrobe Collection.

30. Latrobe's "Essay on Landscape," in the Virginia State Li-
brary, Richmond, remains unpublished except for facsimile
excerpts published in *Virginia Cavalcade* 8 (Spring 1959):
4–38. Quotations are from the manuscript, vol. 2, pp. 9–
15, and vol. 1, p. 46. See also Latrobe's Journal, vol. 2,
August 10, 1806, in Latrobe Collection.

31. Edward Waldo Emerson and Waldo Emerson Forbes,
eds., *Journals of Ralph Waldo Emerson*, vol. 6, p. 501
(entry for March 12, 1844); Barbara Novak O'Doherty,
"The American 19th Century," p. 31; "Remarks on the
Progress and Present State of the Fine Arts in the United

States," *Anal. Mag.*, November 1815, pp. 368–369; "Biography. From the Freeman's Journal. Memoirs of Benjamin West, Esq., President of the Royal Academy, etc.," *Phila. Repert.*, October 26, 1811, pp. 177–178.

32. Stuart quoted in Dunlap, *The Arts of Design*, vol. 1, p. 216; Wilmerding, *History of American Marine Painting*, pp. 3, 27; Black and Lipman, *American Folk Painting*, pp. 16–17, 158, 171–172; advertisement in the *Federal & Baltimore Daily Advertiser*, January 9, 1798, quoted in Sellers, *Charles Willson Peale*, vol. 2, p. 102; "Edward B. Malbone," *Port Folio*, March 26, 1808, pp. 204–206; obituary of Malbone in *New-York Commercial Advertiser*, May 29, 1807, reprinted in Kelby, *Notes on American Artists*, p. 57; "Fine Arts—Wood's Miniature of Cooper," *Pastime*, January 16, 1808; "Benjamin West," *Sel. Rev.*, October 1811, pp. 267–269. Dunlap quoted Allston's very favorable remarks about Malbone, in *The Arts of Design*, vol. 2, p. 140.

33. *The National Advocate*, April 21, 1818, reprinted in Kelby, *Notes on American Artists*, p. 54; Sellers, *Charles Willson Peale*, vol. 1, pp. 105–108; Dreppard, *American Pioneer Arts and Artists*, pp. 15–17; Flexner, "The Scope of Painting in the 1790's," pp. 74–89; Manwaring, *Italian Landscape in Eighteenth Century England*, pp. 95–96; Black and Lipman, *American Folk Painting*, pp. viii, 16–17.

34. *Lit. Mag.*, November 1807, pp. 263–265; "American Academy of Arts," reprinted from the New York *Evening Post*, in *Balance*, September 10, 1811, p. 289; Letter to the Editor, in *Port Folio*, October 1811, pp. 367–368; *Mirror*, April 1811, pp. 263–264; "A Cursory Review of the Exhibition of the Academy of Arts," reprinted from the *American Daily Advertiser*, in *Balance*, July 16, 1811, pp. 228–229.

35. M., "Review of the Third Annual Exhibition of the Columbian Society of Artists and Pennsylvania Academy of Fine Arts," *Port Folio*, August 1813, p. 133.

36. G.M., "Review of the Second Annual Exhibition," *Port Folio*, July, August 1812, pp. 123–131, 177–183.

37. "Pennsylvania Academy of the Fine Arts," *Mo. Rec.*, May, June 1813, pp. 123–131, 177–183; M., in *Port Folio*, August 1813, pp. 122–141. For the importance of Evans' machinery in the history of the American vernacular, see Kouwenhoven, *Made in America*, especially pp. 36–37.

38. G.M., "Notice of the Fourth Annual Exhibition in the Academy of the Fine Arts," *Port Folio*, June, July 1814, pp. 566–570, 94–100; *Anal. Mag.*, April 1815, p. 347; Whitley, *Art in England, 1800–1820*, pp. 278–279.

39. "Illustrations of the Graphic Art; Exemplified by Sketches from the National Museum at Paris," *Port Folio*, December 1811, p. 571; "Some Remarks on Mr. West's Picture," ibid., January 1812, pp. 17–20; "An Analytical Abridgment of the Principal of the Polite Arts; Belles Lettres; and the Sciences—Engraving," *Christ. Schol. Mag.*, June–July 1790, pp. 189–193.

40. Sellers, *Charles Willson Peale*, vol. 1, p. 265; Frank Weitenkampf, "Early American Landscape Prints"; Martin P. Snyder, "William Birch: His 'Country Seats of the United States [1808–1809]' "; Martin P. Snyder, "William Birch: His Philadelphia Views"; "Preface," *N.Y. Mag.*, n. s. 1 (1796): iv; O., "Inutility of Engravings in a Magazine," *Mass. Mag.*, December 1791, pp. 724–725; A Customer, ibid., February 1792, p. 75; "Preface," ibid. 5 (1973): i; "Conrad's Magazine," *Port Folio*, April 27, 1805, pp. 125–126; *Lit. Misc.* 2 (1806):287–291.

41. *Port Folio*, December 5, 1801, p. 388; "Engraving," *Mo. Rec.*, June 1813, pp. 183–184; I.P., "On Engrav-

ings," *Repos.*, June 18, 1803, p. 198; Exetastes, in *Mo. Reg.* 3 (1807):57–60, 119–125, 244–249; *Port Folio*, February 1807, pp. 86–87.

42. Latrobe to Francis Guy, and to the Archbishop of Baltimore, both dated December 27, 1812, in Latrobe Collection; *Port Folio*, January 18, 1806, p. 25; "The Useful Arts," ibid., October 30, 1802, p. 340; review of *The Holy Bible*, in *Mo. Reg.* 2 (1807): 308–309; "The Lion and the Horse, from Stubbs," *Port Folio*, September 1811, pp. 201–203 and plate; review of M. Bertin's China, in *Anal. Mag.*, May 1813, pp. 412–418; review of *The Echo, with Other Poems*, in *Mo. Reg.* 2 (1807): 244–247.

CHAPTER 6

1. Hamlin, *Benjamin Henry Latrobe*, p. 531; Gowans, *Images of American Living*, pp. 206, 262.

2. Rev. James Bannister, "On Architecture," *Mass. Mag.*, July 1789, pp. 401–403; D., "The Fine Arts," *Observer*, February 28, 1807, pp. 131–133; "On the Fine Arts," *Mass. Mag.*, May 1795, pp. 105–106; "Description of Monticello Written by an Englishman, in 1796," *Medley*, May 1803, pp. 99–100; "Description of the Louvre and the Gallery of Antiques, at Paris, by a Traveller," *Lit. Mag.*, June 1805, pp. 458–466; "A Brief Account of Dartmouth-College, in New England," *Mass. Mag.*, February 1793, pp. 67–68; " 'Green Hill' Philadelphia—The Seat of Samuel Meredith," ibid., October 1792, p. 596.

3. "Description of Fanueil Hall," *Lit. Mag.*, September 1806, pp. 205–206; *Columbian Mag.*, January 1788, pp. iii–iv and frontispiece; *N.H. Gaz.*, February 17, 1787, p. 8; Viator, in *Balance*, January 12, 1802, p. 9; *Mass. Mag.*, July 1789, pp. 395–396 and plate.

4. "On the Flavian Architecture at Rome, from a Manuscript Journal," *Lit. Mag.*, March 1805, pp. 167–169; see also the description of Versailles in *Boston Mag.*, September 1784, pp. 471–474.

5. Philocles, "Of the Refinements of Taste and Elegance," *Univ. Asylum*, November 1792, pp. 304–306; *Mass. Mag.*, August 1789, p. 469 and plate; "Description of the Federal Edifice at New York," *Columbian Mag.*, August 1789, pp. 473–474; *N.Y. Mag.*, August 1791, p. 427 and plate; *Mass. Mag.*, November 1792, p. 651 and plate.

6. "Short History of Yale College," *Lady's Pocket Mag.*, November 1796, pp. 193–195 and plate.

7. "Description of St. Peter's Church at Rome," *Eve. Fireside*, August 2, 1806, p. 244; "Temple of Diana at Ephesus," *Free Masons*, August 1811, p. 70; *Port Folio*, January 1807, pp. 41–42; *Church Mag.*, January–February 1809, pp. 79–80; B.I., "Encouragement Given to the *Fine Arts*—Their Rapid Progress Amongst Us," *Observer*, November 14, 1807, pp. 316–318.

8. Extract from Hall's Encyclopedia, published in the *Commercial Advertiser*, June 7, 1803, and in *The Spectator*, June 8, 1803, and reprinted in Gottesman, *Arts and Crafts in New York*, pp. 181–182.

9. Lehmann, *Thomas Jefferson*, pp. 182–185; Gowans, *Images of American Living*, p. 247; Minutes of the Board of Visitors, November 29, 1821, in Lipscomb and Bergh, *Writings of Jefferson*, vol. 19, pp. 405–407.

10. Jefferson to Benjamin Latrobe, July 12, 1812, quoted in Hamlin, *Benjamin Henry Latrobe*, pp. 291–292; James Buchanan and William Hay to Jefferson, March 20, 1785, in Boyd, *Papers of Jefferson*, vol. 8, pp. 48–49; Jefferson to Buchanan and Hay, August 13, 1785, ibid., pp. 366–368; Jefferson to James Madison, September 20,

1785, ibid., pp. 534–535; Jefferson to Madison, September 1, 1785, ibid., p. 462; Jefferson to Edmund Randolph, September 20, 1785, ibid., pp. 537–538.

11. Jefferson to William Buchanan and James Hay, January 26, 1786, in Boyd, *Papers of Jefferson*, vol. 9, pp. 220–222; Jefferson to James Currie, January 28, 1786, ibid. p. 240.

12. Lewis Mumford, *The South in Architecture*, pp. 68–69; Jefferson to Governor Wilson C. Nicholas, April 12, 1816, in Lipscomb and Bergh, *Writings of Jefferson*, vol. 14, p. 453; Jefferson to William Roscoe, December 27, 1820, ibid., vol. 15, pp. 302–303; Gowans, *Images of American Living*, pp. 243–265; Jefferson to Benjamin Latrobe, August 14, 1817, in Thomas Jefferson Papers, Manuscripts Division, Library of Congress; Minutes of the Board of Visitors, October 7, 1817, in Lipscomb and Bergh, *Writings of Jefferson*, vol. 19, p. 367; Latrobe to Jefferson, July 24, 1817, Thomas Jefferson Papers, Manuscripts Division, Library of Congress; Jefferson to George Ticknor, July 16, 1823, in Lipscomb and Bergh, *Writings of Jefferson*, vol. 15, p. 456.

13. The topical distribution of articles in American magazines is tabulated in J. Meredith Neil, "Towards a National Taste: The Fine Arts and Travel in American Magazines from 1783 to 1815," pp. 221–231; "An Account of the Ancient City of Herculaneum," *Am. Moral Mag.*, July 17, 1797, pp. 70–76; "Description of the Colleges at Cambridge," *Mass. Mag.*, June 1790, pp. 323–326; an article describing the Tontine Crescent, with a fold-out elevation and floorplan, is in *Mass. Mag.*, February 1794, p. 67.

14. Latrobe to Jefferson, May 21, 1807; Latrobe to Henry Clay, June 29, 1812; Latrobe to Richard Dale and Wil-

liam Milner, February 10, 1814, all in Latrobe Collection.

15. Latrobe to John Lenthall, August 25, 1804, in Latrobe Collection.

16. Latrobe to the Right Reverend Bishop Carroll, April 27, 1805, quoted in Hamlin, *Benjamin Henry Latrobe*, pp. 235–236; Latrobe to Robert G. Harper, June 4, 1817, and to Joshua Gilpin, December 5, 1810, both in Latrobe Collection.

17. Hamlin, *Benjamin Henry Latrobe*, pp. 197–199, 344, and plate 17; Latrobe to William Waln, March 26, 1805, and to Col. Jonathan Williams, February 10, 1809, both in Latrobe Collection.

18. Latrobe to John Wickham, April 26, 1811; Latrobe to George Bridport, December 11, 1816; Latrobe to John Lenthall, October 24, 1805; and Latrobe to Thomas Law, October 10, 1816, all in Latrobe Collection; Latrobe to Mrs. Madison, April 21, 1809, in Madison Papers, Manuscripts Room, New York Public Library.

19. "The Origin and Progress of Architecture," *Christ. Schol. Mag.*, August–September, October–November 1790, December 1790–January 1791, pp. 305–308, 440–442, 567–572; *Mass. Mag.*, December 1793, pp. 707–709 and plate; "Liverpool Lyceum," *Port Folio*, November 6, 1802, p. 348; "A Description of the Hall of the Legislative Body of Paris, by a Traveller, in 1801," *Lit. Mag.*, September 1805, pp. 173–176.

20. Review of John Foster's *Essays*, in *Mo. Reg.* 3 (1807), 167–168.

21. *New Am. Mag.*, March 1760, p. 104 and plate; "On the Architecture of America," *Am. Museum*, October 1790, pp. 174–176.

22. B., "Philadelphia's Public Buildings," *Columbian Mag.*, January 1790, pp. 25–26 and plate; *Mass. Mag.*, January 1790, p. 3 and plate; ibid., December 1793, pp. 707–

708 and plate; *N.Y. Mag.*, January 1795, p. 1 and plate; *Mass. Mag.*, March 1790, p. 131; review of Biddle's *Letters from Europe* . . . , in *Lit. Mag.*, December 1805, pp. 467–470. Biddle's *The Young Carpenter's Assistant*, first published in 1805, went through seven other editions in the next fifty-three years, according to Henry-Russell Hitchcock, *American Architectural Books*, p. 16.

23. Hussey, *The Picturesque*, pp. 188–189, 217–218; *Mass. Mag.*, March 1789, pp. 131–133 and plate; *N.Y. Mag.*, June 1790, p. 317 and plate; ibid., May 1791, p. 247 and plate; "Description of the State-House, etc. in Philadelphia," *Phila. Mo. Mag.*, June 1798, pp. 333–334; "Sketch of the University of Glasgow," *Mo. Anthol.*, April 1808, pp. 183–184; J.C., "Ruins of an Ancient Work on the Sciota," *Port Folio*, November 1809, p. 419 and plate; Rosenblum, *Transformations in Late Eighteenth Century Art*, pp. 11–19, 109–137; review of Maton's *Essay on British Cottage Architecture*, in *Phila. Mag.*, May 1799, pp. 291–294; "Eddystone," *Lit. Mag.*, March 1804, p. 407.

24. Review of and extracts from *Letters Concerning the United States of America*, in *Port Folio*, August 14, 1802, pp. 249–250; Charles Robertson's advertisement in *South Carolina & American General Gazette*, October 28, 1774, reprinted in A.C. Prime, *The Arts and Crafts*, p. 290; *Commercial Advertiser*, June 15, 1803, in Kelby, *Notes on American Artists*, p. 44.

25. [Benjamin Austen, Jr.], "Amsterdam," *Boston Mag.*, March 1784, pp. 188–189; *Boston Wkly.*, November 20, 1802, pp. 14–15; L., "Description of Westminster Abbey, London," *Lady's Misc.*, March 24, 31, 1804, pp. 196, 202–203; "A View of the Church of Saint Peter at Rome," *Free Masons*, November 1811, pp. 112–118; "Letters from Pennsylvania," *West. Glean.*, January

1814, p. 95; Latrobe to George Bridport, December 11, 1816, in Latrobe Collection.

26. Observer, in *Church Mag.*, June 1807, pp. 218–220; "On Gothic Architecture," *Free Masons*, October 1811, pp. 63–64.

27. "Description of Mt. Vernon," reprinted from Morse's *Geography*, in *Am. Museum*, January 1792, p. 40; *Port Folio*, April 24, 1802, p. 127 and plate; review of Baron von Sack's *A Narrative of a Voyage to Surinam . . .* , in *Sel. Rev.*, August 1811, p. 91; *Polyanthos*, October 1812, p. 1 and plate; "Account of Roslin Castle—By a Lady," *Lit. Mag.*, April 1804, pp. 64–66; "Dorsey's Gothic Mansion," *Port Folio*, February 1811, pp. 125–126 and plate (unfortunately, now missing).

28. Helen Maria Williams, "A Visit to the Ruins of the Bastile," *N.Y. Mag.*, December 1791, pp. 725–728; description of the Paris Temple, in *Mass. Mag.*, October 1793, p. 580 and plate; "Some Account of the Mahometan Temples and Mosques," *N.Y. Mag.*, October 1797, pp. 505–510; Amicus, "Extract from Tooke's *Life of Catherine II*," in *Port Folio*, February 21, 1801, p. 58; "Of the Pagodas of Hindustan," *Sel. Rev.*, February 1810, pp. 114–117; reviews of travel accounts of Persia, ibid., April 1812, pp. 273–293; "Spanish Hermitages and Convent, at Montserrat," reprinted from *The Memoirs of Captain Carleton*, ibid., April 1812, p. 326.

29. "Le Petit Trianon," reprinted from Carr's *Stranger in France*, in *Wkly. Mon.*, October 6, 1804, pp. 80–81; "Old Castles—from a Traveller's Correspondence," *Lit. Mag.*, June 1805, pp. 414–415; M. Gerhard von Hosstrup, "Description of the New Exchange-Hall at Hamburgh," *Mo. Anthol.*, February 1807, pp. 61–65.

30. G.M., "Notes of the Fourth Annual Exhibition in the

Academy of the Fine Arts," *Port Folio*, July 1814, p. 96.

31. Kouwenhoven, *Made in America*, pp. 13–42, 78.

32. X., "The Pleasures of Taste," *Toilet*, February 14, 1801, pp. 34–36; "The American Character," *Lit. Mag.*, July 1804, pp. 252–257.

33. "English Inns—From Mr. Pratt's Gleanings in England," *N.E.Q. Mag.*, April–June 1802, pp. 220–223; Mr. Pinkerton, "The Public Baths at Paris," *Lit. Mag.*, October 1806, pp. 250–252; "Description of the Wapping Docks near London," ibid., August 1805, pp. 146–147.

34. "Observations on the Present Style of American Architecture with a Plan for Improvement," *Archives*, July 1812, pp. 82–86; A Tenant, "On the Style and Economy of Building Houses," *Am. Mag.*, December 1815, pp. 265–268; Latrobe to Count Volney, July 28, 1811, in Latrobe Collection.

35. "An Account of the Intended Iron Bridge, Consisting of a Single Arch of Six Hundred Feet Span," *Nat. Mag.*, no. 7 (1801), pp. 51–56; "Description of Westminster Bridge," ibid., no. 8 (1801), pp. 57–60; *Balance*, January 11, 1803, p. 12; "Cast Iron Bridge over the Thames," *Lit. Mag.*, December 1804, p. 669; O. Biddle, "Description of the Schuylkill Bridge," *Lit. Mag.*, October 1805, pp. 307–308; "Springfield Bridge, in Connecticut," ibid., December 1805, p. 416. For a general history, see David B. Steinman and Sara Ruth Watson, *Bridges and Their Builders*.

36. "A Statistical Account of the Schuylkill Permanent Bridge," *Port Folio*, March 26, 1808, pp. 200–204; Rario, "The Pedestrian," *Companion*, August 17, 1805, pp. 331–333; *Polyanthos*, December 1812, p. 113 and plate.

37. Review of Thomas Pope's *Bridge Architecture*, in *Gen.*

Repos., July 1812, pp. 143–144; "The Columbia Bridge," reprinted from The *Philadelphia Gazette*, in *Wkly. Rec.*, January 26, 1815, pp. 236–237; Latrobe's diary, February 1, 1820, reprinted in Wilson, *Impressions Respecting New Orleans*, pp. 156–157.

38. Philo, "Letter to a Beautiful Woman," in *Lady's Misc.*, September 27, 1806, p. 380; Mentor, in *Balance*, July 7, 1807, p. 209; Observer, in *Church Mag.*, March 1807, pp. 98–101; "A Description of the Representatives' Hall —at Washington," *Am. Reg.* 5 (1807):372–373; "Cost of the Capitol," *Niles Reg.*, April 4, 1812, p. 84.

39. [George Tucker], "Thoughts of a Hermit—On Architecture," *Port Folio*, December 1814, p. 560 (for attribution, see Talbot Hamlin, *Greek Revival Architecture in America*, p. 377); "New Drury-Lane Theatre," *Port Folio*, March 1813, pp. 302–304; "The New Stone Church," *Boston Spect.*, December 31, 1814, p. 210.

40. William Short to Jefferson, July 28, 1784, in Boyd, *Papers of Jefferson*, vol. 7, pp. 385–386; V., in *N.Y. Mag.*, July 1796, p. 337 and plate; The Perambulator, in *Rambler* 1 (1809):8–15; "Remarks on the Progress and Present State of the Fine Arts in the United States," *Anal. Mag.*, November 1815, pp. 373–374; L.M., "On American Mansions," *Mo. Mag.*, October 1800, pp 241–242.

41. Latrobe's speech may be found in *Port Folio* 5 (1811), Appendix.

CHAPTER 7

1. For the European scene, see F.W. Sternfield, "Music," in A. Goodwin, ed., *The New Cambridge Modern History*, vol. 8, *The American and French Revolutions, 1763–1793*, pp. 81–96; and F.W. Sternfield, "Music," in C.W. Crawley, ed., *The New Cambridge Modern History*, vol. 9, *War and Peace in an Age of Upheaval, 1790–1830*, pp. 228–249. For the United States, see Virginia L.

Redway, "Handel in Colonial and Post-Colonial America (to 1820)"; M.D. Herter Norton, "Haydn in America (before 1820)"; and O.G. Sonneck, *Early Concert-Life in America (1731–1800)*, especially pp. 324–325. For the older view, see Lyon N. Richardson, *A History of Early American Magazines, 1714–1789*, pp. 239–242; and John Tasker Howard, *Our American Music: Three Hundred Years of It*, pp. 40–41.

2. J.T. Howard, *Our American Music*, pp. 46–54; Gilbert Chase, *America's Music from the Pilgrims to the Present*, pp. 128–146; Henry W. Foote, *Three Centuries of American Hymnody*, p. 172; Wilfrid Mellers, *Music in a New Found Land*, pp. 7–15; Irving L. Sablosky, *American Music*, pp. 3–34; Irving Lowens, "The Origins of the American Fuguing Tune."

3. H. Wiley Hitchcock, *Music in the United States: A Historical Introduction*, p. 15; Chase, *America's Music*, pp. 106–122; Mates, *American Musical Stage Before 1800*, p. 84, 85.

4. "History, Nature, and Dignity of Music," *Lit. Tab.*, June 17, 24, July 1, 1807, pp. 78–79, 81–82, 87.

5. Rev. John Bennett, "Letter IX—On Music and Dancing," *Am. Museum*, March 1792, pp. 92–93; "The Moderator, No. 3," *Mo. Mag.*, December 1808, pp. 147–151; Veritas, "False Prejudice Against Music," *Lit. Mag.*, January 1805, pp. 9–10; "New Music," *Port Folio*, February 8, 1806, p. 73.

6. "Observations on the Music of Handel," *Port Folio*, June 1810, pp. 472–474; review of W.H. Drummond's *The Battle of Trafalgar*, in *Mo. Reg.* 3 (1807):238–239; "Journal of a Tour from Paris to Amsterdam, in the Year of 1796," *Port Folio*, April 21, 1804, p. 124; review of the Harmonic Society Concert, ibid., March 27, 1802, p. 90.

7. "History, Nature, and Dignity of Music," *Lit. Tab.*, June 17, 1807, pp. 78–79; Reflections on Music—from Feijoo," *Port Folio*, June 21, 1806, pp. 378–381; "On the Present State of Music," *Lit. Mag.*, May 1804, pp. 147–149. For the "Ancient-Modern Quarrel" in England, see Warren Dwight Allen, *Philosophies of Music History: A Study of General Histories of Music, 1600–1960*, pp. 71–75.

8. "Observations on the Music of Handel," *Port Folio*, June 1810, pp. 472–474; "Grand Musical Performances," *Mirror*, May 1810, pp. 428–430; "Life of Joseph Haydn," *Sel. Rev.*, February 1812, pp. 169–173.

9. Donald Nitz, "The Norfolk Musical Society, 1814–1820: An Episode in the History of Choral Music in New England"; Butterfield, *Diary and Autobiography of John Adams*, vol. 2, p. 104; Frank J. Metcalf, *American Writers and Compilers of Sacred Music*, pp. 54–55.

10. "The People the Best Governors. Or a Plan of Government Founded on the Just Principles of Natural Freedom" (1776), reprinted in *The Magazine of History*, Extra Number 84 (1922), pp. 25–35; Elisha P. Douglass, *Rebels and Democrats: The Struggle for Equal Political Rights and Majority Rule during the American Revolution*, especially pp. 15–16; William Billings, "To All Musical Practitioners," in his *The New England Psalm Singer, or American Chorister* (1770), quoted in Gilbert Chase, ed., *The American Composer Speaks: A Historical Anthology, 1770–1965*, pp. 29–31; Hans Nathan, ed., *The Continental Harmony by William Billings*, p. xxxiii.

11. R., in *Mo. Anthol.*, January 1804, pp. 136–138. For Andrew Law, see Chase, *America's Music*, pp. 141–145, and Metcalf, *American Writers and Compilers*, pp. 68–79.

12. Review of *Columbian and European Harmony, or Bridge-*

water Collection of Sacred Musick, in *Mo. Anthol.*, January 1808, p. 51; A.B., "On Music—On Design," *Wkly. Visit.*, July 12, 1806, pp. 217–218; Harmonicus, "Sacred Music," *Balance*, June 17, 1806, p. 186; M., "Observations on Church Music," *Church Mag.*, September–October 1809, pp. 357–360; review of *The Salem Collection of Classical Sacred Musick*, in *Mo. Anthol.*, April 1807, pp. 213–216.

13. "A Letter to the Rev. Doctor White, on Church Music," *Univ. Asylum*, September 1792, pp. 153–155; T. Collyer, "Church Music," *Boston Wkly.*, June 30, July 14, 1804, pp. 142, 149–150. For Hopkinson, see also Oscar G.T. Sonneck, *Francis Hopkinson: The First American Poet-Composer (1737–1791)*.

14. "Church Music," *Christ. Dis.*, April 1814, pp. 108–110; "Norfolk Musical Society," ibid., November 1815, p. 352; "Journal of a Tour from Paris to Amsterdam, in the Year 1796," *Port Folio*, April 14, 1804, p. 118.

15. "Observations on the Music of Handel," *Port Folio*, June 1810, pp. 472–474; E.S. Ely, "Psalmody," *Christ. Mon.*, March 13, 20, 1813, pp. 595–598, 612–615.

16. B., "On Sacred Music," *Christ. Dis.*, July 1814, pp. 206–209.

17. Philo Madan, "Sacred Harmony," *Phila. Repert.*, July 14, 1810, p. 85; Viator, "Sacred Music," *Port Folio*, January 25, 1806, pp. 41–42; O.A., "The Examiner—No. VI: Musical Review," *Polyanthos*, July 1812, p. 86; *Mirror*, August 1810, pp. 123–126; "A General View of the Caracas," *Sel. Rev.*, November 1812, p. 366; Butterfield, *Diary and Autobiography of John Adams*, vol. 2, p. 31; Adams to Abigail Adams, October 9, 1774, in Adams, *Familiar Letters*, pp. 46–47; Abigail Adams to Thomas Jefferson, June 6, 1785, in Boyd, *Papers of Jefferson*, vol.

8, p. 180; Latrobe diary entries for February 16 and 26, 1819, reprinted in Wilson, *Impressions Respecting New Orleans*, pp. 38–39, 61.

18. S., "Thoughts on the Powers of Music," *Mo. Mag.*, February 1800, pp. 85–89; *Mo. Anthol.*, January 1808, p. 51; "Extracts from the Journal of a Gentleman on a Visit to Lisbon," ibid., January 1811, p. 12.

19. Juvenal, in *Lady's*, February 1801, pp. 65–66.

20. Orpheus, "To the Public," *Am. Mag.*, June 1788, pp. 448–450. For attribution, see Richardson, *Early American Magazines*, p. 304n.

21. Cheron, "Remarks on the Use and Abuse of Music, etc., as a Part of Modern Education," *N.Y. Mag.*, April, May, 1794, pp. 224–229, 265–268; "On Music," *Port Folio*, July 30, August 6, 1803, pp. 242–243, 251–253.

22. "Reflections on Music—From Feijoo," *Port Folio*, June 21, 1806, pp. 378–381; "The Fine Arts," *Halcyon*, April 1812, pp. 172–175; "On The Effects of Music—an Observation of Tartini," *Emerald Mis.*, November 1, 1806, pp. 321–322; Pythagoricus, "Essays on Music," *Repos.*, April 10, 1802, p. 174; Butterfield, *Diary and Autobiography of John Adams*, vol. 4, p. 66.

23. Francis Hopkinson to Jefferson, October 23 and December 1, 1788, in Boyd, *Papers of Thomas Jefferson*, vol. 14, pp. 33, 324, 325n; Sonneck, *Francis Hopkinson*, pp. 115–116; Jefferson to Hopkinson, March 13, 1789, in Boyd, *Papers of Thomas Jefferson*, vol. 14, p. 649.

24. "Simple Songs," *Mo. Anthol.*, January 1808, pp. 32–33; "Essay on Musick," *Univ. Asylum*, March 1790, pp. 181–183; Letter of Benjamin Franklin to Mr. P. Franklin, in *Mass. Mag.*, July 1790, pp. 412–414; "Thoughts of a Hermit—On Simplicity in Ornament," *Port Folio*, July 1815, p. 83; "Essay on the Arts, Commonly Called Imitative," *Lit. Mag.*, November 1803, pp. 144–150;

Latrobe to Christian Latrobe, January 5, 1807, in Latrobe Collection; Jefferson to James Monroe, May 26, 1797, in P.L. Ford, *Works of Thomas Jefferson*, vol. 8, p. 180; Marie Kimball, *Jefferson: The Road to Glory, 1743–1776*, pp. 57–59. For contemporary critical responses to early American musical theater, see Mates, *American Musical Stage Before 1800*, pp. 221–222. For the difficulty in finding sheet music for sale even in New York City, see Charles Willson Peale Diary, vol. 11, pp. 11–12 (June 2, 1791), in Peale Papers.

25. Timothy Catgut, "A Musician: A Character," *Repos.*, February 27, 1802, p. 123; *Wkly. Visitor*, September 11, 1810, p. 264; Anthony Evergreen, "Mr. Wilson's Concert," *Salmagundi*, February 4, 1807, pp. 27–31; "An Analytical Abridgment of the Principal of the Polite Arts; Belles Lettres, and the Sciences—Music," *Christ. Schol. Mag.*, (December 1789–January 1790, February–March, April–May, June–July 1790, pp. 593–595, 718–719, 76–80, 186–189.

26. Observer, Letter to the Editor, in *Columbian Mag.*, April 1788, p. 211–213; "Essay on Musical Criticism," *N.Y. Mag.*, March 1793, pp. 171–175; Allen, *Philosophies of Music History*, pp. 76–81, 85; "Musical Review of Mr. Carr's Concert," *Port Folio*, February 21, 1801, p. 59; "On Music as a Female Accomplishment: A Dialogue," ibid., September 18, October 2, 9, 1802, pp. 291–292, 307–308, 315–316.

27. Sellers, *Charles Willson Peale*, vol. 1, p. 130; Jefferson to Martha Jefferson Randolph, February 11, 1800, in Edwin M. Betts and James A. Bear, eds., *The Family Letters of Thomas Jefferson*, pp. 183–184, 184 n1; Jefferson to John Paradise, May 25, 1786, in Boyd, *Papers of Thomas Jefferson*, vol. 9, p. 579; Jefferson to Charles Burney, July 10, 1786, ibid., vol. 10, p. 118; Burney to Jefferson, Jan-

uary 20, 1787, ibid., vol. 11, pp. 59–60; Peale to John J. Hawkins, September 8, 1805, in Peale Papers.

28. For the actual concert scene, see Sonneck, *Early Concert-Life*, and Mates, *American Musical Stage Before 1800*; "An Account of Moravian Settlements in Pennsylvania," *Mass. Mag.*, September 1796, pp. 469–472; Philo-Musices, "Propriety of Using Churches for Musical Exhibitions," *Christ. Obs.*, January 1810, pp. 24–25.

29. Timotheus, Jr., "On the Propriety of Christians Attending Public Concerts," *Christ. Obs.*, December 1804, pp. 752–754; extract from the New York *Evening Post*, in *Port Folio*, February 20, 1802, p. 54; [Eliza Anderson], "Music," *Observer*, May 23, 1807, pp. 333–334.

30. A.L.B., "Strictures on the Present Musical Entertainments of the Theatre," *Lady's*, January 1802, pp. 1–3.

31. Mates, *American Musical Stage Before 1800*, pp. 17, 142, 152–153.

32. "Music," *Lady's Wkly.*, December 10, 1808, pp. 104–106; Cheron, "Remarks on the Use and Abuse of Music, etc., as a Part of Modern Education," *N.Y. Mag.*, April 1794, pp. 224–229; "Letters of an American in Europe," *Mo. Anthol.*, May 1807, pp. 245–249; X.Y.Z., "Musical," *Observer*, December 12, 1807, pp. 368–370; "Sketches of the Life of Mozart, the Composer," *Rambler* 2 (1809): 54–62; Leslie to "Betsey," June 3, 1816, in his *Autobiographical Recollections*, p. 198.

33. Daniel M. McKeithan, ed., *Traveling with the Innocents Abroad: Mark Twain's Original Reports from Europe and the Holy Land*; "Tour through Jamaica," *Port Folio*, August 1812, p. 130; review of *Musical Biography*, in *Anal. Mag.*, December 1814, p. 448; "Account of Spain," *Niles Reg.*, March 7, 1812, pp. 3–4; G.H.M., "Thoughts on Musick, in a Letter to a Friend," *Univ. Asylum*, July 1790, pp. 22–23; Alexis, "On Music," *Wkly. Visit.*, Au-

gust 3, 1805, pp. 348–349; "On Music," *Merrimack*, March 8, 1806, p. 119; *Mo. Anthol.*, January 1807, pp. 50–51; J.Q. Adams to Louisa Catherine Adams, January 24, 1815, in W.C. Ford, *Writings of John Quincy Adams*, vol. 5, pp. 272–273.

34. Mates, *American Musical Stage Before 1800*, pp. 127–128; Sonneck, *Francis Hopkinson*, pp. 10–13; Butterfield, *Diary and Autobiography of John Adams*, vol. 2, pp. 46–47.

35. Mates, *American Musical Stage Before 1800*, pp. 170–171, 20, 21; Latrobe diary, in Wilson, *Impressions Respecting New Orleans*, pp. 49–51; Butterfield, *Diary and Autobiography of John Adams*, vol. 2, p. 284.

36. O . . . , in *Repos.*, February 20, 1802, p. 116; J.I.H. and Frank Liberal, ibid., February 27, 1802, pp. 124, 126–127; Senex and Verus, ibid., March 6, 1802, p. 132; "The Caravansary," *Port Folio*, February 23, 1805, pp. 51–52.

37. "Letters from Europe," *Mo. Anthol.*, June 1806, pp. 281–285; "Letters of an American in Europe," ibid., October 1807, pp. 536–539; "Austrian Dalmatia," *Observer*, August 15, 1807, pp. 97–99; "An Account of Spain," *Niles Reg.*, March 7, 1812, pp. 3–4; Frederick Hall, "Modern Paris," *Lit. Repos.*, September 1814, p. 107.

38. "On Dancing," *Lady's Wkly.*, February 4, 1809, pp. 230–233; "Letters on France and England," *Mo. Mag.*, January 1813, p. 136; from his autobiography, quoted in Sellers, *Charles Willson Peale*, vol. 1, p. 276–277.

CHAPTER 8

1. Throughout this chapter, important insights have been drawn from Roderick Nash, *Wilderness and the American Mind*, especially pp. 30–56.

2. E., in *Port Folio*, May, June, 1811, pp. 450–452, 488–492; *Gen. Repos.*, April 1812, pp. 374–410; *Anal. Mag.*,

February 1814, pp. 89–104; Journal of Dunbar and Hunter's Trip Up the Red River, in *Omnium*, June 1810, pp. 345–354, reprinted from *Am. Reg.* 5 (1809): 311–345; B., Review of Lewis and Clark Expedition, in *Anal. Mag.*, February 1815, p. 137. For similar responses by American poets, see Eugene L. Huddleston, "Topographical Poetry in the Early National Period."

3. *Sel. Rev.*, May 1810, pp. 296–304; *West Glean.*, May 1814, pp. 350–375; review by B., in *Anal. Mag.*, February 1815, p. 141; review of Brackenridge's *Views of Louisiana*, in *West. Glean.*, December 1813, p. 67; review of Ashe's *Travels in America*, in *Mo. Mag.*, June 1812, pp. 81–89, reprinted in *Sel. Rev.*, August 1810, pp. 108–116; review of Stoddard's *Sketches of Louisiana*, in *Port Folio*, December 1812, pp. 569–582; D.T. Madox, "Description of the Mississippi," *Niles Reg.* 5 (1814), Supplement, pp. 176–177; review of Pike's expedition, in *Balt. Repos.*, March, April 1811, pp. 151–159, 187–188, reprinted in *Sel. Rev.*, July 1811, pp. 44–56; H.N. Smith, *Virgin Land: The American West As Symbol and Myth.*

4. Jefferson to André de Dashkoff, August 12, 1809, in Lipscomb and Bergh, *Writings of Jefferson*, vol. 12, p. 304; Adams to Abigail Smith, February 14, 1763, in Butterfield, *Adams Family Correspondence*, vol. 1, p. 3.

5. Entry for April 7, 1796, in Latrobe Journal, vol. 2, Latrobe Collection; Adams to Thomas Brand-Hollis, June 1, 1790, in Adams, *Works of John Adams*, vol. 9, p. 569; Butterfield, *Diary and Autobiography of John Adams*, vol. 1, p. 34.

6. Peale's Diary, vol. 12, pp. 9–10, in Peale Papers; Ellen Randolph Coolidge to Thomas Jefferson, August 1, 1825, in Betts and Bear, *Family Letters*, p. 455.

7. Butterfield, *Diary of John Adams*, vol. 2, p. 136; [Noah Webster], "Miscellanies," *Am. Mag.*, February 1788,

pp. 164–166 (for attribution, see Richardson, *Early American Magazines*, p. 304n); copy of a letter from Latrobe to his brother, March 23, 1796, in Latrobe Journal, vol. 2, Latrobe Collection; B., "Philadelphia Water Works," *Mo. Mag.*, June 1799, pp. 181–182; "Sketch of the Origins and Present State of Philadelphia," *Lit. Mag.*, June 1804, pp. 169–175, reprinted in *Port Folio*, April 6, 1805, pp. 97–98; W., "Philadelphia," *Lit. Mag.*, October 1806, pp. 261–262; "Letters from Pennsylvania," *West. Glean.*, January 1814, p. 93; Will Wizard, "The Stranger in Pennsylvania," *Salmagundi*, May 16, 1807, pp. 197–206.

8. *Columbian Mag.*, December 1787, pp. 787–790 and frontispiece; A Pennsylvanian, "A Tour of the Eastern States," ibid., November 1789, p. 630; *N.Y. Mag.*, July 1794, pp. 387–388 and plate; P., "Beacon Hill," *Emerald*, November 8, 1806, pp. 330–331; "Sketches from Nature. A Landscape," *Port Folio*, November 28, 1807, pp. 339–340.

9. Peale's manuscript Autobiography, in Peale Papers; Butterfield, *Diary and Autobiography of John Adams*, vol. 2, p. 108. See also Thomas Shippen to William Shippen, September 15, 1790, in Boyd, *Papers of Jefferson*, vol. 17, p. 464.

10. Butterfield, *Diary and Autobiography of John Adams*, vol. 2, pp. 103–104; "A Traveller's Letters," *Lit. Mag.*, February, March 1807, pp. 28–33, 119–124. See also St. John de Crévecoeur to Jefferson, October 20, 1788, in Boyd, *Papers of Jefferson*, vol. 14, p. 30.

11. *Columbian Mag.*, December 1789, pp. 692–693 and plate; "A Sketch of Pittsburgh," *Lit. Mag.*, October 1806, pp. 252–254; Latrobe to Abraham Wooley, October 10, 1815, in Latrobe Collection; "Travellers in America," *Niles Reg.*, May 2, 1812, p. 142.

12. "Description of Poughkeepsie," *Rural Casket*, June 5, 1798, p. 3; "Huntingdon County: Pennsylvania—Number 1," *Hunt. Lit. Mus.*, February 1810, pp. 67–70; Secretus, in *Boston Mag.*, May 1784, pp. 277–280; Adams to Abigail Adams, February 7, 1777, in Adams, *Familiar Letters*, pp. 240–242; Constantia, "A Letter to a Friend," *Mass. Mag.*, June 1791, pp. 365–370, reprinted in *N.Y. Mag.*, August 1790, pp. 458–464; "An Account of Moravian Settlements in Pennsylvania," *Mass. Mag.*, September 1796, pp. 469–472; "Cursory Sketches in Pennsylvania and the Border of Maryland and Virginia," *Port Folio*, January 2, 1808, p. 14; Joseph Sansom, "A Description of Nantucket," ibid., January 1811, pp. 30–43 and plate.

13. "Use of Water in Landscapes," *Lit Mag.*, August 1806, p. 123; T.M., in *Am. Museum*, February 1791, pp. 83–84; William Jones, "A Topographical Description of the Town of Concord," Massachusetts Historical Society *Collections*, vol. 1 (1792), p. 239; J.H., "Original Account of the Burrough of Easton, in Pennsylvania," *Phila. Mo. Mag.*, September 1798, pp. 113–115 and plate; "View Near Philadelphia," *N.Y. Mag.*, August 1795, p. 449 and plate; N.C., "Beautiful Prospect from the Town of Washington," *Rural Mag*, June 1795, pp. 299–301; review of Melish's *Travels*, in *Port Folio*, February 1813, pp. 128–129.

14. "Ballston or Milton Springs," reprinted from the New York *Morning Chronicle*, in *Port Folio*, October 30, 1806, p. 340; Latrobe's Journal, vol. 1, entry for August 3, 1806, in Latrobe Collection; Z., "Topography of Saint Louis," reprinted from the *Louisiana Gazette*, in *Balance*, August 6, 1811, p. 256; "A Sketch of Pensacola," *Omnium*, October 1810, pp. 524–529; Jeremy Cockloft, the Younger, "Memorandums for a Tour, to be Entitled,

'The Stranger in New Jersey; or, Cockney Travelling,' "
Salmagundi, February 24, 1807, pp. 61–67.

15. "Of New Orleans—From the Dispatch of the Correspon-
dent to the *Bee*," *Wkly. Mon.*, October 27, 1804, p. 107;
Wilson, *Impressions Respecting New Orleans*, pp. 21, 23–
24, 40–42; "A Description of New Orleans—By a Resi-
dent of Several Years," *Lit. Mag.*, July 1805, pp. 39–42,
reprinted in *Balance*, September 24, 1805, pp. 308–310;
John Pintard, "Description of the Mississippi," ibid., Au-
gust 2, 1803, pp. 245–246; review of *Travels in Louisiana*
translated by John Davis, in *Mo. Anthol.*, December 1806,
pp. 649–652; Captain J.T. Bentley, "New Orleans,"
Am. Reg. 6 (1810):325–327; "A Description of the
Roman Catholic Chapel and the Convent of Ursuline Nuns
in New Orleans," reprinted from N.G.M. Senter's
Travels, in *Olio*, February 20, 1813, pp. 28–29.

16. Presto, "On the Recession of the District of Columbia,"
Lit. Mag., February 1805, pp. 93–96; "An Account of
the City of Washington—Drawn Up by a Foreigner, in
1803," ibid., August 1805, pp. 133–137; "Review of and
Extracts from *Letters Concerning the United States of
America*," *Port Folio*, June 12, 1802, pp. 177–179;
"Annals of America," *Am. Reg.* 5 (1809):34–79; "A
Cursory Review of the Exhibition of the Academy of Arts,"
Balance, July 16, 1811, pp. 228–229; "A Sketch of
American Literature, from 1806–7," *Am. Reg.* 2
(1807):160–162.

17. Latrobe to Signor Mazzei, May 29, 1806, in Latrobe
Collection; "Jefferson's Draft of Agenda for the Seat of
Government," August 29, 1790, in Boyd, *Papers of Jef-
ferson*, vol. 17, pp. 460–461; "Jefferson's Report to
Washington on Meeting Held at Georgetown," September
14, 1790, ibid., vol. 17, pp. 461–463; Jefferson to George
Washington, April 10, 1791, in Lipscomb and Bergh,

Works of Jefferson, vol. 8, pp. 165–166; Jefferson to Johnson, Stewart, and Carroll, undated, ibid., p. 256; Jefferson to the Commissioners of Washington, April 9, 1792, ibid., pp. 322–324; "Notes on Commissioners' Meeting," September 8, 1791, in Saul K. Padover, *Thomas Jefferson and the National Capital*, pp. 70–74; Jefferson to Thomas Johnson, March 8, 1792, ibid., pp. 109–112; Jefferson to the Commissioners, April 20, 1792, ibid., pp. 137–138. A good overall treatment, with a full bibliography, may be found in John W. Reps, *Monumental Washington*. For a fascinating discussion of the ways in which the city's form both affected and symbolized political life, see James Sterling Young, *The Washington Community, 1800–1828*.

18. Reply to the Answer of the Senate, in Adams, *Works of John Adams*, vol. 9, pp. 147–148; Jefferson to Thomas Mann Randolph, December 5, 1800, *Jefferson Papers*, in Massachusetts Historical Society *Collections*, 5th series, vol. 61 (1900), p. 80; "Description of the City of Washington . . . ," *Mass. Mag.*, December 1791, May, 1792, pp. 725–726, frontispiece map, reprinted in *Univ. Asylum*, March 1792, pp. 155–156, and in *Am. Museum*, November 1792, pp. 258–259; A Spectator, reprinted from the *Maryland Journal*, in *N.Y. Mag.*, November 1791, pp. 656–658; "Observations on the River Potomac, the Adjacent Country, and the City of Washington," *N.Y. Mag.*, May 1794, pp. 268–274; Latrobe to Colonel Tatem, February 5, 1810, in Latrobe Collection; Jefferson to Barlow, May 3, 1802, in P.L. Ford, *Works of Jefferson*, vol. 9, pp. 371–372. For an unusually favorable description by a tourist, see Peale Diary, vol. 20, entry for June 1, 1804, in Peale Papers.

19. John W. Reps, "Thomas Jefferson's Checkerboard Towns"; Wilson, *Impressions Respecting New Orleans*,

pp. 62–65; Latrobe to Samuel Mifflin, March 30, 1805, enclosing "Remarks on the Plan of the Town of Nescopeck, Pennsylvania," Latrobe to E.B. Caldwell, July 31, 1810, and Latrobe Journal, vol. 8, Appendix, entry for June 8, 1797, all in Latrobe Collection; Latrobe's "References to the Plan and Sections of the Town of Newcastle," in the 1804 Survey, now in the Hall of Records, Delaware State Archives, Dover. For an excellent general history, see John W. Reps, *The Making of Urban America: A History of City Planning in the United States.*

20. David R. Papke, "The Green"; Alice G.B. Lockwood, ed., *Gardens of Colony and State: Gardens and Gardeners of the American Colonies and of the Republic Before 1840,* vol. 1, pp. 121, 337–338, 266–267, 28; for Battery Park, see Peale's Diary, vol. 20, entry for July 9, 1804, in Peale Papers. Lockwood's cumbersome, encyclopedic work remains virtually the only available work on the subject of gardens and parks in early America.

21. P., "On the Utility of Trees in Cities," reprinted from the Charleston *City Gazette,* in *Mass. Mag.,* August 1795, pp. 299–301; "Sketch of the Origins and Present State of Philadelphia," *Lit. Mag.,* June 1804, pp. 169–175, reprinted in *Port Folio,* April 6, 1805, pp. 97–99; Peale to the Select and Common Councils of the City of Philadelphia [ca. March 20, 1804], in Peale Papers; B., "Philadelphia Water Works," *Mo. Mag.,* June 1799, pp. 181–182; B., in *Columbian Mag.,* January 1790, pp. 25–26; Lockwood, *Gardens of Colony and State*; Mentor, "Thoughts," *Balance,* May 12, 1807, p. 145.

22. *N.Y. Mag.,* July 1794, pp. 387–388 and plate; letters of Rustic to Listless, in *Eye,* October 6, 1808, pp. 161–166; "The Water Works," *Port Folio,* July 1812, pp. 30–31 and plate; "Letters from Pennsylvania," *West. Glean.,* January 1814, pp. 96–97; Jeremy Cockloft, the Younger,

"The Stranger at Home; or, a Tour in Broadway," *Salmagundi*, June 27, 1807, pp. 239–248; Peale to . . . the City of Philadelphia, Peale Papers; "Description of the State-House, etc., in Philadelphia," *Phila. Mo. Mag.*, June 1798, pp. 333–334. A convenient general history of gardening may be found in Richardson Wright, *The Story of Gardening*

23. "Character of the Marylanders," *Am. Museum*, February 1790, pp. 71–74; "On the Small *Attention* Paid to *Gardening* in *America*—translated from Schoepf's *Travels*," *Univ. Asylum*, August 1791, pp. 79–80; "City and Country Contrasted," *Juv. Mag.* 1 (1802):76–81; Knox, "On Forming a Taste for Simple Pleasures," *Observer*, June 11, 18, 1809, pp. 126–127, 134–135; "On the Employment and Pleasures of a Garden," *S.C. Mus.*, May 27, 1797, pp. 658–660.

24. Sarah P. Stetson, "American Garden Books Transplanted and Native, before 1807"; Lockwood, *Gardens of Colony and State*, vol. 1, pp. 6, 7, and vol. 2, p. 28; Peale Diary, vol. 20, entry for June, 1804, in Peale Papers; Butterfield, *Diary and Autobiography of John Adams*, vol. 2, pp. 260–261; Marie Kimball, *Jefferson: The Road to Glory*, pp. 160–165; Jefferson to Anne Cary Randolph, June 7, 1807, in Betts and Bear, *Family Letters*, pp. 307–308; Sellers, *Charles Willson Peale*, vol. 2, pp. 282–285; Latrobe Journal, vol. 3, entry for July 19, 1796, in Latrobe Collection. For comments similar to Latrobe's regarding the estates of South Carolina planters, see John Trumbull to Harriet Wadsworth, April 7, 1791, quoted in Sizer, *Autobiography of Trumbull*, p. 167 n15.

25. "Vauxhall," *Whim*, June 25, July 2, 9, 1814, pp. 152–155, 179, 201–203; "Vauxhall," *Lady's Mon.*, October 19, 1801, p. 79. For a brief history of the pleasure garden in eighteenth-century America, see Mates, *American Mu-*

sical Stage Before 1800, pp. 29–31. For the kinds of entertainment, see the advertisements reprinted in Gottesman, *Arts and Crafts in New York*, pp. 43–44, 459–460.

26. Lockwood, *Gardens of Colony and State*, vol. 1, p. 268; Peale's Diary entry for June 29, 1798, quoted in Sellers, *Charles Willson Peale*, vol. 2, pp. 104–105; "Vauxhall," *Whim*, June 25, 1814, pp. 152–155; Cutler, quoted in Lockwood, *Gardens of Colony and State*, vol. 1, pp. 338–339.

27. Constantia, "A Letter to a Friend," *Mass. Mag.*, July 1791, pp. 413–417.

28. "On the Beauties of *Gray's Gardens*, on the River Schuylkill," *Univ. Asylum*, June 1790, pp. 357–358.

29. K., "On the Folly of Sacrificing Comfort to Taste," *Lady's Misc.*, August 15, 1812, pp. 264–267; "Nature and Art. A Thought," *Rural Casket*, June 5, 1798, p. 9; review of Uvedale Price's *An Essay on the Picturesque*, in *Am. Mo. R.* 2 (1795):232–235; "Correspondence Between Lord Kames and Mrs. Montague," *Mo. Anthol.*, March 1808, pp. 150–153; Ian Ross, "A Bluestocking over the Border: Mrs. Elizabeth Montague's Aesthetic Adventures in Scotland, 1766."

30. "Of the *Art* of Laying out *Gardens* among the *Chinese*," *Univ. Asylum*, December 1790, pp. 389–392; Lord McCartney, "Chinese Gardening," *Lit. Mag.*, April 1805, pp. 249–253, and extracted in *Ladies Wk. Mus.*, November 5, 1814, p. 212; Proclus, "On the Genius of the Chinese," *Port Folio*, April, June 1811, pp. 342–346, 494–506.

31. Lockwood, *Gardens of Colony and State*, vol. 1, pp. 8–9, and vol. 2, p. 22; "American Scenery—The Woodlands," *Port Folio*, December 1809, pp. 505–507; Sarah P. Stetson, "William Hamilton and His 'Woodlands' "; Lockwood, *Gardens of Colony and State*, vol. 1, pp. 268–269;

"American Scenery, Dr. Hosack's Botanic Gardens," *Port Folio*, January 1810, pp. 36–38, and widely reprinted; "Sketch of the Elgin Botanic Garden," *Am. Med. Reg.*, July 1811, pp. 1–4 and frontispiece. For a reproduction of Hugh Reinagle's engraving, ca. 1816, see John Kouwenhoven, *The Columbia Historical Portrait of New York*, p. 102.

32. Review of Miller's *Retrospect* . . . , in *Lit. Misc.* 1 (1805):82–92; John Dunbar, "Horticultural," *Port Folio*, July 1810, pp. 62–64.

33. Mr. Mercier, "Elogy on the Country Life," *N.Y. Mag.*, December 1786, pp. 1–3; Tyro, "My Garden," *Port Folio*, July, September, 1811, pp. 61–63, 275–279; "On Ornamental Gardening," *Rural Mag.*, April 14, 21, 1798, unpaged; "Original Letters," *Gent. Mag.*, September, November 1789, pp. 401–402, 524–526; A.W., "Reflections on Spring," *Repos.*, May 21, 1803, pp. 163–164; "On the Beauty and Variety of Butterflies," *Mass. Mag.*, July 1790, pp. 425–427.

34. "Morality—Nature and Art," *Ladies Wk. Mus.*, July 12, 1813, p. 40; "On the Grandeur and Beauty of Nature," *Juv. Mag.* 3 (1803):179–187; "Nature," *N.Y. Wkly.*, November 30, December 21, 1796, pp. 171, 199; "Juvenis, No. I," *N.Y. Mag.*, January 1790, pp. 6–7; "The Drone—No. XVI," ibid., April 1793, pp. 195–197.

35. Penn's letter reprinted in *Am. Museum*, July 1789, pp. 46–48; "American Prospects," *Lit. Mag.*, February 1805, p. 97; "American Scenery," *Pastime*, April 4, 1807, pp. 49–50; Jefferson to Maria Cosway, October 12, 1786, and September 26, 1788, in Boyd, *Papers of Jefferson*, vol. 10, p. 447, and vol. 13, p. 639; R.H.R., "Buttermilk-Falls Creek," *Port Folio*, February 1809, p. 101 and plate; "The Chameleon, No. VIII—Reflections on the Beauties of Nature," *Observer*, July 4, 1807, pp. 1–7.

36. A Rustic, in *Port Folio*, August 1815, pp. 203–204; Valverdi [Critique of Weld's *Travels*], in *Lit. Mag.*, January 1806, pp. 30–34; Lockwood, *Gardens of Colony and State*, vol. 1, p. 412, with an illustration of Blennerhasset Isle; view of Minisink, New Jersey, in *N.Y. Mag.*, June 1794, p. 323; "American Scenery—Lemon Hill," *Port Folio*, August 1813, p. 166 and plate; "The Archer, No. III," *Mo. Reg.* 1 (1806):345–352; A., "Description of the Yellow Springs, Pennsylvania," *Port Folio*, July 1810, pp. 44–47 and plate. Compare the last with the description of Bedford, New York, by B., ibid., June 2, 1804, p. 172, and of Blue Island on the Muskingum River, in "Western States," *West. Glean.*, August 1814, pp. 166–168.

37. "The Loiterer, No. I," *Mo. Anthol.*, November 1803, pp. 3–6; compare the review of Thomas Ashe's *Travels in America*, in *Mo. Anthol.*, December 1808, pp. 671–677, with *Timepiece*, February 7, 1798, p. 1; J.W., "Bedford Medicinal Springs," *Port Folio*, June 1811, pp. 467–473; "Memorandum on a Journey through Part of Pennsylvania," *Lit. Mag.*, December 1803, January, 1804, pp. 167–173, 250–255; Huddleston, "Topographical Poetry in the Early National Period."

38. *N.Y. Mag.*, February 1794, p. 67 and plate; W., "A Rustic Cemetery," *Lit. Mag.*, August 1805, pp. 127–128; Jefferson to Martha Jefferson Randolph, May 31, 1791, in P.L. Ford, *Works of Jefferson*, vol. 6, pp. 264–265; Latrobe Journal, vol. 8, Appendix, entry for June 9, 1797, in Latrobe Collection; "An Essay on Picturesque Travel—from Gilpin's Essays," *N.Y. Mag.*, December 1793, pp. 736–741; Hussey, *The Picturesque*, pp. 111–116; Martin Price, "The Picturesque Moment"; A Looker On, "On a Taste for the Picturesque," *Mo. Mag.*, July 1800, pp. 11–13; W., "On the Picturesque," *Lit. Mag.*,

July 1806, pp. 6–8; Poussin, "Travel," *Port Folio*, August 8, 1807, pp. 1–7. For an unusual description of a picturesque war scene, see Sizer, *Autobiography of Trumbull*, pp. 34–35.

39. "Sketches from Nature. A Landscape," *Port Folio*, November 28, 1807, pp. 339–340; James Madison to Thomas Jefferson, August 12, 1786, in Boyd, *Papers of Jefferson*, vol. 10, p. 230; "Original Letters from the Interior of the State of New-York," *Balance*, March 5, 1811, p. 73; Jefferson to Ellen W. Coolidge, August 27, 1825, in Lipscomb and Bergh, *Writings of Jefferson*, vol. 18, p. 341; "Western States. Allegheny Mountains," *West. Glean.*, August 1814, p. 155.

40. "The Chameleon, No. VIII—Reflections on the Beauties of Nature," *Observer*, July 4, 1807, pp. 1–7; *N.Y. Mag.*, March 1793, p. 131.

41. "The Natural Bridge," *Hunt. Lit. Mus.*, May 1810, pp. 220–221; "Natural Bridge," *Lit. Mag.*, September 1804, pp. 441–442; William Carmichael to Thomas Jefferson, October 3, 1786, in Boyd, *Papers of Jefferson*, vol. 10, pp. 429–430; "Niagara Falls—In a Letter from Andrew Ellicott to Dr. Rush," *N.Y. Mag.*, November 1794, pp. 97–98; "Description of the Falls of Niagara," *Eve. Fireside*, November 15, 1806, pp. 366–367; J.R., "Niagara Falls," *Port Folio*, September 22, 1804, pp. 298–299; E., ibid., May, June 1811, pp. 450–452, 488–492; "Original Letters from the Interior of the State of New-York," *Balance*, April 9, 1811, p. 113; "Passaic Falls," *Repos.*, January 7, 1804, pp. 5–6; "A Traveller's Letters," *Lit. Mag.*, April 1807, pp. 258–264.

42. "Beacon Hill," *Nightingale*, June 30, 1796, pp. 265–266; "Connecticut Scenery—from a Traveller's Journal," *Lit. Mag.*, March 1805, pp. 205–207; Mr. Mifflin,

"An Oration on the Present and Future Growth of Philadelphia," *Port Folio*, September 1810, pp. 170–173.

43. "Western Scenery," reprinted from the Bardstown, Kentucky, *Repository*, in *Niles Reg.* 5 (1814), Supplement, pp. 177–180; U., "The Missouri Expedition," *Eve. Fireside*, November 29, 1806, pp. 377–378.

44. Perry Miller, "Nature and the National Ego," in his *Errand into the Wilderness*, pp. 204–216.

CHAPTER 9

1. Harris, in his *The Artist in American Society*, pp. 124–168, deals only with the period after the Treaty of Ghent. Baker's *The Fortunate Pilgrims* ignores chronological changes in order to describe overall patterns of the whole period.

2. Abigail Adams to Isaac Smith, Jr., April 20, 1771, in Butterfield, *Adams Family Correspondence*, vol. 1, pp. 76–77; Abigail Adams, Diary, in Butterfield, *Diary and Autobiography of John Adams*, vol. 3, p. 215; Marie Kimball, *Jefferson: The Scene of Europe, 1784 to 1789*, p. 113; Boyd, *Papers of Jefferson*, vol. 13, pp. 269–270; Adams' notes of a tour with Jefferson in April, 1786, in Butterfield, *Diary and Autobiography of John Adams*, vol. 3, pp. 184–186.

3. William E. Mead, *The Grand Tour in the Eighteenth Century*, p. 221 and Chapter 7, "The Tourist and the Tutor," pp. 103–139; Robert C. Smith, "Eighteenth-century Americans on the Grand Tour." On travel books then available, see Mead, *The Grand Tour*, pp. 136–138, 261, and B. Sprague Allen, *Tides in English Taste 1619–1800): A Background for the Study of Literature*, vol. 1, p. 75. How closely Jefferson relied on the standard guidebooks may be seen in Jefferson's letters to William Ship-

pen, May 8, 1788, and to Thomas Lee Shippen, September 29, 1788, in Boyd, *Papers of Jefferson*, vol. 13, pp. 146, 643; also in Marie Kimball, *Jefferson: The Scene in Europe*, pp. 219, 223.

4. "An Account of the City of Edinburgh," *Am. Mag.*, October 1745, pp. 434–438; "Of the Character of the Tuscans, and their Present Condition," *Phila. Mag.*, May 1799, pp. 275–280; "Description of the City of Venice— In a Letter to a Friend," *New Am. Mag.*, June 1759, pp. 502–504; "Extracts from Letters of an American in Europe, to the Editor of the Philadelphia *Gazette*," *Port Folio*, November 20, 1802, p. 364; "Account of Copenhagen—by Wraxall," *Lady's Mon.*, March 13, 1802, p. 235; "A Picture of Modern Rome—By a Traveller," *Lit. Mag.*, September 1805, pp. 168–173; "Original letters of an American Traveller . . . ," *N.E.Q. Mag.*, October–December 1802, pp. 50–56; "Present Population of Lyons," *Merrimack Misc.*, June 15, 1805, pp. 5–6; "Wonders of British Industry," *Lit. Mag.*, June 1806, pp. 471–473; J.Q. Adams, "Journal of a Tour through Silesia," *Port Folio*, February 21, 1801, pp. 57–58; Sizer, *Autobiography of Trumbull*, pp. 140–141.

5. Exilius, "Impressions of Europe," *Univ. Asylum*, April 1791, pp. 215–216; *Am. Mag.*, March 1745, pp. 95– 98; Mr. Pinkerton, "Improvements in Paris Since the Last Revolution," *Lit. Mag.*, September 1806, pp. 225– 227; "French Inns," ibid., November 1806, pp. 378– 379; "A Sketch of the Present State of the Arts and Sciences, Literature, Theology, etc., in France," *Mo. Anthol.*, May 1807, pp. 237–243; "Descriptions of the Boulevards at Paris," *Polyanthos*, June 1807, pp. 163– 166; *Port Folio*, November 15, December 20, 1806, pp. 295–297, 376–377; John Adams to Jefferson, June 7, 1785, and Jefferson to John Page, May 4, 1786, in Boyd,

Papers of Jefferson, vol. 8, p. 183, vol. 9, p. 445; Abigail Adams to Mercy Warren, September 5, 1784, in *Warren-Adams Letters*, Massachusetts Historical Society *Collections*, 5th ser., vol. 78 (1925), pp. 242–246.

6. "Travels in France," *Port Folio*, April 1810, p. 295; "French Theatres," *Lit. Mag.*, November 1806; Frederick Hall, "Modern Paris," *Lit. Repos.*, November 1812, p. 94; Inquisitor, "Picture of Dublin," *Lit. Mag.*, March 1805, pp. 193–194; "Grand Cairo," *Lady's Mon.*, November 14, 1801, pp. 100–101; Butterfield, *Diary and Autobiography of John Adams*, vol. 3, p. 34; ibid., vol. 4, pp. 121–122; John Trumbull to Jefferson, October 9, 1786, in Boyd, *Papers of Jefferson*, vol. 10, pp. 438–441.

7. "Description of the City of Bremen—by Wraxall," *Lady's Mon.*, March 27, 1802, pp. 251–252; Herbert Croft, "Description of Hamburgh," *Balt. Repos.*, February 1811, pp. 79–82; "Sketch of Amsterdam," *Lit. Mag.*, September 1804, pp. 472–476; "Character and Present Condition of the Tuscans," *Companion*, April 26, 1806, pp. 203–206; "Original Letters from Italy," *Port Folio*, October 18, 1806, pp. 226–227; "Account of the State of Society and Manners in Liverpool," *Lit. Mag.*, March 1804, pp. 453–456; *Sel. Rev.*, May 1812, pp. 369–370.

8. "A Description of the Town and Island of Montreal . . . ," *Pa. Mag.*, November 1775, pp. 517–518, with map and a plate; "General Description of the Country of Algiers," *N.Y. Mag.*, January 1797, pp. 39–45; B.C., "Description of the City of Babylon," *Am. Moral Mag.*, May 7, 1798, pp. 731–736; "From a Modern Traveller," *Boston Mag.*, April 1785, pp. 123–125.

9. "Extracts from the Journal of a Gentleman on a Visit to Lisbon," *Mo. Anthol.*, February 1811, p. 79; "Letters from Geneva and France," *Port Folio*, June 18, 1808, pp.

385–389; "Description of the Ladies of Paris," *N.E.Q. Mag.*, April–June 1802, pp. 209–212; Robert R. Livingston to Mrs. James Fairlie, December 26, 1801, in Livingston Family Papers, New-York Historical Society; *Port Folio*, March 1809, pp. 211–220; "Journal of a Tour from Paris to Amsterdam," ibid., March 31, 1804, pp. 100–102; Isaac Smith, Jr. to Abigail Adams, in Butterfield, *Adams Family Correspondence*, vol. 1, pp. 70–71; J.Q. Adams, "Journal of a Tour through Silesia," *Port Folio*, March 28, April 11, May 16, 1801, pp. 97–98, 113, 153.

10. Review of *Tour in Holland in 1784*, in *Mass. Mag.*, January 1791, pp. 46–49; "A Sketch of England in General," *Lady's Mon.*, December 19, 1801, pp. 139–141; "Extract of a Letter from a Gentleman in Paris to His Friend in Philadelphia," *Port Folio*, August 28, 1802, p. 271; Butterfield, *Diary and Autobiography of John Adams*, vol. 2, p. 442; Jefferson to James Monroe, November 11, 1784, and to William Short, March 10, 1788, in Boyd, *Papers of Jefferson*, vol. 7, p. 508, vol. 12, p. 659; "Extracts from the Correspondence of an American in France," *Lit. Mag.*, January 1804, pp. 277–280; "Journal of a Tour from Paris to Amsterdam," *Port Folio*, March 24, 31, 1804, pp. 91–93, 100–102. The standard work on Grand Tour landscape preconceptions remains Manwaring, *Italian Landscape in Eighteenth Century England*.

11. Jefferson to Philip Mazzei, April 4, 1787, in Boyd, *Papers of Jefferson*, vol. 11, pp. 266–267; "A Prospect of Sweden: A Fragment," *Lit. Mag.*, November 1805, pp. 353–354; "Extracts from Mungo Park's Travels," *Repos.*, December 13, 1800, p 3.; "Letters of an American in Europe," *Mo. Anthol.*, May 1807, pp. 245–249; ibid., February 1809, pp. 88–94; "Travels in France," *Port*

Folio, May 1810, pp. 402–419; "Letters from Geneva and France," ibid., April 3, 1808, pp. 208–212; Goldsmith, "Sea Coast of Great Britain," *Eve. Fireside*, November 22, 1806; "Remarks on the Grandeur and Gloominess of Rome," *Ladies Wk. Mus.*, July 23, 1814, pp. 91–92.

12. W., in *Boston Mag.*, October, November, December 1784, pp. 510, 551–554, 601–605; V., "Some Account of Malta," *Lit. Mag.*, August 1805, pp. 83–88; Thomas Barclay to the American Commissioners, September 13, 1786, in Boyd, *Papers of Jefferson*, vol. 10, p. 359; H., "The Drone—No. 26," *N.Y. Mag.*, January 1796, pp. 3–6; S., "Description of Calcutta—By an American," *Mo. Mag.*, September–December 1799, pp. 401–403; "Account of Grand Cairo: A Place Which Has Lately Been an Object of Much Attention," *Col. Phenix*, June 1800, pp. 355–360.

13. "Extracts from the Correspondence of an American in France," *Lit. Mag.*, January 1804, pp. 277–280; "Journal of a Tour from Paris to Amsterdam," *Port Folio*, March 31, 1804, pp. 100–102; Marie Kimball, *Jefferson: The Scene of Europe*, pp. 142–144; "Letters of an American in Europe," *Mo. Anthol.*, July 1807, pp. 356–359; *Port Folio*, January 21, 1804, p. 20.

14. "Journal of a Tour from Paris to Amsterdam," *Port Folio*, April 14, 21, 1804, pp. 117–118, 124; Endymion in Exile, in *Tickler*, February 22, 1809, last page; "Extracts from the Journal of a Gentleman on a Visit to Lisbon," *Mo. Anthol.*, January, April 1811, pp. 12, 227.

15. "Picturesque View of London," *Lit. Mag.*, February 1804, pp. 376–377, and widely reprinted; "A Description of London," *Lady's Wkly.*, May 9, 16, 23, 1807, pp. 216–218, 228–229, 237–238.

16. "Manners and Amusements of Amsterdam," *Port Folio*,

March 7, 1801, pp. 77–78; letter in *Boston Wkly.*, November 20, 1802, pp. 14–15; Mr. Holcroft, "A View of Amsterdam; with Observations on the Manners of the Dutch," *Lit. Mag.*, February 1807, pp. 106–110; Adams to William Vans Murray, September 15, 1800, in W.C. Ford, *Writings of John Quincy Adams*, vol. 2, pp. 468–469, 469 n1; "Description of Dresden and Its Environs," *Lit. Mag.*, April 1804, pp. 39–45; "Pictures in Wales," ibid., September 1804, pp. 443–444; review of David Robertson's "A Tour through the Isle of Man," *Am. Mo. R.*, February 1795, pp. 119–123; "Account of the Orkney Islands," *Lit. Mag.*, September, October 1806, pp. 207–216, 272–275; "Travelling Memorandums," *Pastime*, May 30, June 6, 13, 1807, pp. 73–76, 82–84, 89–91; "Description of the Ancient City of Babylon," *Rep. of Knowl.*, May 1801, pp. 96–102; B.C., "An Interesting Description of Gibraltar," *Phila. Mag.*, March 1799, pp. 133–136; Jefferson to Lafayette, April 11, 1787, in Boyd, *Papers of Jefferson*, vol. 11, pp. 283–284.

17. *Port Folio*, September 3, 1803, p. 285; "Burke's First View of London," *Pastime*, March 7, 1807, pp. 20–21; "Original Letters from Italy," *Port Folio*, November 1, 1806, pp. 257–259; "Travelling Memorandums," *Pastime*, June 6, 1807, pp. 82–84; Robert R. Livingston to Joanna Livingston, November 23, 1801, in Livingston Family Papers, New-York Historical Society; "Letters from Geneva and France," *Port Folio*, June 25, 1808, pp. 401–406, June 1809, pp. 464–474.

18. M. Fernow, "Account of the Present State of Literature and the Arts in Italy," *Merrimack Misc.*, October 5, 1805, pp. 70–71; Adams to Abigail Adams, March 4, 1816, in Ford, *Writings of John Quincy Adams*, vol. 5, pp. 525–526; William Short to Jefferson, February 17, 1789, in Boyd, *Papers of Jefferson*, vol. 14, pp. 571–572.

19. John Ledyard to Jefferson, August 15, September 10, and November 15, 1788, in Boyd, *Papers of Jefferson*, vol. 13, pp. 517, 594–596, vol. 14, p. 181; "Description of the City of Morocco," *Mass. Mag.*, October 1795, pp. 424–426; "*Volney—Account* of the *City* of *Cairo*," *Nat. Mag.*, 1801, pp. 9–12; "Egypt: Description of Damietta and Its Environs," *Port Folio*, April 3, 1802, p. 101; "Of the City of Cairo," *N.E.Q. Mag.*, July–September 1802, pp. 169–172.

20. "When Was Neoclassicism," in Bertrand H. Bronson, *Facets of the Enlightenment: Studies in English Literature and Its Contexts*, pp. 16–17; Hussey, *The Picturesque*, pp. 12, 100–101, 126. For a specific example of this change, compare Jefferson's "Notes of a Tour of English Gardens" with his letter to his daughter Martha, May 21, 1787, in Boyd, *Papers of Jefferson*, vol. 9, pp. 369–374, vol. 11, pp. 369–370.

21. "The Cottage: An Excursion in the Environs of Dublin," reprinted from the *Hibernian Magazine*, in *Ladies Wk. Mus.*, March 1, 1800, pp. 1–2.

22. Boyd, *Papers of Jefferson*, vol. 9, p. 373; "Blenheim Park," *Mo. Anthol.*, August 1807, pp. 430–431, and widely reprinted; "Journal of a Tour from Paris to Amsterdam," *Port Folio*, April 7, 1804, pp. 107–108; Hussey, *The Picturesque*, pp. 136–137, 155–156, 178.

23. J.Q. Adams, "Journal of a Tour through Silesia," *Port Folio*, January 31, March 14, April 4, 1801, pp. 33, 81–82, 105; Hussey, *The Picturesque*, p. 84; Mead, *The Grand Tour*, pp. 255–261; Hans Huth, *Nature and the American: Three Centuries of Changing Attitudes*, p. 7; John Rutledge, Jr., to Jefferson, August 30, 1788, in Boyd, *Papers of Jefferson*, vol. 13, p. 552; *Port Folio*, January 21, February 18, April 21, 1804, pp. 20, 53–54, 124–125; "The Beauties of Switzerland," *Balance*, Sep-

tember 20, 1803, pp. 298–299; "A Sketch of Switzerland and the Swiss," *Lit. Mag.*, January 1807, pp. 21–22; review of de Bray's *Tour in the Tyrol*, in *Sel. Rev.*, June 1810, pp. 361–365; "Letters from Geneva and France," *Port Folio*, May 28, 1808, pp. 337–340; review of *Letters from Europe . . .* , in *Mo. Anthol.*, February 1806, pp. 86–92.

24. "Extracts from Bartolomeo's Voyage to India," *Repos.*, August 8, 1801, pp. 310–311; "The Hindoo City, Dhuboy," *Sel. Rev.*, January 1809, pp. 53–56; review of Valentia's *Voyages and Travels to India*, ibid., January 1810, pp. 3–4; review of de Guignes' *Voyage to Peking*, ibid., May 1810, pp. 321–336.

25. *Port Folio*, April 23, 1803, pp. 131–132; "Letters of an American in Europe," *Mo. Anthol.*, August 1807, pp. 423–426; W., "Pontcysyltty Aqueduct, in North Wales," *Port Folio*, May 1809, pp. 419–420; J.Q. Adams, "Journal of a Tour through Silesia," ibid., January 31, 1801, p. 33; Rosenblum, *Transformations in Late Eighteenth Century Art*, p. 24.

26. Amelius, "Description of Pompey's Pillar," *Eye*, March 10, 1808, pp. 115–117, and reprinted in *Wond. Mag.* 1 (1808):326–329; Q., "Ruins of Thebes, or Luxore," *Mo. Anthol.*, November 1806, pp. 580–581; "The Pyramids of Egypt," *Mo. Mag.*, March 1813, pp. 287–290; "Account of the Remains of the Tower of Babel," *Am. Mag. of W.* 1 (1809):57–60; "A Description of Babylon," *Christ. Mes.*, November 1815, pp. 10–12.

27. "Extracts from John Stoddart's *Remarks on Local Scenery and Manners in Scotland*," *Port Folio*, July 3, 1802, p. 202; "Fete at St. Ives," *Nat. Mag.*, 1801, pp. 57–58; James Galloway, "Mount Olympus," *Lady's Mon.*, January 16, 1802, pp. 171–172; "Turin and the Alps," *Port Folio*, August 1815, pp. 199–201; "Letters from Europe,"

Mo. Anthol., January–June 1806, pp. (by month) 1–4, 61–62, 113–115, 169–170, 225–228, 281–285; "Letters from an American in Europe," ibid., January, May 1809, pp. 9–12, 303–308; "Dr. Moore," *Port Folio*, October 17, 1807, pp. 248–250.

28. On the difficulties of even defining romanticism, see "On the Discrimination of Romanticisms," in Lovejoy, *Essays in the History of Ideas*, pp. 228–253; Antal, "Reflections on Classicism and Romanticism"; and the essays in Frye, *Romanticism Reconsidered*.

29. Butterfield, *Diary and Autobiography of John Adams*, vol. 2, p. 419; *Lit. Mag.*, August 1806, pp. 153–158; "On Madrid" and "Of Portugal," *N.E.Q. Mag.*, July–September 1802, pp. 161–169; A Bostonian, "Journal of a Tour from Cadiz to Seville," *Mo. Anthol.*, November 1809–February 1810, pp. (by month) 305–310, 361–366, 6–11, 75–80; review of Semple's *Second Journey in Spain*, in *Sel. Rev.*, April 1811, p. 227; "Account of Spain," *Niles Reg.*, March 7, 1812, p. 304.

30. Review of Moore's *Letters from Portugal and Spain*, in *Sel. Rev.*, April 1811, p. 227; "Account of Spain," *Niles Reg.*, March 7, 1812, pp. 3–4; B., "Letter from Lisbon," *Port Folio*, October 1813, pp. 404–410; "Extracts from the Journal of a Gentleman on a Visit to Lisbon," *Mo. Anthol.*, December 1810–June 1811, pp. (by month) 361–369, 6–14, 73–83, 145–155, 217–228, 289–307, 365–379; B., "Letter from Portugal," *Port Folio*, March–May 1813, pp. (by month) 265–271, 369–372, 483–489.

31. "Medina," *Miss. Herald*, October 1806, pp. 239–240; *Pastime*, July 11, 1807, pp. 113–114; "Present State of Athens—by a Late Traveller," *Lit. Mag.*, October 1807, pp. 194–196; review of Bartholdy's *Travels in Greece*, in *Sel. Rev.*, February 1811, p. 101; "The Isle of Cos" and "Rhodes and Cyprus," *Wkly. Rec.*, July 19, 26, 1814,

pp. 21, 28–29; extracts from Savary's *Letters of Travel through Rhodes*, in *Friend*, September 1815, pp. 67–73; review of Parson's *Travels in Asia and Africa*, in *Sel. Rev.*, July 1810, pp. 39–48.

32. "Sketches of Palestine," *Balance*, May 14, 1811, pp. 156–157; "General Description of Jerusalem," *Port Folio*, August 1813, pp. 171–182; *Christian Observer*, December 1812, p. 798. For an example of Clarke's emphasis on historical associations, see the extract on "Galilee," in *Wkly. Rec.*, August 2, 1814, p. 37.

33. Adams to his wife, January 27, 1815, in Ford, *Writings of John Quincy Adams*, vol. 5, p. 274; "A Short Account of the Azores or Western Islands," *Mo. Mag.*, May 1812, pp. 26–29.

34. Review of Campbell's *Travels in South Africa*, in *Christ. Obs.*, December 1815, pp. 828–829; "Of the Pagodas of Hindustan," *Sel. Rev.*, February 1810, pp. 114–117; "Description of the Kremlin—by a Recent Traveller," *Olio*, April 10, 17, 1813, pp. 83, 91–92; Sir John Carr, "Account of the Island of Majorca," *Sel. Rev.*, December 1812, pp. 499–507; "Account of the Fejee Islands," reprinted from the *Sydney Gazette and New South Wales Advertiser*, ibid., November 1810, pp. 350–353. For a negative view of Russian "barbarity," see the review of Clarke's *Travels*, ibid., December 1810, pp. 373–397.

35. Review of Walton's *Present State of the Spanish Colonies*, in *Sel. Rev.*, June 1811, pp. 361–368; "Description of a Romantic Grotto in St. Ann's Parish, Jamaica," *Lit. Misc.*, May 1811, pp. 14–19; review of Von Sack's *A Narrative of a Voyage to Surinam*, in *Sel. Rev.*, August 1811, p. 87; "Mexico, or New Spain," *Niles Reg.*, September 7, 14, 21, 28, 1811, pp. 14–16, 27–30, 43–45, 59–61; "Tour through Jamaica," *Port Folio*, May–December 1812, and partially reprinted in *Mo. Mag.*, July 1812, pp. 154–156;

R., "Memoirs of Hayti—In a Series of Letters," *Port Folio*, May 1809–May 1811.

36. "Original Letter," *Mo. Anthol.*, August 1806, pp. 402–404; "Tour in England," *Port Folio*, May, September 1814, pp. 468–476, 287–289; "Letters on England and France," *Mo. Mag.*, July 1812, pp. 136–137; "Extracts from the Journal of a Gentleman on a Visit to Lisbon," *Mo. Anthol.*, December 1810, p. 365, April 1811, pp. 218–219; "An Account of Pernambuco," *Sel. Rev.*, August 1812, p. 167.

37. "Walls of Constantinople," *Lit. Mag.*, October 1805, pp. 251–252; "Extracts from the Journal . . . ," *Mo. Anthol.*, June 1811, pp. 370–372; review of Buffa's *Travels through the Empire of Morocco*, in *Sel. Rev.*, February 1811, p. 90; B., "Letters from Portugal," *Port Folio*, May 1813, pp. 487–488; review of Morier's *Tour of the Middle East*, in *Sel. Rev.*, April 1812, pp. 282, 286.

38. "Austrian Dalmatia," *Observer*, August 15, 1807, pp. 97–99; review of *Four Years Residence in Tongataboo*, in *Sel. Rev.*, December 1810, p. 365; "Tour through Jamaica," *Port Folio*, August 1812, pp. 130–132; "Account of Spain," *Niles Reg.*, March 7, 1812, pp. 3–4; Frederick Hall, "Modern Paris," *Lit. Repos.*, September 1814, p. 107.

39. "Description of the City of Smyrna," *Port Folio*, June 1811, pp. 515–522; extract from Sir John Carr's *Account of Gibraltar*, in *Sel. Rev.*, April 1812, pp. 334–339; "Journal of a Tour through Asia Minor," *Port Folio*, July 1812, pp. 13–16; "Nazareth," *Wkly. Rec.*, August 9, 1814, p. 45; Tour through Jamaica," *Port Folio*, October 1812, pp. 367–370; "Description of the Seraglio," ibid., August 1813, pp. 195–203.

40. "Sketches of Vienna," *Sel. Rev.*, February 1809, pp. 119–123; *Olio*, May 29, 1813, pp. 140–141; "Halifax, Nova Scotia," *N.Y. Mag.*, June 1814, pp. 71–74.

41. A Bostonian, "Some Account of Venice, and the Splendid Entrance of Buonaparte into that City, in December, 1807," *Mo. Anthol.*, August, September 1809, pp. 84–92, 160–166; Emily, "A Tour through France," *Am. Mag.*, June, July 1815, pp. 37–38, 83–85; "An Outline Sketch of the City of London," *Port Folio*, March 1812, pp. 242–248.

42. "Tour through Jamaica," *Port Folio*, May 1812, pp. 440–442.

CHAPTER 10

1. W.S. Wallace, *The Growth of Canadian National Feeling*; F.W. Watt, "Canada," in McLeod, *The Commonwealth Pen*, pp. 20–21; Robert H. Hubbard, ed., *An Anthology of Canadian Art*, pp. 17–18, 23–24; Holcroft, *Discovered Isles*, 22–31; Smith, *Place, Taste and Tradition*, 81; Arthur A. Phillips, *The Australian Tradition: Studies in a Colonial Culture*, p. 48; Daniel Thomas, "Art," in McLeod, *The Pattern of Australian Culture*, p. 354.

2. Lillian B. Miller, *Patrons and Patriotism*, 42, 221–224; Allan Burroughs, *Limners and Likenesses*, pp. 1–2, 16–17; John W. McCoubrey, ed., *American Tradition in Painting*, pp. 8–9; Phillips, *The Australian Tradition*, pp. 37–40, 48.

3. Lillian B. Miller, *Patrons and Patriotism*, p. 227. For a discussion of the dangers of xenophobic negative self-definition, see Daniel Boorstin, *America and the Image of Europe: Reflections on American Thought*, pp. 19–39.

4. Claude T. Bissell, "A Common Ancestry: Literature in Australia and Canada."

5. René Wellek, "Romanticism Re-examined," in Frye, *Romanticism Reconsidered*, pp. 129–132. For the parallel role played by Impressionism in Australian nationalism,

see Bernard Smith, *Place, Taste and Tradition*, pp. 107–109, 133.

6. Holcroft, *Discovered Isles*, pp. 56–57; J.C. Reid, "New Zealand," in McLeod, *The Commonwealth Pen*, p. 67.

7. Colgate, *Canadian Art*, especially pp. 30–31.

8. Pevsner, *The Englishness of English Art*, pp. 21–39, 59–61, 119–122.

9. David Humphreys to Jefferson, November 29, 1788, in Boyd, *Papers of Jefferson*, vol. 14, p. 304.

10. H. Lloyd Flewelling, "Literary Criticism in American Magazines, 1783–1820," pp. 55, 162; William J. Free, *The Columbian Magazine and American Literary Nationalism*, pp. 58, 77–78; Thomas J. Tracy, "The American Attitude toward American Literature during the Years 1800–1812," pp. 17, 94; Sue N. Greene, "The Contribution of *The Monthly Anthology*," pp. 90–93. For confirmation of the colonial nature of American literary taste in the late eighteenth century, see the reading lists in Thomas Jefferson's letter to Robert Skipwith, August 3, 1771, in Boyd, *Papers of Jefferson*, vol. 1, pp. 78–80, and "Books Read by Charles Willson Peale," in Sellers, *Charles Willson Peale*, vol. 2, pp. 434–436.

11. Tracy, "The American Attitude Toward American Literature," pp. 17–18; Free, *The Columbian Magazine*, pp. 7, 77–78; Charvat, *The Origins of American Critical Thought*, pp. 7–23, 39; Martin, *The Instructed Vision*, especially pp. 11, 51; Latrobe Journal, vol. 10, entry for October 13, 1797, in Latrobe Collection; Jefferson to Robert Skipwith, August 3, 1771, in Boyd, *Papers of Jefferson*, vol. 1, pp. 76–77; Jefferson to Nathaniel Burwell, March 14, 1818, in P.L. Ford, *Works of Jefferson*, vol. 12, p. 91.

12. Free, *The Columbian Magazine*, p. 69; Adams to the President of Congress, September 5, 1780, in Adams,

Works of John Adams, vol. 7, pp. 249–251; Jefferson to John Waldo, August 16, 1813, in Lipscomb and Bergh, *Writings of Jefferson*, vol. 13, pp. 338–341; Adams to William Wirt, January 23, 1818, in Adams, *Works of John Adams*, vol. 10, p. 279; Jefferson to Joseph Priestly, January 27, 1800, to John Minor, August 30, 1814, and to Francis Eppes, January 19, 1821, all in P.L. Ford, *Works of Jefferson*, vol. 9, pp. 102–105, vol. 11, pp. 420–426, vol. 12, p. 195; Jefferson to Thomas J. Randolph, December 7, 1808, in Betts and Bear, *Family Letters*, p. 369.

13. Butterfield, *Diary and Autobiography of John Adams*, vol. 3, pp. 189, 189 n3; Jefferson to Joel Barlow, January 24, 1810, in P.L. Ford, *Works of Jefferson*, vol. 10, pp. 131–132; Jefferson to Philip Freneau, February 28, 1791, in Lipscomb and Bergh, *Writings of Jefferson*, vol. 8, p. 133.

14. Jefferson to John Brazier, August 24, 1819, and to Anne Cary Bankhead, December 8, 1808, both in Lipscomb and Bergh, *Writings of Jefferson*, vol. 15, pp. 208–211, vol. 18, p. 255; John Adams to Jefferson, November 15, 1813, ibid., vol. 13, pp. 437–438; Adams to Elbridge Gerry, April 14, 1813, and to Richard Peters, March 31, 1822, both in Adams, *Works of John Adams*, vol. 10, pp. 36–37, 402; Adams to Abigail Adams, December 2, 1778, in Adams, *Familiar Letters*, p. 349; Adams to John Quincy Adams, August 11, 1777, in Butterfield, *Adams Family Correspondence*, vol. 2, p. 307; John Quincy Adams to John Adams, March 22, 1813, and to Abigail Adams, February 21, 1815, both in W.C. Ford, *Writings of John Quincy Adams*, vol. 4, pp. 450–455, vol. 5, pp. 279–280.

15. Robert E. Spiller et al., *Literary History of the United States*, p. 345.

16. Flewelling, "Literary Criticism in American Magazines,"
pp. 12, 134–141; Tracy, "The American Attitude To-
ward American Literature," p. 59; Greene, "The Con-
tribution of *The Monthly Anthology*," pp. 90–91.

⌇ Bibliography

MANUSCRIPT MATERIALS

American Academy of the Fine Arts Records, New-York Historical Society, New York City

Matthew Carey Papers, Historical Society of Pennsylvania, Philadelphia

Delaware State Archives, Dover

Thomas Jefferson Papers, Manuscripts Division, Library of Congress, Washington, D.C.

Benjamin Henry Latrobe Collection, Maryland Historical Society, Baltimore (Latrobe Collection)

Livingston Family Papers, New-York Historical Society, New York City

James Madison Papers, Manuscripts Room, New York Public Library, New York City

Charles Willson Peale Papers, American Philosophical Society, Philadelphia (Peale Papers)

Pennsylvania Academy of Fine Arts Archives, Philadelphia (PAFA Archives)

Manuscripts Room, Virginia State Library, Richmond

PERIODICALS

Am. Gleanor	*American Gleanor and Virginia Magazine* (Richmond, Va., 1807)
Am. Mag.	*American Magazine* (Boston, 1743–1745)
Am. Mag.	*American Magazine* (New York City, 1787–1788)
Am. Mag.	*American Magazine* (Albany, N.Y., 1815)

Am. Mag. of W. *The American Magazine of Wonders* (New York City, 1809)

Am. Med. Reg. *American Medical and Philosophical Register* (New York City, 1810–1814)

Am. Mo. R. *American Monthly Review or Literary Journal* (Philadelphia, 1795)

Am. Moral Mag. *American Moral and Sentimental Magazine* (New York City, 1797–1798)

Am. Museum *The American Museum or Repository* (Philadelphia, 1787–1792)

Am. Reg. *The American Register or General Repository of History, Politics and Science* (Philadelphia, 1806–1810)

Am. R. *American Review, and Literary Journal* (New York City, 1801–1802)

Am. Univ. Mag. *The American Universal Magazine* (Philadelphia, 1797–1798)

Anal. Mag. *The Analectic Magazine* (Philadelphia, 1813–1815)

Archives *Archives of Useful Knowledge* (Philadelphia, 1814)

Athenaeum *The Athenaeum* (New Haven, Conn., 1814)

Balance *The Balance and Columbian Repository* (Hudson, N.Y., 1802–1808)

Balance *The Balance and New York State Journal* (Hudson, N.Y., 1809–1811)

Balt. Repos. *The Baltimore Repository of Papers on Literary and Other Topics* (Baltimore, Md., 1811)

Balt. Wkly. *The Baltimore Weekly Magazine* (Baltimore, Md., 1800–1801)

Boston Mag. *The Boston Magazine* (Boston, 1783–1786)

Boston Spect.	*The Boston Spectator Devoted to Politicks and Belles Lettres* (Boston, 1814–1815)
Boston Wkly.	*Boston Weekly Magazine Devoted to Morality, Literature, Biography, History, the Fine Arts, etc., etc.,* (Boston, 1802–1804)
Casket	*The Casket* (Hudson, N.Y., 1811–1812)
Child	*Child of Pallas* (Baltimore, Md., 1800)
Christ. Dis.	*Christian Disciple and Theological Review* (Boston, 1813–1815)
Christ. Mes.	*Christian Messenger* (Pittsford, N.Y., 1815)
Christ. Mon.	*Christian Monitor and Religious Intelligencer* (New York City, 1812–1813)
Christ. Obs.	*The Christian Observer and Advocate. English Edition* (New York City and Boston, 1804–1815)
Christ. Schol. Mag.	*The Christian Scholars, and Farmers Magazine* (Elizabethtown, N.J., 1789–1791)
Christ. Visit.	*The Christian Visitant* (Albany, N.Y., 1815)
Church Mag.	*The Churchman's Monthly Magazine or Treasury of Divine and Useful Knowledge* (New Haven, Conn., 1804–1809)
Columbian Mag.	*Columbian Magazine or Monthly Miscellany* (Philadelphia, 1786–1790)
Col. Phenix	*The Columbian Phenix and Boston Review* (Boston, 1800)
Companion	*The Companion and Weekly Miscellany* (Baltimore, Md., 1804–1806)
Conn. Mag.	*The Connecticut Magazine or Gentleman's and Lady's Monthly Museum of Knowledge and Rational Entertainment* (Bridgeport, 1801)

Dessert	*The Dessert to the True American* (Philadelphia, 1798–1799)
Emerald Mis.	*The Emerald Miscellany of Literature* (Boston, 1806–1808)
Emerald	*The Emerald* (Baltimore, Md., 1810–1811)
Evan. Intel.	*Evangelical Intelligencer* (Philadelphia, 1805–1809)
Evan. Rec.	*Evangelical Record, and Western Review* (Lexington, Ky., 1812–1813)
Eve. Fireside	*The Evening Fireside or Weekly Intelligencer* (Philadelphia, 1804–1805)
Eye	*The Eye* (Philadelphia, 1808)
Franklin	*Franklin Minerva* (Chambersburg, Penn., 1799–1800)
Free Masons	*The Free Masons Magazine and General Miscellany* (Philadelphia, 1811–1812)
Friend	*The Friend* (Albany, N.Y., 1815)
General Mag.	*The General Magazine and Impartial Review* (Baltimore, Md., 1798)
Gen. Repos.	*General Repository and Review* (Cambridge, Mass., 1812–1813)
Gent. Mag.	*The Gentleman and Lady's Town and Country Magazine* (Boston, 1784, 1789–1790)
Guardian	*The Guardian* (Albany, N.Y., 1807–1808)
Halcyon	*Halcyon Luminary and Theological Repository* (New York City, 1812)
Hive	*The Hive* (Lancaster, Penn., 1810)
Hunt. Lit. Mus.	*Huntingdon Literary Museum* (Huntingdon, Penn., 1810)
Instructor	*The Instructor* (New York City, 1755)
Int. Regale	*Intellectual Regale; or Ladies' Tea Table* (Philadelphia, 1815)

Juv. Mag.	*Juvenile Magazine* (Philadelphia, 1802–1803)
Juv. Mirror	*The Juvenile Mirror, or Educational Magazine* (New York City, 1812)
Juv. Portfolio	*Juvenile Portfolio and Literary Messenger* (Philadelphia, 1812–1815)
Key	*The Key* (Fredericktown, Md., 1798)
Ladies Mus.	*Ladies Museum* (Philadelphia, 1800)
Ladies Vis.	*Ladies Visitor* (Boston, 1806–1807)
Ladies Wk. Mus.	*Ladies Weekly Museum* (New York City, 1788–1815)
Lady's Pocket Mag.	*Lady's and Gentleman's Pocket Magazine* (New York City, 1796)
Lady's	*Lady's Magazine and Musical Repository* (New York City, 1801–1802)
Lady's Mag.	*Lady's Magazine and Repository of Entertaining Knowledge* (Philadelphia, 1792–1793)
Lady's Misc.	*The Lady's Miscellany or the Weekly Visitor* (New York City, 1802–1806, 1812)
Lady's Mon.	*Lady's Monitor* (New York City, 1801–1802)
Lady's Wkly.	*The Lady's Weekly Miscellany* (New York City, 1806–1809)
Lit. Repos.	*Literary and Philosophical Repository* (Middlebury, Vt., 1812–1815)
Lit. Cab.	*Literary Cabinet* (New Haven, Conn., 1806–1807)
Lit. Mag.	*The Literary Magazine and American Register* (Philadelphia, 1803–1807)
Lit. Mirror	*Literary Mirror* (Portsmouth, N.H., 1808–1809)
Lit. Misc.	*Literary Miscellany* (Cambridge, Mass., 1805–1806)

Lit. Misc. The *Literary Miscellany, or Monthly Review* (New York City, 1811)

Lit. Tab. *Literary Tablet* (Hanover, N.Y., 1803–1807)

Mass. Mag. The *Massachusetts Magazine or Monthly Museum* (Boston, 1789–1796)

Medley The *Medley, or Monthly Miscellany* (Lexington, Ky., 1803)

Merrimack *Merrimack Magazine and Ladies Literary Cabinet* (Newburyport, Mass., 1805–1806)

Merrimack Misc. *Merrimack Miscellany* (Newburyport, Mass., 1805)

Mil. Mon. The *Military Monitor and American Register* (New York City and Albany, N.Y., 1812–1814)

Mirror *Mirror of Taste and Dramatic Censor* (Philadelphia, 1810–1811)

Miss. Herald *Missionary Herald or the Panoplist* (Boston, 1805–1808)

Mo. Anthol. The *Monthly Anthology and Boston Review* (Boston, 1803–1811)

Mo. Mag. *Monthly Magazine* [i.e., *The Gleanor or Monthly Magazine*] (Lancaster, Penn., 1808–1809)

Mo. Mag. The *Monthly Magazine and American Review* (New York City, 1799–1800)

Mo. Mag. The *Monthly Magazine and Literary Journal* (Winchester, Va., 1812–1813)

Mo. Rec. *Monthly Recorder* (New York City, 1813)

Mo. Reg. *Monthly Register, Magazine and Review of the United States* (Charleston, S.C., 1806–1807)

Nat. Mag.	*The National Magazine or the Cabinet of the United States* (Washington, D.C., 1801–1802)
Nat. Mus.	*National Museum and Weekly Gazette* (Baltimore, Md., 1813–1814)
New Am. Mag.	*The New American Magazine* (Woodbridge, N.J., 1758–1760)
N.E. Mag.	*The New England Magazine* (Boston, 1758–1759)
N.E. Q. Mag.	*The New England Quarterly Magazine* (Boston, 1802)
N.H. Gaz.	*The New Haven Gazette and Connecticut Magazine* (New Haven, Conn., 1786–1788)
N.J. Mag.	*The New Jersey Magazine and Monthly Advertiser* (New Brunswick, 1786–1787)
N.Y. Mag.	*New York Magazine and General Repository of Useful Knowledge* (New York City, 1814)
N.Y. Mag.	*The New York Magazine or Literary Repository* (New York City, 1790–1797)
N.Y. Wkly.	*The New York Weekly Magazine or Miscellaneous Repository* (New York City, 1795–1796)
Nightingale	*The Nightingale, or a Melange of Literature* (Boston, 1796)
Niles Reg.	*Niles National Register* (Philadelphia, 1811–1815)
Observer	*The Observer* (Baltimore, Md., 1806–1807)
Observer	*The Observer* (New York City, 1809–1811)

Olio *The Olio, a Literary and Miscellaneous*
 Paper (New York City, 1813–1814)
Omnium *Omnium Gatherum* (Boston, 1809–1810)
Pastime *The Pastime* (Schenectady, N.Y., 1807–
 1808)
Pa. Mag. *The Pennsylvania Magazine or American*
 Monthly Museum (Philadelphia, 1775–
 1776)
Phila. Mag. *The Philadelphia Magazine and Review or,*
 Monthly Repository (Philadelphia, 1799)
Phila. Min. *The Philadelphia Minerva* (Philadelphia,
 1795–1798)
Phila. Mo. *The Philadelphia Monthly Magazine or*
 Mag. *Universal Repository* (Philadelphia,
 1798)
Phila. Repert. *Philadelphia Repertory* (Philadelphia,
 1810–1812)
Pioneer *The Pioneer* (Pittsburgh, Pa., 1812)
Pol. Censor *The Political Censor or Monthly Review*
 (Philadelphia, 1796–1797)
Polyanthos *Polyanthos* (Boston, 1805–1807, 1812–
 1814)
Port Folio *The Port Folio* (Philadelphia, 1801–1815)
Rambler *The Ramblers' Magazine* (New York City,
 1809–1810)
Repos. *The Repository and Ladies Weekly Museum*
 [i.e., *The Philadelphia Repository and*
 Weekly Register] (Philadelphia,
 1800–1806)
Rep. of Knowl. *The Repository of Knowledge, Historical,*
 Literary, Miscellaneous, and Theological
 (Philadelphia, 1801)
R.I. Repos. *The Rhode Island Literary Repository*
 (Providence, 1814–1815)

Royal Am. Mag.	*The Royal American Magazine or Universal Repository of Instruction and Amusement* (Boston, 1774–1775)
Rural Casket	*The Rural Casket* (Poughkeepsie, N.Y., 1798)
Rural Mag.	*The Rural Magazine* (Newark, N.J., 1798–1799)
Rural Mag.	*The Rural Magazine or Vermont Repository* (Rutland, 1795–1796)
Salmagundi	*Salmagundi* (New York City, 1807–1808)
Sel. Rev.	*Select Reviews and Spirit of the Foreign Magazines* (Philadelphia, 1809–1812)
Something	*Something* (Boston, 1810)
S.C. Mus.	*South Carolina Museum and Complete Magazine* (Charleston, 1797)
Tablet	*The Tablet* (Boston, 1795)
Theol. Mag.	*The Theological Magazine or Synopsis of Modern Religious Sentiment on a New Plan* (New York City, 1795–1797)
Theophil. Essays	*Theophilanthropist, Containing Critical, Moral, Theological and Literary Essays* (New York City, 1810)
Tickler	*Tickler by Toby Scratch'em* (Philadelphia, 1807–1809)
Timepiece	*The Timepiece and Literary Companion* (New York City, 1797–1798)
Toilet	*Toilet; A Weekly Collection of Literary Pieces* (Charlestown, Mass., 1801)
Town	*The Town* (New York City, 1807)
U.S. Mag.	*United States Magazine or General Repository of Useful Instruction and Rational Amusement* (Newark, N.J., 1790–1792)
Univ. Asylum	*The Universal Asylum and Columbian Magazine* (Philadelphia, 1790–1792)

Va. Rel. Mag.	*Virginia Religious Magazine* (Lexington, 1804–1807)
Visitor	*The Visitor* (Richmond, Va., 1809–1810)
Wkly. Mag.	*The Weekly Magazine* (Philadelphia, 1798–1799)
Wkly. Mon.	*The Weekly Monitor* (Philadelphia, 1804)
Wkly. Rec.	*The Weekly Recorder* (Chillicothe, Ohio, 1814–1815)
Wkly. Visit.	*Weekly Visitant; Moral, Political, Humorous* (Salem, Mass., 1804–1806)
Wkly. Visitor	*The Weekly Visitor* (New York City, 1810–1811)
West. Glean.	*Western Gleanor, or Repository for Arts, Sciences and Literature* (Pittsburgh, Pa., 1813–1814)
Whim	*The Whim* (Philadelphia, 1814)
Wond. Mag.	*Wonderful Magazine and Extraordinary Museum* (Carlisle, Penn., 1808)
Worcester Mag.	*The Worcester Magazine* (Worcester, Mass., 1786–1788)

OTHER PUBLISHED MATERIALS

Abrams, M.H. "English Romanticism: the Spirit of the Age." In Northrop Frye, ed., *Romanticism Reconsidered*, pp. 26–72.

Adams, Charles Francis, ed. *Familar Letters of John Adams and His Wife Abigail Adams, during the Revolution*, with a Memoir of Mrs. Adams. New York: Hurd and Houghton, 1876.

————, ed. *The Works of John Adams*. 10 vols. Boston: Little, Brown & Co., 1850–1856.

Akston, Joseph J. "Editorial." *Arts Magazine* 42 (September–October 1967):3.

Allen, B. Sprague. *Tides in English Taste (1619–1800): A Background for the Study of Literature.* 2 vols. Cambridge, Mass.: Harvard University Press, 1937.

Allen, Warren Dwight. *Philosophies of Music History: A Study of General Histories of Music, 1600–1960.* New York: Dover Publications, 1962.

Antal, Friedrich. "Reflections on Classicism and Romanticism." *Burlington Magazine* 66 (1935):159–168; 68 (1936):130–139; 77 (1940):72–80, 188–192; 78 (1941):14–22.

Antin, David. "Fuseli, Blake, Palmer." In Thomas B. Hess, *The Grand Eccentrics; Five Centuries of Artists Outside the Main Currents of Art History. Art News Annual* 32 (October 1933–September 1934): 109–123.

Art in America Editors. *The Artist in America.* New York: W.W. Norton, 1967.

Artz, Frederick B. *From the Renaissance to Romanticism: Trends in Style, Literature, and Music, 1300–1830.* Chicago: University of Chicago Press, 1962.

Baker, Paul R. *The Fortunate Pilgrims: Americans in Italy, 1800–1860.* Cambridge, Mass.: Harvard University Press, 1964.

Barker, Virgil. *American Painting: History and Interpretation.* New York: Macmillan Co., 1950.

Barzun, Jacques. *Darwin, Marx, Wagner: Critique of a Heritage.* 2nd ed. Garden City, N.Y.: Doubleday Anchor Books, 1958.

Bate, Walter Jackson. *From Classic to Romantic: Premises of Taste in Eighteenth-Century England.* New York: Harper Torchbooks, 1961.

Benisovich, Michel. "The Sale of the Studio of Adolph-Ulrich Wertmüller." Translated by Adolph Cavallo. *Art Quarterly* 16 (1953):21–39.

Berman, Eleanor D. *Thomas Jefferson among the Arts: An Essay in Early American Esthetics.* New York: Philosophical Library, 1947.

Betts, Edwin Morris, and Bear, James Adams, Jr., eds. *The Family Letters of Thomas Jefferson.* Columbia: University of Missouri Press, 1966.

Bissell, Charles T. "A Common Ancestry: Literature in Australia and Canada." *University of Toronto Quarterly* 25 (1956):131–142.

Black, Mary, and Lipman, Jean. *American Folk Painting.* New York: Clarkson N. Potter, 1966.

Boase, T.S.R. *English Art: 1800–1870.* Oxford: Clarendon Press, 1959.

Boorstin, Daniel J. *America and the Image of Europe: Reflections on American Thought.* New York: Meridian Books, 1960.

————. *The Lost World of Thomas Jefferson.* Boston: Beacon Press, 1963 [1948].

Boyd, Julian P., et al., eds. *The Papers of Thomas Jefferson.* Princeton, N.J.: Princeton University Press, 1950–.

Brimo, René. *L'évolution du goût aux États-Unis: d'apres l'histoire des collections.* Paris: James Fortune, 1938.

Bronson, Bertrand Harris. "When Was Neoclassicism?" In his *Facets of the Enlightenment: Studies in English Literature and Its Contexts.* Berkeley and Los Angeles: University of California Press, 1968.

Burroughs, Alan. *Limners and Likenesses: Three Centuries of American Painting.* New York: Russell & Russell, 1965 [1936].

Butterfield, Lyman H., ed. *Adams Family Correspondence.* 2 vols. New York: Atheneum, 1965.

————, ed. *Diary and Autobiography of John Adams.* 4 vols. Cambridge, Mass.: Harvard University Press, Belknap Press, 1961.

————, ed. *The Earliest Diary of John Adams.* Cambridge, Mass.: Harvard University Press, Belknap Press, 1966.

Canaday, John. *Mainstreams of Modern Art.* New York: Simon & Schuster, 1959.

Cappon, Lester J., ed. *The Adams-Jefferson Letters: The Complete Correspondence between Thomas Jefferson and Abigail and John Adams.* 2 vols. Chapel Hill: University of North Carolina Press, for the Institute of Early American History and Culture at Williamsburg, Virginia, 1959.

Charvat, William. *The Origins of American Critical Thought, 1810–1835.* Philadelphia: University of Pennsylvania Press, 1936.

Chase, Gilbert. *America's Music from the Pilgrims to the Present.* New York: McGraw-Hill Book Co., 1966.

————, ed. *The American Composer Speaks: A Historical Anthology, 1770–1965.* Baton Rouge: Louisiana State University Press, 1969 [1966].

Clark, Anthony M. "The Development of the Collections and Museums of 18th Century Rome." *Art Journal* 26 (1966/1967):136–142.

Clark, Harry H. "Changing Attitudes in Early American Literary Criticism: 1800–1804." In Floyd Stovall, ed., *The Development of American Literary Criticism.* Chapel Hill: University of North Carolina Press, 1955.

Colgate, William. *Canadian Art: Its Origin and Development.* Foreword by C.W. Jeffreys. Toronto: The Ryerson Press, 1943.

Comstock, Helen. "Federal Furniture—An American Style." *Antiques* 43 (1943):122–123.

Covey, Cyclone. "Puritanism and Music in Colonial America." *William and Mary Quarterly,* 3rd ser., 8 (1951):378–388.

Craven, Wayne. *Sculpture in America.* New York: Thomas Y. Crowell Co., 1968.

Cummings, Frederick. Review of *Transformations in Late Eighteenth Century Art*, by Robert Rosenblum. *Journal of the Society of Architectural Historians* 28 (1969):137–140.

Denvir, Bernard. "Benjamin West and the Revolution in Painting." *Antiques* 71 (1957):347–349.

De Zurko, Edward R. *Origins of Functionalist Theory*. New York: Columbia University Press, 1957.

Dickson, Harold E. *Arts of the Young Republic: The Age of William Dunlap*. Chapel Hill: University of North Carolina Press, 1968.

————, ed. *Observations on American Art: Selections from the Writings of John Neal*. Pennslyvania State College Studies, no. 12, 1943.

Douglass, Elisha P. *Rebels and Democrats: The Struggle for Equal Political Rights and Majority Rule During the American Revolution*. Chicago: Quadrangle Books, 1965 [1955].

Dreppard, Carl W. *American Pioneer Art and Artists*. Springfield, Mass.: The Pond-Ekburg Co., 1942.

Dunlap, William. *History of the Rise and Progress of the Arts of Design in the United States*. Edited by Alexander Wykoff; Introduction by William P. Campbell. 3 vols. New York: Benjamin Blom, 1965.

Earle, Alice Morse. *Two Centuries of Costume in America*. 2 vols. New York: Macmillan Co., 1903.

Egbert, Donald D. "The Idea of Organic Expression and American Architecture." In Stow Persons, ed., *Evolutionary Thought in America*. New Haven, Conn.: Yale University Press, 1950.

Ellis, Harold Milton. *Joseph Dennie and His Circle: A Study in American Literature from 1792 to 1812*. University of Texas Bulletin no. 40, 1915.

Elson, Ruth M. *Guardians of Tradition: American School-

books of the Nineteenth Century. Lincoln: University of Nebraska Press, 1964.

Emerson, Edward Waldo, and Forbes, Waldo Emerson, eds. *Journals of Ralph Waldo Emerson, with Annotations.* 10 vols. Boston: Houghton-Mifflin Co., 1909–1914.

Evans, Grose. *Benjamin West and the Taste of His Times.* Carbondale: Southern Illinois University Press, 1959.

Evans, Tony. "Equalitarianism in the American Periodical Press, 1776–1801." Master's thesis, University of Hawaii, 1962.

Flewelling, H. Lloyd. "Literary Criticism in American Magazines, 1783–1820." Ph.D. dissertation, University of Michigan, 1931.

Flexner, James T. *American Painting: The Light of Distant Skies, 1760–1835.* New York: Harcourt, Brace & Co., 1954.

————. "The Scope of Painting in the 1790's." *Pennsylvania Magazine of History and Biography* 74 (1950):74–89.

Foote, Henry W. *Three Centuries of American Hymnody.* Cambridge, Mass.: Harvard University Press, 1940.

Ford, Paul Leicester, ed. *The Works of Thomas Jefferson.* 12 vols. "The Federal Edition." New York: G.P. Putnam's Sons, 1904–1905.

Ford, Worthington Chauncy, ed. *Writings of John Quincy Adams.* 7 vols. New York: Macmillan Co., 1913–1917.

Free, William J. *The Columbian Magazine and American Literary Nationalism.* The Hague and Paris: Mouton, 1968.

Frye, Northrop. "The Drunken Boat: The Revolutionary Element in Romanticism." In Northrop Frye, ed., *Romanticism Reconsidered*, pp. 1–25.

————, ed. *Romanticism Reconsidered: Selected Papers from the English Institute.* New York: Columbia University Press, 1964 [1963].

Garrett, Wendell D. "John Adams and the Limited Role of the Fine Arts." *Winterthur Portfolio* 1 (1964):242–255.

Gilbert, Katherine E., and Kuhn, Helmut. *A History of Esthetics*. 2nd ed., rev. Bloomington: Indiana University Press, 1954.

Gloag, John. *Georgian Grace: A Social History of Design from 1660–1830*. New York: Macmillan Co., 1956.

Gottesman, Rita Susswein, ed. *The Arts and Crafts in New York, 1800–1804: Advertisements and News Items from New York City Newspapers*. New York: New-York Historical Society, 1965.

Gould, Nathaniel D. *Church Music in America, Comprising its History and its Peculiarities at Different Periods, with Cursory Remarks on its Legitimate Use and Abuse; with Notice of the Schools, Composers, Teachers, and Societies*. Boston: A.N. Johnson, 1853.

Gowans, Alan. *Images of American Living: Four Centuries of Architecture and Furniture as Cultural Expression*. Philadelphia: J.B. Lippincott Co., 1964.

———. *The Restless Art: A History of Painters and Painting, 1760–1960*. Philadelphia: J.B. Lippincott Co., 1966.

Greene, Evarts B. *The Revolutionary Generation, 1763–1790*. Vol. 4 of *A History of American Life*, edited by A.M. Schlesinger and D.R. Fox. New York: Macmillan Co., 1943.

Greene, Sue Neuenswander. "The Contribution of *The Monthly Anthology, and Boston Review* to the Development of the Golden Age of American Letters." Ph.D. Dissertation, Michigan State University, 1964.

Greenough, Horatio. *Form and Function: Remarks on Art, Design, and Architecture*. Edited by Harold A. Small; Introduction by Erle Loran. Berkeley and Los Angeles: University of California Press, 1958.

Grimsted, David. *Melodrama Unveiled: American Theatre and Culture, 1800–1850.* Chicago: University of Chicago Press, 1968.

Hamlin, Talbot. *Benjamin Henry Latrobe.* New York: Oxford University Press, 1955.

————. "Benjamin Henry Latrobe: the Man and the Architect." *Maryland Historical Magazine* 37 (1942):339–360.

————. *Greek Revival Architecture in America.* New York: Dover Publications, 1964.

Harris, Neil. *The Artist in American Society: The Formative Years, 1790–1860.* New York: George Braziller, 1966.

Hartz, Louis, et al. *The Founding of New Societies: Studies in the History of the United States, Latin America, South Africa and Australia.* New York: Harcourt, Brace & World, 1964.

Hawley, Henry, ed. *Neo-Classicism: Style and Motif.* Cleveland: The Cleveland Museum of Art, 1964.

Hayes, John. "British Patrons and Landscape Painting: 5, The Encouragement of British Art." *Apollo* 86 (November 1967):358–365.

Heiser, M.F. "The Decline of Neoclassicism, 1801–1848." In Harry H. Clark, ed., *Transitions in American Literary History.* Durham, N.C.: Duke University Press, 1953.

Hipple, Walter J., Jr. *The Beautiful, the Sublime, and the Picturesque in Eighteenth-Century British Aesthetic Theory.* Carbondale: Southern Illinois University Press, 1957.

Hitchcock, H. Wiley. *Music in the United States: A Historical Introduction.* Englewood Cliffs, N.J.: Prentice-Hall, 1969.

Hitchcock, Henry-Russell. *American Architectural Books: A List of Books, Portfolios, and Pamphlets on Architecture and Related Subjects Published in America before 1895.* Minneapolis: University of Minnesota Press, 1962.

Holcroft, Montague H. *Discovered Isles: A Trilogy*. Christchurch, N.Z.: The Caxton Press, 1950.

Howard, John Tasker. *Our American Music: Three Hundred Years of It*. New York: Thomas Y. Crowell Co., 1931.

Howard, Leon. "Americanization of the European Heritage." In Margaret Denny and William H. Gilman, eds., *The American Writer and the European Tradition*. Minneapolis: University of Minnesota Press, published for the University of Rochester, 1950.

————. "The Late Eighteenth Century: An Age of Contradiction." In Harry H. Clark, ed., *Transitions in American Literary History*, pp. 49–89. Durham, N.C.: Duke University Press, 1953.

————. *Literature and the American Tradition*. Garden City, N.Y.: Doubleday & Co., 1960.

Hubbard, Robert H. *An Anthology of Canadian Art*. Toronto: Oxford University Press, 1960.

Huddleston, Eugene L. "Topographical Poetry in the Early National Period." *American Literature* 38 (1966):303–322.

Hussey, Christopher. *The Picturesque: Studies in a Point of View*. London and New York: G. P. Putnam's Sons, 1927.

Hutchison, Sidney C. *The History of the Royal Academy, 1768–1968*. London: Chapman & Hall, 1968.

Huth, Hans. *Nature and the American: Three Centuries of Changing Attitudes*. Berkeley and Los Angeles: University of California Press, 1957.

Irwin, David. *English Neoclassical Art: Studies in Inspiration and Taste*. Greenwich, Conn.: New York Graphic Society, 1966.

The Jefferson Papers. Massachusetts Historical Society *Collections*, 5th ser., vol. 61. Boston: Published by the Society, 1900.

Jones, Howard Mumford. *American and French Culture,*

1750–1848. Chapel Hill: University of North Carolina Press, 1927.

―――. *O Strange New World; American Culture: The Formative Years.* New York: The Viking Press, 1964.

―――. *The Theory of American Literature.* Ithaca, N.Y.: Cornell University Press, 1948.

Jones, William. "A Topographical Description of the Town of Concord." Massachusetts Historical Society *Collections,* vol. 1 (1792), p. 239.

Kelby, William, ed. *Notes on American Artists, 1754–1820: Copied from Advertisements Appearing in the Newspapers of the Day.* New York: New-York Historical Society, 1922.

Kerber, Linda K., and Morris, Walter J. "Politics and Literature: The Adams Family and the *Port Folio.*" *William and Mary Quarterly,* 3rd ser., 23 (1966):450–476.

Kimball, Fiske. *Domestic Architecture of the American Colonies and of the Early Republic.* New York: Charles Scribner's Sons, 1922.

―――. "Form and Function in the Architecture of Jefferson." *Magazine of Art* 40 (1947):150–153.

―――. *Thomas Jefferson, Architect: Original Designs in the Collection of Thomas Jefferson Coolidge, Junior.* Boston: Printed for private distribution by the Riverside Press, 1916.

Kimball, Marie. "Jefferson, Patron of the Arts." *Antiques* 43 (1943):164–167.

―――. *Jefferson: The Road to Glory, 1743–1776.* New York: Coward-McCann, 1943.

―――. *Jefferson: The Scene of Europe, 1784 to 1789.* New York: Coward-McCann, 1950.

―――. "Jefferson's Works of Art at Monticello." *Antiques* 59 (1951): 297–299.

Koch, Adrienne, and Peden, William, eds. *The Life and Se-*

lected Writings of Thomas Jefferson. New York: Modern
 Library, 1944.

Kouwenhoven, John. *The Columbia Historical Portrait of New
 York: An Essay in Graphic History in Honor of New
 York City and the Bicentennial of Columbia University.*
 Foreword by Grayson L. Kirk. Garden City, N.Y.: Dou-
 bleday & Co., 1953.

———— *Made in Ameria: The Arts in Modern American
 Civilization.* Garden City, N.Y.: Doubleday Anchor Books,
 1962.

————. "Some Unfamiliar Aspects of Singing in New Eng-
 land." *New England Quarterly* 6 (1933):567–588.

Labaree, Leonard W., and Bell, Whitfield J., Jr., eds. *The
 Papers of Benjamin Franklin.* New Haven, Conn.: Yale
 University Press, 1959– .

Lang, S. "The Principles of the Gothic Revival in England."
 Journal of the Society of Architectural Historians 25
 (1966):240–267.

Larkin, Oliver. *Art and Life in America.* 2nd ed., rev. New
 York: Holt, Rinehart & Winston, 1960.

Latrobe, Benjamin. "Essay on Landscape." *Virginia Cavalcade*
 8 (Spring 1959):4–38.

Laver, James. *Taste and Fashion from the French Revolution
 to the Present Day.* 2nd ed., rev. London: George G.
 Harrop & Co., 1948.

Lawler, John J. "Ideas about Art and Literature from the Per-
 sonal Writings of a Group of Well-Traveled Early Ameri-
 can Writers and Artists: A Critical, Collated Compila-
 tion." Ph.D. Dissertation, Florida State University, 1960.

Lehmann, Karl. *Thomas Jefferson: American Humanist.* Chi-
 cago: University of Chicago Press, 1965 [1947].

Leslie, Charles R. *Autobiographical Recollections, Edited with
 a Prefatory Essay on Leslie as an Artist, and Selections*

from his Correspondence, by Tom Taylor. Boston: Ticknor and Fields, 1860.

Lipscomb, Andrew A., and Bergh, Albert E., eds. *The Writings of Thomas Jefferson.* 20 vols. Library Edition. Washington: Thomas Jefferson Memorial Association, 1903–1906.

Lipset, Seymour Martin. *The First New Nation: The United States in Historical and Comparative Perspective.* Garden City, N.Y.: Doubleday Anchor Books, 1967 [1963].

Lissa, Zofia. "On the Evolution of Musical Perception." Translated by Eugenia Tanska. *Journal of Aesthetics and Art Criticism* 24 (1965):273–285.

Lockwood, Alice G.B., ed. *Gardens of Colony and State: Gardens and Gardeners of the American Colonies and of the Republic Before 1840.* 2 vols. New York: Charles Scribner's Sons, published for the Garden Club of America, 1931–1934.

Lovejoy, Arthur O. *Essays in the History of Ideas.* New York: Capricorn Books, 1960.

Lowens, Irving. "The Origins of the American Fuguing Tune." *Journal of the American Musicological Society* 6 (1953):43–52.

Lowenthal, David, and Prince, Hugh C. "English Landscape Tastes." *The Geographical Review* 55 (1965):186–222.

McCormick, Eric H. *New Zealand Literature: A Survey.* London, Wellington, and Melbourne: Oxford University Press, 1959.

McCoubrey, John W., ed. *American Art, 1700–1960.* Englewood Cliffs, N.J.: Prentice-Hall, 1965.

———. *American Tradition in Painting.* New York: George Braziller, 1963.

McInnes, Graham. *Canadian Art.* Toronto: The Macmillan Company of Canada, 1950.

McKeithan, Daniel M., ed. *Traveling with the Innocents Abroad: Mark Twain's Original Reports from Europe and the Holy Land*. Norman: University of Oklahoma Press, 1958.

McLanathan, Richard. *The American Tradition in the Arts*. New York: Harcourt, Brace & World, 1968.

McLeod, Alan L., ed. *The Commonwealth Pen: An Introduction to the Literature of the British Commonwealth*. Ithaca, N.Y.: Cornell University Press, 1961.

————, ed. *The Pattern of Australian Culture*. Ithaca, N.Y.: Cornell University Press, 1963.

Manwaring, Elizabeth W. *Italian Landscape in Eighteenth Century England: A Study Chiefly of the Influence of Claude Lorraine and Salvator Rosa on English Taste, 1700–1800*. Wellesley Semi-Centennial Series. New York: Oxford University Press, 1925.

Marceau, Henri. *William Rush (1756–1833): The First Native American Sculptor*. Philadelphia: Pennsylvania Museum of Art, 1937.

Martin, Terence. *The Instructed Vision: Scottish Common Sense Philosophy and the Origins of American Fiction*. Bloomington: Indiana University Press, 1961.

Mates, Julian. *The American Musical Stage Before 1800*. New Brunswick, N.J.: Rutgers University Press, 1962.

Mead, William E. *The Grand Tour in the Eighteenth Century*. Boston: Houghton Mifflin Co., 1914.

Mellers, Wilfrid. *Music in a New Found Land*. New York: A.A. Knopf, 1965.

Metcalf, Frank J. *American Writers and Compilers of Sacred Music*. New York: The Abingdon Press, 1925.

Metzger, Charles R. *Emerson and Greenough: Transcendental Pioneers of an American Esthetic*. Berkeley and Los Angeles: University of California Press, 1954.

Miller, Lillian B. "Paintings, Sculpture, and the National

Character, 1815–1860." *Journal of American History* 53 (1967):696–707.

———. *Patrons and Patriotism: The Encouragement of the Fine Arts in the United States, 1790–1860.* Chicago and London: University of Chicago Press, 1966.

Miller, Perry. *Errand into the Wilderness.* New York: Harper Torchbooks, 1964.

Miller, Ralph N. "American Nationalism as a Theory of Nature." *William and Mary Quarterly*, 3rd ser., 12 (1955): 74–95.

Monk, Samuel H. *The Sublime: A Study of Critical Theories in 18th Century England.* Ann Arbor: University of Michigan Press, 1960.

Morgan, Edmund S. "The Puritan Ethic and the American Revolution." *William and Mary Quarterly*, 3rd ser., 24 (1967):3–43.

Morrison, Hugh. *Early American Architecture from the First Colonial Settlements to the National Period.* New York: Oxford University Press, 1952.

Mott, Frank Luther. *A History of American Magazines.* Vol. 1, *1741–1850.* Cambridge, Mass.: Harvard University Press, 1930.

Mumford, Lewis. *The South in Architecture: The Dancy Lectures, Alabama College, 1941.* New York: Harcourt, Brace & Co., 1941.

Murray, Peter. "Art and Architecture." In A. Goodwin, ed., *The New Cambridge Modern History.* Vol. 8, *The American and French Revolutions, 1763–1793.* Cambridge: At the University Press, 1965.

Nash, Roderick. *Wilderness and the American Mind.* New Haven, Conn.: Yale University Press, 1967.

Nathan, Hans, ed. *The Continental Harmony by William Billings.* Cambridge: Harvard University Press, Belknap Press, 1961.

Neil, J. Meredith. "American Indifference to Art: An Anachronistic Myth." *American Studies* 12 (Fall 1972):93–106.

———. " 'Plain and Simple Principles' for an American Art, 1810." *Pennsylvania Magazine of History and Biography* 93 (1969):410–416.

———. "The Precarious Professionalism of Latrobe." *AIA Journal* 53 (May 1970):67–71.

———. "Towards a National Taste: The Fine Arts and Travel in American Magazines from 1783 to 1815." Ph.D. dissertation, Washington State University, 1966.

Newton, Earle. "Jacob Eichholtz," *Pennsylvania History* 26 (1959):102–118.

Nichols, Frederick D., and Bear, James A., Jr. *Monticello.* Monticello, Va.: Thomas Jefferson Memorial Foundation, 1967.

Nitz, Donald. "The Norfolk Musical Society, 1814–1820: An Episode in the History of Choral Music in New England." *Journal of Research in Music Education* 16 (1968): 319–328.

Norton, M. D. Herter. "Haydn in America (before 1820)." *Musical Quarterly* 18 (1932):309–337.

Novak, Barbara. *American Painting of the Nineteenth Century: Realism, Idealism, and the American Experience.* New York: Frederick A. Praeger, 1969.

Nye, Russel B. *The Cultural Life of the New Nation, 1776–1830.* New York: Harper Torchbooks, 1963.

O'Doherty, Barbara Novak. "The American 19th Century, Part I: New Found Land." *Art News* 67 (September 1968):30–44, 60–64.

Oliver, Anthony. "De Loutherbourg and *Pizarro*." *Apollo* 86 (August 1967):135–137.

Orians, G. Harrison. "The Rise of Romanticism, 1805–1855."

In Harry H. Clark, ed., *Transitions in American Literary History*. Durham, N.C.: Duke University Press, 1953.

Padover, Saul K., ed. *Thomas Jefferson and the National Capital*. Washington: Government Printing Office, 1946.

Papke, David R. "The Green." *Yale Alumni Magazine* 35 (January 1972): 22–25.

[Peale, Charles Willson.] "Extracts from the Correspondence of Charles Willson Peale Relative to the Establishment of the Academy of the Fine Arts, Philadelphia." *Pennsylvania Magazine of History and Biography* 9 (1885): 121–133.

Pedder, Laura Green, ed. *The Letters of Joseph Dennie*. Orono: University of Maine Studies, 2nd ser., no. 36, 1936.

"The People the Best Governors. Or a Plan of Government Founded on the Just Principles of Natural Freedom [1776]." Reprinted in *The Magazine of History*, Extra Number 84 (1922):25–35.

Pevsner, Nikolaus. *The Englishness of English Art*. New York: Frederick A. Praeger, 1956.

Phillips, Arthur A. *The Australian Tradition: Studies in a Colonial Culture*. Melbourne: F.W. Cheshire, 1958.

Pleasants, J. Hall. "Four Late Eighteenth Century Anglo-American Landscape Painters." *Proceedings of the American Antiquarian Society*, n.s. 52 (1942):187–324.

Pole, J.R. "Representation and Authority in Virginia from the Revolution to Reform." *Journal of Southern History* 24 (1958):16–50.

Price, Martin. "The Picturesque Moment." In Frederick W. Hilles and Harold Bloom, eds., *From Sensibility to Romanticism: Essays Presented to Frederick A. Pottle*, pp. 259–292. New York: Oxford University Press, 1965.

Prime, Alfred Coxe, ed. *The Arts and Crafts in Philadelphia, Maryland, and South Carolina, 1721–1785: Gleanings*

from Newspapers. Topsfield, Mass.: The Walpole Society, 1929.

Prime, Samuel I. *The Life of Samuel F.B. Morse, Inventor of the Electro-Magnetic Recording Telegraph.* New York: D. Appleton & Co., 1875.

Randall, Randolph C. "Authors of the *Port Folio* Revealed by the Hall Files." *American Literature* 11 (1940):379–416.

Redway, Virginia L. "Handel in Colonial and Post-Colonial America (to 1820)." *Musical Quarterly* 21 (1935): 190–207.

Reps, John W. *The Making of Urban America: A History of City Planning in the United States.* Princeton, N.J. Princeton University Press, 1965.

————. *Monumental Washington.* Princeton, N.J. Princeton University Press, 1967.

————. "Thomas Jefferson's Checkerboard Towns." *Journal of the Society of Architectural Historians* 20 (1961): 108–114.

Richardson, Edgar P. "Allen Smith, Collector and Benefactor." *American Art Journal* 1, no. 2 (1969):5–19.

————. *Painting in America from 1502 to the Present.* New York: Thomas Y. Crowell Co., 1965.

————. *Washington Allston: A Study of the Romantic Artist in America.* Chicago: University of Chicago Press, 1948.

Richardson, Lyon N. *A History of Early American Magazines, 1741–1789.* New York: Thomas Nelson & Sons, 1931.

Rosenblum, Robert. *Transformations in Late Eighteenth Century Art.* Princeton, N.J.: Princeton University Press, 1967.

Ross, Ian. "A Bluestocking over the Border: Mrs. Elizabeth Montague's Aesthetic Adventures in Scotland, 1766." *The Huntington Library Quarterly* 28 (1965):213–233.

Ross, Malcolm, ed. *The Arts in Canada: A Stock-Taking at*

Mid-Century. Toronto: The Macmillan Company of Canada, 1958.

Russell, John. "Melbourne: The National Gallery of Victoria." *Art in America* 56 (November–December 1968):76–83.

Sablosky, Irving. *American Music.* Chicago History of American Civilization Series. Chicago: University of Chicago Press, 1969.

Saisselin, Rémy G. "Neo-classicism: Virtue, Reason, and Nature." In Henry Hawley, ed., *Neoclassicism: Style and Motif,* pp. 1–8.

————. "Some Remarks on French Eighteenth-Century Writings on the Arts." *Journal of Aesthetics and Art Criticism* 25 (1966):187–196.

Sanford, Charles L., ed. *Quest for America: 1810–1824.* Documents in American Civilization Series. New York: New York University Press, 1964.

Sellers, Charles Coleman. *Charles Willson Peale.* 2 vols. American Philosophical Society Memoirs 23, parts 1 and 2. Philadelphia, 1947.

————. "Rembrandt Peale, 'Instigator.'" *Pennsylvania Magazine of History and Biography* 79 (1955):331–342.

————, ed. "Letters from Thomas Jefferson to Charles Willson Peale, 1796–1815." *Pennsylvania Magazine of History and Biography* 28 (1904):136–154, 295–318, 403–419.

Sizer, Theodore, ed. *The Autobiography of Colonel John Trumbull, Patriot-Artist, 1756–1843.* New Haven, Conn.: Yale University Press, 1953.

Smelser, Marshall. "The Federalist Period as an Age of Passion." *American Quarterly* 10 (1958):391–419.

Smith, Bernard. *Place, Taste and Tradition: A Study of Australian Art Since 1788.* Sydney: Ure Smith Pty., 1945.

Smith, Henry Nash. "Origins of a Native American Literary Tradition." In Margaret Denny and William H. Gil-

man, eds., *The American Writer and the European Tradition.* Minneapolis: University of Minnesota Press, for the University of Rochester, 1950.

————. *Virgin Land: The American West as Symbol and Myth.* New York: Vintage Books, 1959 [1950].

Smith, Robert C. "Eighteenth-century Americans on the Grand Tour." *Antiques* 68 (1955):344–347.

Smyth, Albert H. *The Philadelphia Magazines and Their Contributors, 1741–1850.* Philadelphia: Robert M. Lindsay, 1892.

Snyder, Martin P. "Birch's Philadelphia Views: New Discoveries." *Pennsylvania Magazine of History and Biography* 88 (1964): 164–173.

————. "William Birch: His 'Country Seats of the United States.' " *Pennsylvania Magazine of History and Biography* 81 (1957):224–254.

————. "William Birch: His Philadelphia Views," *Pennsylvania Magazine of History and Biography* 73 (1949): 270–315.

Sonneck, O.G.T. *Early Concert-Life in America (1731–1800).* New York: Musurgia Publishers, 1949.

————. *Francis Hopkinson: The First American Poet Composer (1737–1791) and James Lyon: Patriot, Preacher, Psalmodist (1735–1794),* with a New Introduction by Richard A. Crawford. New York: Da Capo Press, 1967.

Spiller, Robert E., et al. *Literary History of the United States.* 3rd rev. ed. New York: Macmillan Co. 1964.

Steegman, John. *The Rule of Taste from George I to George IV.* London: Macmillan & Co., 1936.

Steinman, David B., and Watson, Sara Ruth. *Bridges and Their Builders.* New York: Dover Publications, 1957.

Sternfeld, F.W. "Music." In A. Goodwin, ed., *The New Cambridge Modern History.* Vol. 8, *The American and*

French Revolutions, 1763–1793. Cambridge: At the University Press, 1965.

————. "Music." In C.W. Crawley, ed., *The New Cambridge Modern History.* Vol. 9, *War and Peace in an Age of Upheaval, 1790–1830.* Cambridge: At the University Press, 1965.

Stetson, Sarah Pattee. "American Garden Books Transplanted and Native, Before 1807." *William and Mary Quarterly,* 3rd ser. 3 (1946): 343–369.

————. "William Hamilton and His 'Woodlands.'" *Pennsylvania Magazine of History and Biography* 73 (1949): 26–33.

Sydnor, Charles S. *Gentlemen Freeholders: Political Practices in Washington's Virginia.* Chapel Hill: University of North Carolina Press, for the Institute of Early American History and Culture at Williamsburg, Virginia, 1952.

Thomas, David. "The Visual Arts." In C. W. Crawley, ed., *The New Cambridge Modern History.* Vol. 9, *War and Peace in an Age of Upheaval, 1790–1830.* Cambridge: At the University Press, 1965.

Thorp, Margaret Farrand. *The Literary Sculptors.* Durham, N.C.: Duke University Press, 1965.

Tillim, Sidney. "Three Centuries of American Painting." *Arts Magazine* 39 (April 1965):36–43.

Tinkcom, Margaret B. "Cliveden: The Building of a Philadelphia Countryseat, 1763–1767." *The Pennsylvania Magazine of History and Biography* 78 (1964):3–36.

Tracy, Thomas J. "The American Attitude toward American Literature during The Years 1800–1812." Ph.D. Dissertation, St. Johns University, 1940.

Venturi, Lionello. *History of Art Criticism.* Translated by Charles Marriott. New York: E.P. Dutton & Co., 1936.

Wallace, Richard W. "The Genius of Salvator Rosa." *Art Bulletin* 47 (1965): 471–480.

Wallace, W.S. *The Growth of Canadian National Feeling.* Toronto: The Macmillan Company of Canada, 1927.

Warren-Adams Letters: Being Chiefly a Correspondence among John Adams, Samuel Adams, and James Warren. Massachusetts Historical Society *Collections*, 5th ser., vol. 73. Boston: Published for the Society, 1925.

Waterhouse, Ellis K. *Painting in Britain, 1530 to 1790.* 2nd ed. Harmondsworth, England: Penguin Books, 1962.

————. *Three Decades of British Art, 1740–1770.* Philadelphia: American Philosophical Society, 1965.

Watson, Lucille McWane. "Thomas Jefferson's Other Home." *Antiques* 71 (1957):342–346.

Weitenkampf, Frank. "Early American Landscape Prints." *Art Quarterly* 8 (1945):40–67.

Wellek, René. *A History of Modern Criticism: 1750–1950.* Vol. 1, *The Later Eighteenth Century.* New Haven, Conn.: Yale University Press, 1955.

————. "Romanticism Re-examined." In Northrop Frye, ed. *Romanticism Reconsidered*, pp. 107–133.

Whitley, William T., ed. *Art in England, 1800–1820.* Cambridge: At the University Press, 1928.

Wilmerding, John. *A History of American Marine Painting.* Salem and Boston: The Peabody Museum and Little, Brown, & Co., 1968.

Wilson, Samuel, Jr., ed. *Impressions Respecting New Orleans by Benjamin Henry Boneval Latrobe: Diary and Sketches, 1818–1820.* New York: Columbia University Press, 1951.

Wright, Louis B., et al. *The Arts in America: The Colonial Period.* New York: Charles Scribner's Sons, 1966.

Wright, Nathalia. *American Novelists in Italy: The Discoverers, Allston to James.* Philadelphia: University of Pennsylvania Press, 1965.

Wright, Richardson. *The Story of Gardening from the Hanging Gardens of Babylon to the Hanging Gardens of New York*. New York: Dover Publications, 1963.

Young, James Sterling. *The Washington Community, 1800–1828*. New York: Harbinger Books, 1966.

❧ Index

Academies, 62–82, 85, 87–88, 138, 269–270; American Academy of the Fine Arts (New York), 67–71, 72, 73, 79, 81, 97, 101, 113, 138, 270; Canadian, 274–275; Columbianum, 65–67, 71, 73, 88, 101, 131, 270; Pennsylvania Academy of Fine Arts, 71–80, 85, 91, 97, 113, 132, 144, 270; Quesnay's, 63–65; Royal, 63, 66, 68, 106, 108, 109, 121, 126, 132

Adam, Robert (*Survey of the Arts in England*), 158

Adams, Abigail, 24, 184, 236–237; on education of women, 11

Adams, John, 1, 6, 11, 19, 158, 216; on American cities, 205, 208, 209–210, 211; on art, xii, xiii, 52–53, 59, 82, 273, 279–280; on dancing, 197, 198; on England, xi–xii, 237, 240; on feminism, 9; on music, 177–178, 184, 188; on nationalism, 30; on Spain, 257

Adams, John Quincy, xiii, 242; on American culture, 54, 62; on Joel Barlow, 88; on critics, 20; on the frontier, 26; on Gilbert Stuart, 123; on travels in Europe, 239, 248, 250, 253, 255, 260

Adams, Samuel, 177

Aesthetic theory, x–xi, 1–22, 30–31, 96, 131, 141

Aesthetic vocabulary, 1–22, 23, 96, 159, 195, 268–269, 274, 278; in architecture, 142–144, 147, 148, 161; in travel, 231–234, 249–250

Africa, ix, 275; Algiers, 241; Hottentot village, 260; Morocco, 262; Tangier, 245; Timbuctoo, 260. *See also* Egypt

Alison, Archibald, 30, 184; *Essays on the Nature and Principles of Taste*, 8–9, 16

Allison, Burgess, 65

Allston, Washington, 52, 125, 126, 128; *Dead Man Restored to Life*, 125

American Academy of the Fine Arts, Philadelphia. *See* Academies, Columbianum

American Art Union, 64

American Philosophical Society, 44

American renaissance, x, 281

Amsterdam, 54, 175, 215, 241, 248; Stadt House, 160

Ancients vs. moderns, 5, 25–26, 98, 149, 175–176, 188, 189, 270

Anderson, Eliza, 92

Andrei, Giovanni, 102

Architects, 55–56

Architecture, 97, 140–170, 201, 202, 265, 273, 277; American, 207, 210–213, 216, 230, 271; Baroque, 141, 142; church,

160–161, 167, 168; classical, 56, 86–87, 100, 140–163 passim, 168, 169, 170, 238; English, 140, 153, 159, 164–165, 245; European, 238, 239, 240, 251; evolution of, 86, 87; exotic, 162, 251; French, 153, 155–156, 162, 245; Gothic, 145, 152, 153, 159–163, 214, 245, 249, 250, 257, 261–262; Greek Revival, 143, 144, 145, 153, 170; Italian Renaissance, 143, 160; Moorish, 251, 262–263; picturesque, 157–158, 262; Roman, 146, 152, 153; romantic, 146, 158; Russian, 260; Spanish, 162, 257–258

Armstrong, General John, 72, 73, 74

Art instruction, 30, 48, 64, 66, 80, 197

Artists: patriotic role of, 51–95, 201; professionalization of, 49, 55–60, 63, 64, 65, 78, 157, 172, 269, 277; status of, 31, 61, 78, 190–191, 273–274; use of nature by, 228–229

Ashe, Thomas, 231

Associationism, 9, 184, 185

Astor, John Jacob, 92

Austin, Benjamin, Jr., 54

Australia, ix, 260, 267, 268, 269, 270

Azores, 260

Babylon, 215, 241, 248, 255

Bach, Johann Sebastian, 171

Baker, Paul, 236

Ballet, 198, 199

Baltimore, 59, 132, 144, 215; Cathedral, 152–153; Gay

Street Bridge, 166; Library, 153

Barclay, Thomas, 245

Barker, Virgil, 107

Barlow, Joel, 61, 280; *Columbiad*, 88; *Visions of Columbus*, 279–280

Bartram, John, 226

Belgium: Antwerp, 245; Brussels, 243; Liège, 239

Benjamin, Asher, 140

Bennett, Rev. John, 174

Bernini, Giovanni, 98

Biddle, Nicholas, 73, 74

Biddle, Owen (*The Young Carpenter's Assistant*), 157

Billings, William, 172 177, 180, 182, 185, 191; *The Continental Harmony*, 178–179

Birch, Thomas, 79, 133

Birch, William, (*Country Seats of the United States*), 136–137

Blair, Hugh (*Lectures on Rhetoric and Belles Lettres*), 7–8

Blennerhassett, Harman, 230

Bogert, John G., 81

Boston, 205, 209, 210, 232, 234; Common, 209, 219; Fanueil Hall, 142, 158; Federal Street Meeting House, 161; Hollis Street Meeting House, 155, 157; Tontine Crescent, 151; Triumphal Arch, 157

Boudet, D. W., 124, 126

Brackenridge, Hugh Henry, 279

Bradford, William, 280

Brazil, 267, 275

Bridges, 164, 165–167; Schuylkill River, 134, 166, 170

Bronson, B. H., 252

Brown, Charles Brockden, 278, 279

Buffon, Count de, 51

Bulfinch, Charles, 140, 151, 168; Hollis Street Meeting House, 155, 157; Triumphal Arch, 157

Burke, Edmund, x, 1, 7

Burn, David, 60

Burney, Charles, 191, 193

Canada, 264–265, 268, 270, 275; Halifax, 265; Montreal, 241; Quebec, 265

Canova, Antonio, 101

Carpenters Company of Philadelphia, 56

Castles, 243, 244, 250, 261, 262; Roslin, 161, 162; Warwick, 261–262

Catholicism, 183–184, 242, 257

Ceracchi, Guiseppe, 101

Charleston, S. C., 72, 124, 216

Chateaubriand, Vicomte François René de, 126, 181; *Atala*, 113, 117; *Travels in Greece and Palestine*, 259

China, 225–226; Canton, 245

Circus, 47, 198

City planning, attitudes toward, 207–220, 238–241, 247, 251–252, 256, 266

Claiborne, Major Richard C., 65

Clarke, Edward D. (*Travels*), 259

Class bias, 2, 17, 19, 31, 37, 38, 57, 58, 78, 85, 86, 115, 144, 145, 194, 199, 219, 220, 268

Climate, 28, 29, 152, 153, 157, 217

Clymer, George, 72, 80

Cogdell, John, 124

Colonialism, x, 26, 99, 206, 267, 268, 275, 276, 277

Columbia College, 227

Common sense, 3, 8, 115, 116, 131, 133, 135, 195

Connecticut, 207, 234. *See also* New Haven

Connoisseurs, 96, 130, 190; contempt for, 20–21, 85–86, 116–117, 135, 191, 192, 281

Coolidge, Ellen Randolph, 207

Cooper, James Fenimore, 172, 277; *The Pioneers*, 281

Copley, John Singleton, x, 52, 64, 68, 123, 125, 130

Corelli, Arcangelo, 187, 190

Correggio (pseud.), 110

Cox, James, 66

Crafts, 165, 192–193; exhibited, 72, 132

Criticism, 6, 53, 96, 115, 141, 142; in architecture, 145–146; in literature, 277–279, 281–282; in music, 173–174, 176, 178–179; in painting, 108–109, 116–117, 125–127, 129–136, 272; principles of, 21–22, 275; in prints, 138

Critics, distrust of, 19–21, 94, 191, 281

Cutler, Manasseh, 46, 223

Daggett, David, 41–43

Dancing, 28, 195, 197–201, 263, 271; moralistic distrust of, 10–11, 21, 34, 197–201, 242, 258, 263

Dartmouth College, 141

David, Jacques Louis, 118–119; *Oath of the Horatii*, 118

Decadence, 24, 29, 40, 140, 170

Delaware (New Castle), 212

Democracy: aesthetic implications of, 6, 14, 17, 19, 20, 90, 94, 139; ideology of, 85, 86, 131, 133, 147, 170, 178,

179; values of, 2, 36, 37, 115, 128, 176, 188, 253, 268
Dorsey, John, 74
Dunbar, John, 227
Dwight, Timothy (*Conquest of Canaan*), 279–280

Eddystone Lighthouse, 159
Egalitarianism, xi, 8, 11, 18–19, 22, 86, 90, 107, 120, 126, 145, 170, 178, 179, 187, 189, 190, 195
Egypt: Alexandria, 251; Cairo, 240, 251–252, 274; Pompey's Pillar, 255; pyramids, 255; Thebes, 255
Eicholtz, Jacob, 123
Elson, Ruth, 29
Ely, E. S., 183
Emerson, Ralph Waldo, x, 15, 128, 281
England: Americans' travels in, xi–xii, 239–240, 243; Battle Abbey, 249; Blenheim, 253; Cornwall, 255; Lake District, 252; Litchfield Cathedral, 261; Tintern Abbey, 262. *See also* Liverpool; London
Engraving, 62, 80, 136–139, 141
Enlightenment, x, 126
Etchings, 136–139
European ideas, x, 1, 2, 5, 6, 14, 22, 24, 28, 29, 51, 57, 68, 84, 131, 139, 149, 152, 225

Fashions, 18, 157, 187, 246; critique of, 34–43, 44, 92, 242, 245, 281
Feminism, fear of, 11–13, 38, 281
Fiji Islands, 260
Flaxman, John, 98
Flewelling, H. L., 277
Flexner, James T., 108
Florence, 238, 241, 250–251; Pitti Palace, 250

Florida (Pensacola), 212
Folk arts, 202, 271; architecture, 163, 245; dance, 200, 242, 263; music, 172, 195, 196, 198, 263; painting, 106, 115, 129, 130, 131
France, x, 27, 43, 66, 67, 72, 238, 243, 245, 275; Lyons, 239; Toulouse, 244; Versailles, 265. *See also* Paris
Franklin, Benjamin, x, 104, 189–190; *Poor Richard*, 4, 10
Franklin, William Temple, 103
Free, William, 277
Freneau, Philip, 279, 280
Fulton, Robert, 72
Functionalism, 4–5, 16, 17, 21, 37, 228; in architecture, 146, 149, 153–154, 163, 165, 166, 167; in city planning, 208; in clothing, 42; in human beauty, 12, 40; instrumental, 5, 16, 22, 100, 145, 146, 151, 155, 161, 202, 207, 268; symbolic, 99–101, 145, 146, 207
Furniture, 142, 154
Fuseli, Henry, 112, 113, 121, 125; *The Lazar House*, 112

Gardens, 218, 220–222, 229, 230, 237, 264, 265–266; botanical, 226–227; pleasure, 222–225, 226, 227
Gautherot (*The Funeral of Atala*), 117
Genius, 18–19, 22, 26, 34, 83, 89, 113, 128, 129, 136, 156, 159, 191, 194, 228
Germany, ix, x, 97, 111, 222, 229, 238, 239; Bremen, 240; Dresden, 248; Hamburg Exchange-Hall, 162; Silesia, 242, 248, 255
Gibraltar, 264

Gilpin, William, 231–232
Gothic: ornament, 165; taste, 140, 142, 160, 162, 164, 262; usage of term, 25, 159–160
Gowans, Alan, xiii, 55, 99–100, 140, 146–147, 150
Grand Tour, 235, 237–239, 240–250, 252–254, 256–257, 260, 261, 265, 266
Gray's Gardens, 223–224
Great Britain, x, 1, 8, 20, 22, 236, 238, 244; class structure in, 2, 4; national character of, 4, 29, 43, 275. *See also* England; Scotland; Wales
Greece, 40, 83, 86, 113, 255, 258–259; Aegean Islands, 258, 259; during classical era, 24, 27, 28, 83, 84, 85, 109, 112, 133, 147, 152, 170; Rhodes, 259
Greene, Sue, 282
Greenough, Horatio, 99; and functionalism, 4–5, 152, 164
Guercino (pseud.), 122
Guy, Francis, 124, 132, 138

Haiti, 261
Hall, Frederick, 240
Hamilton, Alexander, 104
Hamilton, William ("Woodlands"), 226–227
Hamlin, Talbot, 140
Handel, G. F., 18, 171, 180, 187, 190, 223; oratorios, 177–178, 184, 246
Harris, Neil, 23, 63, 236
Harvard College, 151
Hawthorne, Nathaniel (*The Scarlet Letter*), 281
Haydn, Joseph, 171, 177
Hierarchy of the arts: 33, 120–121, 174–175, 186, 197, 271–272, 274

Hogarth, William, 108, 113, 118–119
Holy Land, 258–260; Jerusalem, 259; Nazareth, 259; Palestine, 259
Homer, 18
Hopkinson, Francis, 181, 188–189
Hopkinson, Joseph, 73, 85
Hosack, David (Elgin Botanical Gardens), 226, 227
Houdon, Jean Antoine, 100, 103
Hovey, Otis, 123
Huddleston, Eugene, 231
Hudson River Palisades, 127
Humphreys, David, 276
Hussey, Christopher, 157–158

Ibbetson (*Eagle Crag from Scandergile Force, Borrowdale. Effect of Sunshine on a Waterfall*), 135–136.
Illuminations, 59, 71, 222, 224
India, ix; Calcutta, 245; Coromandel coast, 254
Indians, American, 235
Ingersoll, Edward, 83
Inman, Dudley, 55–56
Interior decorating, 150–151, 154–155, 162, 165, 167, 251
Ireland (Dublin), 240, 252
Irving, Washington, x, 258, 277
Italy, ix, 27, 53, 69, 85, 102, 105, 112, 113, 177, 190, 195, 196, 229, 238, 258, 259, 267; Herculaneum and Pompeii, 98, 151, 256; Leghorn, 241; Milan, 215; Palermo, 248, 249; Piedmont, 243, 256. *See also* Florence; Naples; Rome
Izard, Ralph, 41

Jamaica, 261, 263, 266; Kingston, 266

Jarvis, John W. (*Irving*), 131
Jefferson, Thomas, 6, 57, 66, 67,
 205, 226, 229; on aesthetic
 theory, 1, 3, 9, 13–14, 25, 279;
 on architecture, 151, 152, 153,
 154, 156; on the arts, xiii, 75,
 82, 278; on city planning, 215–
 217; on education of women,
 11–12; on fashions, 35; on
 Monticello, 141, 146–147,
 149, 153, 205, 221, 227, 229;
 on music, 189, 190, 192, 193,
 195; *Notes on Virginia*, 3,
 51–52, 147, 156, 233, 271;
 on painting, 124; on patron-
 age, 49, 60–61, 69, 88, 89,
 90, 92, 99, 102, 148, 269, 280;
 on progress, 26, 51–52; on
 symbolic functionalism, 99–
 100, 101, 118, 119, 146–147;
 on travel in Europe, 237, 240,
 243, 249; and University of
 Virginia campus, 61, 146, 147,
 149–150, 153
Johnson, Samuel, 143
Jones, Inigo, 141

Kames, Lord, x, 208
Kentucky (Frankfort), 169
King, Rufus, 59, 70
Kouwenhoven, John, 4, 163, 164
Krimmel, John, 132; *Quilting
 Frolic*, 134; *View of Centre
 Square on July 4*, 133

Landscape design, 167, 207, 212,
 218–220, 222–227, 243,
 252–253
Landscapes, attitudes toward,
 202–207, 209, 211–213, 228–
 235, 238, 242–245, 247, 248,
 252, 253–256, 258, 260, 262,
 264, 268
Latrobe, Benjamin: on America,

 83–84, 86, 90, 93, 147, 165,
 170, 205, 208, 210, 222, 278;
 on architecture, 56–57, 58, 61,
 74–75, 140, 150, 151, 155,
 156, 167, 219, 271; on the
 arts, 76, 102, 103, 104–105,
 112, 160, 184, 190, 280; on
 city planning, 215, 216, 217;
 on New Orleans, 10–11, 198,
 213; on painting, 17, 117, 123,
 127, 129, 130, 138; on pa-
 tronage, 52, 72, 90, 91, 92,
 93, 269; and Waln house,
 Philadelphia, 153–155
Law, Andrew (*The Art of Sing-
 ing and the Musical Primer*),
 179–180
Ledyard, John, 251
Lehmann, Karl, 146
L'Enfant, Pierre C., 215, 216
Leslie, Charles, 112, 115–116,
 121, 123, 124, 125, 196; por-
 trait of Mr. Cooke, 131
Lewis and Clark Expedition, 203
Literature: American, 267, 276–
 282; ancient, 280; English,
 12, 277, 280, 282; French, 12,
 280–281; Scottish, 43
Liverpool, 241; Lyceum, 155
Livingston, Edward, 67, 68, 71
Livingston, Henry, country es-
 tate of, 158
Livingston, Robert R., xiii, 67–
 70, 75, 250, 280
Lockwood, Alice G. B., 221
London, 107, 112, 205, 229,
 239–240, 247–248, 274; baths,
 164; Drury Lane Theatre, 168;
 St. Paul's Cathedral, 55, 141;
 Wapping docks, 164; Westmin-
 ster Abbey, 160
Lorraine, Claude, 127
Lovejoy, Arthur, 114

McCartney, Lord, 226

McIntire, Samuel, 140; and Salem Court House, 157

McMahon, Bernard (*The American Gardener's Calendar*), 221

Madeira, 244–245

Madison, James, 148

Majorca, 260

Malbone, Edward, 129–130

Maryland, 102; Annapolis, 209, 221; Martinsburg, 232. *See also* Baltimore

Massachusetts, 234, 236–237; Concord, 212; Gill house, Princeton, 143; musical societies, 177; Nantucket, 211; Salem Court House, 157. *See also* Boston

Master builders, 56

Mead, William, 237–238

Melville, Herman, 260; *Moby Dick*, 281

Meredith, William, 73

Mexico, 261

Michelangelo, 98, 110, 111–112, 124, 128

Miller, Lillian, 23, 77, 270

Miller, Perry, 235

Miller, Samuel (*Retrospect of the Eighteenth Century*), 227

Milton, John, 183, 280

Missouri (St. Louis), 212

Mona Lisa, 116

Montesquieu, Charles Louis, Baron de, 42

Montgomery, Janet Livingston, 68, 73

Monticello. *See* Jefferson, Thomas

Moralism: and aesthetic theory, 2, 9–11, 16, 22, 25, 26, 29, 30, 31, 32–33, 34, 53, 81, 86, 268, 272, 273; and art exhibits, 47, 75, 76, 82; and artists, 65, 107; and dancing, 197–201, 258, 263; and fashions, 36, 37, 38, 41, 44; and gardening, 220, 224–225; and music, 173, 174, 181, 185, 186, 187, 193, 194–195; and painting, 108, 117; and prints, 138; and sculpture, 98–99; and travel, 228, 229, 237, 241–242, 253, 265

Morgan, Edmund, 42

Morse, Jedidiah, 41–42; *Geography*, 265

Morse, Samuel F. B., 92, 107, 125, 126; *The Dying Hercules*, 125

Mozart, Wolfgang Amadeus, 171

Mumford, Lewis, 149

Murray, George, 78, 119, 133

Museums, 89, 96, 273; Bowen's 49; Louvre, 69, 115, 141, 242; Luxembourg (Paris), 70, 118; Palais Royale, 116; Paris, 45, 250; Peale's, 44–49, 59, 98, 193; Waldron's, 47

Music, 33, 34, 41, 49, 62, 171–197, 200–201, 202, 263, 270, 271, 277, 281, 282; ancient, 176, 188; bravura in, 21; concert, 171, 175, 185, 191, 193, 194, 198; education in, 186–187; fuguing tunes, 172, 173, 177, 179–181, 182, 185, 200, 271; opera, 188, 195–196, 242, 263; organ, 46, 181, 242; "regular," 172, 177, 179–182, 186, 192, 200; sacred, 171, 172, 173, 174, 176, 177, 180–185, 186, 191–192, 246; symphonic, 171, 177, 195, 196; vocal, 173–201 passim, 242

Musicians, 56, 190–191

Naples, 213, 241, 256

Nationalism, ix, 13–14, 20, 23,

24, 43, 51–52, 83, 84, 94–95, 110, 121–122, 155–156, 158, 197, 234–235, 267–282

Nature, 18, 48, 129; appreciation of, 32, 47, 53, 205–206, 222, 224, 231, 232, 253, 256, 259; and architecture, 150, 157; and art, 16–17, 99, 202, 228–229, 235; definitions of, 14–15, 252, 272; and fashions, 35, 36, 41; and garden design, 225; and music, 178, 188, 190, 195; and painting, 111, 114–116, 117, 128, 132–133, 135, 136

Near East, 258–260; Baghdad, 259; Constantinople, 262; Medina, 258; Smyrna, 263–264; Turkish harem, 264

Neoclassicism: and aesthetic theory, 14–15, 17, 23, 24–25, 43, 156, 278, 282; in architecture, 141–170 passim; in Europe, 2, 22, 106, 272; in interior decorating, 151; in music, 171; and nature, 15, 114, 115, 117–118, 138, 231, 235; and painting, 108–122 passim, 135, 139, 163; and sculpture, 100, 102, 104, 271; in travel aesthetics, 236, 249, 255, 261, 262

Netherlands, 54–55, 238, 242, 243. *See also* Amsterdam

New Haven, 208

New Jersey: Pahaquarrie, 231; Princeton, 156; Trenton, 213

New Orleans, 71, 213–214; slavery in, 10–11

New York (city), 30, 47, 63, 67, 70, 71, 73, 130, 158, 169, 209–210; Elgin Botanical Gardens, 226, 227; Federal Building, 143; Government House, 157;

Grace Church, 144; pleasure gardens, 222–223

New York (state): Albany, 210; Anthony's Nose, 233; Lake Cayuga, 232; Lake George, 231; Long Island, 206; Poughkeepsie, 210–211

New Zealand, ix, 268, 269, 273

North Carolina, 101; Dismal Swamp, 231

Ohio, (Chillicothe), 210

Otis, Bass, 134

Paine, Thomas, 53, 88

Painters, 52, 56; portrait, 92; primitive, 93

Painting, 16, 30, 33–34, 106–136, 139, 149, 164, 172, 176, 270, 271, 272, 273, 277, 281; ancient, 25, 110; appreciation of, 21, 237; Canadian, 275; copies of, 60, 69–70, 92, 93; Dutch, 55, 115, 116, 135; exhibitions of, 73, 74, 75–76, 77, 78, 79, 108, 121, 125, 131–136; Flemish, 110, 113, 115, 135; French, 110; genre, 119–120; German, 115; Hudson River School of, 106, 271; Italian, 43, 110, 115, 116, 122, 128; landscape, 116, 126–127, 130, 132–134; portrait, 108, 115, 116, 126, 135

Palladio, Andrea, 141, 152

Panoramas, 45, 130, 209

Paris, 215, 239–240, 242, 265–266, 274; Bastille, 161; baths, 164; dancers, 200; Notre Dame, 250

Parks, 248; Battery Park (New York City), 218, 219; Blenheim, 253; Boston Common,

209, 219; Center Square (Philadelphia), 219; New Haven Green, 208, 218; New Orleans levee, 213; public walks, 219, 238, 239, 248; State House Square (Philadelphia), 44, 157, 219, 220

Patronage, 269, 274–275; and academies, 47, 48–49, 63, 72, 74, 77; in America, 25, 28, 59, 60, 62, 80, 82, 87, 88, 89–94, 279–280, 282; in Europe, xi–xii, 27, 54–55, 89, 242; for painting, 122, 123, 124, 126; for prints, 136, 138; for sculpture, 99, 100, 101, 103

Peale, Charles Willson, xiii, 206–207, 209, 221; and aesthetic theory, 7, 19; and the arts in America, 44–49, 56, 57–58, 59, 65–66, 71, 72, 73, 74, 88, 93, 279, 280; and dancing, 200; and music, 192, 193; and painting, 75, 92, 116, 124; and parks, 219, 220, 223; and sculpture, 103

Peale, James, 46, 132

Peale, Raphaelle, 65

Peale, Rembrandt, 65, 81, 93, 110, 118, 124, 129, 134

Penn, William, 229

Pennsylvania, 106, 229; Bethlehem, 193; 211; Huntingdon, 211; Milton Springs, 212; Pittsburgh, 58, 210; Yellow Springs, 230. See also Philadelphia

Pennsylvania, University of, 83

Persia, 27, 83, 162, 263

Pevsner, Nikolaus (The Englishness of English Art), 275

Philadelphia, 58, 59, 65, 66, 84, 91, 103, 124, 142, 153, 159, 160, 164, 207–209, 214, 215, 216, 217, 218, 227, 230; Bank of, 103; Columbia Anachreontic Society, 194; Dorsey's Mansion, 161; Harmonic Society, 175; Peale's Museum, 45, 49; Pennsylvania Academy, 70, 71, 72, 74; State House, 158; State House Yard, 44, 157, 219, 220

Philistinism, 91, 273–274

Picturesque: gardens, 225, 252–253; point of view, 6, 157–158, 159, 162, 231–232, 247–256 passim, 261, 266

Pine, Robert Edge, 65–66

Pinkerton, Mr., 239–240

Pioneer fiction, x–xi, 87, 94, 276

Poetry, 33, 34, 120, 175

Politics, 27–28, 29, 43, 48, 53, 61, 66–67, 72, 82, 86, 88, 89, 90, 149, 177–178, 179

Polynesia: Easter Island, 98, 260; Tongatabu, 263

Portugal, 258, 262; Lisbon, 185, 258

Poussin, 56, 110, 127

Pratt, Henry, 230

Prints, 80, 136–137

Progress, 23, 25, 26, 27, 29, 35, 36, 37, 43, 44, 51–52, 77, 84, 86, 94–95, 169, 175–176, 197, 205–206, 234–235

Provincialism, ix, 24, 26, 54, 64, 68, 84, 87, 97, 105, 125–126, 140, 206, 262, 267–281 passim

Quesnay, Alexander, 63–65, 67, 71

Raphael, 110, 111–112, 128; St. John, 116

Ramée, Joseph (design for Union College), 163

Raynal, Abbé, 51, 52

Realism, 16–17, 46, 98–99, 108, 115–139 passim, 202, 268

Relativism, 2–3, 17

Religious attitudes, 2, 10, 27, 32–33, 34, 39, 41, 88, 115, 228–229, 259, 273; and music, 173–174, 181, 182–184, 186, 193

Rembrandt, 113–114, 122

Rennie, John, 164–165

Research methods, xii–xiii, 236

Reviews, art exhibit, 75–76, 131–136, 163

Reviews, book, 7–8, 16, 137, 179–180, 203, 204, 210, 242–243, 254

Reviews, concert, 175, 194

Reynolds, Sir Joshua, 15, 112; *Discourses*, 18

Rittenhouse, David, 52

Rivers, 206; Columbia, 203; Hudson, 205, 262; Mississippi, 213; Missouri, 203–204; Mohawk, 233; Ohio, 230; Schuylkill, 133; Tiber, 203; Wye, 262

Robertson, Alexander, 30

Romanticism, x, 15, 32, 156; in architecture, 157, 158, 159, 161, 162, 164; in Europe, 22, 106, 127; in landscape design, 223–224; in literature, 282; in music, 171, 173, 175, 185, 189, 192, 263; in nationalism, 104, 156, 272; in painting, 111, 113, 117, 120, 121, 163; in travel aesthetics, 166, 203, 204–205, 231, 235, 236, 252, 254, 256, 257, 259, 260, 261, 264, 266

Rome, 27, 28, 83, 84, 147, 195–196, 238, 244, 254, 256; Baths of Titus, 255; Flavian Amphitheatre, 142–143; Saint Peter's Cathedral, 160

Rosa, Salvator, 113, 121, 125, 127

Rosenblum, Robert, 112, 158, 255

Rousseau, Jean Jacques, 253, 280

Rubens, Peter-Paul, 70, 110, 118

Rural bias, 202, 204, 207, 219, 221, 224, 227–230, 232, 235, 238, 242, 243, 249, 252, 253, 261, 268

Rush, William, 59–60, 104–105, 134, 271

Russia, 260; Baku, 260; Moscow, 260

Rutledge, John, Jr., 253

Sade, Marquis de, 112

Sansom, Joseph, 211

Scotland, 31, 133, 229, 254–255; Edinburgh, 238; Glasgow, 238

Sculptors, Italian, 90, 103

Sculpture, 96–105, 134, 139, 201, 237, 270, 276; classical, 45, 65–66, 67, 69, 71–72, 74, 75, 85, 97, 100, 101, 110, 160, 176, 250, 251, 252, 254, 273; Greek, 24; Parisian, 43, 242; neoclassical, 96, 134, 139, 271; Portuguese, 98

Shakespeare, William, 119, 280

Shee, Martin, 33–34

Shelburne Light House, 143

Short, William, 169

Smith, John Allen, 71–72

Society of Artists, 76–78, 79, 82, 83, 89, 93, 119, 132, 170

Sonneck, O. G. T., 171

South Carolina. *See* Charleston

Spain, 238, 257–258, 275; Madrid, 257; Seville, 257, 258; Valladolid, 257

Sperry, Jacob, 223

Spotswood, Susanna, 126
Staël, Madame de, 127, 281;
 Corinne, 160
Stuart, Gilbert, 52, 123, 129, 130,
 131, 132
Subjectivism, 8, 122
Sully, Thomas, 79, 82, 89, 123,
 133; *Lady of the Lake*, 133;
 portrait of Mr. Cooke as Rich-
 ard III, 133
Surinam, 261
Sweden, 244
Switzerland, 112, 229, 238, 247,
 253–254, 258, 259; Basle,
 246; Geneva, 242, 250
Symbolism, 102–103, 104, 140,
 145, 147, 148, 149, 150, 155,
 268

Thoreau, Henry David, x, 281
Ticknor, George, 150
Tillion, Sidney, 125
Titian, 110, 128
Transcendentalism, 15, 152
Transparencies, 44, 224
Travel accounts: of Central Amer-
 ica, 196; of Europe, 85, 161–
 162, 164, 175, 185, 188, 195–
 196, 199–200, 235, 236–266;
 of the Near East, 247; of
 South America, 184, 260–261;
 of the United States, 54, 159,
 164, 169, 184, 193, 202–235
Trott, Benjamin, 128–129, 130,
 132, 134
Trumbull, John, 52, 59, 60, 62,
 77, 88, 118, 125, 239; library
 of, 6–7
Tucker, George, 168
Turner, Frederick Jackson, 26
Twain, Mark, *Innocents Abroad*,
 196

Utilitarianism, 4

Vanbrugh, Sir John, 158; Blen-
 heim, 253; Claremont, 245
Vanderlyn, John, 69–70, 130
Van Dyke, Anthony, 110
Vaughn, Samuel, 157
Venice, 98, 238, 265
Vernacular tradition, 88, 135,
 137, 167, 268, 271; in archi-
 tecture, 140, 163–164, 165–
 166, 168, 169, 170; in litera-
 ture, 279, 280; in music, 172,
 173, 182, 185; in painting,
 106, 126, 129, 130, 131, 133,
 139
Veronese, Paul, 110, 128
Vienna, 170, 177, 196
Villaperta (sculptor), 102
Virginia, 102; Alexandria, 215;
 Capitol, 100, 148–149, 169;
 Charlottesville, 146; National
 Road, 167; Natural Bridge,
 229, 233; Norfolk, 208; Rich-
 mond, 205; University of, *see*
 Jefferson, Thomas; Williams-
 burg, 169, 271
Vitruvius Pollio, Marcus, 141
Volozan, Denis, 124, 132
Voltaire (pseud.), x, 1, 5–6

Wales: Llanberis, 248; Pont-
 cycyltty Aqueduct, 255
Waln House, 153–155
Washington, D. C., 58, 103, 149,
 153, 214–217; Capitol, 90,
 102, 103, 147–148, 155, 167–
 168, 269; White House, 169–
 170
Washington, George, 52, 66, 99–
 101, 102, 104, 130, 215, 224;
 Mt. Vernon, 104, 161, 222
Waterfalls, 203; Niagara, 127,
 138, 202–203, 229, 233, 234;
 Passaic, 234
Waterhouse, Ellis, 107

Wayne, Anthony, 104

Webster, Noah, 186–187, 208, 210

Wellek, René, 272

Wertmüller, Adolph (*Danaë*), 75–76, 82, 115

West, Benjamin, 52, 64, 68, 73, 106–109, 111, 113, 121, 122, 123, 124, 125, 131, 139; *Christ Healing the Sick in the Temple*, 107

Westall (painter), 115–116; 120, 121

Whitley, William, 135, 136

Whitman, Walt (*Leaves of Grass*), 281

Wilderness, response to, 127, 202–204, 205–206, 229, 230, 232, 235, 242, 243–244

Wilkie, David, 120, 121

Williams, Helen Maria, 161

Williams, Henry, 89

Williamsburg, Va., 169, 271

Winckelmann, J. J., x, 24, 28, 108, 112, 251

Winter, John, 56

Women, role of, 11–13, 25, 29, 36, 92

Wood (miniature painter), 130

Wren, Sir Christopher, 141

Yale College, 41, 143

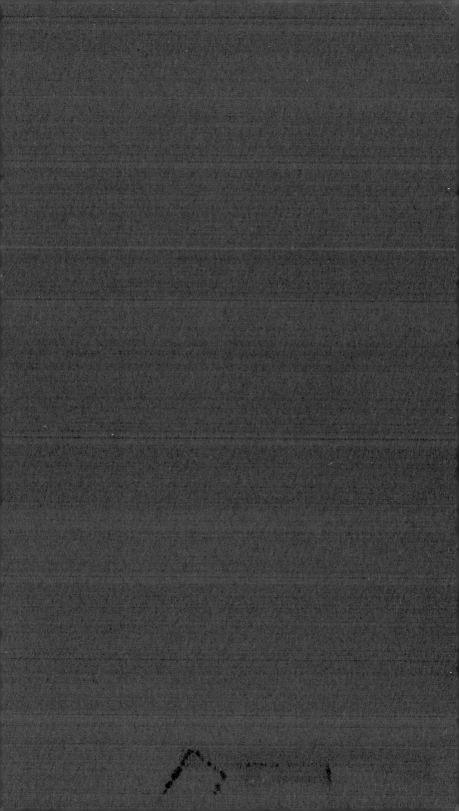